PRINTMAKING IN AMERICA

COLLABORATIVE PRINTS AND PRESSES, 1960–1990

PRINTMAKING
IN AMERICA COLLABORATIVE PRINTS
AND PRESSES 1960– 1990

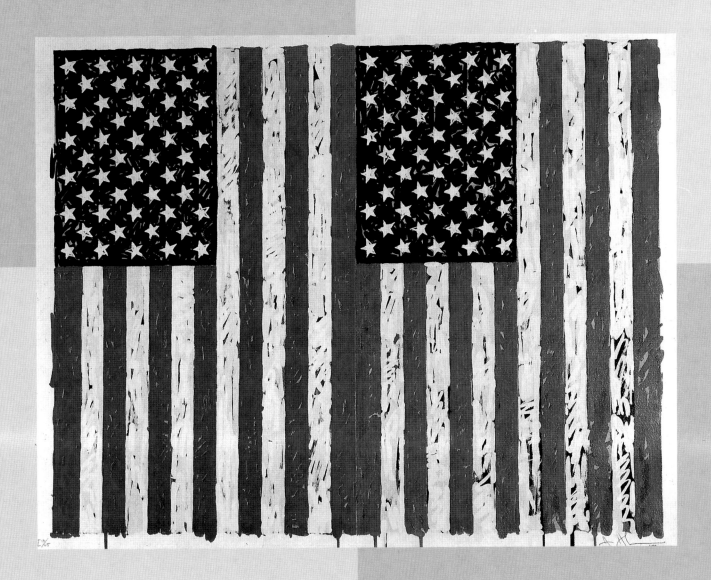

TRUDY V. HANSEN

DAVID MICKENBERG

JOANN MOSER

BARRY WALKER

HARRY N. ABRAMS, INC., PUBLISHERS

IN ASSOCIATION WITH

MARY AND LEIGH BLOCK GALLERY,

NORTHWESTERN UNIVERSITY

Editor: Elaine M. Stainton
Designer: Robert McKee

Exhibition Itinerary:

The Jane Voorhees Zimmerli Art Museum,
Rutgers—The State University of New Jersey
New Brunswick, New Jersey
April 23–June 18, 1995

Mary and Leigh Block Gallery,
Northwestern University
Evanston, Illinois
September 22–December 3, 1995

The Museum of Fine Arts, Houston
Houston, Texas
January 23–April 2, 1996

National Museum of American Art,
Smithsonian Institution
Washington, D.C.
May 10–August 4, 1996

Library of Congress Cataloging-in-Publication Data
Printmaking in America: collaborative prints and presses, 1960–1990/
Trudy V. Hansen . . . [et al.].
p. cm.
"An exhibition organized by the Mary and Leigh Block Gallery, Northwestern University."
Includes bibliographical references and index.
ISBN 0–8109–3743–3 (Abrams hardcover). — ISBN 0–941680–15–0 (Museum paperback)
1. Prints, American — Exhibitions. 2. Prints — 20th century — United States — Exhibitions.
3. Group work in art — United States — Exhibitions. I. Hansen, T. Victoria. II. Mary and Leigh Block Gallery.
NE508.P69 1995
769.973'074'7731 — dc20 94–25246

Printed and bound in Japan

Front cover:
Alan J. Shields, *Sun Moon Title Page* or *Pampas Little Joe*
Collection of Madison Art Center, Madison, Wisconsin

Back cover:
Frank Stella, *Pergusa Three, State I*
University of Michigan Museum of Art, Gift of the Friends of the Museum

CONTENTS

LENDERS TO THE EXHIBITION

Steven Andersen at Akasha Press, Minneapolis

The Art Institute of Chicago

The Baltimore Museum of Art

Mel Bochner

Brooke Alexander Editions, New York

The Brooklyn Museum

Kathan Brown, Crown Point Press, San Francisco

Cirrus Editions, Ltd., Los Angeles

David Winton Bell Gallery, Brown University, Providence, Rhode Island

Diane Villani Editions, New York

Echo Press, Indiana University, Bloomington

Edition Schellmann, Cologne–New York

Editions Ilene Kurtz, New York

Rosa and Aaron Esman

Fawbush Gallery, New York

Fendrick Gallery, Chevy Chase, Maryland

Raymond Foye

Sam Francis and Litho Shop, Inc., Santa Monica, California

Graphicstudio/ University of South Florida, Tampa

The Grenfell Press, New York

Harlan & Weaver Intaglio, New York

Henry Art Gallery, University of Washington, Seattle

The Jane Voorhees Zimmerli Art Museum, Rutgers—The State University of New Jersey, New Brunswick

K. Caraccio Etching Studios, New York

Landfall Press, Chicago

Madison Art Center, Madison, Wisconsin

Rona and Harvey Malofsky

Marshall Erdman and Associates

Mary and Leigh Block Gallery, Northwestern University, Evanston, Illinois

The Menil Collection, Houston

Mount Holyoke College Art Museum, South Hadley, Massachusetts

Multiples Inc./Marion Goodman Gallery, New York

The Museum of Fine Arts, Houston

The Museum of Modern Art, New York

National Museum of American Art, Smithsonian Institution, Washington, D.C.

Pace Editions, New York

Paula Cooper Gallery, New York

R. E. Townsend Studio

Shark's Inc., Boulder, Colorado

Simmelink/Sukimoto Editions, Marina del Rey, California

Martha Singer, Long Island, New York

Solo Impression Inc., New York

Universal Limited Art Editions, West Islip, New York

The University of Iowa Museum of Art, Iowa City

The University of Michigan Museum of Art, Ann Arbor

The University of New Mexico Art Museum, the Tamarind Archive Collection, Albuquerque

Vinalhaven Press

Wadsworth Atheneum, Hartford, Connecticut

Walker Art Center, Minneapolis

Whitney Museum of American Art, New York

INTRODUCTION AND ACKNOWLEDGMENTS

■

BY DAVID MICKENBERG

DIRECTOR, MARY AND LEIGH BLOCK GALLERY,

NORTHWESTERN UNIVERSITY

■

We have come to accept the notion of collaboration as the norm in dance, music, theater, film, and indeed, in almost all creative forms other than the fine arts. The modernist notion of the isolated genius creating in a vacuum, which has come to dominate much of our thinking about painting, sculpture, and the graphic arts, represents a failure to understand the complexities of input that influence and illuminate artistic decisions. On collaboration Bob Blackburn wrote:

> *We must see this as a hierarchy of relationships in which the mind, thought, expressiveness, imagination, mystery, and magical dreams are the artist. Without the total awareness of this fact there is no dream space. The wizardry and alchemy that is wielded by the creative technician enriches the experience or the final image, but it must never dominate or dictate the creative thrust. If highly technical skills override the concept of the artist, the works become hollow. To become a breathing life force, the artistic ingredient must be felt rather than just used as a display of surfaces, textures and colors—beautiful but lacking substance. The work must dance on the edge of the abyss.[1]*

Printmaking in America: Collaborative Prints and Presses, 1960–1990 presents one of the first historical discussions of the multitude of talent and broad array of personalities and creations that have danced "on the edge of the abyss" in collaborative printmaking during the past thirty years. From those who went to Europe to get their training and inspiration, to those who created fundamental and permanent change in the structure of the printmaking community in the United States, this exhibition celebrates the development of the collaborative printmaking process and its distinctly American character in these three decades.

Printmaking in America is the unified vision of two gifted art historians who agreed that an exhibition documenting this unique period in American print history was essential. It originated in a discussion between Trudy V. Hansen, Curator of Prints and Drawings at the Zimmerli Art Museum at Rutgers University, and myself more than three years ago. Given her extensive knowledge of contemporary prints and her role as the curator of The Rutgers Archives for Printmaking Studios at the Zimmerli, and the Block Gallery's expertise in the organization of exhibitions and the publication of catalogues relating to the history of prints, we agreed to bring *Printmaking in America* to fruition. She also proposed bringing Barry Walker into the project as co-curator. Together, Walker and Hansen have guided the exhibi-

tion in selecting the works and in setting its intellectual parameters, and both have contributed essays to the catalogue. It was also a pleasure to ask Joann Moser, one of the leading scholars in American prints, to collaborate with us on this project. Moser was no stranger to the Block Gallery, as she had been a curator of one of our previous exhibitions and has lectured here on several occasions. Her essay joins those of Walker and Hansen in establishing a new level of scholarship in the history of American prints.

A major exhibition of this kind brings together many talents, all directed toward a common goal. In this case, so many have assisted with the conception, organization, and publication that they are literally too numerous to mention. Some whose assistance has been essential are: Steven Andersen, David Bancroft, Apple Bass, Timothy Berry, Leta Bostelman, Peggy Brennan, Elizabeth Broun, Kathan Brown, Kathy Caraccio, Dennis Cate, Neil Cogbill, Marabeth Cohen, Rosanne Colachis, Sylvan Cole, Marjorie Devon, Allan Drebin, Donald Farnsworth, Carma C. Fauntleroy, Joe Fawbush, Robert Feldman, Barbara Fendrick, Danielle Fox, Raymond Foye, Bill Goldstein, Dorothy Halic, Pegram Harrison, Michael Henry, Leo Holub, David Jones, David Keister, Marilyn Kushner, Jack Lemon, Suzanne McCullagh, Robert McKee, Meg Malloy, Peter Marzio, Virginia Mecklenberg, Jennifer Melby, James Miller, Leslie Miller, Carolina Netsch-Jones, Patricia Nick, Mark Pascale, Cheryl Pelavin, Lynnanne Polachek, Steve Poleskie, Charles Robertson, Sylvia Roth, Maurice Sánchez, Bud Shark, Beth Silverman, Doris Simmelink, Judith Solodkin, Elaine Stainton, Andrew Stasik, Susan Teller, Barbara Trelstad, Richard B. Tullis II, James Watrous, June Wayne, Carol Weaver, Janet Wilson and James Yohe.

I would like to thank personally all of the lenders to the exhibition, who have so generously parted with their works for an extended period in order to do justice to history. I also gratefully acknowledge the support of the National Endowment for the Arts, the Elizabeth F. Cheney Foundation and the Rothschild Foundation.

Finally, four individuals in particular, without whom there would be no exhibition and no catalogue, deserve special recognition. Kate Steinmann, Program Assistant, Jennifer Holmes, Registrar, Rhoda Rosen, Program Assistant, and Elizabeth Seaton, Assistant Curator, of the Mary and Leigh Block Gallery, have served valiantly, creatively, and patiently in the organization of almost all aspects of the project. It has been both a personal and professional pleasure to be associated with them.

1. *Printers' Impressions.* (Albuquerque: Albuquerque Museum, 1990), 6.

Collaboration in American Printmaking Before 1960

By Joann Moser

Senior Curator, National

Museum of American Art,

Smithsonian Institution

The Renaissance emphasis on individualism led to a widely accepted notion of the artist as a solitary genius. Art theorists in the fifteenth and sixteenth centuries took great pains to raise painting, sculpture, and architecture from the realm of the mechanical arts to that of the liberal arts. As artists began to emerge from the restrictions of the guild system and assert their intellectual superiority over mere artisans, their recognition as creators at times began to rival that of the divine Creator, leading to such hyperbolic expressions as the "divine Michelangelo." Reinforced by the Romantic tendency to interpret the universal in personal terms during the nineteenth century, the "great person" has been a mainstay of art history from its beginning as a discipline. Consequently, collaboration in the fine arts has been overlooked, deemphasized, and often denigrated by those who subscribe to the notion of the centrality of the individual artist and of the unique masterpiece as the highest expressions of originality and quality in art.

Although the "great person" approach has continued to dominate art history throughout much of the twentieth century, alternative models have gained adherents. Most prominent are Marxist theory, in which economic and social factors are of primary concern, and poststructuralist theory, in which the cultural biases of artists and writers of history assume great importance. Feminist art criticism has also had a signficant impact, and interdisciplinary approaches have greatly enriched our understanding of the factors that influence artistic creation.

More recently a theory of pluralist aesthetics has been proposed that focuses on the role artistic collaboration has played in the history of art.[1] According to the critic David Shapiro, all the great movements of Modernism—Impressionism, Post-Impressionism, Cubism, Fauvism, Expressionism, Futurism, Orphism, Vorticism, Dada, Suprematism, Surrealism, Abstract Expressionism, Pop Art, Minimalism, earthworks—were collaborative in nature. Shapiro observes that "the greater myth of the hero sometimes deforms this communal sense, and we begin to have a van Gogh without Gauguin, a Cézanne who does not sign himself student of Pissarro, an Orphism without the marriage of Sonia and Robert Delaunay and collaborating poets, Dadaism without the pacifistic friendships involved

throughout, Abstract Expressionism without the collaboration of Gorky and de Kooning, earthworks without the fierce alliance of Serra, Holt, and Smithson."[2] This critique not only enhances our understanding of Modernism, but also invites us to reconsider other movements in art from the perspective of collaboration.

Like other approaches to art history, Shapiro's theory of pluralist aesthetics offers valuable insights into the nature of artistic creativity and the history of art. As an alternative to the "great person" model, it focuses attention on interactions and relationships among artists, patrons, and the audience for art. It is especially useful for considering those fields of art in which collaboration has played a central role. For example, in architecture, mural painting, the casting of bronze sculpture, and printmaking, the artist often relies on the hands of others to execute his or her work.

The heroic model of artistic creation is especially ill-suited for understanding the history of printmaking, for a variety of reasons. Printmakers have rarely achieved the elevated stature of painters and sculptors, in part because printmaking has remained more closely associated with the mechanical arts. Many printmakers of the late fifteenth and early sixteenth centuries received their training as goldsmiths, and most of the printing shops retained the structure of medieval guilds. Although expressive, intellectual, and aesthetic considerations were important to the best printmakers, such as Albrecht Dürer, most prints were made to convey information. This practical function kept printmaking closely associated with the crafts. Because prints are, by definition, multiple originals, they were never granted the status that accrues to unique objects. Prints were usually bought by people who could not afford unique works of art, which further diminished their standing in a hierarchy where the wealth of the patron and the preciousness of the object carried great weight. Furthermore, the finished print was rarely the work of a single hand. Although some great printmakers, such as Rembrandt, were intimately involved in every stage of the conception, execution, and printing of their works, many more relied on expert craftsmen to make the plates and run the presses.

Throughout the eighteenth and much of the nineteenth centuries in America, most prints served commercial purposes. Few early printers had the skill or the interest to work with artists to achieve the level of quality necessary for fine art printmaking. Conversely, few artists sought to make prints, making the services of highly skilled printers unnecessary. Over the course of approximately one hundred years, from the mid-nineteenth through the mid-twentieth centuries, the strictly commercial relationship between artists and printers gradually evolved into a more creative interaction between highly skilled individuals. In contrast to artists in Europe and Asia, who inherited long-established traditions, American artists came relatively late to fine art printmaking and artistic collaboration. The evolution was not smooth and steady. Yet the artists, printers, publishers, and workshops who played a role in this development established important precedents for the dramatic transformation that took place during the second half of the twentieth century.

During the early 1960s, collaboration in fine art printmaking began to assert itself in a more positive, organized, and public manner through the emergence of influential workshops and presses in the United States. By the early 1990s, there were more than three hundred fine art printmaking workshops, presses, and independent printers in America, and many leading American artists were devoting a significant amount of their time to making prints. This development did not occur in a vacuum, however, and understanding its background adds an important dimension to appreciating this phenomenon.

THE TRADITION OF ARTISTIC COLLABORATION

Ideally, collaboration might be defined as an undertaking in which two artists of comparable stature participate equally in the conception and execution of a work of art, but in practice working in concert is rarely so pure and straightforward. Collaborative relationships can occur in many forms, and trying to define them too narrowly will unduly limit our understanding of them. We take for granted that the greatest creations of medieval art—cathedrals, stained glass windows, illuminated manuscripts, decorative metalwork—were shared projects, with various artists and craftsmen contributing their special expertise. As a corollary to the elevation of art to the realm of the liberal arts during the Renaissance, however, the importance of the conception of the work of art was emphasized over that of its execution. But even then, when the assertion of individuality was at its height, artists regularly worked together, often as master and student. The exquisite passages painted by Leonardo da Vinci in Andrea del Verrocchio's *Baptism of Christ* and Titian's completion of Giorgione's *Sleeping Venus* were integral to the success of the finished paintings. Despite the unequal relationship of master and student, each of these paintings might be considered a true collaboration.

Monumental works created over long periods of time by a succession of artists might be considered collaborative accomplishments, even though the artists may not have actually worked together. The grandeur of St. Peter's Basilica, for example, owes as much to the dome by Michelangelo and Giacomo della Porta as to the facade by Carlo Maderno and the colonnade by Bernini. Because of our bias toward recognizing individual accomplishment, we tend to break down the work into distinct parts for which we can assign individual recognition rather than acknowledging the collaborative nature of the whole.

The patron, too, sometimes contributed enough to the conception of a work of art to be counted as a collaborator in all but its execution. Consider Jacques Louis David's monumental portrayal of Napoleon's coronation, *Le Sacre* (1806–7, Louvre, Paris). Rather than allowing himself to appear kneeling before the pope to receive his crown, Napoleon preferred to be shown at a moment after his own coronation in the act of crowning his empress. A corps of assistants helped David paint this vast canvas, which measures approximately five hundred square feet. A specialist in perspective named Degotti was responsible for painting the background, and a pupil named Georges Rouget supervised other assistants who transferred David's drawings for each of the heads, which David then finished himself.[3]

If we accept David Shapiro's contention that the genesis of all Modernist movements was collaborative, then the twentieth century might be seen as a heyday of artistic collaboration.[4] Surely the variety of these relationships has expanded, especially during the second half of this century. Husband and wife teams of artists, such as Edward and Nancy Reddin Kienholz, Helen and Newton Harrison, Anne and Patrick Poirier, and Hilla and Bernd Becher, work together on projects, in contrast to most earlier such relationships in which each partner pursued a separate career. In some communal projects of the 1980s, the identity of the individual artist was entirely submerged in the group identity, for example, those of Gilbert and George, Komar and Melamid, or the Starn Twins. Other artists have tried to merge their individual identities into a collective whole. In a recent series of paintings by three California artists, William Allen, Robert Hudson, and William T. Wiley, elements of each artist's distinctive imagery remain visible, yet the paintings are more than the sum of their parts, expressing the close personal friendship and mutual admiration of the three artists.[5] Artists as varied as Andy Warhol, Sol Le Witt, and various makers of earthworks have taken responsibility only for the conception of some of their pieces, leaving the execution entirely to others.

Examples of artistic collaboration have occurred perhaps more consistently in printmaking than in any other medium. The process has always involved a designer who created the image, a person who transferred the image to a printing matrix (a metal plate or woodblock, later a stone, a screen, or other surface), and a printer. In many instances there was also a publisher who initiated the project, a person who approved the print, and another, usually the publisher, who distributed it. Some artists have fulfilled all these roles, but more frequently they have worked together with at least one other person.

To a large extent, this division of labor was dictated by practicality. A printing press was often difficult and expensive to acquire and also required housing and maintenance. As techniques developed beyond simple woodcuts and engravings, making prints required a level of technical expertise that many artists did not have the time or interest to acquire. Once the image on the matrix was ready for printing, the remaining task was the time-consuming and arduous labor of pulling the edition. After that, the works had to be distributed. As artists began to see themselves as creators rather than skilled craftsmen, they usually preferred to turn over the more routine aspects of printmaking to other hands.

The earliest woodblock prints were religious images intended for wholesale distribution to common people. The impetus for creating them probably came from the publisher who distributed them rather than from the artist who made the image. Gradually some artists began to initiate print projects, but the extent of the artists' involvement varied, and only rarely did they undertake all aspects of production on their own. Some artists made drawings intended to be translated into prints by someone else, while other artists remained actively involved throughout the creation of the matrix, turning to a professional printer to produce the edition. Although Albrecht Dürer engraved his own copper plates, he relied on form cutters as well as printers for his woodblock prints. James McNeill Whistler remained personally involved in every stage of the etching process, but he turned over his drawings on transfer paper to a professional printer to be made into transfer lithographs.

The variety of relationships that developed sometimes make it difficult to distinguish between a joint undertaking, in which each participant makes a creative contribution, and a mere division of labor for the sake of expediency. An artist who had designed an image for a print might not have had the equipment, time, and technical expertise to print an edition from it, and turning it over to a professional printer did not necessarily mean that a collaborative relationship had been established. At times, however, the role of the second person was inventive enough to be considered a true collaboration.

In the sixteenth century, it became customary to identify on the print itself each person who had a significant part in its production (Fig. I). The designer was identified by the Latin term *invenit* (abbreviated *inv.*, *invt.*, or *in.*, meaning "He designed") or *inventor*. If the print was based on a painting, the painter was identified by *pinxit* (abbreviated *pinx.* or *pinxt.*, meaning "He painted"). The person who put the image on the matrix was indicated by *delineavit* (abbreviated *delin.*, *delt.*, or *del.*, meaning "He drew"). The person who actually cut the block or engraved the lines was identified by *sculpsit* (abbreviated *sculp.*, *sculpt.*, or *sc.*, meaning "He engraved"), *fecit* (abbreviated *fec.*, meaning "He made"), or *incidit* (abbreviated *incid.* or *inc.*, meaning "He engraved"). The printer was identified by *impressit* (abbreviated *imp.*, meaning "He printed"), and the publisher was identified by *execudit* (meaning "He issued" or "He published").[6]

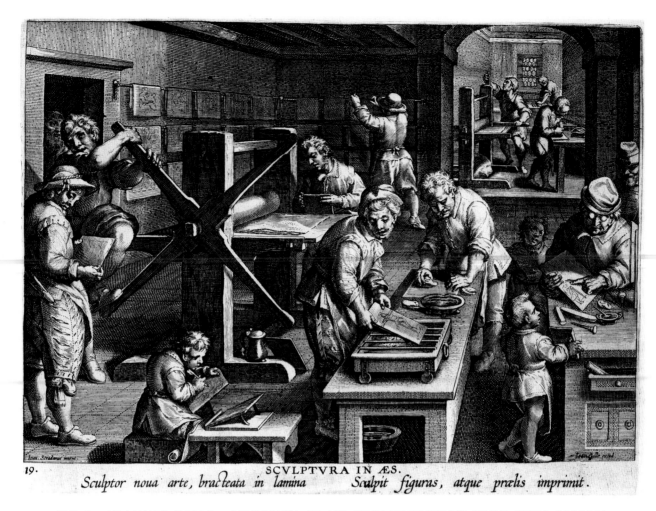

FIG. I ■ JOANNES GALLE ■ *SCULPTURA IN AES (THE ENGRAVERS)* FROM *NOVA REPERTA*
1600. Engraving. Print Collection, Miriam and Ira D. Wallach Division of Art, Prints and Photographs,
The New York Public Library, Astor, Lenox and Tilden Foundations.

Until the middle of the nineteenth century, the primary purpose of printmaking was the multiplication of images. These might have been conceived by the artist specifically for a print, or have been preexisting images that needed to be disseminated. Reproductive printmaking after other works of art, usually paintings, was one of the medium's most important uses from the sixteenth through the mid-nineteenth centuries, after which this function was gradually taken over by photography.

The extent to which reproductive prints can be considered collaborative depends upon the individual circumstances and the breadth of definition one is willing to accept for this concept. In some instances, the artist and engraver worked together closely and the contribution of each is clearly recognizable. In other cases, the engraver was merely a technician, relying on rigid formulas and standard techniques developed over the years to imitate the original as closely as possible. The success of the reproductive print depended as much on the talent of the engraver as on the quality of the original image.[7] Consider, for example, the large body of prints made after paintings by Rubens, who had an entire workshop of skilled printmakers under his close supervision. Most of the prints are engravings—the most common technique for reproductive prints—but some of the most distinguished and memorable of them are the woodcuts of Christoffel Jegher (1596–1652/53), who captured the monumentality and boldness of conception that distinguish Rubens's paintings (Fig. 2).

The analogy to a literary translation is instructive. A literal translation of a great novel rarely captures the spirit of the original as well as a freer, more expressive one that conveys the mood and eloquence of the original vocabulary and syntax. Although the translator is usually viewed as subordinate to the author, a skillful and sensitive translator is as much a collaborator with the author as is a master engraver with an artist.

One of the most dramatic forms of collaboration in printmaking occurs when an engraver or printer modifies established techniques or invents new ones to realize the artist's expression. Etching, for example, became popular at a time when artists felt the need for a more fluent, spontaneous line than engraving allowed. Successive bitings of an etching plate enabled the printmakers to convey the sense of deep space that artists wanted to suggest in their panoramic views. Aquatint and mezzotint were developed when artists wanted large tonal areas and rich blacks that were not achievable by line alone. In the art of seventeenth-century Holland, moody skies, shadowed interiors with candle or lantern light, and dramatically lit genre and religious scenes needed a wide tonal range to be adequately translated into prints. Although a master such as Rembrandt could achieve these effects through etching and wiping alone, the invention of mezzotint allowed other artists to realize these chiaroscuro effects. As techniques became more complex, artists grew even more dependent on the facilities and expertise of professional printers, and this mutual reliance developed into a relationship that long outlasted the interdependence of the artist and the reproductive printmaker.

The tradition of printmaking in Europe supported the proliferation of printers in every major country.[8] Some limited their business to strictly commercial jobs in which large editions were the rule, and a high level of expertise was not essential. Others achieved impressive technical proficiency in their commercial work, and, on occasion, were willing to print for artists. Still others specialized in working with artists and actively solicited their business. Auguste Delâtre, for

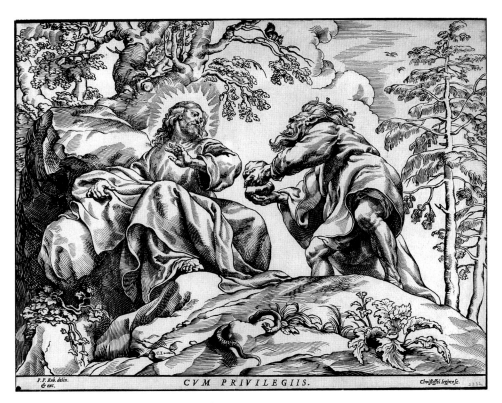

FIG. 2 ■ CHRISTOFFEL JEGHER (AFTER RUBENS) ■ *SATAN TEMPTING CHRIST*
ca. 1630. Woodcut. Division of Graphic Arts, National Museum of American History, Smithsonian Institution.

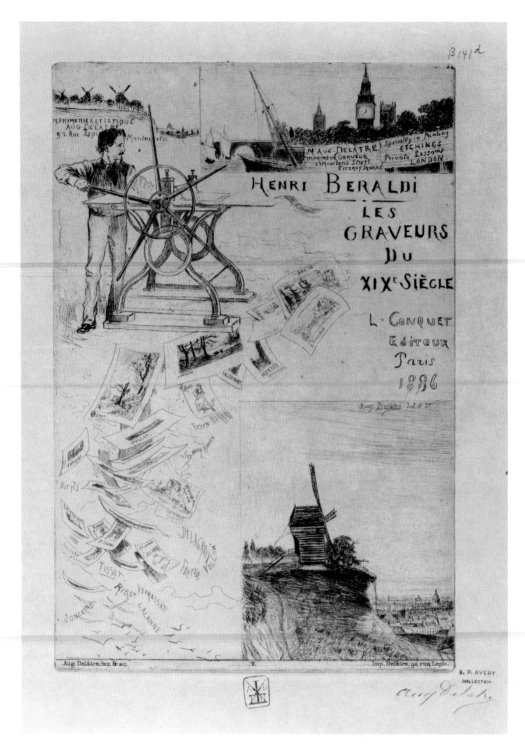

FIG. 3 ▪ AUGUSTE DELATRE ▪ FRONTISPIECE TO BERALDI, *LES GRAVEURS DU XIX*ᴱ *SIECLE*
1886. Etching. New York Public Library.

example, was an etcher himself as well as a highly respected printer of other artists' etchings. He gave lessons and published a treatise on the technique in 1887. In his frontispiece for another book on etching, Henri Beraldi's *Les Graveurs du XIX*ᵉ *Siècle*, Delâtre composed what can only be seen as an advertisement for his own services as an etcher (Fig. 3). Standing at an etching press with his Paris address just above his head in the upper left corner of the sheet and his London address in the upper right corner, Delâtre boasts of his work with Whistler, Haden, Tissot, Delacroix, Meryon, and Millet in the prints that seem to float down from his press. In the lower right corner is a

vignette of a landscape, signed Aug. Delâtre Del. et Sc., referring to his own work as an artist. The subject of this landscape is a windmill, which alludes to Rembrandt, whose use of plate tone Delâtre had reintroduced through skillful back-wiping of the inked plate (*retroussage*). Delâtre trained his son Eugène, who maintained his father's high standards and earned a reputation for his own fine work. Together with Roger Lacourière, Auguste Clot, Charles and Georges Leblanc, Paul and Raymond Haasen, and others, Auguste and Eugène Delâtre were as responsible as the artists themselves for the extraordinary flourishing of the artist-printmaker (*peintre-graveur*) in the late nineteenth and early twentieth centuries.

An important aspect of the relationship between artist and printer is their personal chemistry. An artist usually chooses a printer not only on the basis of his or her technical expertise, but also for the ease with which the artist can work in that printer's shop. A printer sensitive to an artist's expression and manner of working can often anticipate his or her needs and respond to them without even a verbal exchange. A sympathetic ambience can stimulate an artist's creativity, just as a demanding but highly respected artist can inspire a printer's ingenuity.

If the most direct form of collaboration is that of an artist with a printer, the important role of the publisher should not be overlooked. Such farsighted publishers as Ambroise Vollard, Daniel Kahnweiler, Albert Skira, Bruno Cassirer, J. B. Neumann, and Kurt Wolff financed and distributed significant projects that would not have happened without their initiative and support. Vollard persuaded Georges Rouault to devote nine years of his life to producing the monumental series *Miserere et Guerre*, and encouraged Chagall to create his etched illustrations of the Bible. Skira commissioned Picasso to illustrate Ovid's *Metamorphoses* and persuaded Matisse to illustrate Mallarmé's *Poésies*, the first major book for each artist. Without the publishers' persuasion, oversight, and financing, these extraordinary works of art would never have been created.

PRINTMAKING IN THE UNITED STATES

The European tradition of the artist-printmaker was slow to develop in the United States. Even more than in Europe, printmaking in America was, at first, primarily commercial, geared to producing multiple images to disseminate information. Until the late nineteenth century, originality was not as important a consideration as subject matter, competence of execution, and accuracy of detail. Maps and portraits were the mainstay of early American prints, in addition to city views, pattern books, pictures of specific locations and current events, or satirical commentaries on them. Relatively few American artists recognized the possibilities of printmaking beyond its reproductive function.

By the 1820s American prints with no utilitarian purpose began to appear. Among the earliest were John Hill's series of aquatints, *Picturesque Views of American Scenery*, issued in 1820–21 after watercolors by Joshua Shaw. Both Hill and Shaw were born and trained in England, where the practice of collaborative printmaking was well established. Hill's extraordinary skill with aquatint enabled him to capture the fluid, painterly effects of the watercolors, which contributed as much to these prints as Shaw's designs. As more printers like Hill arrived from Europe, printmaking gained a foothold in America.

Prints after paintings played a critical role in the training of American artists and the cultural education of the young nation, for they were disseminated among people who had no access to original paintings and provided important models for artists. Benjamin West knew European art almost entirely from reproductive engravings before he traveled

to Europe and eventually settled in England. Recognizing the importance of the engraver's role, West was the only painter to contest the Royal Academy's exclusion of engravers, whom he believed deserved to be put on an equal footing with painters.

Many American artists began their careers in printmaking shops. Thomas Doughty, an artist of the Hudson River School, initially worked as a print colorer for John Hill. Asher B. Durand, another Hudson River School painter, was apprenticed to the professional engraver Peter Maverick and spent the first fifteen years of his career as a printmaker. Understanding that a sensitive and skillful engraver was vital to the success of a reproductive print, John Trumbull specifically sought out Durand for the engraving of his painting *The Declaration of Independence*, as John Vanderlyn later did for his painting *Ariadne*. By 1850, with Durand's career as a painter sufficiently established, his *Dover Plains* was reproduced by another outstanding engraver, James Smillie. Although Durand was clearly able to do the job himself, the practice of working with a professional engraver was so well established that he entrusted this project to another hand.

Some artists did no more than turn over an image to a printer and then approve a final proof (known as the *bon à tirer*) before the edition was printed, while others remained closely involved at every step of the process. After an unsuccessful attempt to find a printer in Philadelphia, John James Audubon was forced to find one in England for his series *The Birds of America*. He gave exacting specifications to the engravers Robert Havell and his son, sometimes writing instructions in the margins of his watercolors. They translated the images into prints through a combination of etching, aquatint, line engraving, and hand coloring, sometimes incorporating the artist's changes made during the production process. The younger Havell, an artist himself who became a close friend of Audubon's, was called upon to finish the background for some images. Although Audubon monitored every aspect of production right through to the hand coloring, the size and complexity of the project required such an intimate working relationship between the artist and his printers that it can be considered one of the earliest collaborative projects of American printmaking.

Such prints offered several advantages for artists. A painting could be sold only once, whereas the sale of prints made from it could provide a steady source of income. Moreover, wide distribution of a successful image could greatly enhance an artist's reputation and fuel the demand for future work. Lesser-known artists whose paintings were reproduced in prints and sold through the American Art-Union hoped to gain wider recognition and increase the sale of their paintings.[9]

Despite the importance of reproductive printmaking for many nineteenth-century American artists, their relationship with engravers and printers was usually collaborative only in the broadest sense. By that time the methods for transferring images to a plate had become so standardized that engravers or printers rarely contributed more than technical competence. Although a combination of etching and engraving remained the choice for most reproductive prints, by the mid-nineteenth century lithography was fast replacing these intaglio techniques. Made from a crayon drawing on the smooth surface of a Bavarian limestone (later a specially prepared metal plate), lithographs required less skill than engravings to transfer the image to the printing matrix. A virtually unlimited number of prints could be pulled from a well-prepared lithographic surface, whereas engraved plates tended to wear down. Furthermore, a lithographic stone could be cleaned, prepared, and used again, but an engraved copper plate had to be discarded once the edition was complete. Because lithographs could be produced for a significantly lower cost than engravings, they

virtually supplanted engraving for most commercial purposes and also challenged its dominance for reproductive print-making. "The cheapness of lithographic prints brings them within the reach of all classes of society," proclaimed the editors of *Graham's American Monthly Magazine* in 1832.[10]

As a medium for popular art, lithography had great appeal. Publishers exploited its relatively low cost to produce thousands of images geared to a wide spectrum of interests. Perhaps the best known of the many publishing firms was Currier & Ives, a New York company whose name became virtually synonymous with the popular print trade because of its success in marketing an eclectic array of images. Scenes of everyday life and other popular subjects fulfilled a decorative and social function and made no pretense to being fine art. The publishers enlisted the services of numerous artists of varying levels of ability to provide designs. Other artists were employed to copy images onto printing stones. The firm's professional printers produced large editions, and ranks of paid, anonymous colorists applied watercolor individually to many of the finished prints. The production of a single image was more like an assembly line than a true collaboration.

By the 1860s technical advances had made it possible to print color lithographs. Hand coloring was very labor-intensive and inefficient and also varied in quality according to the skill of the colorists and the speed at which they were required to work. Color served both a decorative and an informative function in an art form that valued description and subject matter more highly than individual artistic expression. When the possibility of printing directly in color (chromolithography) was introduced, it was eagerly adopted by makers of labels, greeting cards, reproductive prints, and almost every other printed product.

The process enabled a skilled lithographer to produce high-quality color prints that copied images with great accuracy and subtlety, but few printers invested the time and effort to achieve chromolithographs of this caliber. The marketplace was quickly flooded with inferior prints, characterized by anemic or harsh colors, poor registration, and overly sentimental subjects. Lithography, especially chromolithography, acquired the ineradicable stigma of crass commercialism, and few artists considered it an appropriate medium for fine art. Similarly, engraving had become so closely associated with reproductive work of the most standardized and predictable sort that few artists considered it suitable for original compositions.

Nonetheless, there were exceptions, and outstanding prints based on original compositions were created by some of America's finest artists, including Asher B. Durand, Thomas Cole, Rembrandt Peale, William Rimmer, William Morris Hunt, and Thomas Moran. It was not until the 1880s, however, that American artists fully recognized the creative possibilities of printmaking. They were influenced by the etching revival that had recently taken place in France and England, which led them to consider this medium much more autographic than engraving and conducive to individual expression both in drawing the line and wiping the plate.

By this time photography and photography-based printmaking had almost entirely supplanted the reproductive function of prints. At least partially in reaction to this development, artists began to redefine the role and attributes of the medium. Originality became a meaningful criterion, and the artist's direct involvement in creating the image was particularly visible in the etched line or uniquely wiped plate. Artists began to sign their prints, not only in the plate or stone but on the sheet itself, and the practice of the limited edition was introduced. Rare states and unique proofs were sought by collectors.

As American printmaking emerged from the shadow of commercialism into the realm of the fine arts, relationships among artists, printers, and publishers changed in subtle but significant ways. Instead of always working with professional printers, some artists began to make prints on their own. In the late 1870s and early 1880s, for example, the artists around Frank Duveneck in Florence and Venice began to use a portable etching press that Otto Bacher had carried with him from Munich. During the summer of 1880 in Venice, Whistler became friendly with some of this group and he, too, made etchings on Bacher's press with his assistance. Bacher attributed Whistler's use of rich plate tone in his Venice etchings to his contact with several artists who amused themselves by making monotypes on his press.[11] Whether or not this particular claim is true, Bacher's account of his relationship with Whistler in Venice indicates a level of interaction among artists that, if not a full-fledged collaboration, was certainly a significant step in that direction.

The critic and scholar Sylvester Rosa Koehler was as responsible for the growth of the etching revival in America as were the publisher-promoter Alfred Cadart in France and the critic Philip Gilbert Hamerton in England. Drawing upon his early experience as technical manager of the lithographic firm of Louis Prang & Co., one of the major American publishers of chromolithographs, Koehler determined to establish a level of printing for American etchings comparable to that available in Europe. Although the etching revival had begun in the United States in the 1870s independent of Koehler, his establishment in 1879 of the *American Art Review* as a journal devoted to the publication of "Original Painter-Etchings by American Artists" served as an important stimulus for both the artists and the market for these works. Committed to producing three thousand high-quality impressions of three or more plates per month, Koehler found it difficult to locate fine art printers in a country that traditionally had considered etching a reproductive medium. Turning to the respected commercial New York printing house of Kimmel & Voigt, he worked in close collaboration with Henry E. F. Voigt. Together they selected the finest papers, and Koehler made technical suggestions to assure the production of the highest quality impressions.[12]

Although most American models for collaborative printmaking were based on European precedents, the late nineteenth- and early twentieth-century fascination with things Japanese (*japonisme*) introduced both European and American artists to the traditional Japanese method of color woodblock printing. For nearly two centuries, Japanese prints had been the product of close cooperation and interdependence of artist, carver, printer, and publisher. A highly specialized division of labor, this method depended on the important contribution of each person. The San Francisco artist Helen Hyde learned the technique from the Prague-born artist Emil Orlik, who had gone to Japan in 1900 expressly to learn the art. Hyde spent the better part of the period from 1899 to 1914 in Japan before returning to live in Chicago. Orlik had taught her how to cut blocks, but she soon recognized that the Japanese method of collaborative printmaking saved time and resulted in a much higher level of quality than her own efforts. Although she included the names of the carver (Matsumoto) and the printer (Murata) on only one of her prints, Hyde created more than seventy woodblock prints by this method.

The Japanese system of collaborative printmaking did not take hold in Europe or the United States. This can be attributed largely to the lack of skilled cutters and woodblock printers outside of Japan, but some artists also felt they must design, cut, and print the blocks themselves if the work were to be "original." Even in Japan, the so-called "creative print" movement of the early twentieth century promoted a similar point of view. Bertha Lum, an American

artist who learned the Japanese techniques of block carving and printing in Japan during the early years of the "creative print" movement, made many of her color woodblock prints entirely on her own, although she later returned to the traditional method of working with carvers and printers.

The most influential of the American artists attracted to Japanese woodblock prints was Arthur Wesley Dow of Massachusetts. An exponent of the American Arts and Crafts movement, which valued handcraftsmanship in the face of standardization and mechanization, Dow adhered closely to the Japanese method of cutting and printing woodblocks. Because he was virtually self-taught, his designs entailed long and patient hours of work. According to Dow's biographer, Arthur Johnson, Dow's wife, Minnie Pearson, often printed his color woodblocks: "A large share of the success of this pioneering work belongs to her who . . . brought forth the first successful block prints in America. All through the years she continued to do the major portion of this last stage in the process, developing a skill to which probably no other woman artist has ever attained in this country."[13] In contrast to the commercial overtones associated with prints made with the help of a professional printer, Dow's prints represented a true collaborative effort by husband and wife.

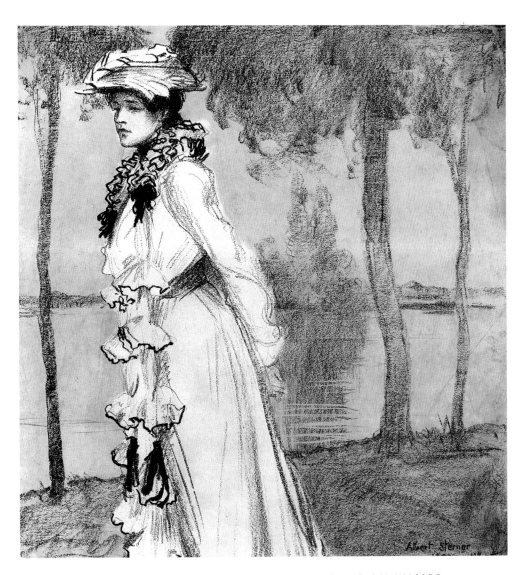

FIG. 4 ▪ ALBERT EDWARD STERNER ▪ *DAME AM WASSER*

1902. Color lithograph. Printed by Klein and Volbert, Munich. National Museum of American Art, Smithsonian Institution.

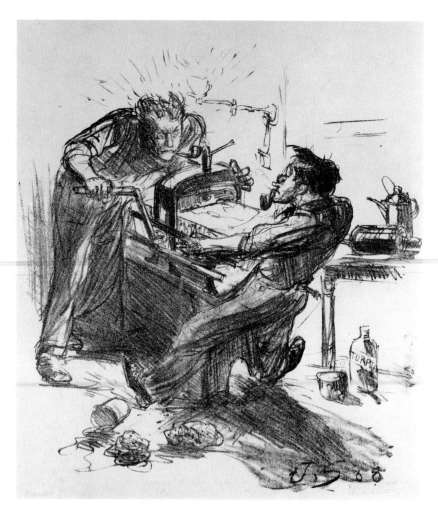

FIG. 5 ▪ JOHN SLOAN ▪ *AMATEUR LITHOGRAPHERS*
1908. Lithograph. Philadelphia Museum of Art: Lessing J. Rosenwald gift and Farrell Fund Income.

The Japanese method was labor-intensive and complex, requiring a separate woodblock for each color, perfectly registered in the final print. American artists imbued with the Arts and Crafts ethic of self-sufficiency adapted the method to their own working conditions. A group who had banded together in Provincetown, Massachusetts in 1915 to make color woodcuts felt the need to simplify the traditional procedure. Although credit for inventing the resulting white-line woodblock technique that came to be known as the Provincetown Print is usually given to the artist B. J. O. Nordfeldt, the creative and collaborative atmosphere in which he worked among like-minded artists was surely a stimulus to his invention. Blanche Lazzell, one of the most talented and prominent of the Provincetown printmakers, credited the artist Ethel Mars as "the originator of the work which led up to the Provincetown Print."[14]

Lithography remained out of favor for fine art printmaking among American artists through the early twentieth century, not only because of its commercial associations, but also because few professional printers had the ability or the patience to work with artists. There was no money to be made from small editions, and artists tended to demand high-quality work. Those who wanted to make fine-art lithographs usually had been introduced to the medium in Europe and were often forced to print their editions there as well (Fig. 4). Although making an image on a lithographic stone was much more direct and autographic than any other printmaking technique, the printing itself was a delicate procedure, requiring great technical skill. Some artists who tried to print their own lithographs found the process frustrating and the results poor (Fig. 5).

George C. Miller in New York City was one of the few professionally trained lithographers willing to work with artists (Fig. 6). Between 1914 and 1917 he received so many printing requests from artists that he opened his own workshop in 1917 exclusively for fine art printing. During his long career he produced lithographs for George Bellows, Thomas Hart Benton, Arthur B. Davies, Stuart Davis, Childe Hassam, Louis Lozowick, Charles Sheeler, and Grant Wood. Although justifiably proud of the high quality of his work, he seems to have considered himself less a collaborator than a skilled craftsman, rarely signing any of his impressions. As Prentiss Taylor, an artist who had worked with him, recalled, "It did not take long to learn that one of the great blessings of the place was that George made no aesthetic judgments. He did not show stylistic prejudices The creative aspects were entirely the realm of the artist. He gave the neophyte, the hack, and the well-known the best printing that could be brought from the zinc plate or the stone."[15]

On the other hand, another important early lithographic printer clearly saw himself as a collaborator. Bolton Brown was himself an artist who produced his own lithographs in addition to printing for other artists. Signing in pencil almost all the impressions he printed for others, he did not hesitate to make technical and aesthetic suggestions.[16] Brown has been described as "stubborn, sensitive, opinionated, brilliant, difficult, and very complex"—characteristics that did not endear him to many.[17] For this reason, Brown formed a long-term association with only two of the artists for whom he printed.

Gradually more American artists grew interested in making lithographs, and more professional printers became amenable to working with them. During the 1920s, when many Americans spent time in Paris, they were welcomed at the lithographic workshop of Edmond Desjobert, where they were introduced to the medium. Those who had previously made lithographs in the United States found Desjobert's expert tutelage and skillful manipulations of the stone to be superior to what was available at home. When they returned to America, they sought comparable expertise. In addition to George Miller and Bolton Brown in New York, Grant Arnold in Woodstock, Lawrence Barrett in Colorado Springs, Lynton Kistler in Los Angeles, and Theodore Cuno in Philadelphia undertook to print lithographs for artists. The professional printers J. E. Rosenthal, Peter Platt (Fig. 7), and Jacob Friedland also operated printshops in New York, and some highly skilled artists, such as Will Barnet, Frank Nankivell, and Emil Ganso, printed for other artists as well.

Outside these centers, however, it was difficult to find willing and competent lithographers for fine art printing. For example, Martin Hennings had settled in Taos, New Mexico, where he experimented with lithography and completed eight images on zinc plates. Because there were no quality printing facilities nearby, he shipped the plates to Chicago where his brother-in-law was art director at the Jahn and Ollier Lithographic Company. The scarcity of highly skilled printers in the United States deterred many artists from trying to make lithographs, and mitigated against the development of a truly collaborative relationship between artist and printer.

As early as 1922, Joseph Pennell established a lithography workshop at the Art Students League in New York City. A strong advocate of fine art lithography after his extended contact with Whistler in England, Pennell had only limited experience with printing and hired professionals to do this work for his classes. Although many artists were introduced to lithography there, few learned how to print their own work. Some who were especially interested in the medium offered to serve as assistants to the printers in order to observe their well-guarded technical secrets. Thus Will Barnet learned from Grant Arnold, and Robert Blackburn learned from Barnet.

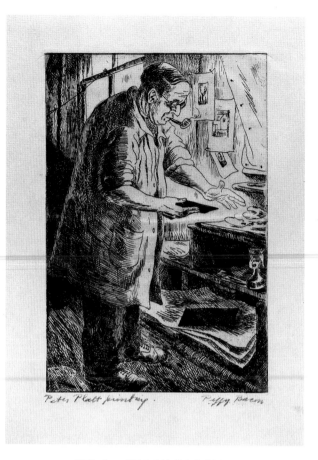

FIG. 6 ▪ ELLISON HOOVER ▪
GEORGE C. MILLER, LITHOGRAPHER
1949. Lithograph. National Museum of American Art,
Smithsonian Institution.

FIG. 7 ▪ PEGGY BACON ▪
PETER PLATT PRINTING
1929. Etching. Philadelphia Museum of Art. Purchased: Lola Downin
Peck Fund from the Carl and Laura Zigrosser Collection.

Blackburn was introduced to lithography at the Harlem Community Art Center in New York by Riva Helfond Barrett, an artist and gallery director, who knew only the fundamentals of printing. When Blackburn sought professional instruction in the medium from George C. Miller, he was told, "Young man, if you want to learn anything from me, you'll have to spend a hundred dollars a week, and I'll teach you something."[18] A hundred dollars was a fortune at that time, so Blackburn gleaned what he could from Barnet.

With Barnet's assistance, in 1948 he established the Bob Blackburn Workshop, where artists and students could work together and share what they knew and discovered. When Blackburn received a fellowship to study art in France in 1953, he chose to work at the Desjobert atelier, hoping to learn some secrets of the trade. However, he was not allowed to observe the printers and returned to America without having acquired much more technical knowledge.[19] Professional printers jealously guarded their secrets, and Blackburn recalls that, as an African American, the discrimination he encountered in the 1950s made his quest to learn lithographic printing especially difficult.[20] One of the guiding principles of his Printmaking Workshop has been to give opportunities to students and artists of all races, nationalities, and financial status to learn lithography and have access to a competent printer.[21] Blackburn's training at the Harlem Community Workshop, his awareness of the Works Progress Administration print projects, and his experience at Stanley William Hayter's Atelier 17 have convinced him that the workshop atmosphere could foster creativity, collaboration, and invention.

The WPA printmaking projects were among the federal government's many undertakings to support artists during the Great Depression of the 1930s. One of the stated goals was the development of color printing in the United States. Louis Schanker took the lead in exploring the possibilities of the color woodcut, but the development of color lithography and silkscreen printing (serigraphy) were collaborative endeavors. Because chromolithography had been thoroughly discredited by the early twentieth century, the skills needed to produce color lithographs had been lost. Through the efforts of WPA administrator Gustave von Groschwitz, artist-lithographer Russell Limbach, several professional printers, and numerous artists, color lithography was revived, not for commercial purposes but as a medium for fine art printmaking.

Similarly the commercial technique of silkscreen printing was developed to meet the needs of artists on a WPA project. Used during the early twentieth century for printing pennants, placards, and labels for consumer goods, screenprinting as a commercial process did not allow for the subtleties of color, modeling, and line that most artists required.[22] Working with administrator Richard Floethe and printer Anthony Velonis (Fig. 8), artists such as Elizabeth Olds, Harry Gottlieb, Hyman Warsager, Leonard Pytlak, and Edward Landon developed screenprinting methods for achieving desired painterly effects.

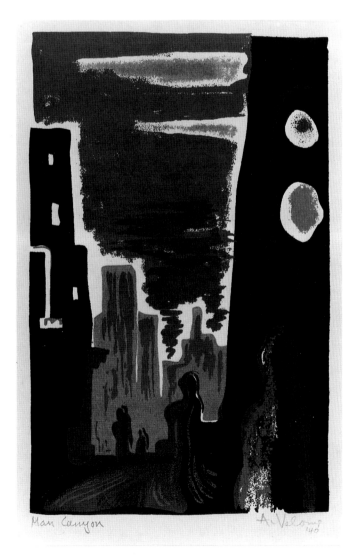

FIG. 8 ▪ ANTHONY VELONIS ▪ *MAN CANYON*
1940. Color silkscreen. National Museum of American Art, Smithsonian Institution. Gift of Richard and Mary Isaacson.

FIG. 9 ▪ WARRINGTON COLESCOTT ▪ *S. W. HAYTER DISCOVERS VISCOSITY PRINTING*
1976. Color etching. Elvehjem Museum of Art, University of Wisconsin–Madison. Friends of the Elvehjem Museum of Art purchase.

Despite the workshop environment of the WPA projects, the conditions for collaboration were not good. Bureaucratic requirements and constant firings and rehirings interfered with sustained communal creativity. Nevertheless, working with other artists in the same space was inspiring. Artist Jacob Kainen recalls that "the experience of producing prints and having them professionally printed was a constant pleasure and made up for numerous indignities. It was in the shop that the printmakers felt most truly at home. There they could proof their blocks, plates, and stones in company with outstanding professionals. . . .There was no 'star' system—we were all in the same boat. We were stimulated by each other's presence."[23]

The most influential printmaking workshop of the period was Atelier 17, established by the British artist Stanley William Hayter in Paris in the late 1920s and transplanted to New York in 1940. Although it was housed in the New School for Social Research in the early 1940s and listed as part of the school's curriculum, Hayter did not regard the workshop as a classroom, but rather as a place where experienced artists could gather to experiment with intaglio printmaking. Nor did he consider himself to be a teacher, but rather a facilitator and colleague. By bringing together young and old, European and American, and neophyte and mature artists under the same roof, Hayter sought to

encourage creative interactions. One of the more interesting consequences of this arrangement was that older, more prominent artists often learned as much from their younger colleagues as the latter did from their elders.

Dedicated to the revival of engraving and other intaglio techniques, Hayter insisted that all discoveries be shared, and that the concept of "trade secrets" be abolished. Because technical innovations were the result of collaboration, he was adamant that credit for them should be shared by all the artists involved. One of the inventions for which Atelier 17 became known was a technique of simultaneous color printing from lines etched or engraved deep in the surface of the plate, and more shallow lines on the surface, on a single run through the press. Several years later this technique was developed into a method of printing several colors at the same time from various levels of the plate, called color viscosity printing. Art historians have tried to assign credit for inventing these techniques to a single artist, but Hayter resolutely refused to cooperate. He insisted that all innovations made at Atelier 17 were collaborative, and that his own relationship with the other artists was that of a colleague rather than a teacher (Fig. 9).[24]

Hayter paid some experienced artists to help with printing, but everyone working in the studio was expected to learn to print his or her own work. Although a few editions were printed for some of the better known artists as a source of income for the workshop, Hayter promoted the idea of the artist-printmaker who could prepare the plate, sharpen the tools, create an image directly on the plate, and print proofs as well as the final edition. In his view, this distinguished art prints from the commercial tradition with which engraving had become associated. Moreover, it seemed to raise the status of the printmaker to that of the painter or sculptor who could single-handedly create a work of art from start to finish (Fig. 10).

FIG. 10 ▪ STANLEY WILLIAM HAYTER ▪ *CINQ PERSONNAGES*

1969. Color engraving, soft ground etching, and silkscreen. National Museum of American Art, Smithsonian Institution. Gift of Ruth and Jacob Kainen.

As the result of an influx of World War II veterans on the GI Bill, art schools, colleges, and universities expanded at a record rate. Many artists who worked at Atelier 17 were hired by educational institutions throughout the country to establish printmaking workshops in their art departments. For example, Mauricio Lasansky organized an intaglio printmaking workshop at the University of Iowa, as did Gabor Peterdi at the Brooklyn Museum, Hunter College, and Yale University, and Letterio Calapai did at the Albright Art School in Buffalo, New York. Artists who received their training at the various new printmaking workshops went on to teach at other colleges and universities, further disseminating Hayter's ideals of technical experimentation, collaboration, and self-sufficiency.

Some printmaking facilities not affiliated with colleges and universities were also established in the 1950s. Among them was a lithography workshop initiated in the mid-1950s by artist, printer, and gallery owner Margaret Lowengrund, which was housed in the basement of the Artists' Association in Woodstock, New York, and used by her in the summer. During the rest of the year she rented a space for the workshop in New York City near her gallery, which she called The Contemporaries Graphic Art Centre. Although she had hoped to subsidize her studio through contract printing, high rent and unreliable support made it too difficult to maintain as an independent facility. Less than a year later, Lowengrund affiliated the workshop with Pratt Institute in order to qualify for a grant from the Rockefeller Foundation as a nonprofit institution.

In Boston in 1959, artist, teacher, and printer George Lockwood opened the Impressions Workshop, which, unlike most ateliers, had facilities for lithography and intaglio printmaking as well as for serigraphy, relief, and letterpress printing. By the time that Tatyana Grosman established Universal Limited Art Editions in West Islip, Long Island, New York, in 1957, and June Wayne founded the Tamarind Lithography Workshop in Los Angeles in 1960, models for collaborative printmaking workshops already existed. Grosman and Wayne, each in her distinctive and forceful way, modified the existing models, built a strong foundation for future development, and spawned numerous additional collaborative workshops that would revolutionize fine art printmaking in the United States.

ORIGINALITY AND COLLABORATION

It is ironic that, just as fine art printmaking was about to become well established in the United States, certain practices were introduced that called into question the originality and authenticity of some types of prints. Several renowned School of Paris artists began to authorize prints made from their paintings, drawings, or watercolors as a means of satisfying the demand for their work in the broader marketplace. A professional copyist would transfer the image to a printing matrix, usually an etching or lithographic plate and sometimes a silkscreen. A professional printer would pull a large but limited edition, which would then be signed by the artist. Although this procedure recalled reproductive practices of the sixteenth through the nineteenth centuries, it carried the taint of deception and commercialism. On both sides of the Atlantic, very high-quality photographic reproductions of paintings, drawings, and prints were being produced, often with the artist's blessing and signature on the edition, and sold as "prints." Salvador Dali even signed blank sheets of paper before "prints" of his paintings were made on them.[25] As a result, signed, limited edition "prints" by internationally known artists were available for little more than original graphics by lesser known American artists. Dore Ashton noted these dubious editions in a 1955 article in *Arts* magazine, lamenting their effect

on American printmakers who had tried to reassert the concept of the authentic.[26] Legitimate print dealers also deplored them, since they undermined the nascent market for fine art prints by confusing the buyer.

The task fell to the Print Council of America to outline criteria for originality in printmaking.[27] Members of this group called for specifying the role of the artist in making the print and limiting the use of photography in transferring the image to the plate, stone, or screen. The artist alone was to create the image on the matrix. The materials and techniques used to create the print were to be honestly revealed, and the final print was to be approved by the artist. This definition of original printmaking allowed for printing by someone other than the artist, but it did not address the practice of artistic collaboration in the new workshops, where more and more artists were beginning to make their own prints.

As soon as this definition was drafted, it met with criticism on various fronts. Among them was Luis Camnitzer's objection that the Print Council's definition did not allow for printing on three-dimensional surfaces, practiced in certain workshops for the creation of three-dimensional "multiples."[28] Some artists opposed restrictions on the use of photography for transferring images to the printing matrix. Artist Fritz Eichenberg succinctly summarized the objections as exemplifying "the ever existing gap between generations: the rear-garde and the avant-garde, the way-in and the way-out, the traditional and experimental."[29]

As more artists began to make collaborative graphics in workshops, and publishers and printers began to play a greater role in their creation, a clamor for new guidelines arose. Some artists maintained that every step in the process should be done by the artist. This attitude was prominent among American artists who had been trained in the Hayter tradition of self-sufficiency and had personal or university workshops where they could create their own work from start to finish. The public was confused by the concepts of originality and authenticity in prints, especially as these affected the investment value of purchases. In response to this, in the 1970s some dealers began to provide "certificates of authenticity" with the pieces they sold to reassure customers.

Because it was recognized that any definition of originality for graphics would probably be obsolete by the time it was made, most fine art printmaking workshops began to issue full documentation with each edition, listing the names and roles of everyone involved in producing it. In some states laws were passed to require this disclosure. Similar in concept to the consumer movement's "truth in labeling" principles, this documentation implicitly acknowledged that collaboration had taken place, and that this did not affect the originality, authenticity, or value of the print.

At the same time that this concern was being expressed in the marketplace, poststructural criticism began to deemphasize the role of the creator, to the point of indifference toward traditional notions of originality or authenticity.[30] Turning away from the idea of the artist as sole creator in favor of a more collaborative mentality, artists began to appropriate images from a variety of sources, including the work of other artists. As Robert C. Hobbs wrote, "The most interesting artists coming after Pollock [who epitomized the cult of originality] recognized the myth of the individuality of the artist as simply another convention to be dealt with, and they gave it the *coup de grace* by presenting it ironically as the subject matter of their art."[31] Jasper Johns and Andy Warhol were among the leading artists who expressed these ideas in their paintings as well as their prints, while at the same time benefiting from the "great person" myth in achieving recognition and financial success.

The quest for a definition of an original print based on the extent of an artist's involvement in its production was closely tied to the traditional "great person" theory of art history. The ideal of the solitary creator persists, even though working together is common and widely accepted in other creative professions: science, architecture, theater, opera, and film. As we recognize that the centrality of the individual is only one cultural and historical mode, we become more aware of the role that collaboration has played, and continues to play, in the making of art. Currently, for example, the entire painted oeuvre of Rembrandt is undergoing careful reevaluation by a group of scholars and specialists. Originally undertaken to detect copies and forgeries, this study has also revealed how extensively Rembrandt relied on studio assistants.[32] Although the discovery of other hands contributing to paintings signed by this quintessential "solitary genius" has affected the market price of certain works, the quality of a given painting remains the same as when it was attributed solely to Rembrandt.

In the twentieth century collaboration has become a distinct mode of aesthetic expression. Joint projects that cross media have become increasingly common, notably the stage sets designed by artists such as Pablo Picasso, Isamu Noguchi, and David Hockney or the extensive interactions among painter Robert Rauschenberg, musician John Cage, and choreographer Merce Cunningham. The collaborative model has expanded well beyond the traditional boundaries of the fine arts to include such unusual undertakings as artists and prisoners making art together for urban communities in crisis.[33]

As facilitators in the joint production of graphics, the many publishers, workshops, and presses that have appeared during the past three decades have allowed artists with little technical knowledge to design major prints that are widely considered to be as important as their work in other media. These collaborations place printmaking at the forefront of one of the most intriguing directions of contemporary art.

Notes

1. David Shapiro, "Art as Collaboration: Toward a Theory of Pluralist Aesthetics 1950–1980," in Cynthia Jaffee McCabe, *Artistic Collaboration in the Twentieth Century* (Washington, DC: Smithsonian Institution Press, 1984), 45–62. Shapiro cites his own indebtedness to Kenneth Koch, whose 1961 issue of *Locus Solis* represented a pioneering effort to bring together Oriental, Surrealist, and contemporary collaborative literature.

2. *Ibid.*, 46.

3. John Canaday, *Mainstreams in Modern Art* (New York: Holt, Rinehart and Winston, 1959), 21.

4. McCabe, "Artistic Collaboration in the Twentieth Century: The Period between Two Wars," 15–44, and Robert C. Hobbs, "Rewriting History: Artistic Collaboration since 1960," 63–87, in McCabe, *Artistic Collaboration*. It should be noted that each of the authors makes only passing reference to artistic collaboration in printmaking.

5. "Advice and Dissent: Collaborative Work," exhibition at John Berggruen Gallery, San Francisco, 6 January – 13 February 1994.

6. This term sometimes indicated reworking and reissue. Fritz Eichenberg, *The Art of the Print* (New York: Harry N. Abrams, 1976), 583. By the eighteenth century these terms were often translated into the vernacular language.

7. Although some reproductive prints were made by other intaglio techniques, woodcut, and lithography, by far the largest number were made by engraving, and the term engraver is used here to refer to the person who transfers the image to the matrix.

8. For an excellent overview of lithographic collaboration in various countries, see Pat Gilmour, "Lithographic Collaboration: the Hand, the Head, the Heart," in *Lasting Impressions: Lithography as Art*, Pat Gilmour, ed., (Canberra: Australian National Gallery, 1988), 308–359.

9. For more information on prints for the American Art-Union, see

Jay Cantor, "Prints and the American Art-Union," in John D. Morse, ed., *Prints In and Of America to 1850* (Charlottesville: The University Press of Virginia, 1970, © The Henry Francis du Pont Winterthur Museum, Inc.), 297–326.

10. *Graham's American Monthly Magazine* (August 1832): 359, quoted in Peter C. Marzio, "American Lithographic Technology before the Civil War," in Morse, *Ibid.,* 214.

11. Otto Bacher, *With Whistler in Venice* (New York: The Century Co., 1908), 116–18.

12. For greater detail about this relationship, see Maureen O'Brien, "To Mr. Henry E. F. Voigt with the Compliments of the Etcher," *The American Painter-Etcher Movement* (Southampton, N.Y.: Parrish Art Museum, 1984), 8–14.

13. Arthur Warren Johnson, quoted in Nancy E. Green, *Arthur Wesley Dow and His Influence* (Ithaca, N. Y.: Herbert F. Johnson Museum of Art, 1990), 9.

14. Blanche Lazzell, quoted in Janet Flint, *Provincetown Printers: A Woodcut Tradition* (Washington, D.C.: National Museum of American Art, 1983), 15.

15. Prentiss Taylor, quoted in Janet Flint, *George Miller and American Lithography* (Washington, D.C.: National Museum of American Art, 1976), n.p.

16. For an excellent comparison of the two printers, see Clinton Adams, *American Lithographers 1900–1960: The Artists and Their Printers* (Albuquerque: University of New Mexico Press, 1983), 32–34.

17. Clinton Adams, *Crayonstone: The Life and Work of Bolton Brown* (Albuquerque: University of New Mexico Press, 1993), xi.

18. Elizabeth Jones, "Robert Blackburn: An Investment in an Idea," in *Tamarind Papers*, 6, 1 (Winter 1982–83): 10–11.

19. For a good overview of the guild-like structure of French printmaking workshops, see Chapter 7 of Stanley William Hayter, *About Prints* (Oxford University Press, 1962) about intaglio workshops in France.

20. Author's interview with Robert Blackburn, Printmaking Workshop, New York, 30 October 1991. Established as the Bob Blackburn Workshop, the name was changed in 1955 to the Creative Graphics Workshop, and in 1959 to the Printmaking Workshop.

21. In 1952 Robert Broner established intaglio facilities at Blackburn's shop, and later other printmaking techniques were added as well.

22. The term serigraphy was coined to distinguish between fine art prints and commercial screenprinting, and the term color lithography was used instead of chromolithography for the same reason.

23. Jacob Kainen, "The Graphic Arts Division of the WPA Federal Art Project," in Francis V. O'Connor, ed. *The New Deal Art Projects: An Anthology of Memoirs* (Washington D.C.: Smithsonian Institution Press, 1972), 166.

24. Author's interview with Stanley William Hayter, Atelier 17, Paris, 22 and 24 October 1974.

25. For an excellent historical background of originality and more information on fraudulent practices, see Carl Zigrosser and Christa M. Gaehde, *A Guide to the Collecting and Care of Original Prints* (New York: Crown Publishers, 1965), 19–35.

26. Dore Ashton, "The Situation in Printmaking: 1955," *Arts* 30, 1 (October 1955), 15–17, 60.

27. *What is an Original Print?* (New York: Print Council of America, 1961)

28. Luis Camnitzer, "A Redefinition of the Print," *Artist's Proof,* VI, 9–10 (1966), 103.

29. Fritz Eichenberg, "Editorial," *Artist's Proof,* VI, 9–10, (1966), 4.

30. David Shapiro, *Art As Collaboration*, 53–54.

31. Robert C. Hobbs, "Rewriting History: Artistic Collaboration since 1960," in McCabe, *Artistic Collaboration in the Twentieth Century*, 70.

32. Paul Richard, "Rembrandt Reconsidered: Did He Paint Them? Does It Matter?" *Washington Post* (30 January 1994), G1, G6.

33. *Women & Children First!: Emergency Art from Behind Bars*, Esther M. Klein Gallery, University City Science Center, Philadelphia, Pa., 19 January–31 March 1994.

MULTIPLE VISIONS: PRINTERS, ARTISTS, PROMOTERS, AND PATRONS

■

BY TRUDY V. HANSEN
DIRECTOR, MORSE RESEARCH CENTER FOR
GRAPHIC ARTS AND CURATOR OF PRINTS
AND DRAWINGS AT THE JANE VOORHEES
ZIMMERLI ART MUSEUM, RUTGERS—THE STATE
UNIVERSITY OF NEW JERSEY

■

The three decades from 1960 to 1990 saw a tremendous increase in the production of prints in the United States. This did not happen in a vacuum; a tradition of collaborative printmaking had already evolved in America in the first half of the twentieth century, and post-war social, political, and economic conditions fostered its further development.[1] The explosion of print production reflected not only new techniques and aesthetic concerns, but also the growing significance of printmaking in the careers of major artists. Support from publishers, dealers, curators, collectors, and critics, which raised the visibility of prints in museums and the art market, was also fundamental to the movement.

Over these thirty years, as printers adapted to changing styles, new techniques, and increased demand, prints assumed a new status. Artists, working with skilled printers, experimented with formats and materials—often blurring the traditional boundaries between various media—and created powerful graphic images worthy to be accepted as major works of art on a level with painting and sculpture.

The first half of the 1990s has seen decreased production, and a sharp drop in the market for prints. In the past decade, the largest and oldest of the contemporary workshops—Universal Limited Art Editions, Tamarind Workshop, Gemini G.E.L., Tyler Graphics, Ltd., and Graphicstudio–South Florida—have each received major retrospective exhibitions and weighty catalogue raisonnés.[2] As a result, study of the collaborative press movement has focused on these major presses and the prints of the best-known artists who worked at them, while the contributions of many important small workshops are only now being documented. This would seem to be a good time, then, to reflect on the developments that accompanied America's rise to supremacy in printmaking during the 1960s, 70s, and 80s.

A few prints produced between 1960 and 1990 have become art historical icons. Thousands of other prints demonstrate the remarkable diversity of the collaborative press movement, and at the same time illustrate several fascinating

truths. Firstly, while the movement was centered in the United States by the late 1960s, the initial impetus for it was international. Secondly, women played major roles, even before 1960, first as publishers, printers, dealers and curators, and then in ever-increasing numbers as artists collaborating at presses. Thirdly, as the demand for prints began to encourage greater production, improvements in materials and new technologies advanced possibilities for collaboration. Finally, the print boom reflected changing socioeconomic conditions which greatly expanded the function of prints, and led artists to experiment with printmaking in ways that significantly enlarged its traditional definitions.

All of these factors affected the look of contemporary prints and the continuing dialogue regarding what actually constitutes a work of art. Rather than merely reflecting postmodern forms and values, printmaking, with its history of appropriation, fragmentation, juxtaposition, and multiple originality, has proven seminal to many artists' exploration of form and content. New techniques have added depth to the careers of many artists, and the resulting works have brought a much wider audience into firsthand contact with their art.

While this essay is primarily concerned with for-profit presses, the interaction between them and nonprofit and university-affiliated printshops has been fundamental to the growth of each, and indeed, real distinctions between different types of workshops are often nonexistent. Contrary to the notion that for-profit shops are concerned only with the bottom line, many have remained small, operating on a slim, often nonexistent, profit margin. Many of the largest presses have published newsletters and participated in exhibitions and scholarly symposia, and thus contributed to the

FIG. I ▪ GÜNTER FÖRG ▪ *THE REASON WHY I WORK WITH MAURICE. . .*
1990. Lithograph. Printed at Derrière L'Etoile Studios, New York.
Photo credit: Jack Abraham. Photo courtesy of The Rutgers Archives for Printmaking Studios,
The Jane Voorhees Zimmerli Art Museum

documentation of contemporary printmaking. At the same time, some nonprofit ateliers have grown large enough to rival the major independent presses. Important prints have been created in all of these settings, and many artists today work regularly at large and small presses, contract shops, university print shops, and cooperative print studios. Each press has an identity reflecting its unique combination of talent and equipment; the artists working there have brought with them differing degrees of knowledge and willingness to experiment, and printers have responded accordingly.

CONTEMPORARY COLLABORATION AND THE ORIGINAL PRINT

Despite the pluralist environment in the art world since the 1960s, a somewhat old-fashioned view has persisted in many people's understanding of the relationship of artist to printer. Moreover, there has been a continuing lack of consensus on what constitutes an original print, even as a dazzling array of new print projects have regularly challenged the most advanced definitions. Meanwhile, the art marketplace has imposed its own qualifications, relating to price as much as originality. As Dr. Moser's essay points out, in the history of printmaking interactions between artist and printer have ranged from relative detachment to intimate creative involvement. Collaboration can follow a predictable course, or it can evolve unexpectedly, depending on personal relationships, accidents, technical developments, and a host of other factors.

Traditional collaborative printmaking required three easily definable stages: the creation of the image by the artist; the preparation and proofing of the printing matrixes; and the production of the edition. An artist might come to a printshop with a preliminary drawing, and create an image on a plate, woodblock, or stone. The printer then proofed the images, corrected and adjusted the plates, and provided the artist various ink colors and paper types to choose

FIG. 2 ▪ Master printer David Kelso inking an intaglio plate
for a Frank Lobdell project at made in California Studio,
Oakland, California, 1989. Photo credit: Leo Holub.
Photo courtesy of Leo Holub

FIG. 3 ▪ Frank Lobdell working on an etching plate at made in California Studio, Oakland, California, 1989. Photo credit: Leo Holub. Photo courtesy of Leo Holub

from. When the artist approved a prototype, a right-to-print proof was signed and the printer then produced a uniform edition of impressions that the artist then approved and signed. This basic procedure is still common.

Today, however, printer and artist often work and experiment jointly in the preparation of matrixes, proofing through many stages to arrive at the final image to be editioned. In these relationships, the printer is often more than a mere translator or replicator of the artist's vision. An artist may arrive at a press with no preconceived idea, and the preparation of plates and proofing may take place as the image is being created. In the making of unique works such as monotypes, monoprints, or hand-colored prints, creation and production often take place simultaneously, with artist and printer working in tandem. The role of the printer has also expanded as more research and experimentation is undertaken independent of actual projects at hand. Thus the printer, often an artist or with a strong background in art, has become a colleague who can assist and inform projects, and the workshop is as much a labaoratory as a production facility.

At the same time, the growing acceptance of photographic and other reproductive techniques has resulted in a definition of originality based on the concept, the working process, and the finished work rather than on the degree of the artist's hands-on involvement with it.[3] As it has become increasingly difficult to separate the hand of the artist from the handiwork of the printer, contemporary graphics, like contemporary works in other media, are being judged for their strength of conception and their quality of execution.

made in
California

David Kelso, Director intaglio proofing & editioning

edition record document impression
project 91-1a.2,3,4,1

artist Frank Lobdell
title 7.20.91
image size 14x17-3/4"
paper size 22½x30"
margining t3¼" s6-1/8" b15¼"
edition paper BFK Rives white
project dates 4/25 - 7/20/91
release date November 1, 1991
publisher made in California
cancellation February 10, 1992

7.20.91 was hand printed by David Kelso at made in California in an edi-
tion of fifty impressions from four 16-gauge copper plates executed entirely
by the artist as a hard- and softground etching with sugarlift aquatint [plate
1]; a softground etching with aquatint and burnishing [plate 2]; a hard-
and softground etching with sugarlift and spit-bite aquatint [plate 3]; and
a softground etching with spit-bite aquatint. The plates, in order of printing
were inked in a mixture of titanium oxide white, cadmium lemon yellow,
and china clay (1.5:1:.8) for plate 4; a la poupee applications of cadmium
red light and a mixture of china clay, vermilion red deep, and Lefranc
& Bourgeois magenta (14:6:1) for plate 3; ultramarine blue for plate 2;
and a mixture of mars black and cadmium red deep (3:1) for plate 1.
Each impression is hand-signed, titled, and numbered in pencil by the artist,
and bears the embossed chop mark of made in California in the lower right
corner, with paper watermark located in the lower left margin.

Extant impressions printed outside the edition total twenty-six impressions
and include fifteen state and duplicate state proof impressions for states
1 through 7, one color trial proof impression for state 8, one bon à tirer
(state 8), one each printer's-, press-, and publisher's- proof impression,
five artist's- and one archival proof impression. All impressions not detailed
above have been destroyed, and a 1/8" kerf no less than 4 inches is removed
from the plates on the cancellation date noted above. Artist and printer
affirm the authenticity of this statement on this day, September 3, 1991.

artist

printer

3246 Ettie Street, Oakland, California 94608 telephone (415) 428 2699

FIG. 4 ■ Print documentation sheet for 7.20.91 by Frank Lobdell.
Photo credit: Jack Abraham. Photo courtesy of The Rutgers Archives for
Printmaking Studios, The Jane Voorhees Zimmerli Art Museum

Today artists have commonly worked with numerous presses. Some, like Brice Marden in the 1960s (Cat. 21, 99)

and Mark Stock in the 1980s[4] (Cat. 96) have also worked for printshops. A few, including Robert Rauschenberg, and

Robert Motherwell, like the late artists Sam Francis and Andy Warhol, have established their own printshops, while

continuing to work at other studios as well.[5] Fundamental to the changing nature of printmaking collaboration is the

fact that many of the young artists of the 1960s had already participated in other literary, dance, art performance, the-

ater, or film collaborations. Indeed, the pluralist aesthetics of all these media suggests that working collectively may be second nature to contemporary creativity.[6]

The evolving organization of many printmaking studios has also affected artistic relationships. While some studios have operated simply as contract shops, printing editions for dealers, independent publishers, and the artists themselves, others have expanded their commitment to their projects by marketing them as well. This vested interest in sales has added another dimension to the artist/printer relationship, helping to promote the artists' work, and enabling printers to play a greater creative and decision-making role in production.

Since 1960, detailed production records have informed both scholars and collectors of the precise circumstances under which prints have been produced, disclosing the size of the edition, the number of proofs, and whether the printing matrixes have been destroyed, and listing the individuals participating in each project (Figs. 2–4). As prints have grown more complex, so have documentation sheets, which have helped to elevate extraordinary projects by their careful descriptions of the creative process.[7]

Although commercial value and originality are separate issues, the escalation of print prices began to confuse them. In 1960, most new prints could be purchased for very modest sums.[8] However, as the reputations of many young artists grew, along with a secondary market for prints in galleries and auction houses, everyone involved with the creation and sale of prints became concerned with authenticity. The 1970s in particular witnessed lengthy debates on originality, and its effects on marketability.

In the spring of 1972, the *Print Collector's Newsletter* asked a few knowledgeable people for their thoughts on originality. Print historian Richard Field commented that "the cult of individualism can no longer be evoked to limit the scope of the artist's creativity," nor can one "prescribe relationships that avoid recognition of the very ideas and materials that today's artists have chosen to use."[9] Tamarind Workshop founder June Wayne stated that "In spite of many requests for my definition of an original print, I have not written one because it seems an exercise in futility. Existing definitions are useful to me as *checklists* of how most prints have been made, but when I seek to make a definition that can embrace what *will be* as well as what *has been*, so many exceptions leap to mind that I drop the effort altogether."[10]

Little has changed since these comments were made. In 1990, the International Fine Print Dealers Association issued a booklet defining print processes that avoided the loaded term "original" altogether, and instead described seven classifications of prints based on who was involved in their production.[11] As ever, the concept of originality is subjective at best, and subject to specific challenges of the moment.

BEGINNINGS: THE CLIMATE OF THE 1960S

The 1960s saw the print, which could reflect and interpret a multitude of images, as a perfect vehicle to explore ideas and technologies, and to bring art new and expanding audiences. In the years after the Second World War, colleges and universities had launched liberal arts and studio art programs, creating a more sophisticated audience for new artists. By the 1960s, as young people embraced Marshall McLuhan's dictum that the "medium is the message,"[12] the medium became posters, album covers, television, magazines, and commercial advertising. Given this barrage of images, artists needed to look no further than the moment to absorb, react to, and interpret events around them.

Pop Art, emphasizing the present, advancing technology, and a new youthful consumer culture, gave impetus to the collaborative press movement, as did the activist political climate of Civil Rights, feminism, and anti-war protest. Lithography and screenprinting, the two media historically tied to reproduction and commercial use, enjoyed a wave of renewed interest, followed quickly by intaglio and relief printing.

By 1960, the two American ateliers that would serve as bicoastal guide posts for the explosive growth of printshops were already in operation. Much has been written about Universal Limited Art Editions and Tamarind Lithography Workshop, and the women who founded them.[13] The success and sense of mission shared by these two extraordinary women were an inspiration for so many of the presses that followed, that a summary of their beginnings certainly bears repeating.

POLAR COORDINATES: UNIVERSAL LIMITED ART EDITIONS AND TAMARIND LITHOGRAPHY WORKSHOP

Tatyana Grosman (1904–1982), a Russian who had escaped from war-torn Europe to New York with her artist husband Maurice, founded Universal Limited Art Editions in 1957 to make a living after her husband suffered a heart attack in the mid-1950s. After first producing screenprinted reproductions of existing works of modern art, the Grosmans were encouraged by museum curators impressed by the technical quality of their work to collaborate with artists in the creation of original prints.[14] Intending to publish illustrated books, Grosman sought the advice of her friend Larry Rivers. Frank O'Hara, a poet who had already been recommended to Grosman, was visiting the painter at the time, and ULAE's first original publication, *Stones*, was begun.[15] During work on *Stones*, Rivers also began producing single images of increasing complexity (Cat. 1). Grosman's dedication to serving the artists' needs and her ability to persuade major talents to work with her printers began to set new standards for the medium. One by one, artists, including Jasper Johns (Cat. 6), Robert Rauschenberg (Cat. 7), Barnett Newman (Cat. 8), Robert Motherwell, Fritz Glarner, Marisol, Grace Hartigan (Cat. 5), Sam Francis, and Lee Bontecou (Cat. 15), arrived to begin making their first marks on stone, some with considerable hesitation. Robert Rauschenberg's famous remark that "the second half of the twentieth century was no time to start drawing on rocks"[16] suggests the obstacles Grosman had to overcome to convince some artists to take printmaking seriously.

Grosman was also fortunate in finding printers who could bridge the gulf between her goals as a publisher and those of the artists whose work she wished to promote. Robert Blackburn, an African-American artist who had studied printmaking both in Europe and the United States,[17] was the first printer to work with artists at ULAE. Before returning to Manhattan and his own workshop in 1963, Blackburn and Robert Rauschenberg, Larry Rivers, Helen Frankenthaler, Jasper Johns, Fritz Glarner, and Robert Goodnough had experimented with both technology and format, making a number of technical improvements by trial and error. Blackburn's last project at ULAE, Robert Rauschenberg's *Accident* (Cat. 7), became the epitome of the "happy accident"—the unexpected event occurring during printing (such as the cracking of the lithographic stone during proofing) that can be capitalized on in the course of collaboration. Zigmunds Priede prepared a second plate incorporating evidence of the broken stone and printed *Accident* after Blackburn's departure. He also found new ways to meet the technical needs of artists as lithographs became larger, more colorful, and more complex.[18]

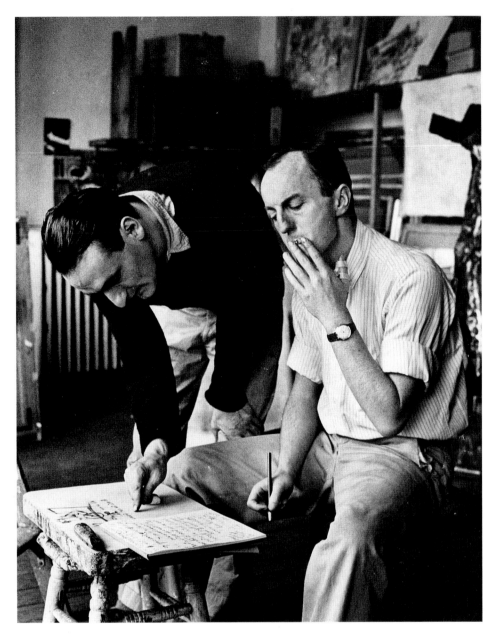

FIG. 5 ▪ Larry Rivers and Frank O'Hara collaborating on preparation of lithographic stone for *Stones* portfolio, 1958. Photo credit: Hans Namuth © Namuth Ltd. Photo courtesy of Namuth Ltd.

As Universal Limited Art Editions grew, Grosman's original goals also expanded. In 1966, a grant from the newly-formed National Endowment for the Arts allowed her to hire Donn Steward[19] to develop intaglio facilities to work with artists such as Helen Frankenthaler, Cy Twombly, Robert Motherwell, Lee Bontecou, and Jasper Johns.[20] In 1970, Grosman bought a large offset lithographic proofing press—synonymous with the commercial printing industry—and thus made available a new range of possibilities. One of the first to use the new press was Jasper Johns. The result was *Decoy*, which demonstrated the technical and conceptual progress Johns had made since his earlier and more direct prints such as *False Start I* (1962) (Cat. 6). The success of *Decoy* depended on the skill of James V. Smith, who had been hired to run the offset press, and Bill Goldston, a student of Priede's who has since become director of ULAE.[21] Many printers have worked at ULAE since 1957; since Grosman considered the artist to be the principal talent, however, many of these creative collaborators have not received recognition.[22]

While Tatyana Grosman was publishing ULAE's first projects in New York, June Wayne was developing a plan for a different type of print workshop in Los Angeles. An artist herself, Wayne had been frustrated in her search during the 1950s for skilled printers to work with. Articulate, accomplished, and driven by a belief that lithography was a dying art, Wayne approached the Ford Foundation with a proposal to establish a lithography workshop. She hoped to develop a new breed of craftsman, an artist-printer who would be a full collaborator in the printmaking process, free of the traditional reactive mentality that prevailed in many European printshops. When the Ford Foundation awarded Wayne the first Tamarind grant in 1959, she joined with two other artists, Clinton Adams and Garo Antreasian, to found the press.[23] Established and emerging artists and printer-trainees were invited to work at Tamarind. Rico Lebrun (Cat. 4), Josef Albers (Cat. 9–11), and Adja Yunkers (Cat. 2) were among the first to collaborate there on the creation of black and white lithographs. In 1970, the Tamarind Institute was established at the University of New Mexico in Albuquerque as a permanent educational and creative center, with Clinton Adams as Director, Garo Antreasian as Technical Director, and Wayne as an adviser, while she continued operating her own professional printshop in Los Angeles.[24]

Although the founding of ULAE and Tamarind are generally cited as the beginning of the printmaking revival in the United States, several other influences shaped it as well. The Pop Art movement was a major impetus, both in America and abroad. Although many European presses were steeped in the tradition of the printer as a replicator of the artist's work, avant-garde trends were being felt in Europe as in America, and new workshops there were beginning to explore and adapt commercial technologies to fine art production. It was in Europe that many American artists and prints were given their first exposure to printmaking.

AMERICANS ABROAD: INFLUENCES AND INTERACTIONS

As Tamarind and ULAE were offering expanded opportunities for collaboration in lithography, a new wave of interest in screenprinting, the medium most closely identified with Pop Art, was finding a host of practitioners on both sides of the Atlantic. Proponents of screenprinting fought hard to overcome its stigma as a commercial process suited only for product labels, posters, and fabric stenciling. In England, whose artists were in the avant-garde of Pop in the early 1960s, printers were working with a wide range of European and American artists. Kelpra Studio, founded in London by Chris Prater in 1957, was one of the earliest print studios to adapt commercial screenprinting techniques to fine art production.[25] Richard Hamilton, Eduardo Paolozzi, David Hockney, and R. J. Kitaj all worked with Prater, each helping to define the possibilities of the medium. Prater's pioneering use of photographic processes for the preparation of screens and his willingness to experiment gave artists new freedom to borrow and adapt imagery from the media-saturated world surrounding them. During the 1960s and early 1970s, the Americans Jim Dine, Robert Motherwell, Adolph Gottlieb, Ted Stamos, Alan D'Arcangelo, and Larry Rivers came to work with Prater. Kelpra published editions as well as printing them, and numerous other publishers and dealers distributed their prints throughout the world.[26] Another English workshop, the Curwen Studio, an outgrowth of the Curwen Press founded by Stanley Jones as a lithography studio in 1958, was among the earliest printshops to make extensive use of offset lithography, and its prints helped to ease the commercial stigma associated with that process.[27]

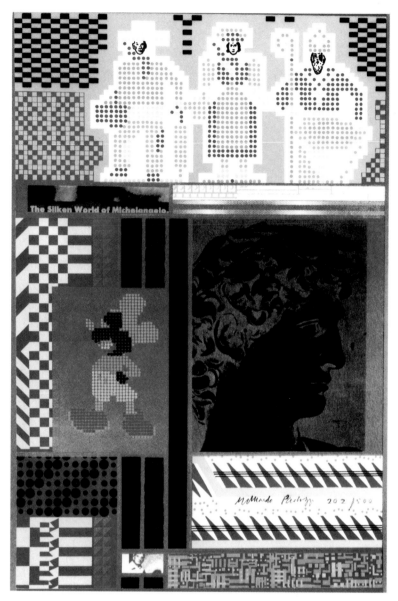

FIG. 6 ▪ EDUARDO PAOLOZZI ▪ *THE SILKEN*
WORLD OF MICHELANGELO, FROM THE
MOONSTRIPS EMPIRE NEWS PORTFOLIO
screenprint, 1967, printed at Kelpra Studio, London. Photo credit: Jack Abraham.
Photo courtesy of The Jane Voorhees Zimmerli Art Museum

Another English press, Editions Alecto Limited, was founded in London in 1962 by Joe Studholme and Paul Cornwall Jones. In 1963 it merged with Robert Erskine's St. George's Gallery to include not only an atelier, but also an exhibition and educational center.[28] Robert Erskine was already a strong advocate of contemporary printmaking before he joined Alecto.[29] Just as June Wayne had formulated a program combining creative collaboration with professional training, Editions Alecto and the Print Centre mounted traveling exhibitions and published substantial catalogues. Alecto also developed new marketing and advertising approaches and redesigned the shop to facilitate both the visiting artists and the buying public. Such promotional efforts, aimed at rapidly growing corporate collections, would soon become common in the United States as well.[30]

One of Alecto's first commissions in 1962 was David Hockney's *The Rake's Progress*, a suite of sixteen etchings that won first prize at the 1963 Paris Biennale. In 1964, Alecto expanded to include additional printmaking studios, business offices, and accommodations for visiting artists.[31] Printers were hired to collaborate with artists, and projects were also published with other printers, including a number of important early commissions with Kelpra Studio. In its first ten years, Alecto published more than eight hundred editions, including Jim Dine's *Tool Box* (1966), Eduardo Paolozzi's *As Is When* series (1965), and Edward Ruscha's *News, Mews, Brews, Stews, Pews, Dues...* (1970). Alecto also played a leading role in the production of multiples,[32] including Claes Oldenburg's *London Knees* (1968),[33] Peter Sedgeley's motorized *Videodisques*, an acrylic chess set by David Pelham, and, in 1970, George Segal's ambitious *Girl on a Chair*.[34] In 1971 Alecto International was formed to research the application of industrial methods to artistic expression, and to publish both multiples and prints. The previous year, Paul Cornwall Jones had left Alecto to found Petersburg Press, which became a major force in the print world almost overnight. Like Editions Alecto, Petersburg also opened a New York studio to accommodate an impressive roster of American artists and a growing marketing operation.

While Editions Alecto provided an example for many presses in the United States, galleries, dealers, and publishers in England were also enlivening the scene. Marlborough Fine Arts in London started a print department in 1964 and began publishing for both European and American markets. The Redfern Gallery, Bernard Jacobson, and Leslie Waddington, all London dealers, also began publishing new editions on a regular basis. Meanwhile, English art schools like the Slade School of Fine Art and the Central School of Art and Design in London were training ever-growing numbers of printers.

Outside Great Britain, American artists had many opportunities to make prints, and a surprising number of the American prints considered icons of the 1960s were created abroad. Editions Domberger, established in the late 1950s in Stuttgart, was an early screenprinting studio, specializing in the use of intricate hand-cut stencils and in the use of fluorescent inks.[35] Most of Robert Indiana's early screenprints were produced there, and Josef Albers, Victor Vasarely, Les Levine, Nicholas Krushenick, Richard Anuszkiewicz, Allan D'Arcangelo, Marisol, and Richard Estes all worked there as well.[36] Hans-Peter Haas also collaborated with artists in Stuttgart, screenprinting for George Segal and others, while lithographer Kurt Lohwasser worked with American artists in Munich.

In Italy, Valter Rossi and Eleonora Romeo opened 2RC Editrice in 1965 in Rome, with facilities for intaglio printmaking, lithography, and screenprinting.[37] Floriano Vecchio produced screenprints with Grace Hartigan and Andy Warhol in the 1950s,[38] and in Milan Sergio and Fausta Tosi and Editrice Electa worked with American artists throughout the 1960s. In Zurich, Emil Matthieu printed Sam Francis's first lithographs, a series of sixteen prints published by the dealer E. W. Kornfeld in Bern, Switzerland.[39] In Paris, the ateliers of Aldo Crommelynck, Georges Leblanc, Marcel Durassier, and Imprimerie Mourlot also produced numerous editions with American artists.

European dealers and independent publishers also underwrote a wide range of print projects. Arturo Schwarz, a Milanese art dealer, began publishing the *International Anthology of Contemporary Engraving: The International Avant-Garde* in 1962, a series of six portfolios featuring prints by an international group of artists. The fifth of these, *America Discovered*, printed at the Atelier Leblanc in Paris, contained twenty prints by American artists, including Jim Dine, Allan Kaprow, Allan D'Arcangelo, Roy Lichtenstein, Red Grooms, Andy Warhol, and James Rosenquist.[40] E. W. Kornfeld also published *1-Cent Life* in 1964, a portfolio of sixty-two lithographs by various artists conceived by the painter

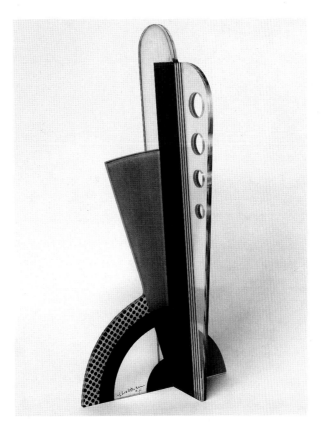

FIG. 7 ▪ ROY LICHTENSTEIN ▪ *MODERN OBJECT*
1967, screenprint on Mylar and plexiglass, printed at Maurel Studios,
New York. Photo credit: Nathan Rabin. Photo courtesy of
The Jane Voorhees Zimmerli Art Museum

Walasse Ting and edited by Sam Francis.[41] Jörg Schellmann began publishing editions in Munich in 1969,[42] as did Dorothea Leonhart with Edition München International.[43] These were only a few of the publishers who supported young American artists as they launched international careers.[44] Many other Americans went abroad during the 1960s and 1970s to train in European printshops, forming professional friendships with American artists that would be continued at home. Printers, too, went to Europe after training in America, returning later to establish their own shops.[45]

THE FIRST WAVE: DIVERSITY IN THE 1960S

While California and New York became the primary American printmaking centers in the 1960s, a few early presses were established elsewhere. In 1959, George Lockwood had founded Impressions Workshop in Boston, specializing in lithography and intaglio printing and later adding screenprinting and letterpress equipment. Peter Milton (Cat. 40), Michael Mazur, Saul Steinberg, Robert Birmelin, Bernard Childs, Sam Gilliam, and Adja Yunkers were among the artists working at the studio with printer Robert Townsend. Other shops began to spring up near colleges and universities with printmaking programs, often specializing in the work of regional artists. By 1973, the art critic and historian Diane Kelder would state that "print studios have been at the forefront of the decentralization of the art world."[46] With the success of ULAE and Tamarind, Tamarind-trained printers were soon establishing new shops around the country. Irwin Hollander was the first of these to move east, opening the Hollander Workshop Gallery in New York in 1964. With a strong affinity for the Abstract Expressionists, Hollander worked with Robert Motherwell, Louise Nevelson, Ellsworth

Kelly, Willem de Kooning (Cat. 23), Esteban Vicente, and Jack Tworkov; he also collaborated with Pierre Alechinsky, Leonard Baskin, Salvator Dali, Philip Guston, Allen Jones, Richard Lindner, Claes Oldenburg, Moses Soyer, Saul Steinberg, and Karl Knaths. Hollander, having adopted Tamarind's goal to improve and advance the technology of printmaking, was one of the first printers to use the new presses being made by Charles and William Brand.[47]

Several Tamarind printers remained in California and started new workshops there. Joe Funk, who had worked in Lynton Kistler's shop before training at Tamarind, opened Kanthos Press in 1963. Joseph Zirker founded Original Press in San Francisco in 1965, working with such artists as Deborah Remmington, Frank Lobdell, and Richard Diebenkorn.[48] Original Press's successor, Collector's Press, was established in San Francisco in 1967, with printer Ernest de Soto working with such artists as Masuo Ikeda, Nathan Oliveira, Peter Voulkos, Jules Olitski, Roy De Forest, Bruce Conner, Mel Ramos, Peter Saul, and Arnaldo Pomodoro.[49]

Best known of the Tamarind printers to set up his own shop is the legendary Kenneth Tyler.[50] Tyler's technical genius and his passion for collaborative work helped produce extraordinary art works, and set high standards and expanded definitions for contemporary prints. At Tamarind, Tyler had quickly risen to the position of Technical Director, developing new equipment and methods to improve the preparation and printing of lithographic stones. In 1965, he founded Gemini Ltd. in Los Angeles and soon after joined with two partners to form Gemini G.E.L.[51] Tyler's commitment to improving technology led to the design of custom hydraulic presses and to the development of new registration systems for the precise printing of multiple colors. Gemini G.E.L. also researched and developed new papers, inks, and other supplies and equipment. Some of Tyler's innovations were begun at Tamarind, where he had worked with artists such as Josef Albers[52] (Cat. 9–11), but it was not until Gemini G.E.L. was formed that Tyler began to work extensively with artists who shared his enthusiasm for the new and untried. Gemini G.E.L. soon became the proverbial candy store for artists to produce prints of astonishing size and complexity.

Robert Rauschenberg first visited Gemini in 1967, and the resulting *Booster and 7 Studies* (Cat. 17) immediately redefined the contemporary print. Measuring 75 inches tall and 35½ inches wide, this combination lithograph and screenprint was based on a full-sized X-ray of Rauschenberg's body. With no stones of this size available, *Booster* had to be printed in two stages, with two separate stones printed in sections on one large sheet of paper. One has only to compare *Booster* with Rauschenberg's *Accident* (Cat. 7) of a few years earlier to appreciate how far the artist's thinking had evolved. Frank Stella came to Gemini in 1967 to work on his first published print, *Star of Persia I* (Cat. 18), which also tested Tyler's ingenuity.[53] In 1968, Tyler began another ambitious collaboration with Claes Oldenburg's *Profile Airflow*, which required extensive experimentation with plastics, and took two years to complete.[54] Gemini prints soon became a standard by which ambitious projects were judged. Besides Kenneth Tyler, a number of printers have worked at Gemini G.E.L. Serge Lozingot, who had trained in France and at Tamarind, collaborated as printer and shop manager with Jasper Johns, Richard Diebenkorn, David Hockney, Roy Lichtenstein, and Robert Rauschenberg on prints using a variety of processes and techniques.[55]

Some printers, especially screenprinters, were self-taught, and their work abounded in exploration and experimentation. Sheila Marbain, for example, had learned the basics of traditional screenprinting in the early 1950s, including the preparation of tusche and glue stencils in the tradition of the WPA artists who had pioneered the medium. After working briefly for a commercial screenprinting firm, Marbain opened Maurel Studios in 1960. By the mid-1960s

Marbain was working with Claes Oldenburg, Robert Rauschenberg, Robert Motherwell, Roy Lichtenstein, Alan Shields, Arakawa, Larry Poons, and Helen Frankenthaler, producing prints, posters, and three-dimensional editions, including experimental projects printed on a variety of plastics, metals, and other nontraditional materials.[56]

Several other screenprinting shops founded in the 1960s enjoyed brisk business. Steven Poleskie opened Chiron Press in New York, producing classic Op and Pop images by artists such as Richard Anuszkiewicz (Cat. 13). Brice Marden's connection with Chiron began when he began working for Poleskie in 1965, soon after moving into a loft above the shop. Marden mixed inks and assisted printers during the day, and he often used extra proof sheets of flat color for his own drawings.[57] By the time Marden's important early lithograph *Gulf* (Cat. 21) was printed, Poleskie had already left Chiron to teach at Cornell University.[58] The shop continued under the direction of screenprinter Roger Loft and lithographer Michael Knigin,[59] working on a variety of projects (Cat. 22). In New Haven, Connecticut, Norman Ives and Sewell Sillman began publishing as Ives-Sillman, producing at Sirocco Screenprints such works as Josef Albers's *Ten Variants* of 1967. Styria Studios, started by Adolf Rischner in Glendale, California in 1968, and providing custom screenprinting to Gemini G.E.L. before setting up as an independent printshop in 1970,[60] moved to New York and quickly began working with James Rosenquist, Robert Rauschenberg, and others. Arnold Hoffman in Easthampton; Jerry Solomon, the Bank Street Atelier, and Aetna Silk Screen Products in New York; and Cirrus Editions in Los Angeles were just a few of the other shops that established screenprinting as a suitable vehicle for a broad range of artistic expression.

Cirrus Editions began working with numerous California artists, and many early editions such as Bruce Nauman's *Raw-War* of 1971 (Cat. 27) are key examples of the prints made by new Conceptual artists.[61] In addition to the well known print studios, commercial shops with names like Salvatore Screen Print Company, Color Craft Press, Fine Arts Creations, Inc., Seri-Arts, and Knickerbocker Machine and Foundry were also printing editions, and were instrumental in introducing new commercial color techniques such as the rainbow or blend roll to fine art presses.

Artists and printers meanwhile continued to explore offset lithography for new effects. In offset lithography, the image is transferred from a printing plate to an intermediate rubber blanket, which then transfers the image to the sheet of paper. This two-step procedure saves the artist from having to create the original image in reverse. Moreover, plates can be made using a variety of hand-drawn or photographic techniques. Since offset requires far less water and ink than traditional lithography, greater accuracy in registration, finer detail, and faster drying times are possible, allowing the artist and printer to build up complicated images in multiple layers. Despite the commercial overtones of photomechanical processes, and the further removal of the hand of the artist from the finished piece, offset lithographs appeared in many different forms.[62] Long before Universal Limited Art Editions made its first offset prints with Jasper Johns, Eugene Feldman had experimented with offset technology and photographic manipulations on various papers at Falcon Press in Philadelphia.[63] Similarly, the nonprofit Art-Research-Technology workshop in Massachusetts was founded to work with industrial facilities to experiment for both commercial and artistic purposes, with such printmakers as Hiroshi Murata introducing a number of artists to offset lithography.[64] Frank Stella first used offset when he worked with Petersburg Press in London in 1972, and later introduced the process to Gemini G.E.L.[65]

While lithography and screenprinting dominated the 1960s, some shops were already focusing on new techniques. Garner Tullis, whose name has become synonymous with handmade papers and monotype printing, began collaborat-

ing with artists in 1961. Encouraged by the sculptor David Smith and the printmaker Eugene Feldman, Tullis was one of the first printers to rethink printmaking in terms of definition, process, paper, and scale.

Intaglio prints, once associated with the Surrealists and Abstract Expressionists, attracted artists committed to line and drawing. In 1962, Kathan Brown returned from study in London to found Crown Point Press in Oakland, California. Her earliest projects with Wayne Thiebaud (Cat. 12), Richard Diebenkorn, Beth Van Hoesen, and Bruce Connor quickly demonstrated the effects that could be achieved with etching and aquatint, as well as achieving a high degree of precision and uniformity.

PRO-PRINT: EARLY EDUCATION AND ADVOCACY

In the United States, as in Europe, early support for contemporary prints came from diverse sources. The Print Council of America had been formed in 1956 by museum curators, dealers, artists, collectors, and scholars with a goal to "foster the creation, dissemination, and appreciation of fine prints, old and new."[66] New prints were the subject of many of the Council's discussions, with such topics as the lack of recognition for contemporary printmakers and for printmaking as a medium, the confusion between original and reproductive prints, the lack of standards of quality for new prints, and the lack of publications devoted to prints and printmaking. The advocacy of the Print Council did much to legitimatize collaborative printmaking and bring it to the attention of wider audiences. New publications were also giving attention to prints. *Artist's Proof, Print Review*, the *Tamarind Papers*, and, by 1970, *the Print Collector's Newsletter* were all periodicals devoted to printmaking. Museums added staff and broadened their scope to acquire, exhibit, and publish catalogues of new prints. Important exhibitions gave wide exposure to the early prints of established artists.[67] Museums and art centers also sponsored print clubs, who would meet to learn more about prints of all types. Some commissioned and published their own editions, providing opportunities for artists to have their work appreciated and collected outside the commercial centers of the country.[68]

While traditional collectors had generally stored their prints in portfolios to be brought out for study and appreciation, new collectors began to frame and display their prints as they might paintings. When Carl Zigrosser, a pioneering print curator at the Philadelphia Museum of Art, had sold American prints of the 1930s for the Weyhe Gallery, he had found that, even at low prices, prints were difficult to sell because they "had no snob appeal."[69] Print collectors in the 1960s were clearly a new generation. Well educated and upwardly mobile, they bought prints by well known artists and displayed them to signify both cultivation and social status.[70] As prints grew larger to compete with paintings, presses invested in larger machines to accommodate the taste for grand scale.[71] Museums and corporations also began buying large works for gallery and boardroom walls.

Dealers and publishers were quick to see new markets for prints, and they worked hard to bring the buying public into the marketplace. By the late 1960s, New York galleries such as Pace, Marlborough-Gerson, Leo Castelli, Richard Feigen, and Gimpel Weitzenhoffer were publishing editions. The New York dealer Martha Jackson played a major role, publishing early prints by artists such as Jim Dine and exhibiting graphics by a wide-ranging group of artists throughout the 1960s.[72] Marlborough Graphics and Transworld Art, among others, issued illustrated catalogues and sold their editions by mail. Presses also learned to market their own editions, developing a clientele eager to purchase prints directly from the source.[73] In addition to having the first rights to purchase, these clients were often welcome to visit

the workshop during various stages of the collaboration to meet the artists and see their prints as they were being created.

One development of the 1960s was the practice of publishing the prints of several artists together in portfolios. Gallery owner Rosa Esman released the first of a series of these in 1965 with *New York 10*, a collection of the work of ten New York artists (Cat. 13).[74] Marion Goodman established Multiples, Inc., in 1965 to produce, exhibit, and sell prints and editioned objects in her New York gallery. The publishing firm of Harry N. Abrams produced Abrams Original Editions, and in 1965 released three volumes of *Pop Artists II*, a broad survey of important figures in the Pop movement.[75]

Portfolios were also sold to support a variety of cultural, political, and social causes, allowing collectors to support favorite charities while buying art. Political organizations such as Artists and Writers Protest, the Academic and Professional Action Committee for a Responsible Congress, the Center for Constitutional Rights, and the Scholarship, Education, and Defense Fund for Racial Equality gained wide support from artists (Cat. 22). In 1964 the Wadsworth Atheneum in Hartford was one of the earliest museums to publish contemporary prints with the *Ten Works + Ten Painters* portfolio, setting an example that would be followed by a flood of other nonprofit art organizations.[76]

Throughout the 1960s and early 1970s the market for prints was vigorous, and prices rose steadily. As the political events and economic recession of the late sixties dampened the nation's optimism, fascination with Pop, Op, and Happenings waned, and there was a renewed interest in art that was formal, intellectual, and cooler in spirit.

PROFESSIONALISM IN THE 1970S: THE COLLABORATIVE PRESS COMES OF AGE

Despite shifts in artistic tastes, collaborative workshops sustained steady growth throughout the 1970s. If the decade of the 1960s was committed to developing an audience for prints, the 1970s were devoted to developing and expanding their market. Established presses worked with many of their original artists and with new talent; new printshops developed their own relationships; and a growing number of dealers and publishers promoted editions with increasingly sophisticated marketing techniques.

While many of the artists who had made stylistic breakthroughs in the 1960s continued to explore ideas and formats in their printmaking, new aesthetic and intellectual concerns found expression in a daunting array of styles. Rejecting the Pop artist's fascination with the mass-produced world, the New Realists, Photorealists, Conceptual artists, and Minimalists of the early 1970s approached printmaking with renewed objectivity and formalism. Ideas superceded virtuosity for many Minimalists and Conceptualists, and printmaking became a vehicle for exploring the meaning of art and a medium to resolve the conflicts between the intellectual and the visual. While some printers continued to perfect technical capabilities to serve the needs of a Robert Ryman, a Donald Judd, or a Robert Cottingham, many were simultaneously learning to bend the rules when necessary to provide artists with ways in which to combine processes and to further individualize their prints with the addition of handwork. Whereas many of the Pop and Op styles of the 1960s had featured the transferring of images, and the systematic laying down of lines and flat areas of color with the machine-like precision of lithography and screenprinting, the 1970s ushered in a renewed interest in mark-making. Intaglio processes—etching, aquatint, and drypoint—which could express every linear or tonal nuance of the hand, became a favored medium for many artists.

Throughout the 1970s, shops bought presses that allowed the printing of larger sheets, investigated new papers, and hired printers trained to work with multiple processes. As an alternative to large single-image prints, many artists produced work in portfolios or series, a format particularly suited to the work of artists who were concerned that their art reflect the concept, the techniques, and the working process involved in its creation.

Fascination with paper, both as a support for the printed image and as a material that could be manipulated on its own, reflected a new interest in craft and the physicality of the print. Presses looked for new papers for proofing, while some artists produced editions of embossed paper that did not include any actual printing. While artists challenged printers to combine processes and to assist in the creation of painterly prints that explored gestural and spontaneous possibilities, printers enticed artists with new equipment and encouraged experimentation, resulting in increasingly sophisticated and diverse images.

In California, Kathan Brown's Crown Point Press developed a unique relationship with the New York publisher Robert Feldman and his Parasol Press. Brown, sensitive to new minimal modes of expression, had already demonstrated that the increasingly exacting standards of contemporary printing could apply to intaglio processes. Feldman began sending artists including Sol LeWitt (Cat. 26), Brice Marden, Dorothea Rockburne, Robert Mangold, Robert Ryman, Dan Flavin, and Barry Le Va to work with Brown in California, with results that amount to a survey of the Minimalist print. Ryman's *Seven Aquatints*, printed with Crown Point Press in 1972, demands a careful eye on the part of the viewer lucky enough to study them, as nuances embodying the qualities of line and texture of each mark on the paper, the paper itself, the relationship of marks to the debossed platemark and to the normally ignored artist's inscriptions force shifts and slight changes of focus in the pictorial space. The sensibilities of artist and printer in this series are a perfect blend of vision and realization. In 1972, Crown Point undertook a very different challenge as Parasol Press arranged to send Chuck Close to work with Brown on the ambitious mezzotint portrait of *Keith* (Cat. 29). Close had been reluctant to make a print, agreeing only if the project could be a "stretch for the printshop" as well as for him.[77] The project required the purchase of a large 42" x 60" press and a commercial photoengraving machine that allowed a photomechanical preparation of the very large mezzotint plate by transferring and etching a photographic half-tone screen with fine resolution onto it.[78] The plate was approved for editioning after three months of proofing, and printer, artist, and publisher were all pleased with the resulting edition of ten prints.[79]

By 1977, Crown Point began to focus on its own publications,[80] and the press broadened its scope to work with such artists as Vito Acconci (Cat. 51), Pat Steir, Chris Burden, Daniel Buren, Jannis Kounellis, and Claes Oldenburg. Certain collaborations stand out, for example, the thirty-year working relationship enjoyed by Kathan Brown and Richard Diebenkorn, which resulted in such masterworks as *Green* (1986) (Cat. 78), or the long and multi-faceted relationship Brown enjoyed with John Cage.

On the East Coast, new print workshops mushroomed. Condeso/Brokopp Studios, founded by Orlando Condeso and Nancy Brokopp in New York in 1973, began printing large etchings with Susan Shatter, Alex Katz, Philip Pearlstein, Richard Haas, and Jane Freilicher.[81] Prawat Laucheron opened an intaglio studio in 1974, collaborating with Alex Katz, among others. The cool, stylized realism of works such as Katz's *The Swimmer* (Cat. 38) demonstrated the suitability of etching and aquatint for the detached observances of much of the realism of the early 1970s. Kathleen Caraccio, who apprenticed and taught at Robert Blackburn's Printmaking Workshop, where she had worked with Romare Bearden[82]

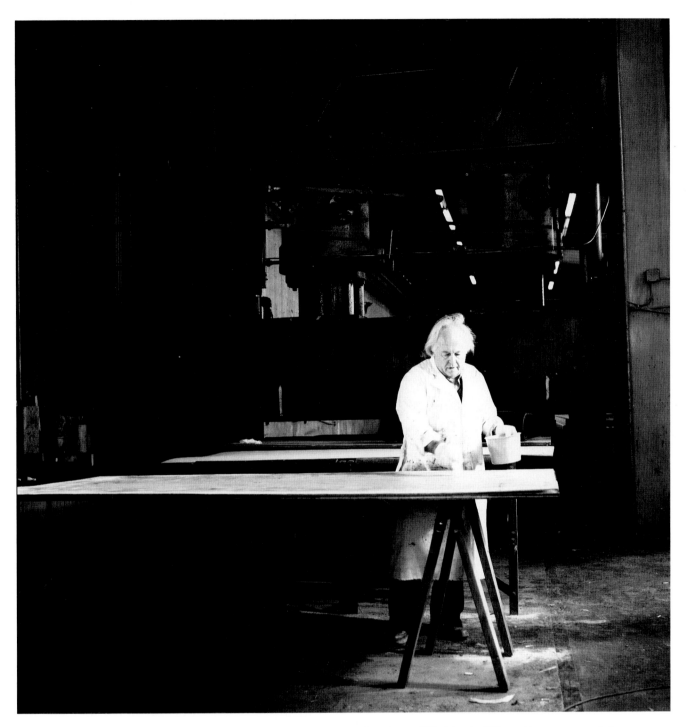

FIG. 8 ▪ Sam Francis standing in front of a hydraulic press at Experimental Workshop in 1982, working on an extended
series of woodcut monoprints. Photo credit: Richard Tullis II ©. Photo courtesy of Richard Tullis II

(Cat. 41), opened K. Caraccio Etching Studios in 1977, which has strongly supported women artists and printers.[83]
Catherine Mosley also established an etching studio in 1974, printing for Richard Haas, Robert Beauchamp, Lucio Pozzi,
Agnes Denes, and Harvey Quaytman. Mosley was also among Robert Motherwell's circle of printer-collaborators.
Her association with Motherwell lasted eighteen years, and accounted for many of Motherwell's arresting intaglio
images (Cat. 65).

Print workshops specializing in lithography and screenprinting continued to expand and develop new techniques. By
1970, Gemini G.E.L. could boast three custom-designed hydraulic presses, screenprinting facilities, a sculpture shop,

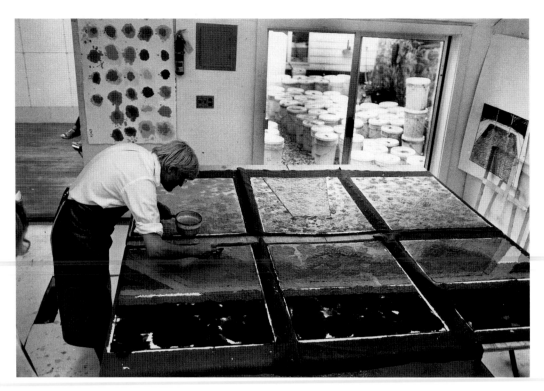

FIG. 9 ■ David Hockney working on *Paper Pools* series at Tyler Graphics, Ltd., Bedford Village, New York, 1978.
Photo credit: Lindsay Green. Photo courtesy of Tyler Graphics, Ltd.

large inventories of supplies, including standard and custom handmade papers, a staff of eighteen and associations with a number of specialized independent collaborators.[84] By 1979, a full etching studio had been added. The 1970s saw a dizzying cast of artists working on Gemini G.E.L. prints, paperworks, and multiples.[85] Styria Studio, founded by Adolph Rischner in Glendale, California, in 1968 moved to New York to collaborate with James Rosenquist, Larry Rivers, Arakawa, Robert Rauschenberg, Andy Warhol, and Donald Judd.

Tamarind-trained printers continued to open new workshops around the country. In 1970, Jack Lemon opened Landfall Press in Chicago and began making lithographs with realist and photorealist artists including Philip Pearlstein, Chuck Close, Alfred Leslie, and Robert Cottingham (Cat. 31) and with Chicagoans Edward Paschke, Jim Nutt, and Roger Brown (Cat. 42).[86] Soon Landfall was publishing the prints of Jim Dine, Christo, William Wiley, Claes Oldenburg, and Pat Steir (Cat. 39). In 1974, Landfall established an etching studio with the assistance of Timothy Berry to begin a project with Oldenburg,[87] and to work with many of the other artists who were collaborating regularly at Landfall (Cat. 44, 45, 47). Three years later, Berry moved his Teaberry Press to the San Francisco Bay area, where he continued working with William Wiley and a number of other California artists.[88] By the late 1970s, Landfall became one of the early studios to make a renewed commitment to relief printing. Lemon has described his collaborations as "not making prints as far as I'm concerned. It's making art."[89] Indeed, many of his studio's projects blurred the lines between prints and other art forms, including William Wiley's *Coast Reverse* diptych, which was printed partially on animal hide (Cat. 30), and Christo's collaged "wrap" pieces. Judith Solodkin, the first woman to complete Tamarind's master printer program, opened Solo Press in New York in 1975, specializing in lithography and letterpress in the production of prints with such artists as Dottie Atty, Robert Kushner, Nancy Spero, Howardena Pindell, Susan Shatter, and Howard Hodgkin.

Both new and established print studios responded quickly to the new interest in paper. When Garner Tullis moved to California and opened the Institute of Experimental Printmaking (later the Experimental Workshop) with Ann McLaughlin in 1972, papermaking facilities formed a major component of the shop.[90] As the largest printshop devoted to monotypes and monoprints, Tullis continued long associations with artists such as Sam Francis (Cat. 57) and introduced young artists like the painter Nancy Haynes to working with paper (Cat. 97). When Kenneth Tyler left Gemini G.E.L. to found Tyler Graphics in Bedford Village, New York in 1974, he too included space for papermaking. Before long, Tyler was collaborating with artists on a variety of innovative paperworks, including David Hockney's remarkable *Paper Pools* series.[91] Other molded paper projects at Tyler Graphics were Frank Stella's 1975 series of 183 paper pulp reliefs and Kenneth Noland's equally ambitious 1978 series of two hundred unique pulp-painted pieces. Sheets of TGL handmade paper began to figure in many of the shop's projects, notably Frank Stella's ambitious *Circuits Series* in the early 1980s (Cat. 64).

Further afield, printmaker and teacher William Weege, with a mind free of traditional proscriptions, opened the Jones Road Print Shop and Stable near Madison, Wisconsin. Artists invited to work at Jones Road were encouraged to incorporate collage, flocking, sewing, and a wide range of techniques in their works. The shop also began making handmade paper, and in collaborating with the Upper U.S. Paper Mill run by Joseph Wilfer, encouraging artists to experiment with paper pulp in innovative ways.[92] Important early collaborations with such artists as Sam Gilliam and Alan Shields (Cat. 28, 32) were daring, original, and often difficult to classify. Weege characterized many of these works not as prints, but rather as "things with printmaking techniques."[93]

While many shops were making their own paper, several paper mills were making handmade papers for artists. Douglass Howell was one of the first papermakers to begin working extensively with contemporary presses.[94] Twinrocker Paper Mill in Brookstone, Indiana,[95] Farnsworth Paper Mill in San Francisco, Imago in Oakland, California, John Koller Handmade Papers in Connecticut, and Dieu Donné Papermill in New York are a few of the shops whose unique papers became integral to many contemporary print projects.

Despite the renewed interest in line, painterly approaches to printmaking also persisted in the 1970s. In part a reaction to the impersonal and mechanistic 1960s styles and the formalism of the early 1970s, increasing numbers of painters and sculptors began to focus on expressive possibilities. Once again, printers responded to accommodate the creation of works combining processes as well as monoprints and monotypes that continued to break down distinctions between prints and one-of-a-kind artworks.

For presses publishing their own projects, the growing interest in unique paperworks presented both challenges and rewards. While marketing unique works was time-consuming, their prices reflected the elite appeal of one-of-a-kind works over multiple originals. Moreover, just as artists often preferred the spontaneity and directness of creating monoprints and monotypes, many printers enjoyed the freedom from the tedious editioning process. Soon presses began to encourage artists to produce unique works while they were working at the shop to collaborate on editions.

Artists' interest in a painterly approach led to some surprising developments, particularly in screenprinting. Leading the way was Simca Print Artists,[96] which in 1973 began working with Jasper Johns on *Flags I* (Cat. 34), using thirty-one screens to amass the dense marks and textures suited to Johns's multi-layered images.[97] Between 1979 and 1981, Johns worked with Simca on several projects that served as an exciting new medium for him and also demonstrated radically

new directions for screenprinting. At the same time, Gemini G.E.L. was producing editions with Claes Oldenburg, Michael Heizer, and Sam Francis that bore little resemblance to the screenprints of a decade earlier.[98]

As workshops proliferated and the print market expanded during the 1970s, a number of galleries began selling artists' prints along with their paintings and sculptures. A few new galleries, such as Prints on Prince Street in New York, specialized in new editions.[99] 724 Prints, run by Nancy Melzer and Dorothy Pearlstein, capitalized on the owners' close associations with a wide circle of New Realist artists.[100] Brooke Alexander began publishing print editions in 1969, working with a number of workshops and artists. His exhibitions were bellweathers of new trends, with shows dedicated to the New Realists and a prescient 1973 exhibition of "Hand Colored Prints."[101] Over the course of a decade, his publications ranged from the 1969 portfolio *Six New York Artists*, which showcased the work of Jack Beal, John Clem Clarke, Alex Katz, Malcolm Morley, Philip Pearlstein, and Robert Stanley, to Jennifer Bartlett's tour-de-force *Graceland Mansions* in 1979 (Cat. 48). *Graceland Mansions* was a high point in the history of collaboration, as Bartlett worked with five different printers on the five panels, using varying processes. Brooke Alexander coordinated meetings with the printers to discuss papers and inks to insure an overall uniformity, playing a role similar to that of a conductor directing a symphony. Bartlett's was no less ambitious; she mastered four new print techniques to create a series that elegantly fused the decade's representational, conceptual, and painterly concerns.

Joining dealers and publishers were independent art consultants who bought prints for private collectors, corporate and museum curators, and even hotels and hospitals. Corporate buying and support for the arts continued to increase, as did funding to museums from the National Endowment for the Arts for exhibitions, catalogues, and even purchasing prints for their collections. More presses began to publish their own editions, often adding extra staff to help document, publicize, and market new editions. The growing popularity of art fairs, notably in Chicago, New York, and Los Angeles, also gave many presses a taste of direct exposure to the buying public.

One sign that printmaking had been elevated to the sacred groves of fine art could be found in various marketplace abuses that occurred during the 1970s. As prices continued to rise and secondary gallery and auction markets saw prices for the prints of the best known contemporary artists appreciate rapidly, a new sales tactic, that of promoting print buying as an investment, took hold. The most unfortunate manifestation of this was the short-lived phenomenon of the tax-shelter print.[102] When tax reform legislation in 1976 made oil wells, gas, real estate, and the film industry less attractive to people looking for tax deductions, a number of dealers, publishers, and artists began creating print editions to be sold as investments. While the details of each scheme varied, the result was a flood of mediocre prints, some of which never had a life on the open market but which were stored away as the investors took deductions for the printing plates and claimed losses on unsold prints. Most of the prints created for this market did not represent any significant collaboration by either artists or printers. In 1976, the IRS moved to enact rulings that would make art investment shelters as unattractive as the earlier ones, and by the early 1980s the entire episode had subsided.[103] However, the affair cast a cloud of suspicion over the print market, particularly for those investors who could not distinguish the best works of an artist or period from lesser images.

Meanwhile the debate regarding print documentation continued. While questions regarding the definition of an "original" print still surfaced as new techniques unsettled print purists, discussion of prints in the 1970s was chiefly focused on disclosure and with a buyer's right to know exactly what was being purchased. Once again, this concern

reflected the expanded market, which now included people who were buying prints as an alternative to other investments. Many collectors preferred to buy the work of "blue chip" artists whose earlier prints were bringing high prices. This attitude helped support the expansion of some of the larger presses that had long-established ties to these artists, although many of the smaller and newer shops had a difficult time gaining exposure for the prints of lesser-known artists. Nevertheless, a small number of astute collectors and curators supported exciting projects by young talent at new presses. The hearings that resulted in legislation to regulate the print market in several states, including New York, California, and Illinois, both educated the public and encouraged professional responsibility on the part of presses and dealers.

FULL CIRCLE: NEW LEVELS OF DIVERSITY IN THE 1980S

As American culture grew increasingly fragmented, the 1970s evolved into an eclectic and compartmentalized 1980s. In keeping with the common wisdom that stylistic movements tend to be followed by an equal and opposite reaction, a group of young painters emerged with renewed interests in expression and figuration. Labeled as Neo-Expressionists and New Narrative or New Image artists, they approached both abstract and representational subjects in highly personal ways. Artists were also making prints expressing issues of ethnicity, race, gender, and politics.[104] Meanwhile, many of the painters and sculptors of the 1970s continued to explore concepts and focus on process. Throughout the 1980s, appropriation and serial imagery could be seen in prints that once again challenged notions of originality, and demanded intense intellectual engagement, or at least a knowledge of art and current issues, from the viewer. Debates regarding originality continued to be more concerned with content than with form, as evidenced in the work of artists such as Sherrie Levine (Cat. 94) or Jeff Koons. The art world became internationalized again, evidenced by a wave of German and Italian artists making prints and in the arrival in the United States of several European printers who had come to work with American artists. The British printer Maurice Payne, for example, established his own intaglio print studio in New York after working for Petersburg Press (Cat. 82, 87–90). Aldo Crommelynck, who had enjoyed numerous collaborations with Jim Dine, David Hockney, and Jasper Johns in Paris,[105] in 1988 set up an etching studio in New York in association with Pace Prints's Spring Street Workshop. There he worked with David Salle, Eric Fischl, Richard Bosman, Dan Flavin, and Chuck Close, and on collaborative projects with the Spring Street Workshop, with artists including Julian Schnabel (Cat. 73).

One major printmaking development of the 1980s was a renewal of interest in relief processes. Inspired by sources as diverse as early 20th-century German Expressionist prints, traditional Japanese woodblocks, contemporary Minimalist art, and international folk art, interest by artists of both abstract and representational work led to an explosion of relief prints, some combining relief with lithography, screenprinting, and intaglio processes. A traditional approach to relief printing could be found in new shops such as those started by Chip Elwell in Manhattan and by Michael Berdan in Cambridge, Massachusetts. Elwell, who established his studio in 1975, offered artists such as Richard Bosman (Cat. 55), Louisa Chase (Cat. 61), Susan Crile, Joan Snyder (Cat. 66), Alex Katz, Jack Beal, and Sean Scully a wide range of wood relief, linocut, and stencil printing until his untimely death in 1987.[106] Berdan's Mulberry Press, established in 1980, specialized in traditional Japanese hand-printed woodblock techniques and produced collaborations with artists as diverse as Tom Wesselmann and Sol LeWitt.[107]

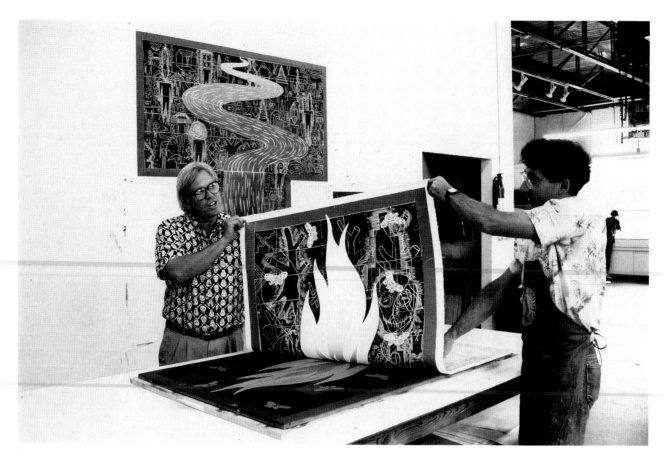

FIG. 10 ■ Master printer Bud Shark (right) and artist John Buck (left) pulling an impression of *The Times* during a proofing session at Shark's Inc., 1991. Photo courtesy of The Rutgers Archives for Printmaking Studios, The Jane Voorhees Zimmerli Art Museum

Many established ateliers also embraced relief printing enthusiastically. Bud Shark, a Tamarind-trained printer who had worked in London at both Editions Alecto and Petersburg Press, founded Shark's Lithography in Boulder, Colorado, in 1975.[108] Among Shark's first major publications was Red Grooms's three-dimensional *Ruckus Taxi*, a cut and folded lithograph that led to a number of ambitious three-dimensional works by Grooms and other artists, including Yvonne Jacquette and Hollis Sigler (Cat. 75). The studio has consistently supported women artists by publishing editions by Laurie Anderson, Susan Hall, Janis Provisor, Minna Resnick, Suzanne Anker, Susan Crile, Sondra Freckelton, Phyllis Bramson, Betty Woodman, and others. When Shark's Lithography changed its name to Shark's Inc. in the mid-1980s with the expansion of the studio into monoprinting and relief printing, projects with artists such as the sculptor John Buck (Cat. 68) demonstrated innovative approaches to the wood relief tradition.

Kathy Caraccio also became interested in traditional watercolor woodblock printing, and her etching studios in New York expanded to offer artists hand-printing of wood blocks as well as an ever-increasing array of intaglio and other specialized techniques (Cat. 83).[109] Gemini G.E.L., Tyler Graphics, and Universal Limited Art Editions also added relief printing to their repertoires. New power tools and the services of laser-cutting, die-casting, and even sand-blasting experts were also sought to work on oversize plates and blocks as traditional tools became inadequate for many large-scale projects.

Beginning in 1982, Kathan Brown began to encourage artists to explore traditional Japanese and Chinese woodblock printing by arranging to send them to Japan and China to work with master printers under the auspices of Crown

Point Press. As artists including Pat Steir, Alex Katz, Helen Frankenthaler, Francesco Clemente, April Gornik, Chuck Close, Eric Fischl, Richard Diebenkorn, and Sylvia Plimack Mangold traveled to Asia to proof blocks cut and printed after their drawings by master craftsmen, the program attracted considerable controversy. Brown had crossed the ever-shifting line of acceptability; and critics once again brought up the issue of originality.[110] Crown Point also continued to work with a wide array of artists in San Francisco, publishing not only prints but scholarly catalogues and interviews with its artists.

During the late 1970s and throughout the 1980s, new printshops continued to open. As interest in monotypes, monoprints, and other unique prints gained momentum, studios set up larger work spaces for artists who were spending extended time working there. Several presses added equipment to facilitate the use of multiple processes, as well as papermaking operations. In some cases, printshops with different specialties collaborated on projects,[111] the physical size and prices of which continued to grow.[112]

Derrière L'Etoile Studios, founded by Maurice Sánchez in New York in 1978, epitomized the new flexibility with which printmaking studios adapted to the needs of artists and publishers. Although Derrière L'Etoile has published special projects from time to time, the shop operates primarily on contract and has collaborated with a range of artists on projects incorporating hand, photo, and offset lithography, wood relief, collage, screenprinting, and other techniques. With his extensive experience,[113] Maurice Sánchez and his assistant James Miller have produced editions for Brooke Alexander, Inc., Peter Blum Edition, Paula Cooper Gallery, Marlborough Gallery, Editions Ilene Kurtz, Diane Villani Editions, Edition Schellmann, Sonnabend Editions, Editions Julie Sylvester, Printed Matter, and Castelli Graphics.[114] Projects with leading artists of the 1980s such as Robert Longo, Barbara Kruger, Elizabeth Murray, and Jennifer Bartlett have become modern classics, marking major developmemts in the artists' careers (Cat. 48, 53, 63, 71).

Although new presses opened throughout the country, New York and California continued to support the largest number of printshops. In California, Magnolia Editions, started by Donald Farnsworth in 1980, had capabilities for lithography, intaglio, and monoprinting, as well as for making paper (Cat. 96).[115] Several former Crown Point printers also started their own intaglio printshops, including David Kelso with made in California, Patrick Foye, Doris Simmelink with Simmelink/Sukimoto Editions (Cat. 69), and Pat Branstead with Aeropress (Cat. 49, 50, 56). New City Editions, established by Joel Stearns in 1983 (Cat. 60), Limestone Press, 3EP Press, Trillium Graphics, Arion Press, and Angeles Press are only a few of the numerous Los Angeles and San Francisco Bay area shops working with regional, national, and international artists.[116] In New York, a host of new studios opened, including Pelavin Editions (Cat. 100), Jennifer Melby (Cat. 80, 99), XPress, Yama Prints, Mohammad Khalil/M.O.K., Harlan-Weaver Intaglio (Cat. 92), Grenfell Press (Cat. 95), John Nichols Printmakers and Publishers (Cat. 72), and Jeryl Parker Editions (Cat. 85).

Further afield, other presses opened, including Hudson River Editions, started by Sylvia Roth in Nyack, New York, in 1981, which, true to its name, specializes in intaglio and monoprinted landscape images by artists such as John Beerman (Cat. 77).[117] On an island off the coast of Maine, Vinalhaven Press sponsors an ambitious summer program for artists and printers (Cat. 93). In Minneapolis, former ULAE printer Steven Andersen has collaborated with both regional and nationally known artists (Cat. 59), while Land Mark Editions began by working with Midwestern artists on a wide range of lithographic, monoprint, and multiples projects.[118] Chicago dealer William Van Straaten opened Riverhouse Editions in Clark, Colorado, in 1988, bringing New York master printer Pat Branstad and others to collaborate with

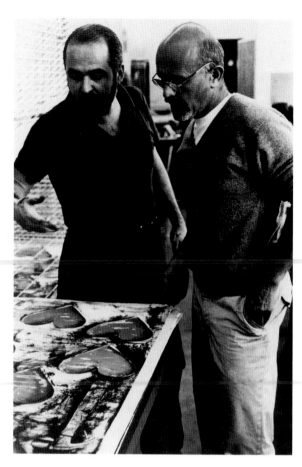

FIG. 11 ▪ Printer Maurice Sánchez collaborating with Jim Dine
at Derrière L'Etoile Studios, New York, 1984. Photo courtesy of
The Rutgers Archives for Printmaking Studios,
The Jane Voorhees Zimmerli Art Museum

artists in a remote, idyllic setting. In Spruce Pine, North Carolina, glass artist Harvey Littleton has long experimented with printing from glass plates, and in 1981 began inviting artists including Warrington Colescott, Glen Alps, Hollis Sigler, Karen Kunc, and Walter Darby Bannard to produce editions at the Littleton Studio.[119] By the late 1980s, new presses of all types and sizes were in operation throughout the United States.[120]

Established presses continued to evolve and expand as well. At Solo Press, Judith Solodkin began to produce collaborations on monoprints and other unique paperworks with artists such as Michael Mazur and Robert Kushner (Cat. 58, 79).[121] For Kushner's *Rhonda* series, Solodkin's assistant Arnold Brooks printed the litho plate at Solo Press on sheets of paper handmade at Twinrocker Paper Mill, and Solodkin and Kushner then traveled to Indiana to work with Kathryn Howard at Twinrocker to complete the series of eleven monoprints. Universal Limited Art Editions has continued to publish works with established artists like Jasper Johns's *Four Seasons* series (Cat. 98) and projects with new artists such as Carroll Dunham and Terry Winters (Cat. 67). Kenneth Tyler and a small army of associates worked with James Rosenquist during 1988–89 on *Welcome to the Water Planet*, a nine-print multi-process series so large and ambitious that it inspired a catalogue and a video documenting it. Gemini G.E.L. also continued working with Roy Lichtenstein, Ed Ruscha, Ellsworth Kelly, Richard Diebenkorn, and Bruce Nauman, while beginning major projects with Jonathan Borofsky, the sculptor Richard Serra (Cat. 74), and many others.

Support for prints continued to grow, with new publishers such as Perma Press, Diane Villani, Peter Blum Edition, Mere Image, Strother/Elwood Art Editions, Edition Ilene Kurtz, Inc., Joe Fawbush Editions, Art Matters, Raymond Foye and dealers Lorence-Monk, Betsy Senior, Matthew Marks, Larry Gagosian, Dolan-Maxwell, and Barbara Krakow exhibiting a variety of new work. Throughout the 1980s, American prints enjoyed a strong market in Europe and Asia, where collectors eagerly purchased expensive works by well-known artists. Landfall Press, Gemini G.E.L., and Crown Point Press opened New York galleries and sales offices, and cultural institutions continued to commission fund-raising projects.

By the late 1980s, prices for new print editions were at an all-time high, and prices for contemporary prints at auction reached astronomical figures.[122] An inevitable correction came as auction prices began to level off during 1989, and by May of 1990 they had fallen into sharp decline. Throughout the first few years of the 1990s, print publishers and dealers were forced to scale back on price, number of editions published, and sheer size of projects as corporate patronage came almost to a halt.[123] Auction prices dropped drastically, with many feeling that the market had once again become "normal." While the recession caused cutbacks in most printshops, very few presses actually went out of business. Many shops that were born in and have survived the 1980s have yet to receive their retrospectives, or even much critical attention; many of their individual collaborations, however, have been accorded recognition as they have been included in surveys of an artist's work or within a thematic exhibition dealing with specific trends of the 1980s.

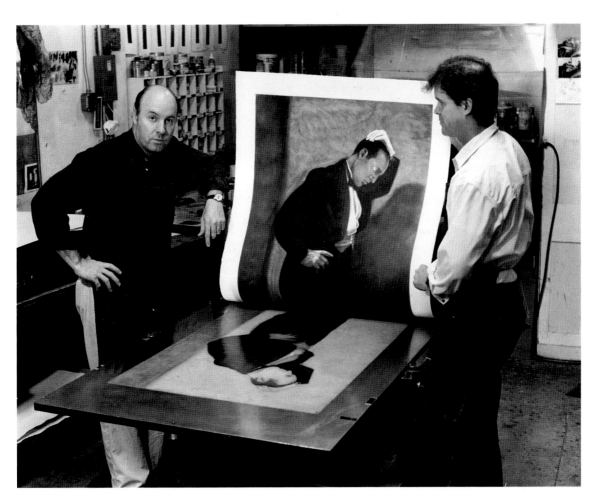

FIG. 12 ▪ Mark Stock and Master Printer Donald Farnsworth printing monotype version of *The Butler's In Love* at Magnolia Editions, Oakland, California, 1991. Photo credit: Luke Butler. Photo courtesy of Magnolia Editions, Oakland, California

MULTIPLE ISSUES/MULTIPLE CHALLENGES

Many of the challenges facing collaborative presses today differ little from those faced by presses in 1960. Issues of content remain a constant, as do the developments and controversies regarding new formats, new tools, and new techniques. Unlike the prosperity and enthusiasm of the 1960s, economic and cultural realities in the 1990s have led new printshops to start modestly and gauge their growth carefully. In many ways, the economic recession of the late 1980s and resulting paralysis in the art world represented far more than a mere market slump. In a pluralist environment in which many forms of expression have been validated—Video Art, earthworks, Performance, Postmodernist revivalism, Installation Art, and Appropriation art—many critics have come once again to view contemporary printmaking as a mere marketing device. And indeed, many prints of the 1980s were produced more for virtuosity and collectibility than as vehicles for new expression.

Despite this malaise, technology and ingenuity continue to break new ground. Artists and printers have experimented with computer technology for both expressive and technical applications. At Magnolia Editions, for example, Donald Farnsworth has outfitted a large plotter, normally used to prepare architects' drawings, with various drawing materials and handmade papers to enable artists to create images on a computer screen and then produce an edition of drawings, a concept which once again challenges traditional definitions of the unique and the multiple original. Also in California, presses such as Nash Editions are testing the colorfast qualities of computer inks, experimenting with papers, and adapting software programs and computer hardware to offer artists new tools for preparing images. Other presses have begun to use computers to produce color separations and assist in other technical applications.

FIG. 13 ▪ Artist Carole Seborovski and Press Director Hank Hine discussing plates and proofs at Limestone Press, 1993. Photo credit: Leo Holub. Photo courtesy of Leo Holub

FIG. 14 ■ Master printer Judith Solodkin (right) and assistant Helene Dugros editioning an April Gornik lithograph at Solo Impression, Inc., New York, 1994. Photo credit: T. Hansen. Photo courtesy of The Rutgers Archives for Printmaking Studios, The Jane Voorhees Zimmerli Art Museum

Health, safety, and environmental concerns have also prompted presses to explore new materials and processes such as "waterless lithography," "sun prints," and etching processes that eliminate the need for acid baths in making the intaglio plates, and the use of nontoxic and environmentally-friendly chemicals such as water-based screenprinting inks. Clearly, the collaborative press remains a place of experimentation, innovation, and exchange on a variety of levels.

Support for new prints has also grown and evolved. Exhibitions and catalogues continue to present and document new works. Print enthusiasts today can even subscribe to *Prints-L*, a new on-line computer service that serves as a clearinghouse for information on a wide variety of printmaking topics.

Working in concert embodies intrinsic intellectual consequences as well as expanded communication and production, and the prints made between 1960 and 1990 stand as examples of a process that has played a fundamental role in defining, and not merely reflecting, current artistic values. Artists, printers, and their supporters of all attitudes and approaches have chosen to work together to explore and advance forms and ideas, making major contributions to the dialogue of visual representation. These three decades of energy and activity have transformed the field of printmaking and added a host of nuances to the realm of creative collaboration.

Notes

1. A few books that provide basic histories of the art of the 1960s and 1970s are Irving Sandler, *American Art of the 1960s* (New York: Harper & Row, 1988), William C. Seitz, *Art in the Age of Aquarius 1955–1970* (Washington, D.C.: Smithsonian Institution Press, 1992), Edward Lucie-Smith, *Art Now: From Abstract Expressionism to Superrealism* (New York: William Morrow, 1970), and Corinne Robins, *The Pluralist Era: American Art, 1968–1981* (New York: Harper and Row, 1984). Sandler's book includes a particularly thorough bibliography, with sections on individual artists and movements.

2. Many museums across the country now house the archives of collaborative presses, including: Universal Limited Art Editions (The Art Institute of Chicago), Tamarind Lithography Workshop (The University of New Mexico-Albuquerque), Graphicstudio and Gemini G.E.L. (The National Gallery of Art), Landfall Press (The Milwaukee Art Museum), Cirrus Editions (Los Angeles County Museum of Art), Crown Point Press (Achenbach Center for the Graphic Arts, San Francisco), Experimental Workshop (Santa Barbara Museum of Art), Tyler Graphics Ltd. (Walker Art Center), Vermillion (Minnesota Institute of Art), and Tandem Press (Elvehjem Art Museum, The University of Wisconsin-Madison). The Rutgers Archives for Printmaking Studios at The Jane Voorhees Zimmerli Art Museum—Rutgers University was established in 1982, becoming the archive for Auclair Graphics, K. Caraccio Etching Studios, Condeso-Brokopp Studios, Derrière L'Etoile Studios, Echo Press, Chip Elwell, Fox Graphics-Merrimac Editions, Grin Graphics, Hudson River Editions, Lisa Mackie Studios, made in California, Magnolia Editions, Maurel Studios, Catherine Mosley Studios, John Nichols Printmakers and Publishers, Pelavin Editions, Rutgers Center for Innovative Printmaking, Shark's, Inc., Solo Impression, Teaberry Press, Larry B. Wright Art Productions, XPress, and Yama Prints.

3. Of course, as a healthy market for prints developed, some printing firms did a booming business in offset reproductions of artwork, produced from photographic color separations in much the same manner as a poster reproduction with little or no involvement on the part of the artist. These reproductions, though often printed using high printing standards and beautiful papers, provided added confusion for print enthusiasts trying to make a distinction between originals and reproductions. An example of the ambiguous nature of many projects can be found in prints such as Robert Motherwell's *Capriccio* of 1961. This collotype and photo silkscreen was printed in an edition of 200 by Daniel Jacomet in Paris and published by Berggruen & Cie.; the work, however, is clearly a reproduction of a mixed media drawing that Motherwell created in 1960. Because it was signed and numbered, and sold inexpensively in conjunction with an exhibition of Motherwell's collages at the Berggruen & Cie. gallery in Paris in 1961, it has often turned up in auction catalogues as an original print.

4. One of Brice Marden's early jobs was at Chiron Press in New York, while Mark Stock worked as a printer for Gemini G.E.L. in Los Angeles.

5. Robert Motherwell set up extensive print studios next to his painting studio in Connecticut to work with printers including Catherine Mosley and Robert Bigelow, and Sam Francis opened The Litho Shop in Santa Monica in 1970, working with printers Hitoshi Takatsuki and George Page. Robert Rauschenberg established his Untitled Press on Captiva Island in Florida in 1971 to print and publish his own works and those of friends including Cy Twombly, Brice Marden, and James Rosenquist with former Gemini printer Robert Peterson. Rauschenberg had been involved with a more experimental endeavor earlier when he founded the short-lived E.A.T. (Experiments in Art and Technology) with Billy Klüver in 1966. The goal of E.A.T. was to promote collaboration between artists and engineers, and to stimulate the creation of wide-ranging works of art which combined artistic vision with sophisticated technical realization.

6. As Dr. Joann Moser points out in her introductory essay to this catalogue, the theory of pluralist aesthetics is particularly appropriate for this study. See David Schapiro, "Art as Collaboration: Toward a Theory of Pluralist Aesthetics 1950–1980," in Cynthia Jaffe McCabe, *Artistic Collaboration in the Twentieth Century* (Washington, D.C.: Smithsonian Institution Press, 1984) 45–62.

7. Mere complexity does not make a good print. A mediocre image printed using dozens of screens or plates or blocks, or with the addition of collage or handwork or any number of other possibilities, would remain a mediocre image. However, for a powerful image, the added feature of a detailed documentation sheet describing the steps taken to produce the work provides a new form of seduction for the viewer and collector. More and more museums have also begun to include more detailed information in labeling the prints they exhibit. Exhibition catalogues, particularly those that focus on the careers of a few of the major artists whose print collaborations have introduced innovations in process and concept, have begun to include detailed descriptions of the circumstances of collaborations.

8. Most of ULAE's prints during the early years were published at prices ranging from $65 to $200 (see E. Sparks, *Universal Limited Art Editions: A History and Catalogue, The First Twenty-Five Years.* Chicago and New York: 1989, 26 and note 19). Jasper Johns's *Coat Hangers* (1960), for example, was published at $90.

9. Richard Field. "On Originality." *Print Collector's Newsletter* III (May–June 1972), 28.

10. June Wayne. "On Originality." *Print Collector's Newsletter* III (May–June 1972), 28.

11. Sylvan Cole, et al. *What is a Print?* New York: International Fine Print Dealers Association, 1990.

12. See Marshall McLuhan, *Understanding Media: The Extensions of Man* (New York: McGraw-Hill, 1964) and Marshall McLuhan and Quentin Fiore, *The Medium is the Message* (New York: Bantam Books, 1967).

13. Numerous entries for Universal Limited Art Editions and Tamarind Lithography Workshop can be found in the bibliography under the heading Printmaking Workshops. See especially Esther Sparks, *Universal Limited Art Editions: A History and Catalogue, The First Twenty-Five Years* (Chicago and New York: 1988), Marjorie Devon, *Tamarind: 25 Years* (Albuquerque, NM: University of New Mexico Art Museum, 1985), and *Tamarind Lithographs: A Complete Catalogue of Lithographs Printed at Tamarind Institute 1970–1979*, compiled by Rebecca Schnelker and Judith Booth, edited by Rebecca Schnelker (Albuquerque, NM: Tamarind Institute, 1979).

14. William S. Lieberman at the Museum of Modern Art , Carl Zigrosser at the Philadelphia Museum of Fine Art, and Adelyn D. Breeskin of the Baltimore Museum of Art were among the first curators Grosman approached. Breeskin, for example, made her first acquisition from ULAE in 1958 with the purchase of Larry Rivers's *The Bird and The Circle* and then recommended Grosman to the Museum's Sales and Rental Gallery, where ULAE prints were placed on consignment and actively purchased by local print collectors.

15. *Stones*, a portfolio of twelve lithographs, a title page, and a colophon page, was produced at Universal Limited Art Editions between 1957 and 1959. It was packaged in a wooden box, with an inner folder made from linen cuttings and blue denim from a pair of Larry Rivers's jeans. The edition of twenty-five was printed by Robert Blackburn on paper handmade by Douglass Howell, with typography by Herbert Matter.

16. See Edward A. Foster, *Robert Rauschenberg: Prints 1948–1970* (Minneapolis: Minneapolis Institute of Art, 1970), unpaginated introduction.

17. See Noah Jemison, *Bob Blackburn's Printmaking Workshop: Artists of Color* (New York: Printmaking Workshop, 1992), 9–14, and Nina Parris, *Through a Master Printer: Robert Blackburn and the Printmaking Workshop* (Columbia, S.C.: The Columbia Museum, 1985).

18. See the *Print Collector's Newsletter* (September–October 1986), 138–139, for Pat Gilmour and Clinton Adams's clarifications of the printing of *Accident*. Robert Blackburn's collaborations at Universal Limited Art Editions included projects with Jim Dine, Fritz Glarner, Helen Frankenthaler, Robert Goodnough, Grace Hartigan, Jasper Johns, Robert Motherwell, Robert Rauschenberg, and Larry Rivers. Zigmunds Priede was, by his own account, largely self-taught. Priede began his association at ULAE by flying to New York on weekends from his teaching job at the University of Minnesota. Tatyana Grosman recalled that Priede would often stay late in the studio, experimenting with the lithographic stones and staying one step ahead of the artists (Esther Sparks, *Universal Limited Art Editions: A History and Catalogue, The First Twenty-Five Years*. Chicago and New York: 1989, 28 and note 28).

19. Donn Steward had studied intaglio printmaking with Mauricio Lasansky at the University of Iowa and also had been a printer-trainee at Tamarind. After receiving a $15,000 grant from the National Endowment for the Arts to establish an etching studio, ULAE purchased a Charles Brand Etching Press and installed it in the basement; within the year, Steward was working on etching projects with Robert Motherwell, Barnett Newman, Jasper Johns, Lee Bontecou, Helen Frankenthaler, James Rosenquist, Marisol, and Cy Twombly.

20. Between 1967 and 1969, Steward and Jasper Johns worked together on Johns's portfolios entitled *First Etchings* and *First Etchings, Second State*, which combined etching, aquatint, and photoengraving. The series was based on sculptural work Johns had produced between 1958 and 1960, and showed the artist recasting and transforming familiar subjects such as the light bulb, flashlight, ale cans, flags, numbers, and paintbrushes. While successful as early works, it remained for Johns to visit the studio of Aldo Crommelynck in Paris to realize his finest works in the intaglio medium, the exquisite multi-nuanced images created for *Foirades/Fizzles*. *Foirades/Fizzles*, by Samuel Beckett, was published by Petersburg Press in 1976 and contained thirty-three etchings, aquatints, and drypoints by Jasper Johns.

21. Bill Goldston was responsible for many of the technical advances at ULAE, including finding better ways to photosensitize lithographic stones to accommodate Robert Rauschenberg's imagery and modifying the new offset press for use by Jasper Johns, James Rosenquist, Jim Dine, and others. Goldston was also instrumental in responding to Helen Frankenthaler's desire to try wood relief printing in 1973, and the resulting *East and Beyond* and *Savage Breeze* became important precursors to the revival of interest in relief processes later in the decade.

22. Other printers who collaborated with artists at ULAE. during its first twenty-five years included Keith Brintzenhofe, Thomas Cox, Ben Berns, Frank Akers, Fred Genis, Steven Anderson, John Lund, Juda Rosenberg, Dan Socha, David Umholz, and Frank Burham. Maurice Grosman also printed reproductive editions of the work of Mary Callery, Jacques Lipshitz, and Max Weber during ULAE's first few years, along with his own projects.

23. In addition to their careers at Tamarind and as teachers, both Adams and Antreasian have lectured and written widely, including joint authorship of the definitive *Tamarind Book of Lithography: Art and Techniques* (New York: Harry N. Abrams, Inc., 1971, with a foreword by June Wayne). Their work has been exhibited internationally and both have served as jurors for

countless national and international print exhibitions.

24. For a discussion of Wayne's Tamstone Group, Inc., the workshop located on North Tamarind Avenue, Hollywood, in the space formerly occupied by the Tamarind Lithography Workshop, see Maurice Bloch et al., *Made In California: An Exhibition of Five Workshops* (Los Angeles: Grunwald Graphic Arts Foundation, 1971), 31.

25. For a complete history of Kelpra Studio, see Pat Gilmour, *Kelpra Studio: Artist's Prints 1961–1980* (London: Tate Gallery, 1980).

26. Among the dealers and publishers who commissioned prints at Kelpra were Marlborough Graphics (New York, Germany, and Japan), Edition Alecto, Rowan Gallery, Hayward Gallery, Waddington Graphics, and Petersburg Press (London), Edition Bischofberger (Zurich), Propylaen Verlag (Berlin), and Galerie Ariadne (Vienna). For descriptions of the projects, see Pat Gilmour, ibid.

27. For histories of the Curwen Studio and the artists who worked there, see Pat Gilmour, *Lithographs from the Curwen Studio: A Retrospective of Fifteen Years of Printmaking* (London: Camden Arts Centre, 1973) and *Artists at Curwen* (London: Tate Gallery, 1977).

28. For a history of Edition Alecto, see Charles Spencer, *A Decade of Printmaking* (New York: St. Martin's Press, 1973).

29. Robert Erskine had opened his London Gallery in 1954 with a goal to promote and sell contemporary prints. In 1956, in a catalogue accompanying an exhibition of new screenprints at the gallery, Erskine wrote that the printmaking process had become "a full-fledged artist's medium" (as quoted in Pat Gilmour, *Kelpra Studio: Artists' Prints 1961–1980*, London, Tate Gallery, 1980, 16).

30. The gallery operation, named the Print Centre, quickly became a primary venue for the exhibition of new British and foreign prints. In November of 1963, Edition Alecto collaborated with other London arts organizations to mount an exhibition entitled *Modern Graphics* at the London Business Complex at Berkeley Square in the hope of stimulating corporate patronage. Robert Erskine wrote an article on investment tips for buying contemporary prints for the London *Daily Mail* in January of 1964, which also was directed at the new corporate client (Charles Spencer, *A Decade of Printmaking*. New York: St. Martin's Press, 1973, 10). In 1966, Alecto opened a new gallery in New York intended to establish a direct link to the American market. The Edition Alecto Collector's Club also was started as a subscription program to help assure distribution and ongoing funding for Alecto's expanding programs, offering both prints and multiples to its subscribers.

31. In 1964, a former wine distillery in London was completely redesigned to create spacious lithography, screenprinting, and intaglio studios, as well as studio and living quarters for visiting artists, and gallery and office spaces.

32. See Robin Campbell, et al., *3 ∞: New Multiple Art* (London: Arts Council of Great Britain, 1970). For an early study of multiples in the United States, see John L. Tancock, *Multiples: The First Decade* (Philadelphia: Philadelphia Museum of Art, 1971). This exhibition catalogue was in itself a multiple, conceived and designed by Eugene Feldman and printed at Falcon Press in Philadelphia in an edition of 3,000.

33. Claes Oldenburg's multiple *London Knees*, made of cast latex, was published by Alecto in 1968 in an edition of 120. The project was initiated in 1966, taking countless experiments to meet Oldenburg's demand that the paint color of the knees match the color of the Elgin Marbles in the British Museum and that the plastic for the multiple be soft and flexible.

34. George Segal's multiple *Girl on a Chair* (91" x 61" x 38") was published by Alecto in 1970 in an edition of 150.

35. Luitpold Domberger, having seen an exhibition of screenprints in Germany after World War II, opened the workshop in Stuttgart. As the business grew, Luitpold's son Michael took over the shop while his father continued as a dealer and publisher.

36. Estes' *Urban Landscapes* series, particularly the *Urban Landscapes I* portfolio Parasol Press published in 1972, epitomize the Photorealist print. *Urban Landscapes I* consisted of eight screenprints, with each print in the portfolio requiring the printing of between 50 and 115 colors from stencils cut by both Domberger and Estes. For a full description of the project, see *Elizabeth Armstrong, First Impressions. Early Prints by Forty-Six Contemporary Artists* (New York: Hudson Hills Press, in association with the Walker Art Center, 1989), 84–85. Robert Indiana made most of his important prints of the 1960s with Domberger, including *LOVE Wall*, a suite of four screenprints from 1967, the *Numbers* portfolio (with poems by Robert Creeley) of 1968, and *6666* of 1969.

37. For information on the history and collaborations of 2RC, see Nathan H. Shapira, *Big Prints from Rome* (Los Angeles: Center for Contemporary Culture, 1980) and *Grafica Oggi: Contemporary Graphics from the Studio 2RC in Rome* (New York: The Finch College Museum of Art, 1974). Among the American artists who have worked at 2RC were Alexander Calder, Sam Francis, Helen Frankenthaler, Nancy Graves, Man Ray, Louise Nevelson, Beverly Pepper, and George Segal.

38. Between 1953 and 1956, Italian printmaker Floriano Vecchio printed four issues of *Folder*, a literary journal edited by poet Daisy Aldan and art historian Richard Miller, which contained original poetry, new musical scores, and art criticism by Frank O'Hara. Hartigan made her first prints with Vecchio for *Folder*, three screenprints for the first issue and covers for the third and fourth issues. According to Vecchio, it was he who taught Andy Warhol to use screenprinting (see Robert Saltonstall Mattison, *Grace Hartigan: A Painter's World* (New York: Hudson Hills Press, 1990: 35 and note 4).

39. Sam Francis had originally been encouraged to make prints by

the New York dealer Martha Jackson, who had actually brought lithographic stones to Francis's studio for him to work on in 1959. These stones were not printed until 1968. For more information on Francis's early printmaking experiments and the artist's thoughts on printmaking, see Peter Selz, *Sam Francis* (New York: Harry N. Abrams, Inc., 1982, rev. ed.). For information describing Martha Jackson's career as a dealer and publisher, see Harry Rand, *The Martha Jackson Memorial Collection* (Washington, D.C.: The Smithsonian Institution Press, 1985).

40. Other artists in the *American Discovered* portfolio included George Brecht, Stephen Durkee, Lette Eisenhauer, Stanley Fisher, Sam Goodman, Robert Indiana, Boris Lurie, Claes Oldenburg, George Segal, Richard Stankiewicz, Wayne Thiebaud, Robert Watts, and Robert Whitman. Instrumental to the project was Billy Klüver, an American electrical engineer and contemporary art lover who had himself assisted several artists, such as Robert Rauschenberg with some of his mechanized artworks, and who assisted Schwarz with the selection of artists for the fifth portfolio. *America Discovered* was published in an edition of sixty by the Galeria Schwarz, Milan.

41. The *I-Cent Life* portfolio contained sixty-two signed lithographs and was printed in a numbered edition of 100. Another edition of 2,000, containing unsigned and unnumbered lithographs and packaged in a dust jacket and slipcase, also was published. Artists represented in the portfolio included Pierre Alechinsky, Karel Appel, Enrico Baj, Alan Davie, Jim Dine, Oyvind Fahlstrom, Sam Francis, Robert Indiana, Alfred Jensen, Asger Jorn, Kiki O.K., Alan Kaprow, Alfred Leslie, Roy Lichtenstein, Joan Mitchell, Claes Oldenburg, Mel Ramos, Robert Rauschenberg, Reinhoud, Jean-Paul Riopelle, James Rosenquist, Antonio Saura, Kimber Smith, K.R.H. Sondorborg, Walasse Ting, Bram Van Velde, Andy Warhol, and Tom Wesselmann.

42. Jörg Schellmann published an offset lithographic poster version of Larry Rivers's *Dutch Masters* in 1968. Edition Schellmann operated in association with Katia von den Velden and Bernd Klüser from 1969 to 1974, as Edition Schellmann and Klüser from 1975 to 1984, and currently publishes as Edition Schellmann in Munich and New York. Among the international cast of artists who have been published by Edition Schellmann are Andy Warhol, Joseph Beuys, Donald Judd, Christo, Sol Lewitt, Sandro Chia, Francesco Clemente, Robert Longo, Troy Brauntuch, Enzo Cucchi, Keith Haring, Peter Halley, Robert Mapplethorpe, Jannis Kounellis, Mimmo Paladino, and Nam June Paik.

43. See Heidi and Claus Colsman-Freyberger, "The German Print Market." *Print Collector's Newsletter* (May–June 1972), 32–34.

44. The variety of collaborative experiences undertaken by some of the period's most noted artists are indeed daunting. Beginning in 1962, for example, printers of **Andy Warhol's** images included M. Leblanc (Paris), Ives-Sillman (New Haven), Maurice Beaudet (Paris), Total Color (New York), Knickerbocker Machine and Foundry (New York), Billy Miller's Wallpaper Studio (New York), Fine Creations, Inc. (New York), Maurel Studios (New York), Aetna Silkscreen Products (New York), Salvatore Silkscreen Co., Inc. (New York) Silkprint Kettner (Zurich), Gemini G.E.L. (Los Angeles), Styria Studio (New York), Atelier Henrici (New York), Il Fauno (Milan), and Rupert Jasen Smith, Warhol's printer at Factory Additions from 1977 to 1987. **Sam Francis** also has collaborated at numerous printshops, including those of Emil Matthieu (Zurich), and at Tamarind Lithography Workshop (Los Angeles), Universal Limited Art Editions (West Islip), Edition 2RC (Rome), Gemini G.E.L. (Los Angeles), 3EP Press (Palo Alto), the Experimental Workshop (Santa Barbara), in Japan, and at The Litho Shop, Francis's own press in Santa Monica. Among the presses **James Rosenquist** has worked at are Universal Limited Art Editions, Gemini G.E.L., Mourlot (New York), Hollander's Workshop (New York), Graphicstudio USF (Tampa), Petersburg Press (London), Styria Studios (New York), Shorewood Atelier (New York), Topaz Editions, the Workshop Nebraska Avenue, Derrière L'Etoile Studios (New York), Flatstone Studios, and the Hartford Art School print program. In addition to early intaglio projects at Atelier 17 in New York, **Robert Motherwell** created more than two hundred editions in collaboration at Hollander's Workshop, Universal Limited Art Editions, Gemini G.E.L., Tyler Graphics, Kelpra Studio and Petersburg Press (London), Trestle Editions, Ltd. (New York), Derrière L'Etoile Studios, Ives-Sillman (New Haven), with Emiliano Sorini (New York), Maurel Studios (New York), Erker-Presse (St. Gallen, Switzerland), as well as with Robert Bigelow and Catherine Mosley at his own print studios in Greenwich, Connecticut.

45. For example, after studying printmaking at the University of Wisconsin and at Tamarind, Bud Shark moved to London where he taught and printed first at Edition Alecto and later at Petersburg Press. Joining him at Petersburg was fellow Tamarind-trainee Maurice Sánchez, who would also work independently in London before returning to the United States. Kathan Brown studied printmaking in London and worked at the print studio of Birgit Skiold before returning to California to start Crown Point Press in 1962. Timothy Berry, attended evening classes at Morley College in London in 1972 and worked at Studio Prints before entering graduate school at the Central School of Art in London. There he editioned prints for the well-known British printmaker Norman Ackroyd and also worked at Petersburg Press before returning to the United States to establish Teaberry Press in conjunction with Landfall Press in Chicago in 1974. Dan Weldon trained with Kurt Lohwasser in Munich before returning to Deer Park, New York, to start Hampton Editions, Ltd., in 1971, printing editions for artists including Elaine de Kooning.

46. Diane Kelder, "Prints: Made in Graphicstudio." *Art in America* 61 (March–April 1973), 84.

47. Charles and William Brand owned the Experimental Precision

Tool Company on East 10th Street in New York. In the late 1950s, the firm began repairing lithography presses for a variety of printshops, including those at the Pratt Institute and the Art Students League. Seeing room for improvement, the Brands began fabricating their designs and inviting artists to come to work on the presses and give additional advice. In 1960, the Brands applied for their first patent for an etching press. With greatly improved systems for adjusting pressure and a solid steel pressbed, the presses quickly set new standards for reliability and durability. The shop also built custom presses to suit the needs of individual artists and presses, and the brothers' reputation for maintenance and desire to continually improve their presses gained them a reputation that remains admired today.

48. Zirker, who founded Original Press with partners Bruce Lowney and Frank Bergenhalter, had also been a co-founder of Joseph Press in Venice, California, where his work included projects with Sam Francis and Rico Lebrun. After operating for less than one year, Original Press was forced to close after seven entire editions of lithographs by Richard Diebenkorn were stolen.

49. For additional information on early presses in California, see Ebria Feinblatt and Bruce Davis, *Los Angeles Prints, 1883–1980* (Los Angeles: Los Angeles County Museum of Art, 1981) and Maurice Bloch and Kathyrn A. Smith, *Made In California: An Exhibition of Five Workshops* (Los Angeles: Grunwald Graphic Arts Foundation, 1971).

50. See Pat Gilmour, *Ken Tyler, Master Printer and the American Print Renaissance* (Canberra: Australian National Gallery, 1986), and Liz Armstrong, Pat Gilmour, and Ken Tyler, *Tyler Graphics: Catalogue Raisonné, 1974–1985* (Minneapolis: Walker Art Center, and New York: Abbeville Press, 1987).

51. Sidney Felsen and Stanley Grinstein became Kenneth Tyler's partners in Gemini G.E.L. in February of 1966. For a thorough discussion of the founding of Gemini G.E.L., see Ruth Fine, *Gemini G.E.L.: Art and Collaboration* (Washington: National Gallery of Art and New York: Abbeville Press, 1984).

52. For a detailed account of the collaborations between Ken Tyler and Josef Albers, see Pat Gilmour, *Ken Tyler, Master Printer and the American Print Renaissance* (Canberra: Australian National Gallery, 1986), 37–46.

53. Challenges in printing the *Star of Persia I* were numerous. Printers experimented with the use of metallic inks for the first time, finding that the metallic inks required different varnishes, driers, and extenders than traditional inks. Registering a silver base color under the colors of the stripes of the chevron form, and aligning all printings with the lines of the graph paper required an extraordinary degree of precision.

54. Claes Oldenburg's vision for *Profile Airflow* included finding a plastic for the molded overlay that would remain flexible rather than rigid. Once a combination of chemicals was found and the project was fabricated, it was discovered that the plastic discolored.

New experiments led to improved plastic, and in a wonderful example of art imitating life, the *Profile Airflows* were recalled and the plastic overlays were replaced.

55. Serge Lozingot was trained as an apprentice in hand lithography at Les Orphelins d'Auteuil in Paris from 1949 to 1953. After printing for Jean Dubuffet in the artist's studio for five years, he went to work at the Atelier Mourlot in 1963, printing artists' book projects. Lozingot came to the United States in 1966 to work as master printer and studio manager at the Tamarind Lithography Workshop, and, with June Wayne and Alice Woodro, opened Tamstone Press after Tamarind moved to New Mexico in 1970. Beginning in 1971, Lozingot's seventeen-year career as master printer, supervisor, and studio manager at Gemini G.E.L. included collaborations with most major artists of the period, including Jasper Johns, Richard Diebenkorn, Sam Francis, Robert Rauschenberg, Roy Lichtenstein, Ellsworth Kelly, Frank Stella, Claes Oldenburg, and countless others. In addition to Lozingot, printers including Anthony Zepeda, Ron McPherson, Alan Holoubek, James Reid, Ken Farley, Doris Simmelink, Patrick Foye, and a host of others have trained and worked at Gemini G.E.L.

56. For more information and a description of many of the projects produced at Maurel Studios, see Margot Lovejoy, "In Celebration of Sheila Marbain: A Conversation About a Life In Prints," in *Surface Printing in the 1980s* (The Jane Voorhees Zimmerli Art Museum: New Brunswick, NJ, 1990).

57. See Jeremy Lewison, *Brice Marden: Prints 1961–1991* (London: Tate Gallery, 1992), 19.

58. Steven Poleskie sold Chiron Press in 1968. For a discussion of Poleskie's screenprinting methods, see Fritz Eichenberg, *The Art of the Print* (New York: Harry N. Abrams, Inc., 1976), 510.

59. Michael Knigin was a Tamarind fellow and had also worked for Irwin Hollander at the Hollander Workshop in New York prior to joining Roger Loft at Chiron Press in 1968.

60. Roy Lichtenstein's *Peace Through Chemistry* and Frank Stella's forty-one color *Pastel Haystack* are among the projects that Rischner assisted with at Gemini. Styria Studios started as a true family operation, with Adolph Rischner, his wife Theresa, and son Adi working on early projects. One of their best-known early projects was Robert Rauschenberg's *Currents*, which at six feet by sixty feet was the largest print undertaken by an artist at the time. Over the years, Styria has expanded to offer a wide variety of printing processes and has employed a number of printers.

61. Cirrus Editions, established by Tamarind-trained printer Jean Milant in 1970, began producing screenprints, lithographs, and multiples with a wide range of California artists including Vija Celmins, Terry Allen, Joe Goode, Doug Edge, Ed Moses, and Ed Ruscha. In addition to experimenting with resin casting and printing on plastics, printers also used nontraditional materials

such as Pepto-Bismol and Romanoff Caviar for some of Ed Ruscha's screenprints. Several Tamarind-trained printers worked with Jean Milant at Cirrus during its first decade including Paul Clinton, Ed Hamilton, and David Trowbridge.

62. Among the earliest use of offset in artistic projects in the United States was Lynton Kistler's collaborations in Los Angeles prior to World War II with artist Jean Charlot. June Wayne had also worked with offset technology in 1955 in the creation of her *Fables*, although Tamarind remained focused on hand lithographic processes.

63. See Pieter Brattinga, "Eugene Feldman's Creative Experiments in Photo-Offset Lithography," *Artists' Proof*, no. 4, 1962, 25. For an in-depth discussion of the growing use of offset lithography as an artist's medium, see Louise Sperling and Richard S. Field, *Offset Lithography* (Middletown, CT: Davison Art Center, Wesleyan University, 1973).

64. See Hanlyn Davis and Hiroshi Murata, *Art and Technology—Offset Prints* (Bethlehem, PA: Lehigh Unversity, 1983) and Wendy M. Watson, *Offset Prints* (South Hadley, MA: Mount Holyoke College Art Museum, 1977).

65. See "Frank Stella and the Offset Press," in Pat Gilmour, *Ken Tyler, Master Printer and The American Print Renaissance* (Canberra: Australian National Gallery, 1986) 77–79.

66. As quoted in Carl Zigrosser (ed.), *Prints*. (New York: Print Council of America, 1962) ix. The group that would become the Print Council of America actually began meeting in the fall of 1956. During its first few years, activities of the group included circulating newsletters and calendars, planning a major print exhibition entitled *American Prints Today–1959*, granting fellowships to train two print curators, and in 1961 publishing the pamphlet *What is an Original Print?*, edited by Joshua Binyon Cahn (New York: Print Council of America, Inc., 1961).

67. In 1959 and 1961, the young Print Council of America circulated exhibitions entitled *American Prints Today*. In 1963, Billy Klüver organized *The Popular Image Exhibition* with Alice Denney at the Washington Gallery of Modern Art in Washington, D.C. The show featured Andy Warhol's first editioned screenprint, *$1.57 Giant Size*, and was published by Klüver in conjunction with the exhibition, with the screenprint serving as the cover for a recording of interviews by artists participating in the exhibition. In 1964, Curator William Lieberman opened newly renovated galleries at the Museum of Modern Art with an exhibition entitled *American Painters as New Lithographers*, a show which consisted primarily of prints from Universal Limited Art Editions. The Brooklyn Museum began mounting its National Print Annual exhibitions in 1946, with increasing numbers of prints coming from collaborative workshops after 1960.

68. One of the oldest print clubs in the United States, established in 1920, is associated with the Cleveland Museum of Art, and has a distinguished history of publishing prints. For a historically interesting though out-of-date listing of print clubs around the country, see Lisa Peters, "Print Clubs in America," *Print Collector's Newsletter* XIII (July–August 1982), 88–90.

69. Elizabeth Stevens, *Prints Today: A Short Guide to the Graphic Art Market* (Washington, D.C.: Washington Print Club, 1971), 10. Zigrosser left the Weyhe Gallery in 1940 to become Curator of Prints and Drawings at the Philadelphia Museum of Art, and among his many accomplishments was his leading role in founding the Print Council of America.

70. For a discussion of the contemporary print collector, see Barry Walker, *Public and Private: American Prints Today* (Brooklyn: The Brooklyn Museum, 1986).

71. See Elke Solomon, *Oversize Prints* (New York: Whitney Museum of American Art, 1971).

72. Martha Jackson opened her first gallery on 66th Street in New York in 1953. While her support for painters of the Abstract Expressionist movement is legendary, her extraordinary vision was reflected in an eclectic and wide-ranging series of annual exhibitions. In 1960, she mounted two exhibitions entitled *New Forms—New Media* (the first exhibition featured works by Steven Antonakos, Lee Bontecou, Alberto Burri, Chryssa, Joseph Cornell, and Jim Dine; the second featured Robert Indiana, Jasper Johns, Louise Nevelson, Robert Rauschenberg, John Chamberlain, Dan Flavin, Claes Oldenburg, and Henry Moore). Early print exhibitions, some held in conjunction with her son David Anderson's gallery in Paris, included shows of Larry Rivers (1961), John Hultberg (1963), Sam Francis: New Lithographs (1964), Clayton Pond (1968), and Nathan Oliveira and Garo Antreasian (1969).

73. Private collectors were instrumental in helping several presses get a start. Subscription programs became a popular way for presses to raise the capital to start or expand their operations. Presses all had their own champions, evidenced by the donor names on many large contemporary print collections which have entered major museums. For example, Dr. Joseph Singer, an early patron of ULAE, donated a large collection of the press's prints to the Metropolitan Museum of Art. Morton and Carol Rapp were also long-time ULAE collectors who often lent their collection for exhibition. John and Kimiko Powers also helped Tatyana Grosman devise a subscription program in 1964.

74. *New York 10* included prints by Richard Anuszkiewicz, Jim Dine, Helen Frankenthaler, Nicholas Krushenick, Robert Kulicke, Mon Levinson, Roy Lichtenstein, Claes Oldenburg, George Segal, and Tom Wesselman. In 1966, Tanglewood Press published two more important portfolios, the *New York International*, with ten prints and objects by Armen, Mary Bauermeister, Oyvid Fahlstrom, John Goodyear, Charles Hinman, Jones, Robert Motherwell, Ad Reinhardt, James Rosenquist, and Saul Steinberg, followed by the multiple 7 *Objects in a Box*, with objects by Alan D'Archangelo, Jim Dine, Roy Lichtenstein, Claes Oldenburg, George Segal,

Andy Warhol, and Tom Wesselmann. In 1968, Tanglewood Press published *Ten from Leo Castelli*, which included works by Lee Bontecou, Jasper Johns, Donald Judd, Roy Lichtenstein, Robert Morris, Larry Poons, Robert Rauschenberg, James Rosenquist, Frank Stella, and Andy Warhol.

75. Each portfolio was published in an edition of 200. For complete listings of the artists and projects included in each portfolio, see Joseph E. Zanatta (ed.), *Contemporary Print Portfolio: A Guide to Auction Prices 1987–1993* (Shawnee, KS: Bon A Tirer Publishing, 4th edition, 1993), 164.

76. Artists in the Wadsworth Atheneum portfolio included Stuart Davis, Robert Indiana, Ellsworth Kelly, Roy Lichtenstein, Robert Motherwell, George Ortman, Larry Poons, Ad Reinhardt, Frank Stella, and Andy Warhol. The portfolio consisted of ten screenprints and was published in an edition of 500. For a good overview of portfolios published, see the listings under the heading "Portfolios-Various Artists" in Joseph E. Zanatta (ed.), *Contemporary Print Portfolio: A Guide to Auction Prices 1987–1993* (Shawnee, KS: Bon A Tirer Publishing, 4th edition, 1993).

77. As quoted in Elizabeth Armstrong, *First Impressions. Early Prints by Forty–Six Contemporary Artists* (New York: Hudson Hills Press, in association with the Walker Art Center, 1989), 13.

78. Mezzotint plates, generally relatively small in size, are traditionally prepared by hand using a tool called a rocker. This tool, which had many small teeth on a curved, blade-like surface, was "rocked" by hand over the plate in various directions until a network of small pits was laid down over the entire plate. If inked and printed at this stage, the resulting image would be a dense, velvety black square. To create an image, the artist would take a prepared (rocked) plate and use a burnisher to smooth out, or partially smooth out, areas that would then print as white or light tones and lines. As opposed to other printmaking processes, the artist works in reverse, from black to white. For a complete treatment of the mezzotint process, see Carol Wax, *The Mezzotint: History and Technique* (New York: Harry N. Abrams, Inc, 1990).

79. For detailed discussions of the Keith collaboration, see ibid., 82–83, and Judith Goldman, *American Prints: Process and Proofs* (New York: Whitney Museum of American Art, 1981), 64–69.

80. In 1977, Crown Point also added its first staff to concentrate solely on sales, and in 1978 the first issue of *View*, a quarterly newsletter devoted to interviews with Crown Point artists by Robin White, was published. During the late 1970s, the press also became active in organizing traveling exhibitions, such as *Music Sound Language Theater, Etchings by John Cage, Tom Marioni, Robert Barry and Joan Jonas* in 1979 and in collaborating on book publications and conferences. In addition to traveling to major art fairs around the world, Crown Point Press opened its first gallery space in 1981.

81. Orlando Condeso received training in printmaking in Peru before moving to the United States in 1971, and subsequently began working in New York at both the Printmaking Workshop and the Pratt Graphics Center. Nancy Brokopp had studied printmaking at the University of Wisconsin-Madison. Some of the larger prints produced at the shop included Alex Katz's *Vincent* of 1982, an etching and aquatint which measured 62" x 39" (published by Brooke Alexander, Inc.), and Susan Shatter's *Prouts Neck* of 1981, an etching that measured 14½" x 41" (published by 724 Prints and Condeso/Brokopp Studios).

82. While many of Bearden's prints were taken more or less directly from his paintings and collages, *The Train* involved significant experimentation and collaboration. Working from one of the artist's collage pieces, Robert Blackburn photographed the work several times using a variety of screens to create new line and tonal effects in the photo-etched key plate. Kathy Caraccio then added color plates using aquatint with à la poupée and viscosity inking, printing numerous proofs in various inks colors for Bearden to approve.

83. Among the printers who have worked at K. Caraccio Etching Studios are Lisa Mackie, Esther Goetz Light, and Alice Helander. Artists who have collaborated at the press include Emma Amos, Harriet Shorr, Louise Nevelson, Betty Tompkins, Sarah Brayer, Gail Flanery, Vivian Browne, and Diane Hunt.

84. Numerous outside collaborators have assisted in the production of Gemini print and multiple editions. Krofft Enterprises collaborated on Claes Oldenburg's *Ice Bag–Scale B* of 1971, Amsco Industries on Jasper Johns's *Lead Reliefs* series of 1969, Pacific Manufacturing for Oldenburg's *Geometric Mouse–Scale C* of 1971, and Tomkins Tooling for Roy Lichtenstein's *Untitled Head I* and *Modern Head Relief* of 1969–70. Ron McPherson's La Paloma Studios and Peter Carson Enterprises are two independent firms formed by former Gemini printers that enjoy ongoing relationships with both the press and artists. Prior to setting up screenprinting facilities, Gemini contracted with screenprinters such as Adolph Rischner of Aero Display Company (later Styria Studios) of Glendale and Jeffrey Wasserman.

85. Some of the artists working at Gemini during the 1970s included Donald Judd, John Chamberlain, Frank Stella, Edward Kienholz, Mark di Suvero, Ellsworth Kelly, Michael Heizer, Ronald Davis, Sam Francis, Bruce Nauman, Keith Sonnier, David Hockney, Robert Motherwell, Edward Ruscha, Joe Goode, James Rosenquist, Philip Guston, Robert Rauschenberg, and Jasper Johns.

86. After training at Tamarind, Jack Lemon established and directed the Lithography Workshop at the Nova Scotia College of Art and Design in 1968. For a thorough account of the prints of the Chicago Imagists, see Dennis Adrian and Richard A. Born, *The Chicago Imagist Print: Ten Artists' Works, 1958–1987: A Catalogue Raisonné* (Chicago: The David and Alfred Smart Gallery, The University of Chicago, 1987).

87. The project was *Spoon Pier*, a soft-ground etching and aquatint of 1975 (published in an edition of 50 by Landfall Press).

88. While Timothy Ferrell Berry was associated with Landfall Press, he collaborated with artists including Christo, Robert Cottingham, Robert Arneson, William Allan, Don Nice, Claes Oldenburg, Ed Paschke, Philip Pearlstein, Pat Steir, Jack Tworkov, and William Wiley. Since moving to California, Berry has continued collaborations with several California artists and worked with a wide range of new California artists including Beth Van Hoesen, Mark Adams, Rupert Garcia, Ed Ruscha, Terry Allen, Charles Arnoldi, Squeak Carnwath, Sabina Ott, Laddie John Dill, Oliver Jackson, Deborah Oropallo, and David Ireland. In addition, Berry has taught widely in the San Francisco Bay area and has been able to pursue his own career in both painting and printmaking.

89. See "A Conversation with Jack Lemon and Pauline Saliga" in *Landfall Press: A Survey of Prints 1970–1977* (Chicago: Museum of Contemporary Art, 1977), 5.

90. In 1984, Garner Tullis left to establish his own workshop, the Garner Tullis Workshop, in Santa Barbara and to collaborate with artists on the production of monotypes. Tullis has since moved his shop operation to New York, while his son Richard Tullis II continues to run the Santa Barbara facility. See Phyllis Plous and Kenneth Baker, *Collaborations in Monotype* (Santa Barbara: University Art Museum, 1988) and Phyllis Plous, *Collaborations in Monotype II* (Santa Barbara: University Art Museum, 1989).

91. See Nikos Stangos (ed.) and David Hockney, *Paper Pools* (New York: Harry N. Abrams, 1980).

92. Joe Wilfer, a graduate of the University of Wisconsin printmaking program, established the Upper U.S. Paper Mill in Oregon, Wisconsin, in 1974, and worked with artists such as Rafael Ferrer and William Fares on various projects. In 1985, Wilfer moved to New York to co-found the Spring Street Workshop with Dick Solomon of the prestigious Pace Prints. At the Spring Street Workshop, Wilfer would continue collaborating with artists on paper projects as well as prints, most notably with Chuck Close on his pulp-painted portrait series.

93. Loring, John and David Acton. *Jones Road Print Shop and Stable. 1971–1991: A Catalogue Raisonné* (Madison, WI: Madison Art Center, 1983), 10.

94. Douglass Howell made the paper used for the Larry Rivers/Frank O'Hara *Stones* portfolio of 1957–1959 at Universal Limited Art Editions and on numerous other projects. In fact, it was Howell's slow production of the handmade paper sheets that led Larry Rivers to work on single print editions at the press.

95. Twinrocker Paper Mill had originally been founded by Howard and Kathryn Clark in association with Collector's Press prior to their move to the Midwest.

96. Simca Print Artists began collaborating on projects in the United States in the early 1970s. With roots in Japan, Kawanishi and his master printers Takeshi Shimada and Kenjiro Nonaka had worked with the innovative Japanese screenprinter Tadanori Yokoo, who had been advancing the possibilities for screenprinting as a well-respected poster artist. Simca's association with Jasper Johns was sustained through numerous projects; however, the press has also worked with other artists on important projects including Jennifer Bartlett's *At Sea, Japan* (1980), Mel Bochner's *Range* (1979), Alex Katz's *Ada With Flowers* (1981), Robert Moskowitz's *Swimmer* (1983), and untitled projects with Elizabeth Murray (1982), Joel Shapiro (1980), and Brice Marden (1973).

97. *Flags I* was based on Johns's painting of the same year, painted in encaustic and oil on canvas. Johns would continue to collaborate with Hiroshi Kawanishi and his staff at Simca Print Artists on projects including *Usuyuki* and *Cicada* (1979–1981). See Katrina Martin, "An Interview with Jasper Johns about Silkscreening," published in *Jasper Johns: Printed Symbols* (Minneapolis: Walker Art Center, 1990), 51–61.

98. In 1977, for example, Michael Heizer began a series of screen-printed monoprints that were inked through an open screen in an expressive gestural style with an extraordinary surface richness and texture.

99. Prints on Prince Street opened in the fall of 1972 at 99 Prince Street in Soho. A cooperative venture, the gallery exhibited the prints of a wide range of presses and publishers including Edition Domberger (Stuttgart), Art in Progress (Zurich), HK/Ltd. (Boston), Graphics International Ltd. (Washington), Marion Locks/Grant Jacks Editions (Philadelphia), and Martha Jackson Graphics and Parasol Press (New York).

100. See Charles T. Butler and Marilyn Laufer, *Recent Graphics from American Print Shops* (Mount Vernon, IL: Mitchell Museum, 1986), 28, 38.

101. Ibid, 16, 34. See also Judith Goldman, *Brooke Alexander: A Decade of Print Publishing* (Boston: Boston University Art Gallery, 1978) and Wendy Weitman, *For Twenty-Five Years: Brooke Alexander Editions* (New York: Museum of Modern Art, 1994).

102. Throughout the late 1970s and early 1980s, the *Print Collector's Newsletter* reported regularly on the tax shelter debate, with three particularly lengthy and insightful notes in the issues of March–April 1978 (17), March–April 1980 (12), and March–April 1981 (5–14).

103. In the July–August 1983 issue of *Print Collector's Newsletter*, it could be reported that "the IRS Art Print Advisory Panel had reviewed 486 claims involving 660 prints in 1982 and advised reductions in every case, totaling some $102,600,000, or 99.3% of the deductions claimed. This compares to a 97% reduction, again on 100% of the cases reviewed, in 1981." (*PCN*, XIV, 99).

104. See Deborah Wye, *Committed to Print* (New York: Museum of Modern Art, 1988).

105. Aldo Crommelynck had established his atelier in Paris in 1953, collaborating with European artists including Picasso, Braque, and Corbusier. For an excellent description of Crommelynck's contemporary collaborations, see Pat Gilmour, "Symbiotic Exploitation or Collaboration: Dine & Hamilton with Crommelynck" *Print Collector's Newsletter* XV (January–February 1985), 193–198.

106. Chip Elwell studied printmaking at the Cooper Union School of Art and Architecture from 1965 to 1969 and then worked as a curator at the Bank Street Atelier. His intention on starting his own studio in 1975 was to specialize in hand stencil printing, but he soon starting working with artists on wood relief projects as well. Ted Warner worked as Elwell's assistant at the studio, establishing his own Damage Press in Brooklyn in 1987. Brooke Alexander, Diane Villani, and Perma Press were among the publishers who commissioned projects at the studio. One of his last projects was Sean Scully's *Standing I*, which he proofed but did not edition.

107. See "Collaboration East and West: A Discussion," *Print Collector's Newsletter* XVI (January–February 1986), 196–205. Berdan has also included collaborations with Roy Lichtenstein, Francesco Clemente, Saul Steinberg, and Faith Ringgold among the diverse projects undertaken at Mulberry Press.

108. Bud Shark had studied printmaking at the University of Wisconsin as an undergraduate and then enrolled in graduate school at the University of New Mexico in 1968. During the summer of 1969, Shark attended a special 3½ month summer program at Tamarind Lithography Workshop in Los Angeles, and on his return to Albuquerque he served as Garo Antreasian's teaching assistant at the University and also worked on Tamarind projects. At the suggestion of British artist Bernard Cohen, Shark was offered a position at Edition Alecto and in 1970 moved to London to work on projects at Electo and then Petersburg Press with artists including James Rosenquist, Henry Moore, and David Hockney. He also taught printmaking part-time at London's Slade School of Fine Art. In addition to Bud Shark, Jeffery Moore, Ron Trujillo, and Matt Christie have worked as printers at Shark's Inc. since 1975.

109. During the 1980s, artists visiting Caraccio's shop created prints utilizing photogravure, mezzotint, white-ground and soap-ground etching, pochoir, and collagraph processes in addition to standard etching and aquatint techniques.

110. The *Print Collector's Newsletter* covered the debate, perhaps summed up best in the exchange between David Kelso, Director of made in California and a former printer at Crown Point, and Kathan Brown. See Kelso's comments in the March–April 1985 issue of *Print Collector's Newsletter*, 15, and Kathan Brown's response in the May–June 1985 issue, 53. A further entry by Kathan Brown, published in the November–December issue of the *Print Collector's Newsletter* (172), notes that both artist and craftsmen involved in the woodblock program were signing and/or stamping each print to further identify the nature of the collaboration. A good discussion of the differences between Eastern and Western traditions in printmaking can be found in "Collaboration East and West: A Discussion," *Print Collector's Newsletter* XVI (January–February 1986), 196–205.

111. For example, Derrière L'Etoile Studios would often collaborate with Maurel Studios on projects that utilized screenprinting as well as other processes.

112. In 1984, Frank Stella's *Pergusa Three Double* was published by Tyler Graphics with a release price of $30,000. In 1987, Jasper Johns's *The Seasons*, a set of four intaglio prints, was published by Universal Limited Art Editions at $40,000. Gemini G.E.L. published an 18-foot Ellsworth Kelly lithograph in 1988 with a starting price of $35,000 and during the same year released Roy Lichtenstein's *Imperfect,* a large (*58" x 92⅝"*) wood relief, screenprint, and collage piece at $25,000. Richard Diebenkorn also produced a series of 18 monotypes during 1988 at the Garner Tullis Workshop in Santa Barbara; the small works (26" x 20") were released at $40,000, while the larger (41" x 24") works were sold for $60,000.

113. Maurice Sánchez had studied at Tamarind and at the San Francisco Art Institute in the late 1960s, and while in San Francisco he had also worked at Collector's Press. In 1970, Sánchez moved to Vancouver to teach lithography and painting at the Vancouver School of Art. In 1972, Sánchez was hired by Petersburg Press and he moved to London. While at Petersburg, Sánchez collaborated with James Rosenquist on the monumental *F–III* print project. After three years' work on the project, Sánchez went to work solely for Rosenquist on various print projects. When Brooke Alexander approached him to collaborate on Jennifer Bartlett's *Graceland Mansion* series in 1978, Derrière L'Etoile Studios was established as an independent print studio.

114. A good idea of the scope of Derrière L'Etoile's projects can be found in the four volumes of illustrated catalogues published by the Rutgers Archives for Printmaking Studios in 1983, 1988, 1992, and 1994 (see Bibliography).

115. See Charles T. Butler and Marilyn Laufer, *Recent Graphics from American Print Shops* (Mount Vernon, IL: Mitchell Museum, 1986), 23, and Donald Farnsworth *Magnolia Editions: Works on Paper 1981–1992* (Oakland: Magnolia Editions, 1992) for an illustrated catalogue of collaborations with artists including Squeak Carnwath, Rupert Garcia, Robert Arneson, David Best, Joan Brown, Christopher Brown, Rick Dula, Farnsworth, Joseph Goldyne, Karen Kunc, Margo Humphrey, Georges Miyasaki, Claire Van Vliet, and numerous others.

116. **Limestone Press**, started by Hank Hine in 1975, has published artists' books, prints, and portfolios with artists including Günther Förg, James Brown, David Salle, Markus Lüpertz, Joan Mitchell, and Richard Tuttle. **made in California**, the shop

opened by David Kelso in Oakland in 1980, works with California artists including Frank Lobdell, Gertrude Bleiberg, Drew Beattie, Jack Jefferson, and Beth Van Hoesen. **Arion Press**, established by Andrew Hoyem in 1976, has produced and published an extraordinary group of artists' books collaborating with artists such as Robert Motherwell, John Baldessari, Mel Bochner, and Jim Dine. **Trillium Graphics**, started by David Salgado in San Francisco in 1979 as a lithography studio, collaborates using a wide variety of processes and techniques with artists including Raymond Saunders, Nathan Oliveira, Joseph Raffael, Edward Ruscha, Mark Adams, Françoise Gilot, Wayne Thiebaud, and Fritz Scholder. **3EP Press**, founded in Palo Alto by Paula Kirkeby, Joseph Goldyne, and Moo Andersen in 1978, has specialized in etching and monotypes projects. Kirkeby's efforts to promote the unique print had begun in 1970 as she mounted exhibitions of monotypes at the Galerie Smith-Andersen in Palo Alto, and continued after her association with 3EP as she founded Smith-Andersen Editions in 1984. **Angeles Press**, founded by Tobey Michel in Los Angeles in 1980 and now in Venice, CA, has worked on lithographic and wood relief projects with artists such as Peter Alexander, Jim Dine, Jill Geigerich, Bill Jacklin, and Allen Jones.

117. In addition to a focus on the landscape images of artists such as April Gornik, Christopher Pfister, Sylvia Roth herself, and Beerman, Sylvia Roth has also collaborated on numerous projects with a generation of artists with roots in abstraction and surrealism including Alfonso Ossorio, Grace Hartigan, Stephen Greene, Esteban Vicente, Richard Pousette-Dart, John Chamberlain, Jonathon Ellis, Paul Benney, and Milton Resnick. Prior to starting her own studio, Roth worked as a master printer for the Atelier Royce. For the past several years, Mary Seibert has assisted Roth as master printer and shop manager.

118. **Vermillion Editions Ltd.**, now run by Anderson with the new press name Acacia, has collaborated with Nicholas Africano, Sam Gilliam, Arakawa, Malcolm Morley, and others and a variety of mixed-process projects since 1977. **Land Mark Editions**, run by Tamarind-trained printers Jon Swenson and Bernice Ficek-Swenson, has developed a strong regional reputation for innovative projects with emerging and nationally-known artists including Michael Manzavrakos, Miriam Schapiro, Jim DeWitt, Barbara Nei, and Bill Moylan.

119. See Jane Kessler, *Luminous Impressions: Prints from Glass Plates* (Charlotte, NC: Mint Museum, 1987) and Harvey K. Littleton and Kenneth A. Kerslake, *Vitreographs: Collaborative Works from the Littleton Studios* (Gainesville, FL: University Gallery-University of Florida, 1992).

120. Two listings of presses have been published by the *Print Collector's Newsletter* in the January–February 1983 and the January–February 1993 issues. The most recent effort to document presses throughout the United States can be found in

Carol Pulin's *Guide to Print Workshops in Canada and the United States* (Washington, D.C.: American Print Alliance, 1993).

121. Judith Solodkin worked with an amazing variety of artists at work at **Solo Press** during the 1980s including Ida Applebroog, Howard Hodgkin, the graffiti artist DAZE, James de Woody, Mary Frank, Steven Gianakos, Richard Haas, Komar and Melamid, Joyce Kosloff, Joan Nelson, Richard Basil Mock, Howardena Pindell, Michael Jed Robbins, Altoon Sultan, Donald Sultan, Judy Rifka, Betty Woodman, and Joe Zucker.

122. The most astounding example can be found in the listing for Jasper Johns in the International Auction Review section of the January–February 1989 issue of *Print Collector's Newsletter*. The four entries note prices realized for prints sold in 1988 at auction at Christie's New York on November 1 (*Target* of 1974 realized $200,000) and at Sotheby's New York on November 5 (*Flags I* of 1973 brought $250,000, *Gray Alphabets* of 1968 reached $155,000, and *0 Through 9* of 1960 sold for $170,000, not including commissions). Of course, at the same time Johns's paintings were breaking even higher records, with the paintings *False Start* realizing $15.5 million dollars and *Diver* selling for $3.8 million during the same year. For good discussions of the market for contemporary prints in the late 1980s, see Ronny H. Cohen, "Up & About: The Market for Contemporary Prints," *Print Collector's Newsletter* XX (March–April 1989), 10–14, and Kristin Brooke Schleifer, "Fighting Back: Coping With Contemporary Prices," *Print Collector's Newsletter* XX (September–October 1989), 124–127.

123. See "Cast of Four with a Target: The Contemporary Print Market," *Print Collector's Newsletter* XXI (January–February 1991), 214–224.

Printmaking 1960 to 1990

■

By Barry Walker
Curator of Prints and Drawings,
The Museum of Fine Arts, Houston

■

The three decades from 1960 to 1990 were a time during which American printmaking achieved a prominence unprecedented in the history of American art. Prints were important to a generation of emerging painters and sculptors to a degree that would have been unimaginable a mere decade earlier. It was in this period that the European concept of the *peintre-graveur* took root in the United States, in a way that was altogether American.

The era began in a spirit of optimism with the election of John F. Kennedy in 1960, after the relative somnolence of the Eisenhower years. Kennedy brought with him a feeling of youthful vigor, a belief that anything was possible. Painters, poets, and musicians were honored guests in the White House, not just symbols trotted out as window decoration for state occasions. Interest in and response to the literary, plastic, and performing arts became much more widespread, no longer the exclusive province of a circumscribed elite.

A new audience for all the arts arose from a generation that considered a university education a right rather than a privilege. Museums, once quiet ivory tower retreats, began to attract new visitors who were either already informed about the visual arts or were eager to be. Many museums, especially those with imaginative directors, responded with new installation techniques, expanded education programs, and a new willingness to exhibit the work of contemporary artists. Exposure to new work gradually led to a tentative but growing market for it.

In the early 1960s, a new generation of painters was just beginning to enter the public consciousness. American painting in the post-war years had been dominated by a somewhat loosely-connected group known variously as Abstract Expressionists or the New York School. The group was roughly divided into two segments: those who responded to nature and those who worked in a vocabulary of geometry. The first segment consisted of such painters as Jackson Pollock, Arshile Gorky, Hans Hoffman, Clyfford Still, and Willem de Kooning; the latter revolved around Barnett Newman and Ad Reinhardt. The most prominent sculptor involved with the movement was David Smith.

The Abstract Expressionists shared a reverence for the act of creation. They believed that the very act of painting was a quest for the sublime. The previous generation of American artists, the American Scene painters, had had to deal with the realities of the Great Depression and the approaching world war, and their work was, for the most part,

a direct representational response to the overwhelming issues of the day. The Abstract Expressionists rebelled against what they perceived as the parochialism of the American Scene painters and their apparent lack of ambition.

The imagery of the American Scene painters had been highly adaptable to the print medium, and the Federal Art Project of the Works Progress Administration provided both facilities and an established distribution network for printmaking. More importantly, the work of the period had been conceived as a wholly American art that the average American could understand and respond to. It was a democratic art, and the print has always been considered a democratic medium.

The concerns of the Abstract Expressionists were not topical, nor did they make any attempt to make their art easily accessible. Few galleries, and even fewer museums, were interested in showing their work, and the work that was exhibited was an easy target for a potshot from anyone from conservative critics to Norman Rockwell. The market for their paintings was minute and most of these painters lived at a subsistence level. Even if the Abstract Expressionists' imagery had been conceptually suitable for prints—and there was almost no tradition of non-objective prints—no market for them existed.

A number of the Abstract Expressionist artists had experienced limited contact with the émigré artists at Stanley William Hayter's Atelier 17 (see the essay by Joann Moser in this volume) when it was in New York. Robert Motherwell produced three or four prints there in 1943, none of which were editioned and no proofs of which are known to exist.[1] At Motherwell's urging, Jackson Pollock engraved several plates there in 1944–45. These plates

> . . . were packed away when he moved to a small farmhouse in Springs, Long Island, with his new wife, Lee Krasner, in November 1945. No editions were taken of the prints, nor, probably, were they ever referred to by the artist. While Pollock later approved some serigraphs made after his black and white paintings, he never again tried his hand at printmaking. Like many other American artists, he had made lithographs in the 1930s, so it was not lack of technique that kept him from the printing press. It is evident, however, that living far from any workshop, disdaining group activity, . . . and a deepening of his commitment to the active method of Abstract Expressionist painting, which was so absolutely individual in attitude, removed most possibilities of making prints.[2]

William Baziotes and Mark Rothko also made a few prints with Hayter, but neither created significant bodies of work in the medium. Adolph Gottlieb had a small etching press in his studio, but his prints of that period were private endeavors, not meant for distribution, much like the Impressionist etchings of Edgar Degas and Camille Pissarro.

The attitude of the Abstract Expressionist artists toward printmaking was, in fact, in many ways like that of the majority of Impressionist painters. Both groups were intimately concerned with the act of painting, the individual brushstroke of the artist. Claude Monet never made prints and Auguste Renoir did so only toward the end of his career, at the urging of Ambrose Vollard, the leading Parisian publisher and dealer of his time, when Renoir was far past his peak. Paul Signac and Alfred Sisley created only a few graphic images, as did Paul Cézanne. Like the Abstract Expressionists who did eventually become involved in printmaking, it was only after a younger generation of painters demonstrated the viability of printmaking as a creative medium that the Impressionists turned to graphics. Edouard Manet was the only one of the Impressionists to create a considerable body of editioned prints during his prime, yet a number of his most important lithographs, such as The Execution of Maxmilian, were published only posthumously.

The artists who arrived at aesthetic maturity in the late 1950s and early 1960s had to face the juggernaut of Abstract Expressionism in all its forms. Although largely unappreciated and misunderstood by the public, the Abstract Expressionist artists had achieved heroic stature within the New York art world. Just as the Abstract Expressionists had rebelled against the mundane concerns of the American Scene painters, so the new generation of artists, also centered primarily in New York, opposed the high seriousness of their work.

The most obvious form that this rebellion took was that of a return to recognizable subject matter. Whereas the Abstract Expressionists strove for the sublime, the new generation of painters embraced the mundane, but in a way entirely different from that of the American Scene painters. Their subject was not the life of the ordinary working American, but the artifacts and images to which everyone was exposed. Just as John Cage refused to distinguish between "music" and "noise" in his compositions, so such painters as Robert Rauschenberg, Jasper Johns, and Larry Rivers treated such quotidian objects as anonymous newspaper photographic reproductions, the American flag, and cigar box illustrations as valid subjects for serious art.

This new generation was the first to realize, well before Marshall McLuhan, the stultifying effect that television had wrought on American life. Television in all its forms—news, sports, variety and entertainment programs, and especially advertising—produced an unending barrage of imagery so constant and desensitizing that it was, for the most part, ignored. Discrimination in viewing, McLuhan stated, was not really the issue. What he perceived as important was the constant spewing of images in a moderately high-resolution dot pattern.

When Jasper Johns painted the American flag, he in fact postulated that the flag had, through overexposure, lost its potency as an icon, that the flag was now like any other object that happened to be composed of a uniform arrangement of geometrical shapes. Using this basic format, he painted with such eloquent sureness of touch that his painted flag images came to occupy a whole new realm balanced somewhere between the familiar-but-ignored and the exotically new.

Painters like Johns, Rauschenberg, Rivers, and Grace Hartigan did not make a complete break with the techniques and many of the tenets of the Abstract Expressionists—rather they evolved from and through them. Just as de Kooning had reintroduced the figure into his paintings of the early 1950s, but composed them using his characteristically expressive strokes, so these younger painters combined figurative subjects with gestural brushstrokes that at once enhanced the image and stood on their own as expressive marks. Johns's flag paintings followed the Abstract Expressionist credo that all areas of the painting should bear the same pictorial weight rather than guiding the eye to a particular focus.

The group of painters who came to be known as the Pop artists made a much more complete break with the painting style of the immediate past. Whereas the painter's individual touch was of utmost importance to the Abstract Expressionists, such Pop artists as Andy Warhol and Roy Lichtenstein independently created styles that revealed no trace of the artist's hand. They not only used the most lowly objects of consumerism as subjects, they also depicted their images in the utterly depersonalized mode of the cheapest mass printing techniques.

For artists of the new generation, painting was not a sacramental act as it had been for the Abstract Expressionists. Visual art, they believed, need not be restricted to painting and sculpture alone, but could embrace other art forms, particularly the performing arts. By 1960, artists like Jim Dine were already working in what would now be called per-

formance art, but were then called Happenings, an art form created by Allan Kaprow. Dine said of Kaprow: "In 1959, when I came to New York, Allan Kaprow particularly impressed me—influenced me. Kaprow expounded a point of view of art as a process of continuing change. If something was not new, Kaprow argued that the artist had sold out."[3] In fact, Dine's first prints, *Car Crash I–V* and *End of the Crash* (1960), document one of his performances.

Red Grooms was another early proponent of performance, by nature a collaborative undertaking. Rauschenberg designed sets and costumes for the Merce Cunningham dance company, as Alex Katz was later to do for Paul Taylor. The late 1950s and early 1960s were a time in which artists in various disciplines consciously sought to eradicate traditional boundaries separating the modes of writing, performing, and plastic arts. Painters needed no longer to be confined to the solitude of the studio. Artists could, and were expected to, participate in all aspects of cultural activity.

Both aesthetically and philosophically, the Pop artists and their contemporaries who comprised the post-Abstract Expressionist generation were open to the possibilities of multiple work created in a collaborative situation. The history of American printmaking of the previous twenty years, however, was unlikely to inspire much interest or excitement to an artist of boundless ambition. Still, an audience for relatively inexpensive works by emerging artists of stature was a distinct possibility. Only the facilities to create such work were lacking.

Largely as a result of Hayter's theory that an artist should be involved in every step of the production of prints, including editioning, the category of the specialist printmaker had arisen in America in the post-war years. By far the vast majority of contemporary prints in solo shows and group exhibits of American graphics were the works of artists whose primary medium was etching or woodcut. American printmaking in the 1950s was a small, enclosed world and thus appealed almost exclusively to people who collected only prints.

American prints of the later 40s and the 50s today seem dated in a way that prints of the 30s do not. Because of their absorption in a medium that contains a considerable element of craft, specialist printmakers in this period all too often became bogged down in technique. It was a period of frequent experimentation with new matrices which, like Boris Margo's cellocuts or Rolph Nesch's metal relief prints, never really led anywhere. It became evident that technical novelty was more important to the artists than the imagery. These techniques were created in a spirit of invention for its own sake, the images being only a secondary consideration.

Universal Limited Art Editions

When Tatyana Grosman founded Universal Limited Art Editions in 1957, she had to attract artists by referring to the European tradition of the *peintre-graveur*, as no such practice was then established in the United States. Looking at the products of the specialist printmaker, a talented painter or sculptor was hardly likely to become interested in the medium. Outside the circumscribed world of American printmaking, the general perception was that of the Abstract Expressionist painters: that prints were a feeble and decidedly secondary art form, far removed from the important strides of the first generation of American painters to challenge successfully the art of the then-dominant School of Paris.

Mrs. Grosman's most difficult task, therefore, was to attract artists to work in a medium that was aesthetically undervalued. At first she tried, without success, to attract the major figures of the New York School to ULAE. Only after she failed in this quest did she turn her attention to the younger generation who, being less established, had little

to lose. Her particular interest was *livres d'artiste*, and ULAE's first major publication was a collaboration between Larry Rivers and the poet Frank O'Hara, *Stones* (1957–59).

Part of the legend that now surrounds ULAE is the prescience Mrs. Grosman displayed in her selection of artists. In her catalogue of ULAE's first twenty-five years, Esther Sparks clarified the contribution of Mrs. Grosman's husband Maurice as well as how the roster of artists working at ULAE evolved:

> One factor that has been neglected in almost every description of the studio at West Islip, but universally reported in the interviews for this book, was the influence of Maurice Grosman on his wife. It was Maurice [Grosman] who guided the choice of artists. He went constantly to galleries and museums, he watched the young artists emerge, and he listened to the talk where artists congregated. His judgment was all the more remarkable hen one considers the sad contrast between the work he recommended and the work he himself produced. The Grosmans chose artists with astonishing prescience. Larry Rivers's description of Jasper Johns and Robert Rauschenberg may be applied to the entire roster of artists who came to ULAE in the 1960s: "At this time their rise in the firmament was a little above the horizon, promising, but nowhere near its present position."

> The Grosmans also listened to the advice of artists and art-world figures they respected. Rivers recommended Grace Hartigan, Helen Frankenthaler, and Marisol. Rivers's dealer, John Brenard Myers, recommended Robert Goodnough. Frank O'Hara suggested Tony Towle (a poet who assisted Mrs. Grosman). Mrs. Grosman met Robert Rauschenberg through Jasper Johns. Rauschenberg and Johns recommended Jim Dine. Rauschenberg brought Cy Twombly. Johns recommended James Rosenquist and Edwin Schlossberg. William S. Lieberman (then curator of prints and illustrated books at the Museum of Modern Art) suggested Barnett Newman. Schlossberg brought Buckminster Fuller.[4]

Tatyana Grosman would almost certainly not have succeeded in attracting Newman to West Islip in 1963 had she not already published distinguished works by Rivers, Johns, and Rauschenberg. Newman was the leading exponent of the geometric faction of the Abstract Expressionists, highly intellectual, and a mentor to younger painters. At the urging of the painter Cleve Gray, he had made three lithographs at Pratt Graphic Art Center in 1957, at a time when he was emotionally blocked in his painting.

As the wife of a painter, Mrs. Grosman had developed an intuitive understanding of the needs of an artist and had a genius for adapting her shop and herself to the characteristics of each artist. Her way of working with Newman typifies her methods.

> Although many asked, Mrs. Grosman was the only print publisher who was able to entice Newman to come. In his eyes, she was "serious" about her work. She had high standards, and, above all, she recognized how difficult it was for him to work in a strange environment. "Studio is sanctuary," he always said. . . . Therefore, Newman was pleased to find that Mrs. Grosman assumed he wanted to work on the stones in his own studio, without hovering printers or other distractions. . . . When he went to West Islip to meet the ULAE staff and to work with Zigmunds Priede (then ULAE's printer), Newman was delighted to find that the shop was totally his. There were no other artists or other artists' work to be seen.[5]

Mrs. Grosman afforded her artists the luxury of time, and she concerned herself with every detail. She was a fanatic about choosing the right paper, so much so that the supply of a particular handmade paper would limit the size of an edition. One reason that the Rivers-O'Hara *Stones* took two years to edition was the time it took the papermaker Douglass Howell to fabricate the special sheets. Unlike most publishers, who bemoan the cost of lengthy proofing, Mrs. Grosman insisted on it.

Newman's masterwork in the graphic medium is the ULAE publication *18 Cantos*, a suite of eighteen color lithographs plus title page. Originally conceived as a suite of fourteen images, he increased the number in order to create further variations in the red sequences. The nineteen images were printed from seven stones in various inkings and layered in differing orders. Although originally Newman wanted to trim the sheets to the image size, Mrs. Grosman persuaded him to reconsider. The margins eventually became an essential component of the image, not the negative support that he had originally envisioned.

Thirty years later, *18 Cantos* is as startling and bold as when it was issued. The colors, particularly the jarring greens, yellows, and browns of *Cantos X* through *XIII*, are unexpected, ranging from the white-on-white formalism of *Canto I* to the exuberance of the reds of the final five images. Newman used nine different papers, with numerous proofings

FIG. 1 ▪ BARNETT NEWMAN ▪ *CANTO XVI*
1963–64. Lithograph. Cat. no. 8

to determine the ideal paper quality for each image. Atypically for a suite of prints, the sheet sizes varied as well, deter-mined by the amount of white surround that the artist conceived as part of the image.

18 Cantos can be said to typify ULAE's production. Not being a printer herself, Mrs. Grosman was not bound by the traditional limits of any medium. By de-emphasizing the role of the printer, more than any other American workshop, ULAE came as close as is possible not to develop a "house style."

ULAE has always adapted itself to the working style of its artists. It would be hard to imagine a greater divergence of working styles than between those of Newman and Rauschenberg. Already experienced in collaborative projects,

FIG. 2 ▪ ROBERT RAUSCHENBERG ▪ *ACCIDENT*
1963. Lithograph. Cat. no. 7

Rauschenberg arrived at ULAE for the first time in 1962 with no preconceived notion, either formally or aesthetically, of what he wanted to do. He gathered the components of his imagery on his way out to West Islip and in the workshop itself. He delighted in working communally. While Newman, in an almost monastic way, sought to elevate the viewer through his work, Rauschenberg celebrated the mundane with images appropriated from newspapers and magazines, transferred to the stone or plate with solvents that further blurred the already anonymous images.

His 1963 lithograph *Accident* (Cat. 7) exemplified an unprecedented disregard for traditional standards of the medium.

> *After a few impressions, the stone broke in two pieces. Both the stone and proofs were discarded. Rauschenberg made another, which broke after three impressions. Rauschenberg placed the two fragments back on the press bed, added another stone he called "the debris," and printed the edition.*[6]

Any other publisher would have viewed the breaking of the stone as an embarrassment, but Mrs. Grosman entered *Accident* in the Fifth International Print Exhibition at Ljubljana, Yugoslavia, where it was awarded the Grand Prize.

When Mrs. Grosman tried to persuade Rauschenberg to create a book, he responded with *Shades* (1964). It consisted of six lithographs printed on Plexiglas mounted in a slotted aluminum container complete with movable light bulb. Only one Plexiglas sheet was stationary. The others could be arranged in any way by the viewer. *Shades* is generally considered the first important multiple—an editioned three-dimensional object—of the 1960s.

Almost certainly Mrs. Grosman's most important early achievement was persuading Jasper Johns to work in lithography. From his first print at ULAE, *Target* (1960), he grasped and explored the complexities inherent but rarely deployed in lithography. "Johns often said later that he started lithography to see what he could do to complicate the process."[7] Complicate it he did, and thus established a whole new standard for the medium.

False Start I (Cat. 6) was his first truly complex print, both in the number of colors and in spatial and imagistic complexity. A term that later became popular for painters' prints, "surrogate paintings," found its prototype in this image. He showed his serious identification with the medium by insisting on keeping a set of proofs recording the color proofing of *False Start I* at a time when Mrs. Grosman did not feel it important to keep precise records of proofs. It was Johns who established and standardized the archiving of proofs at ULAE.

TAMARIND

For the first ten years of its existence, ULAE was strictly a lithography workshop. It was that medium that first sparked the interest of a young generation of painters and sculptors in graphics, and it was specifically to revive the practice of lithography in the United States that June Wayne founded Tamarind Lithography Workshop in Los Angeles in 1960.

Tamarind differed from ULAE in that it was an educational institution, the purpose of which was to teach lithography to a new generation of printers before the craft disappeared altogether in this country. As part of the learning process, the student printers worked with professional artists who were invited to Tamarind by an advisory board for defined periods. It was at Tamarind that the concept of the printer as collaborator with the artist was first fully realized.

Mrs. Grosman ran ULAE in the traditional European system whereby the printer carried out the artist's instructions without comment or input. As Esther Sparks pointed out:

> Although Mrs. Grosman often praised her printers and took a maternal interest in their affairs, they quickly learned that she believed in a definite hierarchy: Printers were not encouraged to rise above the rank of artisan; the artist was supreme without doubt or rival. Next stood Mrs. Grosman—the artist's interpreter, monitor, and friend.[8]

The training printers received at Tamarind was designed to make them partners, albeit somewhat junior partners, with the creator of the image. Whereas in Europe, printers learned by serving an apprenticeship, the applicants to the Tamarind program were generally college graduates with studio experience, often artists themselves. The American printmaking workshop, as Tamarind was—more than any other influence—to define it, functions more nearly as a democracy in which the printer's contributions received their due acknowledgment.

In the training of printers, Tamarind has been and continues to be a remarkable success. In its first decade alone, it produced such master printers as Kenneth Tyler, Jack Lemon, Jean Millant, Judith Solodkin, Maurice Sánchez, and Irwin Hollander, all of whom have made significant contributions to printed art in America. As a publisher of art, Tamarind's record has been far less spectacular.

The original panel that advised the selection of artist fellows[9] at Tamarind was composed of print curators, critics, and artists who were primarily printmaking specialists. Whereas Grosman begged and wheedled painters and sculptors whose experience in printmaking was scanty or non-existent, the Tamarind panels tended to invite the already proven—painters experienced in the medium already or those whose reputations rested on printmaking. The selection of artists, at least initially, was quite conservative. Outstanding work has been printed at Tamarind, but it has been more the exception than the rule.

As a teaching institution, Tamarind could not lavish the time that an independent workshop could on a project. Schedules had to be maintained, and behind the philosophy of bringing guest artists was the rationale that the students were to have the experience of working with a wide range of artists of differing styles rather than collaborating with one or two artists in depth.

Riva Castleman, curator of prints and illustrated books at the Museum of Modern Art, pointed out some of the difficulties that Tamarind faced in attracting artists:

> Many of the people who came to Tamarind were artists whose careers were bound to the West Coast. Few major painters found the time or the interest to participate (and were often discouraged from doing so by their dealers), but many mature artists who had the incentive made dozens of fine lithographs there. Rico LeBrun (Cat. 4), other figurative painters such as Leon Golub, James McGarrell, and Nathan Oliveira, and quite a few representational printmakers worked at Tamarind in the early years. Richard Diebenkorn, who in the 1970s and 80s made abstract prints derived from landscape subjects, created several figurative prints at Tamarind in 1965.[10]

One very important early success produced by Tamarind was Josef Albers's 1964 suite of eight lithographs Midnight and Noon/Homage to the Square (Cat. 9–11).

Gemini G.E.L.

Because he was the master printer for the Tamarind Albers suite, Kenneth Tyler was able to approach Albers, the dean of geometric abstraction and color theory, for one of the first publications of Gemini G.E.L., the workshop and publishing firm that Tyler established with partners Sidney Felsen and Stanley Grinstein in 1966. Although Tyler, perhaps more than any other American printer, typifies the strong collaborator, his role in the project *White Line Squares* was more active than was to prove the norm. As Ruth Fine observed in writing of Gemini's early years:

> White Line Squares, *Gemini's first major undertaking, was unusual in that the collaboration occurred via long distance. After initial discussion between Albers and Kenneth Tyler in the artist's New Haven studio, Albers sent instructions and examples to Gemini by mail. Considerable communication between the artist and collaborator then took place by telephone. This unusual cross-country collaboration on a project that required extraordinary exactitude in the refinements of color was undoubtedly possible because a bond of understanding had been established during Albers's earlier association with Tyler at Tamarind.*[11]

The tradition of strong collaboration and innovative problem solving persists to this day at Gemini as it does at Tyler Graphics, Ltd., which Tyler founded in Bedford Village, New York, in 1973. It is the concept of the printer as full-fledged collaborator that differentiates American printmaking since 1960 from what had gone before in this country and that persists to this day in most European workshops. Strong collaborators like Tyler can challenge the artist with a vast range of possible technologies. Indeed, from the late 1960s on, American prints often are characterized by a complexity and a scale never before seen in graphics.

Printmaking Media

Lithography was the medium preferred by those individuals who initiated the collaborative movement in America. Since an artist can work in both crayon and liquid tusche, lithography is a painterly medium, much less rigid than engraving or traditional etching. It worked as well in geometric images of saturated color, as in the prints by Newman and Albers, as in the semi-transparent washes of gestural imagery. It is also the most complicated medium in terms of fixing the image on the stone or plate and rolling out the colors. Aside from the influence of Stanley William Hayter, a primary reason that specialist printmakers of the period chose to work in intaglio or woodcut was that these techniques are generally straightforward and are relatively easy to print. Lithographic printing, however, requires the services of a highly-trained technician.

While lithography worked particularly well for painterly imagery, the technically much less complex medium of screenprinting worked well for the hard-edge abstraction and Pop imagery of the 1960s. Here the aesthetic was that no trace of the artist's hand be visible. Screenprinting requires less equipment and far less expertise than lithography and so is a more economical way of producing prints. While lithography workshops founded by Tamarind graduates were springing up around the United States, they were closely followed by studios that worked primarily in screenprinting.

When screenprinting was first used as a creative medium by artists working with the Federal Art Project, they used semi-transparent inks in an effort to make the medium more painterly than lithography. Its use in the 1960s was

just the opposite. Many painters of the time liked to work in screenprinting because it was easy to achieve highly defined edges and to print flat, opaque colors, with no modulation, in either matte or enamel surfaces.

Pop painters like Andy Warhol and Roy Lichtenstein found the lingering taint of commercialism that was still attached to screenprinting in the early 1960s an attractive attribute that perfectly matched their particular aesthetics. The fine, handmade papers and the time lavished on projects at studios like ULAE would have been totally inimical to these artists. Both took their imagery from disposable, mass-produced commercial printing and exaggerated the inherent defects, Lichtenstein with benday dots and Warhol with deliberately off-register printing.

Since Warhol was already employing silkscreens to transfer blown-up photographs to canvas for his paintings, he was using printmaking devices before becoming seriously involved in the medium per se. This ability to transfer photographic imagery to paper or canvas made screenprinting very attractive to artists who wanted to experiment with using nontraditional sources for their imagery, but it was anathema for conservative critics and curators. Screenprints, especially those employing photographically-derived imagery, were excluded from most competitive print exhibitions and did not fall within the Print Council of America's definition of an original print.[12]

Because screenprinting did not require the specialized technical skill that lithography did, Warhol could easily set up his Factory Additions in his own studio. Some painters and early publishers employed the services of commercial silkscreen houses for the very reason that the aesthetic was anti-aesthetic. As soon as it became obvious that a market for screenprints was evolving, however, specialized facilities came into being.

Ives-Stillman in New Haven printed most of the screenprints that Albers created late in his career. Conforming to his needs, their work was precise and highly professional. Many early screenprinting shops, however, operated on a more casual basis. They were often founded by artists and staffed, on a project basis, by young painters in need of money.

Steve Poleskie, now a member of the art department at Cornell University, founded Chiron Press on New York's lower east side in the early 1960s. Unlike Gemini and ULAE, Chiron was not a publishing firm, but one that did contract work for publishers who did not have their own shop facilities. By today's standards, the quality of printing at Chiron was rather crude, but screenprinting at that time was such a new medium that no standards against which to measure existed. Equally important, artists creating in the medium chose it precisely because it lacked the subtleties of lithographic printing.

Chiron's early ongoing contract work was printing original silkscreen posters for *Paris Review*. Soon New York artists like Alex Katz, Saul Steinberg, Robert Motherwell, Helen Frankenthaler, Ellsworth Kelly, and Ernst Trova began making screenprints there. Because screenprinting was relatively uncomplicated, Poleskie could hire young painters to do the editioning. One such was Brice Marden.

After leaving Yale in 1963, Marden had worked in New York for a year, then spent several months in Paris. Upon his return to New York, he worked in a frame shop and then, in 1965, at Chiron Press, eventually taking over the loft above the workshop. Marden's print cataloguer, Jeremy Lewison, explained his role at Chiron:

> Marden never cut any screens but he mixed inks and helped to print. He describes how "we would print the first color and I would make a few extra ones on this good paper. I would get a big rectangle and I would take it upstairs and draw over it."[13]

Working at Chiron thus allowed Marden to collaborate in more than one sense of the word.

Whereas the pioneering printmaking workshops produced and published work by invited artists only, a new phenomenon, and one that was distinctly American, Chiron worked in a more traditional fashion akin to such Parisian printing houses as Le Mercier and Clot. Chiron, for the most part, did not select the artists who made prints there. That selection was made by the independent publishers (or galleries) who were in the business of publishing prints but, like the great French publisher Ambrose Vollard, did not have their own workshops.

Both ways of publishing had advantages and drawbacks. Printer/publishers could control every aspect of a print's production. Moreover, since they worked with a limited group of artists, a rapport developed between the creator and the producer of the imagery that grew from project to project. If, however, an artist wanted to try a new medium, the shops, especially in the early years, could not provide the facilities.

For the independent publisher, who did not have to set up and equip a workshop, the costs were considerably less. The publisher would first decide on the artist; then, after ascertaining what type of printmaking would best serve that artist, select from the growing numbers of contract printers. As a project succeeds best when the personalities of the collaborators are in accord, the independent publisher had the advantage of a much larger pool of printers from which to choose. Once the artist started proofing with the master printer, however, the publisher's control of the project began to erode.

The very fact that a number of independent publishers were flourishing by the end of the 1960s indicated the strength of the market. The most important artists of the new generation that came of age in the early years of the decade were willing, and indeed eager, to make prints. Facilities had sprung up to accommodate them, and publishers were financing and marketing the results. The profile of the print collector changed radically in the 1960s.

COLLECTING

Print collecting in America had hitherto been a fairly specialized pursuit, with the majority of collectors concentrating on etchings, engravings, and woodcuts by old masters. The prints produced under the Federal Art Project, not intended for private collections, were distributed to public institutions. The market for the specialist prints of the post-war years was slight. Suddenly large-scale prints, usually in color, were appearing on the market, often to the accompaniment of advertisements in the major art magazines.

The market for contemporary prints certainly did not develop overnight. Early publishers and workshops had to struggle to stay afloat. The acceptance of the new type of print by influential museums was an important factor in spurring a public awareness and interest in the medium. The mounting of such exhibitions as *Tamarind: Homage to Lithography* (1969) and *Technics and Creativity: Gemini G.E.L.* (1971) at the Museum of Modern Art did much to legitimize the collaborative print.

The 1960s saw the creation of a new phenomenon in American life—the artist as celebrity. The Pop artists caught the imagination of the public and, although attention in the press was often unfavorable, it created an unprecedented awareness of contemporary American art. Warhol's soup cans and Brillo boxes might be deplored by most critics, but they were, on a superficial level at least, a form of art that the American people could understand. Their very familiarity certainly led to contempt on the part of many but, on a different level, this familiarity connected with the public at

large in a way that the high idealism of the Abstract Expressionists could not. The public might not understand Lichtenstein's aim of banishing aesthetics from his printing, but everyone knew what a blown-up cartoon panel was. Enough sophisticated people understood and appreciated the irony inherent in Pop to create a market for the art. And the proliferation of prints made its acquisition possible to a whole new audience.

Once prominent painters began making prints, other painters became excited about the possibilities of the medium. In speaking of his decision to start making prints in 1965, Alex Katz expressed what many artists were reacting to at that time:

> You get what you want to do and what you don't want to do from other people's prints. Johns' prints were really important because they made you think about prints seriously. I don't know that they influenced me, but they became like a marker in printmaking, an idea of what a print could be. And almost everything—his whole technique and way of doing things—was nothing like what I wanted to do. He's a person you had to think about if you thought about making prints seriously.

> And I think you had to think about Warhol too. When he started making prints, you had to pay attention. Those photo screens. Everyone started running out and doing them, myself included. And then you had to think of what you liked and what you didn't like.

> I think they were the two printmakers who really challenged the European tradition—Warhol by making it, in a sense, more graphic, and Johns by making it more painterly. The whole atmosphere here in the sixties was a very exciting time to be looking at prints.[14]

The very fact that painters of the caliber of Johns, Newman, Rauschenberg, Albers, and Warhol were making major statements in the medium conferred an unprecedented legitimacy upon printmaking. Although such distinguished American artists as Winslow Homer, Frank Duveneck, Thomas Moran, Childe Hassam, George Bellows, and John Sloan had made important prints, printmaking had never really been a movement before. In the 60s, however, it became such an integral component of mainstream American art that any survey of the period could not overlook its importance.

While painters and progressive curators reacted quickly and favorably to the collaborative movement in printmaking, the somewhat puritanical doctrines of Stanley William Hayter had been too important for too long for many curators, scholars, and dealers to abandon suddenly. Many of the new techniques, particularly photo-screenprints, did not meet the criteria for originality that the Print Council of America had established.

Collaborative prints also *looked* entirely different from the recent American prints people were used to seeing. In the first place, they conveyed the aesthetic of painters, not of specialist printmakers. Second, they looked effortlessly professional and were thus somewhat suspect. Because many artists, like Johns and Katz, used the medium to further develop images that they had already created in paintings, the originality of their prints seemed questionable to those followers of Hayter who believed that the artist should create the image spontaneously on the matrix.

Such critics saw printmaking as a separate activity, while many painters, like Katz, viewed their prints within the continuum of the entire body of their work:

> What it meant was taking a painting with a lot of inflection and a lot of tones and reducing, say, three hundred tones down to five or six. So it becomes much cruder, but you had some energy out of the medium to compensate for that, and hopefully the thing would have as much energy or more than the original. [15]

For an artist like Johns, who works within self-imposed limits with a variety of imagery, prints are an opportunity to examine a pre-established image in yet a different way. For Katz, "Prints are supposed to be, with my work, the final synthesis of a painting." [16] With Warhol, whose paintings were actually prints on canvas, the link between painting and printmaking is so close that his works are conventionally classified on the basis of the support and whether or not they have been editioned.

The viewpoint of the old guard was expressed by Jo Miller in the introduction to the catalogue of the last National Print Exhibition that she curated for The Brooklyn Museum:

> More than one-half of the artists in this exhibition have publishers. The print has indeed become a desirable and marketable item. Despite the various commercial connotations, the artist benefits from these new business enterprises, for the publishers are men and women of taste and sensibility who work closely with the artists to produce fine prints. But my deepest admiration remains for the artist who produces his own work from beginning to end. [17]

The new collector of prints was not the old-time connoisseur to whom Ms. Miller spoke, but someone who did not make fine distinctions among media, often someone who was excited by contemporary art and wanted to collect it. Prints happened to be the most affordable way of collecting. The young collector might specialize in prints or move on to collecting paintings and sculpture as well.

Interestingly, many of the pioneering publishers followed the same route. Publishers who had printmaking facilities have tended to continue to specialize in prints. The independent ones, however, often come to feel that it is easier, and to them more interesting, to sell one painting than twenty impressions of a print. As publishers usually work with a limited stable of artists, and become increasingly aware of every aspect of their work, such a development is not surprising. Although a few independent publishers, notably Robert Feldman of Parasol Press, and Diane Villani of Diane Villani Editions, have continued to publish prints exclusively, more have abandoned the medium in varying degrees. Rosa Esman, whose Tanglewood Press was extremely influential in the early years of the collaborative movement, now deals almost exclusively in unique work. Marian Goodman (Multiples) and Brooke Alexander (Brooke Alexander Editions) continue to publish sporadically, but are more involved as primary dealers for their artists' paintings and sculpture.

Printers, too, particularly those who created their own work as well as printing that of others, often moved on. A case in point is Irwin Hollander, a Tamarind graduate who opened Hollander's Workshop in New York in 1964. It was Hollander, more than anyone else, who was able to persuade members of the Abstract Expressionist group to attempt lithography. Robert Motherwell made his first great lithograph, *Automatism A* (1965), with Hollander. Other painters for whom Hollander printed included Sam Francis, Philip Guston, and Jack Tworkov.

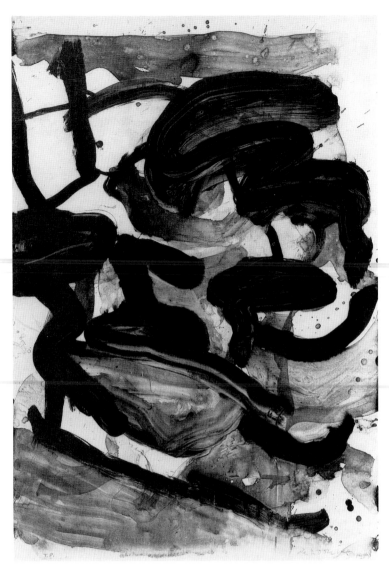

FIG. 3 ▪ WILLEM DE KOONING ▪
UNTITLED (LARGE SUMI BRUSH STROKES)
1970. Lithograph. Cat. no. 23

In the middle 1960s, the great holdout, the painter everyone wanted to work with, was Willem de Kooning. Although he had made a few prints with Hayter, now lost, and one etching—*Revenge*, printed by Anderson-Lamb in 1957 and published in 1960 in *21 Etchings and Poems*[18]—he had only made two lithographs, and those almost by accident. As a guest of the art department at the University of California at Berkeley in 1960, de Kooning was talking with Nathan Oliveira and George Miyasaki at the printmaking studio. At their urging, de Kooning drew with a floor mop in sweeping gestural strokes on two large stones. Oliveira and Miyasaki editioned the two images, *Litho #1 (Waves #1)* and *Litho #2 (Waves #2)*, in editions of eight and nine, respectively.[19] In conversation with this author in 1987, Miyasaki revealed that since the water had been turned off in the studio that day, he and Oliveira had sponged the stones with beer.

In 1966, Hollander persuaded de Kooning to work with him on two projects. De Kooning made twenty drawings on mylar, three of which were published in a memorial edition of Frank O'Hara's poems, *In Memory of My Feelings*, along with mylar transfer lithographs by twenty-nine other artists. He also made eight lithographs on transfer paper, only one

of which, *Clam Digger*,[20] was published by Hollander in *Portfolio 9* (1967). The salability of prints in 1966–67 was still so uncertain that de Kooning's lawyer and his dealer urged him not to flood the market. Editioned but unsigned, the seven other lithographs[21] remained in Hollander's storage until 1990.[22]

In 1970–71, de Kooning returned to Hollander, where he created an additional thirty-eight images. By this time, there was no question that the print market could indeed absorb a large body of work released at one time by a painter of de Kooning's stature. Knoedler, his gallery at the time, published twenty lithographs drawn on transfer paper.[23] Subsequently, in the same year, Hollander published four more lithographs[24] in conjunction with Xavier Fourcade, these drawn directly on stone. The fourteen other proofs Hollander found impossible to edition, as the subtleties disappeared after two or three pulls. *Untitled (Large Sumi Brush Strokes)* (Cat. 23) is one of the uneditioned proofs. Of the other two known proofs, one is so light and the other so dark that they lack inflection.

Shortly after this campaign with de Kooning, in 1972, Hollander closed his workshop to pursue his own work and a teaching career. He retired from printing and publishing just when it had become economically viable. When this author asked Hollander why he left the field at the time of his greatest triumph, he replied that he had achieved his ultimate goal in working with de Kooning, and hence felt that any other collaborations would seem stale.

Lithography too had triumphed by the beginning of the 1970s. It had demonstrated its flexibility as a vehicle for styles as different as de Kooning's gestural sweeps, the rigid geometry of Albers, Johns's painterly yet controlled gestures, and Rauschenberg's photographic transfers. Shown its possibilities by a younger generation, even such deans of Abstract Expressionism as de Kooning, Newman, and Motherwell had created significant work in the medium. With lithography, followed by screenprinting, leading the way, it was inevitable that other forms of printmaking were ripe for exploration.

MINIMALIST PRINTS

The next major development in the collaborative movement was initiated, at least in part, to meet the needs of an entirely different type of image. Lithography ideally suited the concerns of painters who were draftsmen, while screenprinting was the preferred vehicle for Pop and hard-edge work. The other important movement of the mid and late sixties was Minimalism.

Since Minimalism is virtually always based on a grid system, either real or implied, its basis is a linear network. Because in pure etching whole areas of tone are built up through cross-hatching, the medium was, by nature, compatible with Minimalist imagery. Although, in the early 60s, etching was still the province of the Hayter-influenced specialist printmaker, the success of lithography and screenprinting made the idea of working in any graphic discipline exciting and challenging. For most American artists who became involved seriously in printmaking, it was naturally instructive to examine the work of European *peintres-graveurs*, particularly that of Picasso. His famous *347* series, published in 1968, demonstrated the rich, often painterly, possibilities of etching.

The first important workshop to specialize in etching was Kathan Brown's Crown Point Press, which she opened in Oakland in 1962. An intaglio printmaker herself, Brown first viewed the press as a place where she and fellow Bay Area artists could experiment in the medium. Although Crown Point now publishes all the prints created there, in the early years it also functioned as a contract shop, printing work for independent publishers. Among her early clients

were Pace Editions and Multiples. Crown Point achieved its greatest early fame, however, with its 1965 publication of Richard Diebenkorn's *41 Etchings and Drypoints*, done at a time when the artist was still working in his figurative mode.

The other critical factor in Crown Point's early success was its contract work with Minimalist artists for Robert Feldman's Parasol Press. Feldman sent the most important Minimalists—Brice Marden, Robert Mangold, and Robert Ryman—to Crown Point, where they created masterpieces of Minimalist printmaking. Brown had a particular affinity for the work of Minimalist and Conceptual artists, so, although she went on to print and publish work in more imagistic styles as well, Crown Point has the distinction of printing and publishing the most important corpus of early Minimalist and Conceptual graphics. Feldman shares this honor as a publisher. When he first began sending artists to work with Brown, the market for Minimalist prints was almost nonexistent, so his early publications had few takers.

Another extremely important body of work produced at Crown Point are the intaglio prints of Sol LeWitt, who usually produced ideas and schematics that would be realized by someone else. As Riva Castleman explained:

> Behind LeWitt's work of this period lies the principle followed by many of his generation: art should no longer be elitist; it should exist as universally as possible (in books, in unrestricted excavated areas of land transformed into man-made works of non—functional beauty, in free performances); and it should not be in any way precious. By providing instructions for his wall drawings and other works, LeWitt made it possible for anyone to reproduce him.

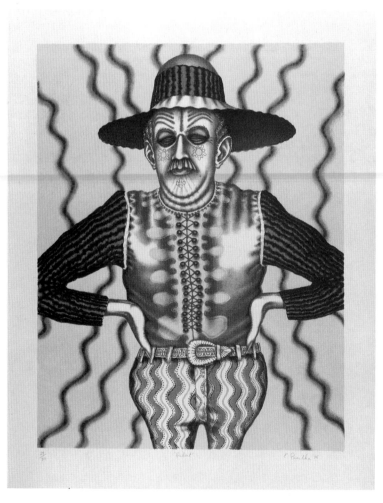

FIG. 4 ▪ ED PASCHKE ▪ *HUBERT*
1976–77. Lithograph. Cat. no. 42

His etchings, however, led to something else, since the plates were all drawn by him. Ultimately, the medium itself seemed to insist that he return to the role of craftsman and revel in the luxurious perfection of his work. The process of making fine prints, which required considerable investment of time, manpower, and materials, all of which cost money, was a temptation that many artists whose moral principles were at odds with the "system" could not resist. From 1971 to 1983 (and later) LeWitt made over three hundred etchings at Crown Point, usually in series of plates following finite systems, which were meant either to be shown together or bound into books. In some cases only two or three copies of these prints were made, the costs being prohibitive.[25]

Although the ideas behind the Minimalist and Conceptual work that Crown Point produced were rigorous in the extreme, the methods they developed or improved for the use of aquatint greatly enhanced the lush, painterly possibilities of the medium. Thus Ryman's white aquatints had a liveliness of surface that created interesting tensions between the severity of composition and the seductiveness of execution. When artists like Diebenkorn, who maintained a relationship with Crown Point almost until the time of his death, or Robert Kushner created color aquatints there, they were painterly in a way that rivaled lithography and had an inimitable richness of surface.

When Feldman sent Chuck Close to Crown Point in 1972, to make his first intaglio print, *Keith* (Cat. 29), the artist decided to work in mezzotint, the most difficult and time-consuming technique of printmaking, in a scale of almost four feet by three feet. As in the rest of his work, the plate was to be gridded. Rather than spending weeks rocking grids, Brown and the printers at Crown Point developed a system of printing aquatint in half-tone that was every bit as rich as a traditionally rocked plate. Close then scraped and burnished in the mezzotint style, creating a well-over-life-size image of immense power and richness of surface.

A major development of the late 1960s and early 1970s was that many of the major printing/publishing shops, in response to the evolving interests of the artists, became multi-disciplinary. One reason for this was that an artist who had worked in lithography, for example, might see the intaglio work of another artist, such as David Hockney, and decide that it would be interesting to investigate that medium. For the artist, it was often more comfortable to work in a different technique at a studio where he or she was comfortable than to work with unknown printers. Other artists, however, welcomed the opportunity to explore a new medium in an entirely new environment. In 1967, with a $15,000 grant from the National Council for the Arts, ULAE established an etching studio in the basement with Donn Steward as master printer.[26] Other major workshops followed suit, opening facilities for etching and screenprinting.

Another reason for workshops to diversify was that, as artists became increasingly aware of the possibilities of the various media, they were no longer content to work in pure lithography or intaglio. Sometimes the workshops had to provide additional facilities somehow to meet the artist's requirements. The classic case is Rauschenberg's *Booster* (Cat. 17) of 1967.

In his first project with Gemini, Rauschenberg created a six-foot-high lithograph, the central focus of which was a life-size X-ray of the artist, combined with found images including a straight-backed chair printed in a blue that consciously evoked blueprints at the upper left and again in fragments at the center right and lower left. As the top layer of the lower two-thirds of the image, Rauschenberg wanted an astronomy chart showing the 1967 orbital paths of Saturn and Jupiter printed in red. In lithography, red cannot be printed over black and be legible. Unlike lithography,

however, in which the ink is absorbed partially by the sheet, screenprinting sits on the surface. After the lithographic images were printed in two different sections, therefore, Tyler sent the sheets to Wasserman Silkscreen in Santa Monica, where the red chart was printed by Jeff Wasserman.

Combining more than one graphic medium is, by no means, a new development—Elisha Kirkall was doing it in eighteenth-century England—but *Booster* (its working title was *Large Print*) did it on a scale and with a panache hitherto unprecedented. It started a rage for mixed-media printing, forcing major workshops to expand their facilities if they wanted to maintain quality control of every aspect of a print's production. That such facilities were necessary—and economically feasible—was a clear demonstration of the health of the print market by the early 1970s.

Gemini was the most creative in the use of new technologies. With *Profile Airflow,* Claes Oldenberg presented the shop with the challenge of creating a three-dimensional, albeit still wall-mounted, object. He created a wooden bas-relief, from which molds were made, and whose form was then cast in polyurethane and placed over a lithographic image. Considerable experimentation was needed before the shop achieved the correct formula for the plastic. *Profile Airflow* opened a new avenue for Gemini, which continued producing multiples for such artists as Rauschenberg, Lichtenstein, and Edward Kienholz.

Some technical developments of the period were less felicitous. One such was the "rainbow roll" in which several colors were rolled on a lithographic stone or plate in a continuous blend from one roller. Working at Gemini, Johns made masterful use of the technique in his *Color Numeral Series* (1968–69). When Pat Steir made her first lithograph with Jack Lemon at Landfall Press in Chicago, she actually responded to the phrase, but used the technique masterfully. As Elizabeth Broun explained:

> The title of the print, Roll Me a Rainbow *(Cat. 39), refers to the instructions given to the printer for the multicolor blend at the top of the print. Steir enjoyed the connotations of the phrase. "But it sounds so romantic. Roll me a rainbow. It sounds like a movie from 1940."*[27]

In the hands of artists of the caliber of Johns and Steir, the rainbow roll was a well-thought-out component of an image. It made sense. With lesser artists, it was too often a gimmick, the main idea behind the print, with the imagery at the service of the technique. All the rage in the early 70s, the rainbow roll has blessedly fallen into disuse. With the exceptions noted above, prints from the period using it now seem remarkably dated.

THE 1970s

In the various modes of primary imagemaking, the 1970s was a decade of pluralism. Such was the case with prints, too. Whereas the pioneering publishers had faced considerable difficulty in cajoling important artists into making prints, by the second decade of the collaborative movement it was simply assumed that printmaking would be a part of the repertoire of any ambitious painter or sculptor. As more and more printers were graduated from academic programs, workshops proliferated throughout the country. After working with established shops, many printers struck out on their own. Tyler left Gemini to open his own facility, Tyler Graphics, Ltd., in Bedford Village, New York. The strength of the print market would have been inconceivable just a decade earlier.

The market was indeed so successful that it attracted the attention of consortia of investors looking for loopholes in the tax structure. The concept of the tax shelter print, simply stated, was this: A group of investors purchased an image from an artist, often sight unseen. The artist either created the image as a print or sold a pre-existing image in another medium to be turned into a print. The rights to the image passed from the artist to the consortium. If the edition sold, the investors would recoup their investment. Should the image prove extremely popular, they could use it on anything from posters to place mats. If the edition did not sell, they could take a five-year depreciation on the plates, stones, or screens.

Although a few good prints resulted from tax shelters, most were decidedly minor efforts by artists who sorely needed the lump-sum payment the consortium offered. Combined with a downturn in the economy at mid-decade that eliminated the impulse buyer, the net result of the tax shelter scheme was to flood the market with uninspired work. Eventually a committee of concerned print curators, publishers, and dealers reviewed tax shelters with the Internal Revenue Service and helped the IRS to effect changes in its code that effactually killed the tax shelter scheme. Fortunately, important prints by serious artists had achieved a prominent enough stature that the tax shelter prints, although initially damaging to the credibility of the medium, did little lasting damage.

One of the major developments of the decade was a movement that eventually came to be known as Photorealism, a bastard relation of the *trompe l'oeil* painting of the previous century. Photorealism adapted the look of the photograph to painting and, later, printmaking. On the West Coast, its major proponent was Robert Bechtel who created an interesting body of etchings with Crown Point and other shops. In the East, Audrey Flack maintained the strongest tie to *trompe l'oeil* with her elaborate still lifes. Robert Cottingham created images of the isolated five-and-dime store and movie theater signs that were beginning to disappear from American towns. With his treatment of the about-to-be-nostalgic, Cottingham was the romantic figure of the movement. His 1973 lithograph *Fox* (Cat. 31), made at Landfall, depicts a sign from the type of movie theater that was about to give way to the multiplex.

The best known Photorealist is Richard Estes, who depicted the facades of urban buildings ranging from the distinguished Seagrams Building to Lower East Side storefronts. With his concern with light and reflections, his are the most complex compositions. Estes has created an important body of printed work, published, oddly enough, by Robert Feldman of Parasol Press, the early and still current champion of Minimalist prints. Feldman has chosen not to use an American printer for Estes's work, contracting the screenprints, which often require over one hundred screens, to Domberger in Stuttgart, Germany.

Screenprinting in this country reached remarkable new levels of subtlety and sophistication at Hiroshi Kawanishi's Simca Print Artists. As Alex Katz once remarked in conversation, screenprinting in America in the 1960s was "like chicken soup." It was flat, opaque, and uninflected, as suited the aesthetic of many artists who worked in the medium. Kawanishi returned to the concept of the WPA silkscreens where the medium was esteemed for its translucent, painterly capabilities. He took the medium to such heights of subtlety that, comparing screenprints produced at Simca with early Pop prints, one would be surprised to learn that they employed the same medium. Simca's print of Johns's 1973 *Flags I* (Cat. 34) looked like no other screenprint before it. Johns, working with Kawanishi, made such assured, inventive use of the medium that it could never be thought of in the same way again.

With the wealth of workshops in this country and abroad, many artists work with a number of printers, taking advantage of what each shop has to offer. Alex Katz decided at the outset of his printmaking activities that he wanted to explore the possibilities of as many print facilities as possible:

"Every shop has its parameters and you have to make something inside of that." By working with various print-ers, he decided that he would create a variety of situations in which he could work both with and against their strengths and weaknesses, expanding his range by taking on new sets of challenges. "In most printmaking, every time I try something different. I want to give it a vocabulary that is not completely technical, but I want to try something new."[28]

When, in 1988, the Walker Art Center acquired a large group of Jasper Johns's prints that, together with those already in their collection, made a complete holding of the artist's graphic work, curator Elizabeth Armstrong organized an exhibition that was structured by Johns's work with four different printers: ULAE, Gemini, Simca, and Atelier Crommelynck. By the time *Jasper Johns: Printed Symbols* opened in Minneapolis in February of 1990, another section was added: the carborundum etchings he had made with Maurice Payne in 1988.

The installation vividly documented Johns's reaction to each creative environment, ranging from the subtlety of the early ULAE lithographs to the more aggressively colorful prints and the three-dimensional lead reliefs of Gemini, the transparency of the Simca screenprints to the lush Crommelynck aquatints.

No work of the 1970s better demonstrates the interests of artists in the peculiar properties of the various print disciplines than Jennifer Bartlett's 1978–79 *Graceland Mansions* (Cat. 48), a five-panel work employing two aspects of intaglio and one each of lithography, screenprint, and wood relief. The drypoint and aquatint panels were printed by Prawat Laucheron, an independent printer who worked with a number of New York artists in the 1970s, but has since ceased printing to pursue his own work. The screenprint panel was printed with Kawanishi at Simca, the wood relief with Chip Elwell, and the lithograph with Maurice Sánchez at Derrière L'Etoile. Using a generic house shape for each image, *Graceland Mansions* is a primer on the properties of each medium and one of the landmark prints of the decade.

Relief printing, the oldest and most direct form of printing, began a revival in the late 70s that achieved fruition with the work of the Neo-Expressionists of the early 80s. The late Chip Elwell was the most important printer of wood and linoleum relief prints although, oddly, his chief interest was in pochoir printing, a medium he attempted to revive with little success. As artists became interested in working in woodcut, however, it was easy for workshops to comply, as very little equipment was necessary to implement the process.

Woodcut had been a popular medium with such specialist printmakers as Leonard Baskin and Antonio Frasconi in the 1950s, but almost entirely disappeared in the 1960s and early 70s. Robert Flynn Johnson of the Achenbach Foundation for Graphic Art has observed that the woodcut seems to flourish during Republican administrations, when artists, as a group almost always liberals, take out their frustration with the state of the country by cutting and gouging blocks. The revival of relief printing that began in the 70s and became extremely popular in the 80s was given valida-tion with Riva Castleman's 1982 exhibition *Prints from Blocks* at the Museum of Modern Art. That show revealed such a range of expressive possibilities for the medium that it inspired many artists to work in it.

Woodcuts from the late Gothic/early Renaissance period through the first half of the twentieth century are a vigorous, if sometimes rather crude, way of rendering representational imagery. Carol Summers's woodcuts of the 60s and 70s approached abstraction, but were always firmly rooted in landscape. Against this background, Helen Frankenthaler's pioneering work in the early 70s, virtually a reinvention of the medium, is all the more innovative and exciting.

Unlike other Color Field painters, whose work often did not adapt well to the graphic medium, Frankenthaler has made a singular contribution in each discipline she has addressed. She began her mature printmaking career in 1961 at ULAE, working first in lithography and then in etching. In 1972, when Mrs. Grosman suggested woodcut to Frankenthaler, who had always admired Japanese woodcuts, she responded enthusiastically.

Most American woodcut artists use soft wood, but Frankenthaler carved hers from eight mahogany plywood blocks. *East and Beyond* was quickly perceived as "the first of a new breed of woodcut . . . a departure so profound that virtually all subsequent woodcuts incorporated the thinking it embodied."[29] The irregular sheet, an important component of the image, seems exotic, but is actually Nepalese toilet paper, doubled to withstand the pressure of the press. Frankenthaler subsequently made three additional woodcuts with ULAE, primarily in 1974, that, while vastly admired, remained isolated examples until the end of the decade. When she made her most famous woodcut, *Essence Mulberry* (Cat. 46) at Tyler Graphics in 1977, however, many artists were ready to follow suit.

Unlike Frankenthaler, many of the artists who took up woodcut in the late 70s and early 80s used it for representational imagery. While Conceptualism, Color Field, and Minimalism had dominated the early part of the decade, inevitably a new generation rebelled against what they perceived as the bloodlessness of these styles that were based on intellectual theory. Like the artists of the 60s, the new generation that reached maturity in the late 70s and early 80s returned to recognizable imagery. The trend was first documented in Richard Marshall's 1978 exhibition *New Image Painting* at the Whitney Museum of American Art.[30]

A major influence on this movement was the appearance on the American scene of striking work by European painters, primarily Germans and Italians. Since the end of World War II, American painting had dominated the international art world. It was generally considered that Europe was drained by two world wars and that virtually all the vital work was coming from the United States. A new generation of European artists was emerging, though, whose members were either too young to remember the war or were born after it. Such artists as Enzo Cucci, Sandro Chia, Francisco Clemente, and Mimo Paladino from Italy, and Anselm Kieffer, Georg Baselitz, Gerhard Richter, Binky Polermo, and Sigmar Polke shattered American complacency. The work was representational and, except for the notable exceptions of Richter and Polke, extremely personal. American artists reacted quickly.

The Reemergence of Representational Imagery

The return to emotionally charged imagery eventually came to be known as Neo-Expressionism as many artists looked to German painting of the early part of the century as a touchstone. As the preferred graphic medium of the early Expressionist was woodcut, many of the new generation felt that it suited their concerns ideally as well. Painters like Richard Bosman captured the critical moment of high emotional drama in such narrative woodcuts as *Man Overboard* of 1981 (Cat. 55). Louisa Chase envisioned a highly personalized nature in relief prints like *Red Sea* of 1983 (Cat. 61), while Joan Snyder dealt with grief and pain in such woodcuts as *Things Have Tears and We Know Suffering* (Cat. 66).

The 1970s saw an interest in materials and aspects of craft. One aspect of this concern was fired by the feminist movement, in which artists used crafts traditionally associated with women as the stuff of art. An outstanding example was the vastly complex installation *The Dinner Party* that toured museums in 1979–80. Organized by the conceptual artist Judy Chicago, every object was made by a vast team of volunteer assistants in such media as pottery and lace. Miriam Schapiro is but one of the artists of strong feminist principles who continues the tradition today in her unique work, and in such prints as *Frida and Me* (Cat. 101).

Work involving fabric and pattern was not restricted only to women artists. In the late 1970s, the term "decorative" lost its pejorative connotations in the work of such artists as Robert Zakanitch and Thomas Lannigan Schmidt. Robert Kushner customized sheets of handmade paper by embedding fabric and sequins, and then collaborated with a printer to produce graphics on them. Each sheet of his *Rhonda* series (Cat. 58) is unique although the lithographic element on each sheet was constant. Likewise Alan Shields employed sewing and other domestic arts in such prints as *Sun/Moon Title Page or Pampas Little Joe* as early as 1971 (Cat. 28).

In printmaking a collary to the craft movement found expression in handmade papers, often made by artists. A lot of such work has the tendency to be precious, particularly in the hands of those who specialize in the medium to the exclusion of all else. In the case of painters and sculptors of strongly defined vision, however, pulp pieces can be very strong indeed. Kenneth Tyler was an enthusiastic proponent of the movement, and Tyler Graphics produced major statements in the medium in the late 1970s by such artists as Frank Stella, Kenneth Noland, and Ellsworth Kelly. The most notable pulp project undertaken at Tyler Graphics in 1978 was David Hockney's *Paper Pools*, which differed from the pulp pieces by the above-mentioned artists in being representational.

The return to figuration in the 1970s was not without context. Such painters as Yvonne Jacquette, Alex Katz, and Philip Pearlstein have worked in each other's particular representational style from the late 1950s and continue to do so to this day. In Chicago, the group The Hairy Who and other funk artists worked in a representational style that continues to be detached and ironic, and not at all related to the angst of the Neo-Expressionists. Such leading artists of the Chicago School as Roger Brown, Jim Nutt, and Ed Paschke have created a distinguished body of graphic work, primarily at such Chicago workshops as Landfall Press and its off-shoot Teaberry Press.

Another important development of the 1970s that gained even more strength in the 1980s was the interest in monotype. This medium, which yields only one impression from an untreated flat surface, was developed in the seventeenth century by Castiglione and has regularly gone in and out of fashion ever since. Viewed historically, certain artists have created a considerable body of work in the medium and then abandoned it. Eugenia Parry Janis's 1974 exhibition of Degas's monotypes at the Fogg Art Museum was immensely influential, not only to painters who saw the exhibition, but to others who saw only the catalogue.

The print establishment had never quite known how to view the monotype. Because each impression is unique, the very basis of printmaking, the concept of multiple originals, seems to be violated. Through the 1970s, almost all juried competitions refused to consider monotypes. After the Degas monotype show, however, a number of artists, principally Mary Frank, Michael Mazur, Nathan Oliveira, and Matt Phillips, created important bodies of work in the medium that could not be ignored. Eventually, in 1980, the Metropolitan Museum of Art and the Museum of Fine Arts, Boston mounted an exhibition, *The Painterly Print,* that in effect, gave the official seal of approval to the medium.

THE 1980S

The monotype became one of the forms of expression that defined printed art of the 1980s. A number of important printers/publishers, most notably Garner Tullis, printed monotypes exclusively. Sam Francis, Helen Frankenthaler, Sean Scully, and Nancy Haynes are but a few of the artists who made significant statements in the medium while working with Tullis. In the mid-1980s, Cheryl Pelavin changed the focus of Pelavin Editions from etching to monotype. Pelavin worked with younger artists, notably Alexis Rockman, and continues to be a proselytizer of the medium.

Along with the popularity of the monotype came the interest in the monoprint, or the *edition variée*, in which part of the image is fixed in any one of the traditional printmaking disciplines while other elements of the print vary. The variations can be achieved by printing flat areas of the matrix as monotype or with handcoloring. As in the case of Kushner, the variation can be in the artist-made paper.

Arguably, one of the reasons for the tremendous interest in monotypes and monoprints was that editioned printmaking had succeeded too well. Tamarind taught its printers to create editions that were absolutely uniform, and this was also the criterion for printers of etching, screenprints, and relief. It fit perfectly the aesthetic of such movements as Pop and Minimalism. With the return to a more emotionally charged art, the perfectly even edition was no longer so desirable. Evidence of the artist's hand was once again important and no form of printmaking is more personal than the monotype. Monoprinting, too, made each impression a personal statement.

Innovative new publishers of the 1980s brought in a new generation of artists as well as a more international tone to American printmaking. Swiss-born Peter Blum first distinguished himself by publishing such European artists as Clemente, Cucci, and Martin Diesler. He went on to persuade artists like the Conceptual/Earthworks luminary James Turrell, who had never considered graphics, to work in the medium. Eric Fischl's 1983 six-part etching *Year of the Drowned Dog* was one of the single most important publications of the decade. For that and his Turrell prints, Blum contracted the intaglio printing to Peter Kneubühler in Zurich. Interested in Conceptual work, he also published works like Sherrie Levine's *Meltdown* suite (Cat. 94) and Barbara Kruger's *Untitled (We Will No Longer Be Seen and Not Heard)* (Cat. 71), both printed at Maurice Sánchez's Derrière L'Etoile.

Ilene Kurtz, who had lived in Germany, was the American representative of Verlag Sabine Knust before starting to publish such American artists as Mel Kendrick, John Newman (Cat. 80), Carroll Dunham, and Jeff Koons. Another American with a German background, Julie Sylvester, published both German artists like Günther Förg and American artists like Michael Byron. Both these publishers brought an interesting new viewpoint to American printmaking.

Peter Blum was not the only publisher to send artists abroad to work with distinguished printers. Crown Point established a program in 1982 to send American artists to Japan to work with printers trained in the *ukiyo-e* tradition, in which the artist supplies a watercolor to skilled craftsmen, who cut the wood blocks. Artists who participated in the program include Francisco Clemente, Alex Katz, Pat Steir, and Wayne Thiebaud. Their woodblock prints caused a flurry of letters to *Print Collector's Newsletter,* arguing that these were not original prints and that they looked so much like watercolors that an unsuspecting buyer would not realize that they were editioned woodblock prints. This writer's opinion is that, as long as they are marketed as *ukiyo-e* prints, which Crown Point has been scrupulous in doing, it is an interesting experiment that has produced some very fine images indeed.

American artists in the 1970s and 80s often traveled to Paris to work with the legendary intaglio printer Aldo Crommelynck who, with his brother Pietro, had printed Picasso's late intaglio work. Crommelynck is particularly noted for his extraordinarily rich aquatint printing. When Richard Solomon of Pace Editions established the Spring Street Workshop in New York's Soho district, along with facilities for Joe Wilfer and his staff, he created a studio for Crommelynck. American artists could proof with the legendary printer in New York, and the prints would be editioned in Paris at Atelier Crommelynck.

By the end of the 1980s, printmaking was so firmly established in America that almost every major artist had made some contribution to the medium. Sotheby's and Christie's each had semi-annual auctions devoted exclusively to contemporary prints. Artists no longer made one or two prints at a time, but spent extended periods at workshops on highly involved projects. This can be explained in part by the revival of interest in Minimal and Conceptual work at the end of the decade as Neo-Expressionism ebbed from the scene. The nature of the imagery often required sequential presentation.

Another factor was economic. Prints had entered the mainstream to such an extent that private collectors, as well as museums, were collecting in depth. There was every indication that the marketplace could and would absorb the ever-increasing flow of prints from the workshops. The prices that "classic" contemporary prints were fetching made them seem an ideal investment even to people not seriously interested in the medium. The print market, like the rest of the art market, however, functions in concert with the general economy.

The contemporary print market crashed in the 1990 spring auctions at Sotheby's and Christie's. With a major recession in the country, art was quickly perceived as a nonessential luxury. Lot after lot was passed and, at Christie's, the audience began to boo the auctioneer in the afternoon session for not stating audibly that lots were passed. Although the market has revived somewhat since that time, it seems unlikely that it will reach the dizzying heights of the late 1980s any time soon.

Print publishing has been seriously curtailed as publishers and workshops try to survive on their inventory. Many are in a quandary as prints that were released at very high prices sell, if at all, for a fraction of their retail price at auction. If the publishers do not reduce prices, it is hardly likely that they can sell these prints. If they do lower the prices, however, they will in effect destroy the investment of their customers who bought at the original price.

This depression in the market, however, is unlikely to spell the end of collaborative printmaking in this country. In the thirty years of the movement, printmaking has become part of the fabric of the American art scene. No longer a step-child, it is a medium that truly interests and challenges the most important talents. One can safely predict that when the economy recovers, so will the print market.

NOTES

1. Stephanie Terenzic and Dorothy C. Belknap, *The Painter and The Printer: Robert Motherwell's Graphics, 1943–1980* (New York: The American Federation of Arts, 1980), 157.

2. Riva Castleman, *American Impressions: Prints Since Pollock* (New York: Alfred A. Knopf, 1985), 7.

3. Thomas Krens, "Conversations with Jim Dine I," *Jim Dine, Prints: 1970–1977* (New York, Icon Editions, Harper and Row and Williamstown, Williams College Artist-in-Residence Program, 1977), 13.

4. Esther Sparks, *Universal Limited Art Editions. A History and Catalogue: The First Twenty-Five Years*, Exhibition Catalogue (Chicago: The Art Institute of Chicago and New York: Harry N. Abrams, Inc., 1989), 20.

5. *Ibid,* 206, 7.

6. *Ibid,* 432.

7. *Ibid,* 125.

8. *Ibid,* 36.

9. James Watrous, *A Century of American Printmaking, 1880–1980* (Madison: The University of Wisconsin Press, 1984), footnote 22, 319–20.

10. Castleman, *op. cit.,* 24.

11. Ruth E. Fine, *Gemini G.E.L., Art and Collaboration*, Exhibition Catalogue (Washington, D.C.: National Gallery of Art and New York: Abbeville Press, 1984), 45.

12. Watrous, op. cit., 225.

13. Jeremy Lewison, *Brice Marden: Prints 1961–1991. A Catalogue Raisonné* (London: Tate Gallery, 1992), 19.

14. Barry Walker, *Alex Katz: A Print Retrospective*, Exhibition Catalogue (New York: Burton Skira, Inc. and Brooklyn: The Brooklyn Museum, 1987), 13, 14.

15. *Ibid,* 15.

16. *Ibid,* 17.

17. Jo Miller, *Nineteenth National Print Exhibition*, Exhibition Catalogue (Brooklyn: The Brooklyn Museum, 1974), unpaginated.

18. Lanier Graham, *The Prints of Willem de Kooning. A Catalogue Raisonné, 1957–1971 II* (Paris: Lebon, 1991), 1.

19. *Ibid,* 2, 3.

20. *Ibid,* 4.

21. *Ibid,* 42–48.

22. Lanier Graham, *Willem de Kooning: Printer's Proofs from The Collection of Irwin Hollander, Master Printer*, Exhibition Catalogue (New York: Salander-O'Reilly Galleries, 1991), 20.

23. Graham, *op. cit.,* 5–24.

24. *Ibid,* 25–28.

25. Castleman, *op. cit.,* 110.

26. Sparks, *op. cit.,* 35.

27. Elizabeth Broun, *Form Illusion Myth: Prints and Drawings of Pat Steir*, Exhibition Catalogue (Lawrence: Helena Foreman Spencer Museum of Art, The University of Kansas, 1983), 56.

28. Walker, *op. cit.,* 14.

29. Richard S. Field, "On Recent Woodcuts," *The Print Collector's Newsletter*, 13, 1 (March–April, 1982): 2. As quoted in Sparks, *op. cit.,* 87.

30. *New Image Painting*, 1978–79, consisted of work by: Nicholas Africano, Jennifer Bartlett, Denise Green, Michael Hurson, Neil Jenney, Lois Lane, Robert Moskowitz, Susan Rothenberg, David True, and Joe Zucker.

Multiple Purposes: Collaboration and Education in University and Non-Profit Workshops

■

By David Mickenberg

Director, Mary and Leigh Block Gallery,

Northwestern University

■

A handful of creative people is all that is needed for a renaissance in an art, if that handful comes together at the right time, in the right place. Half a dozen master printers, scattered across the United States, with a cluster of artists revolving around each, could cause a resurgence and a blossoming-forth of the art of the lithograph that would attract the interest of the world. Such a renaissance is the purpose of this project.[1]

June Wayne, 1959

As we approach the last half of the final decade of this century, it can be difficult to remember the spirit of optimism and the belief in the possibility of making change that we see in the writings and efforts of people three or four decades ago. The very notion of recognizing problems and trying to solve them by creating new institutions, developing new educational curricula, establishing new standards of excellence, and training a new generation of leaders seems almost utopian today. Yet many persevering individuals have altered the course of history with ideas, leadership, and commitment to excellence, often in ways that were controversial at the time, but in retrospect seem prescient and even inspired. The history of collaborative printmaking in America is characterized by several such individuals, who defied prevailing attitudes and significantly extended the realm of the graphic arts.

These pioneering individuals, along with other artists, printers, and publishers, and the aid of foundations, universities, and numerous others, have played significant roles in both the profit and not-for-profit organizations that came into being at end of the 1950s and later. The history of collaborative printmaking in this country can be considered from the point of view of both "for profit" and non-profit institutions. Like the leaders of any movement at its beginning, the founders of this one passionately desired to spread their message, to see new ideas perpetuated, to breed a generation that would develop them further, and to create an environment fostering such change. Thus, education played almost as important a role in the movement as the creation of art itself. For some, association with an institution of higher learning meant access to a wide range of talent and experience and an environment in which they could

concentrate upon their art while leaving administrative duties to a "benevolent parent." For others, non-profit status met a need to supplement income from the sale of prints or contract printing with grants from sources supportive of an educational mission. Although the "benevolent parent" has often been less than benevolent, and the unreliability of 'soft money' has been a problem for many non-profit workshops, the collaborative presses of America have educated many and produced significant bodies of printed work.

One of the most fascinating aspects of the history of American art is the array of organizations founded specifically to support artists and to disseminate their works to a broad public. The *American Art-Union,* established in the mid-nineteenth century to purchase works of art and sell prints through subscription; Katherine Dreier's *Société Anonyme,* the champion of the international avant-garde; Hugh Stix's New York *Artists Gallery,* founded in 1936 to assist artists, including many newly arrived immigrants, in presenting their works without fee for the space or commission charged against sales, and Stanley William Hayter's *Atelier 17,* represent a tradition of innovation from which many of the collaborative printmaking institutions emanated.

June Wayne's 1959 proposal to the Ford Foundation that resulted in the founding of Tamarind Lithography Workshop is certainly one of the finest examples of this tradition of leadership and creativity. In it, Wayne argued that the state of contemporary lithography was so dismal that a rescue effort was of high importance:

> *In the United States, the artisan-printer, never firmly rooted, and existing in minuscule numbers at best, now has all but vanished from the scene. The four or five that one might mention either no longer make lithographs, or do so in such financially uncertain (and therefore esthetically timid) circumstances as to be unable to maintain themselves, let alone extend the range of their craft. In certain techniques their skill-level at no time equalled that of the French artisans, and their esthetic immaturity repels those few mature American artists who could make use of and pay for the services of a master printer.*
>
> *A few American artists with the physical endowment and temperament to be their own printers have continued on in lithography. A few others manage somehow to breach the esthetic and economic barriers from time to time. But by and large lithography in the United States has fallen into disuse and disrepute, criticized and rejected by ill-informed artists, curators and collectors who suggest that the artist is too cozy to become a printer too. These persons forget that Toulouse-Lautrec, Vuillard, Bonnard, Renoir, Picasso, Miro and many others could not have made their superb lithographs without the participation of the artisan-printer.* [2]

Wayne, herself a noted lithographer, went on to state that public interest in all facets of the printed arts, the active market for prints of all media, the absence of cynicism of the type found in Europe pertaining to the making of lithographs, and the existence of foundations offering tangible support to artists in this country presented a favorable climate for the collaborative process to flourish.

From the beginning, the project had six goals:

> *1. Create a pool of master artisan-printers in the United States by training apprentices under one or more European master-printers imported for this purpose.*
>
> *2. Develop a group of American artists of diverse styles into masters of this medium.*
>
> *3. Habituate artist and artisan to intimate collaboration so that each becomes responsive and stimulating to*

FIG. 1 ■ June Wayne

the other in the work situation. Encourage both to experiment widely and extend the expressive potential of the medium.

4. Stimulate new markets for the lithograph.

5. Plan a format to guide the artisan in earning his living outside of subsidy or total dependence on the artist's pocket.

6. Restore the prestige of lithography by actually creating a collection of extraordinary prints.[3]

To accomplish these goals Wayne proposed the creation of Tamarind Lithography Workshop, Inc., a tax-exempt, non-profit corporation that would establish a model lithography studio in Los Angeles. In proposing this non-profit corporation Wayne followed the example of Margret Lowengrund, who altered the tax status of The Contemporaries Gallery in 1956 by entering into association with Pratt University so as to attract private financial support. Yet, unlike Lowengrund, Wayne refused to associate with a university for fear that "*The program promptly would suffer from conflict of interest between the student-oriented school, and the intense, round-the-clock, maximum effort workshop geared to mature professionalism. Furthermore, an independent corporation would be able to cut across groups, styles, and regions to be national in outlook and character.*"[4] While Lowengrund's Contemporaries Gallery, renamed Pratt Graphic Art Center in 1957, was interested in providing artists as well as the uninitiated with experiences in all forms of graphic production and emphasized the exposure of the artist to new techniques in printmaking, Tamarind was conceived as an institution devoted solely to lithography and to the creation of a corps of printers, trained in the collaborative

FIG. 2 ■ Wilson McNeil Lowry. ©Ford Foundation, 1973

process, who could carry the lithographic craft throughout the United States. No fewer than two artists at a time (eight to twelve annually) were to be offered two-month positions at the workshop (and a stipend of $1,000) based not only on the quality of their work but on their potential ability as printmakers. Their names were to be submitted to Tamarind's Director by a national panel of print experts and were to be selected along with two apprentices to be trained as printers. Both artist and apprentice were to work with a master printer brought in from Europe.[5]

Wayne had other plans for Tamarind, not the least of which was that within the first eighteen months of operation a satellite workshop on the model of the one in Los Angeles was to open in New York. She was also concerned about the fiscal stability of artists and artisans, and she hoped to exhibit and create a market for prints produced in the workshop, and ultimately propagate interest in lithography through collaboration with college and university art departments. Also part of the original conception of Tamarind, as proposed to the Ford Foundation, were a number of other goals: the establishment of a code of ethics governing the limiting of editions and the nature of collaboration; the development of further support for artists, possibly from the commercial lithography, paper or ink industries; the development of relationships with corporations, museums, and galleries to expand the market for lithography; and the creation of a plan for the enhanced business acumen of future print workshops.

It is testimony to the perseverance and independence of the Ford Foundation in the late 1950s and 60s, and in particular, of Wilson McNeil Lowry, Director of the Ford Foundation's Program in the Humanities and the Arts, that Tamarind found a sympathetic reception. Indeed, Lowry's interest in Wayne's ideas prompted the inception of the proposal to the Foundation. Of the twenty-seven noted specialists in the field of printmaking including, Fritz Eichenberg,

Josef Albers, Will Barnet, Ebria Feinblatt, Gustave von Groschwitz, Arthur Heintzelman, Harold Joachim, Una Johnson, William S. Lieberman, A. Hyatt Mayor, Dorias Meltzer, Elizabeth Mongan, Andrew Ritchie, Lessing Rosenwald, Ben Shahn, Benton Spruance, James Johnson Sweeney, Frederick S. Wright and Carl Zigrosser, asked to review the proposal only a small minority gave it support. Many believed that the status quo was acceptable, that training the artist was more important than training in technique, that collaboration was unnecessary and artists should do their own printing, that transplanting a European printer to teach in the United States was a project doomed to failure, and that in any case, New York was the only logical place for such a program. Others, pointing in particular to the life of Rembrandt, suggested that printmaking was either for the young, unknown artist or the artist in decline, never for the artist in his or her prime. A few believed that sending the very best artists to Europe to study was more logical, that the project was too expansive and should be more narrowly defined or that association with a university or museum would insure adequate administration of the program and its proper fiduciary care. A few, however, curators like Joachim, Feinblatt and von Groschwitz, dealers like Meltzer, artists like Barnet, museum directors like Wright, and others, strongly supported the proposal.[6]

While the Ford Foundation acknowledged the controversial nature of the proposal, it strongly supported the creation of Tamarind as a project that would meet the objectives of the Foundation:

> *A principal objective of the Foundation's current program in the arts is to help to set standards and to open new avenues. In its interests in the graphic arts, the program is no more concerned with lithography than with intaglio etching or woodcut printing. The latter two media of printmaking, however, do not present the critical problems in technical resource affecting lithography, a medium that has often produced artistic masterpieces in Europe and which did so in the United States in the era of Bellow [sic]. The program recommended is seen by Mrs. Wayne and one or two other devoted lithographers as potentially raising the prestige of lithography to the level of oil painting in the United States, although the program is not recommended on this assumption. The staff expects two objectives to be met: (1) the creation of a small pool of lithographic printers in the United States, and (2) the creation of a collection of fine lithographs by American artists. Whether the second result would also ensure continuing economic stability to the new master printers upon the American scene cannot now be accurately estimated.[7]*

The Foundation awarded Tamarind a three-year, $165,000 grant to establish its program. Interestingly, the Foundation concurrently awarded a grant of $21,000 to the Pratt Graphic Art Center for the purposes of attracting a European lithographic printer to the workshop during the same three year period. While for Pratt this was a means of expanding support and programs, the Foundation's perspectives were different. In awarding the grant to Pratt, it was hoped that this would be the first stage in a collaboration between the two institutions that would result in the fulfillment of Tamarind's goal of having a New York venue for their training program.[8] The Ford Foundation realized that Pratt was essentially a very different organization. Devoted to the education of artists in printmaking, as well as to an intense continuing educational program in printmaking open to almost anyone who wanted to participate, Pratt Graphic Art Center was also struggling to define its relationship to its parent, Pratt Institute. The Foundation agreed with Wayne that the Tamarind program could not be assigned to a university or college because "*...master printers can-*

not be produced from student apprentices, and an institution devoted to more general objectives could not provide the necessary concentration upon the man who is artist, entrepreneur, and laborer at one and the same time."[9] It therefore added the proviso to the Pratt grant that the European printer was to be made available to mature artists and not solely to students or those newly arrived to the field.

The varying issues faced by Tamarind, Pratt and the Ford Foundation in 1959 laid the basis for the experimentation and diversity as well as some of the difficulties that non-profit and university-affiliated workshops were to have in the next three decades. The problem of university affiliation is one that would be confronted throughout the period. It was not unusual for print workshops to be associated with institutions of higher learning. At the time of the Tamarind request John Paul Jones's graphic workshop at the University of California, Gabor Peterdi's at Yale and Mauricio Lasansky's at the University of Iowa were all in existence. While most of these were intaglio presses led by artists trained at Atelier 17, they were fundamentally different from Tamarind as each was predominantly a university art program geared to students. Tamarind's goal of the production of a significant body of printed work from predominantly established artists, its aspiration to have a major impact on the market for prints and to insure that these prints were exhibited and sold to an ever increasing audience, its emphasis on research and its lack of student involvement were distinct departures from these intaglio workshops.

Though it was associated with a university, Pratt also served as a model of a different type for a non-profit printmaking facility. As its relationship to students and curricula was not central to its purpose, it functioned essentially as a contract printing shop inviting well known artists to print while remaining accessible to students. While some prints remained at Pratt, forming a quasi-archive, Pratt Graphic Art Center was not involved with marketing and generated little income from sales. As such, Pratt was never the creative hybrid of free enterprise, philanthropy, research and education that was envisioned for Tamarind. Yet both were potent educational forces yielding considerable public appreciation and comprehension of the expressive potential of prints. The non-profit status of both, however, pointed to the inability of the market to support such educational endeavors and the limited access many artists had to collaborative print facilities.

While Tamarind and Pratt both successfully attained their original goals of propagating interest and appreciation for prints, each developed in a manner reflecting their separate sources of income, leadership and intellectual and aesthetic concerns. In their similarities and differences both had an impact on the direction and scope of later non-profit and university-affiliated print shops. Both provided many artists with their first experiences in printmaking. Lowell Nesbitt, Adolph Gottlieb and Philip Pearlstein began their printmaking careers at Pratt while Philip Guston, Jack Tworkov, Elaine de Kooning and Robert DeNiro first went to Tamarind to experiment with lithography. Both engaged in extensive but vastly different publications programs. Pratt began *Artist's Proof* in 1961. Conceived and edited by Fritz Eichenberg, the magazine presented articles on the history of prints, the recollections of artists, and the presentation of artists' portfolios. Once *Artists Proof* ceased publication, Pratt began *Print Review* under the editorship of Andrew Stasik, Pratt's director since 1966. A more scholarly publication, *Print Review*, published articles by leading scholars on the history of prints, sometimes producing whole issues devoted to individual artists. Tamarind, being principally a research institute, published a manual on the selling of prints, an economic survey to assist publishers in establishing their own operations, and a series of "fact sheets" covering technical data on the conservation, presentation, display and storage of litho-

graphs. Both institutions presented lectures as well as exhibition programs. While Tamarind exhibited works created in its own shop, Pratt became a veritable 'kunsthalle' for the presentation of a wide variety of exhibitions on aspects of the history of prints, their political and social nature and on the ethnic diversity inherent in print production. These exhibitions would subsequently circulate to museums and libraries throughout the country.[10]

Here, however, many of the similarities of these two important institutions ended. Pratt, although originally endowed by the Rockefeller Foundation, never had the depth of funding that Tamarind had. While many of its projects were supported by corporate gifts and memberships, and while fundraising programs were undertaken, money was always a problem. Moreover, the Graphic Art Center's relationship with Pratt Institute, and with the students and faculty of its graphic arts program, was always problematic. There were objections raised to the location of the workshop in Manhattan rather than on the same campus in Brooklyn as the Institute itself, and the level of support that could be expected from the financially plagued school was never high. Obstacles to Pratt's existence eventually proved insurmountable. In 1986, after a series of funding cutbacks from the Institute, Pratt Graphic Art Center closed its doors.

While support from foundations, fees from contract printing, income from publications and fundraising efforts could not, in the final analysis, save Pratt, Tamarind survives. Rarely have other print shops enjoyed the level of funding that Tamarind received from the Ford Foundation. The initial $165,000 grant was renewed in 1962 for $400,000, in 1964 for $900,000, and again in 1970 for $705,000, the last two times each for a period of four to five years. With each renewal, Tamarind expanded its program, took on new initiatives, and reanalyzed its existing programs with an eye to improvement and to making additional contributions to the understanding of lithography.

Whereas Tamarind never fully shed its reservations about the university system, it discovered early in its history that part of its purpose could be achieved off-site through an association with students trained by Garo Antreasian, its first master printer and a professor at the Herron School of Art, and subsequently with students of Antreasian and Clinton Adams at the University of New Mexico. The final request for support to the Ford Foundation was to assist in the transformation of the Tamarind Lithography Workshop, Inc. to the Tamarind Institute of the University of New Mexico where it resides today. In so doing, Tamarind sought both to stabilize its funding base and to develop a comprehensive center for training in the creation, curation, selling, displaying and teaching of lithography. Its audience was to be artists, printers, dealers, curators, those in business and others from throughout the general public who could foster the creation of and appreciation for prints. Today, while few of the original founders are involved to the degree that they were thirty years ago, Tamarind is one of the most stable of printmaking facilities. Funding from the University of New Mexico accounts for approximately one third of its annual budget, while its remaining income is generated by the sale of its published prints and contract printing. As a research institute within the university, Tamarind functions relatively independently, but it does offer courses for graduate students in collaborative lithography.[11] It has trained scores of technically proficient printers, many of whom originally began as artists and have turned their attention to the printer's side of the process. These graduates of the Tamarind program, in turn, have spawned numerous other lithography workshops throughout the country and fostered some of the most successful collaborations in print history. The presence of strong ideological leaders throughout its history (Wayne, Adams, Antreasian), the commitment of a secure financial base (from Lowry and the Ford Foundation), and the association with a large educational institution whose relationship to it is dictated through contractual obligations have been essential to Tamarind's success.

Of the many university-affiliated presses in the United States, Graphicstudio at the University of South Florida in Tampa stands as one of the most significant and representative of some of the assets and problems inherent in the university-affiliated structure. Unlike Pratt, which associated with a university institution for financial reasons but never fully defined its role there, or Tamarind, which gradually evolved into a university structure, Graphicstudio was conceived from the outset as a research institution within the University of South Florida. Like them, however, Graphicstudio was conceived and guided in its early history by the force of a singular personality, Donald Saff, chair of the visual arts department and dean of the College of Fine Arts at the University of South Florida when the studio was founded in 1968. Like Tamarind, where Clinton Adams held similar positions at the University of New Mexico, Graphicstudio benefitted from the administrative expertise of its leadership.[12] As Saff put it, "If one believed in the value of art, one believed in its value to teach; and it was just as good as another professor standing in front of the class pontificating...The object was to fund this teaching process through the same procedure that you would fund a faculty member except divert the funds into salaries for technicians and consultants and the purchase of ink and paper..."[13]

Saff wanted Graphicstudio to be independent of the structured academic environment, and to create an exciting, informative but informal atmosphere for the students and faculty. The workshop originally occupied a converted class-

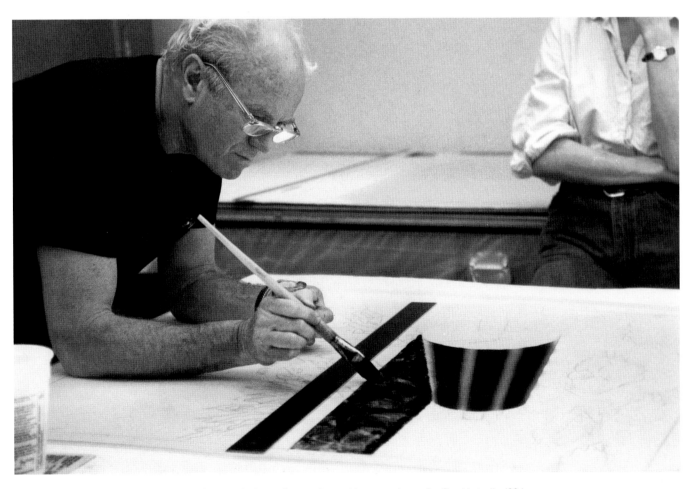

FIG. 3 ▪ Artist James Rosenquist working on an image for Graphicstudio, 1994

room and was funded by a patchwork of small income sources. Grants from the Florida Arts Council and the National Endowment for the Arts, a subscription to the prints published by the studio, and a loan from a private collector were all essential to the studio in its early years. The most important aspect of funding was the establishment of prices for the prints expected to be published and sold to subscribers.

Originally, Saff's conception for Graphicstudio was that artists should come and work there for short periods of time. As the program developed, as projects acquired greater complexity, and as the name of the workshop became more widely respected, the length of residency increased. In what is now known as the first stage in Graphicstudio's history, the period between 1968 and 1976, an astonishing number of important artists produced prints there, including Robert Rauschenberg, Philip Pearlstein, Arakawa, James Rosenquist, and Adja Yunkers.

Despite these successes, Graphicstudio suffered from the same ailment that killed Pratt. While its independence benefited the artists, it prevented the development of a symbiotic relationship with the university. The market-driven nature of the selection of artists, the lack of formal academic ties to the university, the absence of a firm financial commitment on the part of the university to the studio, and a gap in understanding the nature of the education and research that occurs at a collaborative press led to the closing of Graphicstudio in 1976.

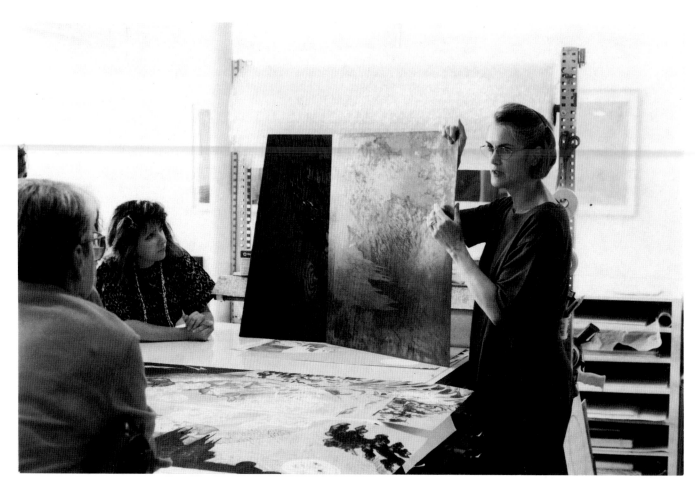

FIG. 4 ▪ Students at Echo Press with Pegram Harrison, Echo Press Director

Graphicstudio was resurrected in 1980 with a grant from the Florida legislature. Headed by the chair of the Art Department and the director of the university art gallery and advised by Saff, the studio's new mission included developing closer ties to the students and faculty of the university. The engagement of more students in creative work at the studio, a new system of student internships, the involvement of guest artists in the academic program, the teaching of printmaking courses, the emphasis on the exhibition and acquisition of works produced at the studio by the university art museum, and the integration with other divisions of the university as research needs arose, all helped to make the concept of a university research center/collaborative press a reality. Since its rebirth, Graphicstudio has followed in the footsteps of Tamarind by firmly establishing itself within the university through its commitment to the dual missions of teaching and research. At the same time it has secured support through an annual legislative allocation. Today, while Graphicstudio is about to be placed under the administration of the College of Fine Arts, it remains a vital, independent center at the University of South Florida, its budget equally split between income derived from the state and from the sale of published works. Its strength lies as much in the quality of its resident artists as in its ties to the university.

Echo Press is another prestigious collaborative workshop associated with a major university, which like Graphicstudio, arose from the strengths of the university itself. Founded at Indiana University in 1979, Echo came into existence as a result of the presence of several key individuals on the faculty and a history of interest in prints at the university museum. Rudy Pozzatti, a teacher at Indiana since 1956, had been a resident at Tamarind in 1963 and had later printed at Il Torcoliere and at Landfall Press, where he had met David Keister, Landfall's master printer for three years. In 1976, Keister came to Indiana University to pursue an MFA in printmaking and photography. Pozzatti gives credit to his conversations with Keister, the interest of Professor Diether Thimme of the Fine Arts Department, the long tradition of teaching both printmaking and its history within the department and of the collecting of prints at the Indiana University Art Museum for the inception of a collaborative workshop on campus.[14] From its beginnings, Echo fostered an environment in which it was possible to develop close, long-term relationships between artists that would greatly encourage innovation. While many on the faculty published editions at the press, Echo, like Graphicstudio and Tamarind, was meant to function as an independent research institute. Both established artists and emerging younger artists from throughout the country were to avail themselves of the expertise of the press's collaborative environment, to have their ideas given fruition, and to have the language of the print matched with the expressive language of the artist.

Echo Press was to be financed by the Indiana University Foundation and from the sale of works published at the press. While Foundation revenue was on solid ground, and as long as there was an enthusiastic market for prints this partnership of philanthropy and entrepreneurship worked well. For the university, the presence of the press on campus with its diversity of talent, the opportunity for students and faculty to experiment in collaboration, the lectures, tours, and presentations made to students by press staff and guest artists, and the production of printed work that would be a significant addition to the history of prints was justification enough to support the existence of an endeavor such as Echo.

Echo, like many presses, exemplifies the paradigm of success bridled by difficult financial times. As Echo entered the 90s, at the very moment that it reached a plateau of excellence and national prominence, as its facilities expanded and as its administrative costs grew, grant money grew scarce and the market for prints collapsed. Recent collaborations

with artists such as Sam Gilliam, Miriam Schapiro, Dennis Kardon, and Steve Sorman have produced an impressive body of work at Echo. In 1993, however, the university informed Echo that their annual allocation, approximately one third of their budget, was to be eliminated. With a one year period of grace before all funding is withdrawn, Echo is being asked to become more entrepreneurial and to develop a greater expertise in fundraising. In part, the dilemma faced by Echo is no different than that encountered by Graphicstudio. The years in which Echo's relationship with a structured academic program were deliberately kept informal created an environment in which it was easy for the university to reduce support in economically difficult periods. Echo's future is endangered, in great part, by the existence of the very factors that made it a success. As Echo takes on additional activities both to make it more indispensable to the university and to insure its income stream, it has fears of losing its quality.

Many university presses throughout the country have become key to educational programs while producing significant work. Normal Editions at the University of Northern Illinois, Tandem Press at the University of Wisconsin-Madison, The Center for Innovative Printmaking at Rutgers University, and the Print Research Facility at Arizona State University are among many examples of university-affiliated collaborative presses organized in the last twenty years as educational, research and printmaking facilities. Each has, in its own way, responded to the needs of printmaking as well as to the specific needs of its parent organization. Each has extended the boundaries of collaboration and education.

Another formula for the structuring of a non-profit collaborative workshop during this period now known as the American Print Renaissance is the Printmaking Workshop in New York. Founded by the now legendary Robert Blackburn, the Printmaking Workshop is one of the oldest artist-directed studios in the country. A recipient of the prestigious MacArthur Prize, Blackburn is a product of both the profit and non-profit print worlds. Like many who established workshops in the early fifties, he trained at Hayter's Atelier 17, before that learning his craft at the Harlem Community Arts Center (a W.P.A. project), the Uptown Community Workshop, and the Art Students League in New York. Originally opened in 1948 as Bob Blackburn's Creative Graphics Workshop, the facility provided a concentration on lithography through classes and an open studio for printing and experimentation. Blackburn left the workshop for a number of years to study in France as a Whitney Fellow, served as Master Printer at the National Academy of Design, and as instructor of graphics at the New School for Social Research, and was master printer for ULAE for five years beginning in 1957. Along the way, Blackburn developed a reputation both as an extraordinary printer and for enticing many to attempt their first work in the collaborative process.[15] *"Each artist,"* wrote Blackburn, *"is a distinctly different individual. You cannot take the same yardstick for Jasper and apply it to Rauschenberg. I think that it is so important to preserve the creative identity of the artist. It is the marriage of the printer's expertise with the creative energy of the artist that makes the fine print."*[16]

Blackburn returned to his Printmaking Workshop in 1962. Six years prior, however, due to a shortage of funds, the workshop had become a cooperative, enforcing an annual fee for use of its facilities in which artists and printers could collaborate. With the closing of Atelier 17 in New York in 1955, intaglio printing capabilities were added to the workshop to provide for a more comprehensive printmaking environment, yet a lack of funding continued to be problematical. In 1971, following in the footsteps of Lowengrund's and Wayne's workshops, Blackburn's Printmaking Workshop was incorporated as a non-profit organization so as to qualify for federal, state and local grants as well as contributions from foundations, corporations and individuals.

Regardless of its financial difficulties, the Printmaking Workshop has established one of the most remarkable educational, exhibition and printmaking facilities anywhere. Not formally associated with other educational institutions, the workshop has chosen instead to serve as an educational resource to a variety of individuals and schools throughout the city of New York. Like Tamarind and Pratt, Blackburn's workshop has trained numerous printers who have gone on to develop their own printmaking facilities. Like those presses also, it has invited both well known and emerging artists, and specifically artists of color, to the press to learn the various print processes. Thus, the workshop has supported many in their quest to define a new terrain for themselves, to gain an exposure to the collaborative process and to have an opportunity to experiment, to introduce new visions to those as dedicated to printmaking as Blackburn himself. Blackburn's workshop begs comparison to the printshops of the WPA, where Blackburn himself studied, and it needs hardly to be stated that the experiences that one can have there are hard to find at established, for-profit presses. As Blackburn put it, *"Probably the next strongest experience of the collaborative effort came out of my desire and need to establish a workshop for artistic lithography. This occurred as a direct result of discrimination and exclusion of the Black artist from the creative activities of the established male-dominated, white art world. At that time, one could not separate life in Georgia, Mississippi, Texas and Louisiana—American life in general—from the world of the arts, printmaking and teaching."*[17]

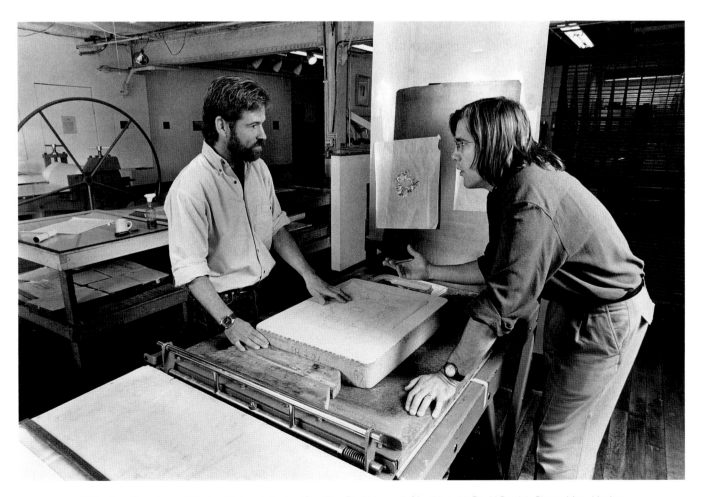

FIG. 5 ▪ Director and Master Printer at Anchor Graphics, David Jones (left) with artist David Russick. Photo: Mary Hanlon

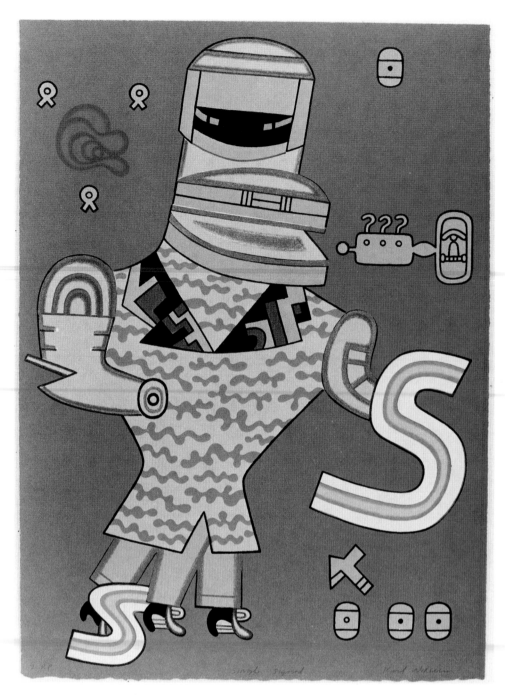

FIG. 6 ▪ KARL WIRSUM ▪ *SINGLE SIGNED*
1994. Lithograph. Printed at Anchor Graphics, Chicago. Photo: Mary Hanlon

In Blackburn's desire to make the knowledge and appreciation of printmaking accessible to an ever greater audience, to make facilities available to those outside of the mainstream, and to communicate his extraordinary wealth of knowledge to anyone capable of enriching the medium, and also in maintaining an interest in the exhibition of printed work, he reflected the goals of both Tamarind and Pratt. In directing such desires to artists of color, and in integrating itself with underserved populations throughout New York City, the Printmaking Workshop established a unique direction and scope for a non-profit workshop. Senior citizen centers, day care centers, public schools, museum educational programs, community centers and a host of other inner city programs and locations have benefitted from the Workshop's outreach, which has introduced people of all ages to printmaking, its processes and its expressive potential.

The heritage of education, of offering many people their first opportunity to make prints, and of a concern for the quality of both the experience and the art produced in the collaborative process has brought about the development of non-profit workshops far outside of New York. Lamenting some of the developments in printmaking in recent years, Blackburn wrote in a 1990 exhibition catalogue:

"Very few of the newer shops seem so motivated, but I am certain that many printers have felt this extreme fire of collaboration. Perhaps the difference in time and the extreme need for financial rewards have pushed some of the dream aside. Also, I think the number of highly skilled printers, assistants, and publishers has sometimes exacted a toll upon the artist. Instant gratification has taken over the spirit of love and search and trust in the artist. We cannot lament the decline of the old, but we can hope that the young printers and studios will see the wisdom of retaining some of these old values." [18]

One such non-profit studio that follows in the spirit of Blackburn's Printmakers Workshop is Anchor Graphics in Chicago. Founded in 1988 by David Jones, a former artist/printer at Landfall Press, Anchor is a multi-faceted, non-profit studio integrating the teaching and promotion of printmaking within a professional collaborative workshop, accompanied by a small gallery. While Blackburn's Printmaking Studio is more national in scope in terms of the artists who print there, Anchor concentrates on both established and emerging artists in the Chicago region (David Russick, Michiko Itatani, Hollis Sigler and Karl Wirsum, as examples). Like the New York workshop, however, Anchor is concerned with the production of technically proficient and aesthetically significant works yet maintains an innovative educational program integrating its studio, artists and printers with various aspects of the community. Classes offered throughout the year, open studio sessions with guest artists, internships for undergraduate students at nearby universities, workshops in printmaking offered to teachers through the Department of Museum Education at the Art Institute of Chicago, exhibits of the prints of regional artists accompanied by opening lectures given by the artists, and an extensive program offered to High School students during the summer months in cooperation with the Marwen Foundation have extended the definition of accessibility and education that was so firmly established by Blackburn in New York.

Anchor's non-profit status allows it to accept individual donations and governmental grants and to run an annual fundraising benefit. Its budget is supplemented with fees from contract printing, studio rentals, and sales from a newly instituted subscription program. Without a secure base of support from a large umbrella organization (such as Tamarind has from the University of New Mexico) this type of financial structure, with an array of income sources, becomes an absolute necessity.

There are numerous other small, non-profit, unaffiliated workshops throughout the country that maintain similarly innovative approaches to the study of printmaking and to developing a rapport with various aspects of the community, and that often direct their energies to providing access to minority artists. The Women's Studio Workshop, founded in 1979 in Rosendale, New York, offers grants to artists in papermaking and in various forms of printmaking, summer courses for adults and cooperative programs with regional public schools, and also presents exhibitions. The Brandywine Workshop in Philadelphia, formed by Allan Edwards in 1972, made printmaking and the collaborative process accessible to a culturally diverse audience through a series of opportunities for minority artists. [19] Pyramid

Atlantic, formed in 1981 by Helen Frederick and now located in Riverdale, Maryland, began as a studio for various arts related to book manufacture, such as papermaking and printmaking. Workshops, lectures, performances, summer institutes, joint programming with Washington area museums, internships for college students, residencies, apprenticeships and a host of other programs complement its efforts at training artists in collaborative print processes.[20] The Taller Mexicano de Grabado, founded in Chicago's predominantly Mexican/Latino neighborhood of Pilsen in 1990, is dedicated to fostering the rich Mexican tradition of printmaking. Classes, contract printing, joint programs with other community arts organizations, and an exhibition program exemplify the activities that have come to characterize the small, non-profit workshop in the last twenty years.

Non-profit and university-affiliated presses have played an integral role in the development of collaborative printmaking in this country. Presses of both types have attempted to provide an environment in which experimentation, collaboration and emerging technologies can be merged with artistic vision and instinct. Tamarind, Pratt, Echo, Graphicstudio, the Printmaking Workshop, and many of the other non-profit and university-affiliated workshops proudly point to technological advances made in their studios that have significantly expanded the potential of the various printmaking media. As each functions in great part as a research center, the communication of these advances to a broad audience has been one of their principal *raisons d'être*. Their influence, however, has gone beyond technological innovation. As educational resources, as centers of artistic accessibility, and as organizations devoted to communication, their influence has been both immediate and oriented towards the future. While the nature of many of these organizations insures that the quality of artistic production varies, and while they often suffer challenging financial setbacks, they have offered many the opportunity to explore the vast potential of printmaking in a manner that the profit-oriented presses cannot. As we approach the end of this century, changes in the demands of higher education, in the ability to raise significant resources for non-profit art organizations, and in the market for contemporary prints will insure that non-profit and university-affiliated workshops will continue to metamorphosize into different and more challenging structures with greater business and marketing acumen, fundraising skills, and educational prerogatives.

Notes

1. June Wayne, *Proposal for the Planning and Development for Tamarind Lithography Workshop, Inc.*, July, 1959, p. 25. Ford Foundation Archives, Report #60–119.

2. June Wayne, *Proposal for the Planning and Development for Tamarind Lithography Workshop, Inc.*, July, 1959, p. 9–10. Ford Foundation Archives, Report #60–119.

3. June Wayne, *Proposal for the Planning and Development for Tamarind Lithography Workshop, Inc.*, July, 1959, p. 13. Ford Foundation Archives, Report #60–119.

4. June Wayne, *Proposal for the Planning and Development for Tamarind Lithography Workshop, Inc.*, July, 1959, p. 15. Ford Foundation Archives, Report #60–119.

5. This aspect of the program proved to be impossible to execute. The issue of a master printer was resolved through the ensuing relationship between Tamarind and Garo Antreasian from the Herron School of Art who became Tamarind's first master printer.

6. All letters from those individuals asked to review Wayne's proposal are located in the Ford Foundation Archives, Report #60–119.

7. Recommended action to the Board of the Ford Foundation from the Program of Humanities and the Arts, p. 4, September 24, 1959. Ford Foundation Archives, Report #60–119.

8. Recommended action to the Board of the Ford Foundation from the Program of Humanities and the Arts, p. 4, September 24, 1959. Ford Foundation Archives, Report #60–119.

9. Recommended Action to the Board of the Ford Foundation from the Program of Humanities and the Arts, p. 3, September 24, 1959. Ford Foundation Archives, Report #60–119.

10. For more information on the activities of Pratt see, Amy Slaton, "Pratt Graphics Center: 1956–1981," *Print Review*, XIII, 1981, 15–24.

11. Conversation between this author and Marjorie Devon, current director of Tamarind, September 29, 1994.

12. Additional support was to be found in the former chair of the department of fine arts and, in 1968, Associate Dean of the College of Liberal Arts, Harrison Covington. Ruth E. Fine and Mary Lee Corlett, *Graphicstudio: Contemporary Art from the Collaborative Workshop at the University of South Florida*, National Gallery of Art, Washington D.C., 1991, p. 14–15.

13. *Ibid.,* p. 14.

14. Rudy Pozzatti, "The History of Echo Press," *Echo Press: A Decade of Printmaking*, Indiana University Art Museum, Bloomington, Indiana, 1990, p. 9–18.

15. For a more detailed discussion of the history of the Printmaking Workshop, see Nina Parris, *Through a Master Printer: Robert Blackburn and the Printmaking Workshop*, the Columbia Museum, Columbia, South Carolina, 1985 and Noah Jemison, *Bob Blackburn's Printmaking Workshop: Artists of Color*, Hillwood Art Museum, Brookville, New York, 1992.

16. Nina Parris, *Through a Master Printer: Robert Blackburn and the Printmaking Workshop*, the Columbia Museum, Columbia, South Carolina, 1985, p. 3.

17. *Printers' Impressions*, the Albuquerque Museum, Albuquerque, New Mexico, 1990, p. 5.

18. *Printers' Impressions*, the Albuquerque Museum, Albuquerque, New Mexico, 1990, p. 7.

19. Jan Howard, *Pyramid Atlantic and Brandywine Workshop Print Show*, Maryland Art Place, Baltimore, Maryland, 1989.

20. Joann Moser, "Paper Alchemy at Pyramid Atlantic," *Hand Papermaking*, VIII, 1, Summer 1993.

EXHIBITION CHECKLIST

Measurements represent overall sheet size.

1. LARRY RIVERS
born New York, NY 1923
Jack of Spades, 1960
Lithograph on Rives BFK paper
Edition of 35 with 1 artist's proof
Size: 107.7 × 76.0 cm.
Printed by R. Blackburn at Universal Limited Art Editions
Published by Universal Limited Art Editions, West Islip,
New York
The Art Institute of Chicago: ULAE Collection, Challenge grant
of Mr. and Mrs. Thomas Dittmer; Restricted gift of supporters
of the Department of Prints and Drawings; Centennial
Endowment, 1982.255, photograph copyright 1994, The Art
Institute of Chicago, All Rights Reserved. Copyright 1995 Larry
Rivers/Licensed by VAGA, New York, NY

2. ADJA YUNKERS
American, born Latvia 1900–1983
Untitled V, from *The Skies of Venice*, a suite of ten
lithographs including title page, 1960
Lithograph on Rives BFK paper
Edition of 10 with 3 artist's proofs
Size: 105.1 × 74.3 cm.
Printed by B. Horak at Tamarind Lithography Workshop
Published by Tamarind Lithography Workshop, Los Angeles
The University of New Mexico Art Museum; the Tamarind
Archive Collection, #74.447.9.5, Photo by: Damian Andrus

3. JIM DINE
born Cincinnati, OH 1935
An Informal Tie, 1961
Drypoint with handcoloring on Rives BFK paper
Edition of 10
Size: 101.0 × 66.0 cm.
Printed by Pratt Graphic Art Workshop, New York
Published by Martha Jackson Gallery, New York
The Art Institute of Chicago, Restricted gift of Mr. and
Mrs. Gene R. Summers and Mr. and Mrs. Joseph Lo Giudice,
1969.48, photograph copyright 1994, The Art Institute of
Chicago, All Rights Reserved

4. RICO LEBRUN
American, born Italy 1900–1964
Grunewald Study, 1961

Lithograph on Rives BFK paper
Edition of 20 with 3 artist's proofs
Size: 62.4 × 77.4 cm.
Printed by B. Horak at Tamarind Lithography Workshop
Published by Tamarind Lithography Workshop, Los Angeles
National Museum of American Art, Smithsonian Institution,
Gift of Dr. and Mrs. Seymour Dubroff

5. GRACE HARTIGAN
American, born 1922
Pallas Athene, 1961
Lithograph on Arches Satine paper
Edition of 30 with 1 artist's proof
Size: 76.4 × 56.7 cm.
Printed by R. Blackburn at Universal Limited Art Editions
Published by Universal Limited Art Editions, West Islip,
New York
The Baltimore Museum of Art: Gift of Gertrude Kasle, Franklin,
Michigan BMA 1988.146

6. JASPER JOHNS
born Augusta, GA 1930
False Start I, 1962
Lithograph on Rives BFK paper
Edition of 38 with 6 artist's proofs
Size: 76.7 × 56.5 cm.
Printed by R. Blackburn at Universal Limited Art Editions
Published by Universal Limited Art Editions, West Islip,
New York
The Art Institute of Chicago: ULAE Collection, Challenge grant
of Mr. and Mrs. Thomas Dittmer; Restricted gift of supporters
of the Department of Prints and Drawings; Centennial
Endowment, 1982.941, photograph copyright 1994, The Art
Institute of Chicago, All Rights Reserved, Copyright 1995 Jasper
Johns/Licensed by VAGA, New York, NY

7. ROBERT RAUSCHENBERG
born Port Arthur, TX 1925
Accident, 1963
Lithograph on Rives BFK paper
Edition of 29 with 4 artist's proofs
Size: 97.8 × 69.2 cm.
Printed by R. Blackburn and Z. Priede at Universal Limited
Art Editions
Published by Universal Limited Art Editions, West Islip,
New York
The Art Institute of Chicago: ULAE Collection, Challenge grant
of Mr. and Mrs. Thomas Dittmer; Restricted gift of supporters
of the Department of Prints and Drawings; Centennial
Endowment, 1982.1122, photograph copyright 1994, The Art
Institute of Chicago, All Rights Reserved, Copyright 1995
Robert Rauschenberg/Licensed by VAGA, New York, NY

8. BARNETT NEWMAN
born New York, NY 1905–1970
Canto XVI, from *18 Cantos*, 1963–64
Lithograph on Angoumois à main paper
Edition of 18
Size: 45.4 x 34.3 cm.
Printed by Z. Priede at Universal Limited Art Editions
Published by Universal Limited Art Editions, West Islip,
New York
The Menil Collection, Houston, Photo by: George Hixson,
Houston. Reproduced courtesy of Annalee Newman insofar as
her rights are concerned

9. JOSEF ALBERS
American, born Germany 1888–1976
Untitled (Midnight and Noon V), from
Midnight and Noon/Homage to the Square, a suite
of eight lithographs plus title and colophon pages, 1964
Lithograph on Arches white paper
Edition of 20 with 3 artist's proofs
Size: 48.0 x 52.1 cm.
Printed by K. Tyler at Tamarind Lithography Workshop
Published by Tamarind Lithography Workshop, Los Angeles
The University of New Mexico Art Museum, the Tamarind
Archive Collection, # 74.447.614.5, Photo by: Damian Andrus

10. JOSEF ALBERS
Untitled (Midnight and Noon VI), from
Midnight and Noon/Homage to the Square, a suite
of eight lithographs plus title and colophon pages, 1964
Lithograph on Arches white paper
Edition of 20 with 3 artist's proofs
Size: 48.0 x 52.1 cm.
Printed by K. Tyler at Tamarind Lithography Workshop
Published by Tamarind Lithography Workshop, Los Angeles
The University of New Mexico Art Museum, the Tamarind
Archive Collection, # 74.447.614.6, Photo by: Damian Andrus

11. JOSEF ALBERS
Untitled (Midnight and Noon III), from
Midnight and Noon/Homage to the Square, a suite
of eight lithographs plus title and colophon pages, 1964
Lithograph on Arches white paper
Edition of 20 with 3 artist's proofs
Size: 48.0 x 52.1 cm.
Printed by K. Tyler at Tamarind Lithography Workshop
Published by Tamarind Lithography Workshop, Los Angeles
The University of New Mexico Art Museum, the Tamarind
Archive Collection, # 74.447.614.3, Photo by: Damian Andrus

12. WAYNE THIEBAUD
born Mesa, AZ 1920
Delights, 1964

Etchings, aquatints, and drypoints in a bound portfolio
of 17 prints
Edition of 100
Size: 32.7 x 27.4 cm. (each sheet)
Printed by K. Brown at Crown Point Press
Published by Crown Point Press, Oakland, California
National Museum of American Art, Smithsonian Institution,
Gift of Mr. Frank Lobdell, Copyright 1978, Wayne Thiebaud

13. RICHARD ANUSZKIEWICZ
born Erie, PA 1930
Diamond Chroma, from the portfolio *New York 10*, 1965
Screenprint on Beckett Vellum Finish paper
Edition of 200
Size: 55.8 x 43.2 cm.
Printed by S. Poleskie at Chiron Screen Print Company,
New York
Published by Tanglewood Press, Inc., New York
Rosa and Aaron Esman. Copyright 1995 Richard Anuszkiewicz/
Licensed by VAGA, New York, NY

14. ROY LICHTENSTEIN
born New York, NY 1923
Reverie (The Melody Haunts My Reverie), from *11 Pop Artists*
portfolio, Vol. I, 1965
Screenprint
Edition of 200 with 50 artist's proofs
Size: 76.5 x 60.9 cm.
Printed by Knickerbocker Machine and Foundry, Inc., New York
Published by Original Editions, New York
National Museum of American Art, Smithsonian Institution,
Gift of Philip Morris Incorporated

15. LEE BONTECOU
born Providence, RI 1931
Seventh Stone, 1965–68
Lithograph on Chatham handmade paper
Edition of 31 with 4 artist's proofs
Size: 63.3 x 50.8 cm.
Printed by F. Genis at Universal Limited Art Editions
Published by Universal Limited Art Editions, West Islip,
New York
The Jane Voorhees Zimmerli Art Museum, Rutgers—
The State University of New Jersey, Anonymous Gift,
Photo by: Victor Pustai

16. EDWARD RUSCHA
born Omaha, NE 1937
Mocha Standard, 1969
Screenprint on cream wove paper
Edition of 100
Size: 63.8 x 101.6 cm.
Printed by Cirrus Editions Workshop, Los Angeles

Published by the artist
Modern Art Museum of Fort Worth, Anonymous Gift
in Memory of Sam F. Cantey, III.

17. ROBERT RAUSCHENBERG
born Port Arthur, TX 1925
Booster, from the series *Booster and 7 Studies,* 1967
Lithograph and screenprint on Curtis Rag wove paper
Edition of 38 with 12 artist's proofs
Size: 182.9 × 90.2 cm.
Lithography printed by K. Tyler and R. Bigelow at Gemini
G.E.L.; silkscreen printed by J. Wasserman at Wasserman
Silkscreen, Santa Monica
Published by Gemini G.E.L., Los Angeles
Henry Art Gallery, University of Washington, Gift of Anne
Gerber, Acc. # 67.24.6, Copyright 1995 Robert
Rauschenberg/Licensed by VAGA, New York, NY

18. FRANK STELLA
born Malden, MA 1936
Star of Persia I, 1967
Lithograph on English graph paper
Edition of 92 with 9 artist's proofs
Size: 66.1 × 81.2 cm.
Printed by K. Tyler, J. L. Webb, Y. Samson, and O. Pereira
at Gemini G.E.L.
Published by Gemini G.E.L., Los Angeles
Walker Art Center, Minneapolis, Gift of Kenneth E. Tyler, 1985

19. ANDY WARHOL
born Cleveland, OH 1928–1987
Marilyn Monroe, 1967
Screenprint (from a portfolio of ten) on wove paper
Edition of 250 with 26 artist's proofs
Size: 91.5 × 91.5 cm.
Printed by Aetna Silkscreen Products, Inc./Du-Art
Displays, New York
Published by Factory Additions, New York
National Museum of American Art, Smithsonian Institution,
Museum purchase with the aid of funds from Mr. and Mrs. Jacob
Kainen and the National Endowment for the Arts, Copyright
1994, The Andy Warhol Foundation for the Visual Arts, Inc.

20. PHILIP PEARLSTEIN
born Pittsburgh, PA 1924
Two Nudes, 1969
Lithograph on Arches Cover cream paper
Edition of 40 with 4 artist's proofs
Size: 56.8 × 74.0 cm.
Printed by A. Stoeveken, Graphicstudio
Published by Graphicstudio, University of South Florida-Tampa
University of South Florida Collection, Courtesy of USF
Contemporary Art Museum, Tampa, Photo by: Dean Beasom

21. BRICE MARDEN
born Bronxville, NY 1938
Gulf, from the portfolio *New York 10/69,* 1969
Lithograph on smooth wove paper
Edition of 100
Size: 50.8 × 66.0 cm.
Printed by M. Knigin at Chiron Press, New York
Published by Tanglewood Press, Inc., New York
Rosa and Aaron Esman

22. TOM WESSELMANN
born Cincinnati, OH 1931
Nude (for SEDFRE), 1969
Screenprint on Strathmore smooth wove paper
Edition of 100
Size: 58.4 × 73.7 cm.
Printed by R. Loft at Chiron Press
Published by Chiron Press, New York, for the benefit of
Artists for SEDFRE (Scholarship, Education, Defense Fund
for Racial Equality, Inc.)
Museum of Modern Art, New York, Gift of the Artist, photo-
graph copyright 1994, Museum of Modern Art, New York
Copyright 1995 Tom Wesselmann/Licensed by VAGA, New
York, NY

23. WILLEM DE KOONING
American, born Holland 1904
Untitled (Large Sumi Brushstrokes), 1970
Lithograph on Japan paper
One of 3 or 4 signed proofs (not editioned)
Size: 130.8 × 92.0 cm.
Printed by F. Genis at Hollanders Workshop, New York
The Museum of Fine Arts, Houston, Gift of Mr. and
Mrs. Meredith Long

24. RED GROOMS
born Nashville, TN 1937
AARRRRRRHH, from *No Gas* portfolio, 1971
Three-dimensional lithograph on Arches Cover paper
Edition of 75
Size: 55.9 × 71.1 × 21.3 cm.
Printed by M. Guiffreda and M. Tabard at the Bank Street
Atelier, New York, New York
Published by Abrams Original Editions, New York
The Jane Voorhees Zimmerli Art Museum, Rutgers—The State
University of New Jersey, Class of 1921 Art Purchase Fund,
Photo by: Jack Abraham

25. RED GROOMS
No Gas Cafe, from *No Gas* portfolio, 1971
Lithograph on Arches Cover paper
Edition of 75
Size: 71.1 × 55.9 cm.

Printed by M. Guiffreda and M. Tabard at the Bank Street
Atelier, New York
Published by Abrams Original Editions, New York
The Jane Voorhees Zimmerli Art Museum, Rutgers—The State
University of New Jersey, Class of 1921 Art Purchase Fund,
Photo by: Jack Abraham

26. SOL LEWITT
born Hartford, CT 1928
Squares with a Different Line Direction in Each Half Square, 1971
Ten etchings on Rives BFK paper
Edition of 25
Size: 36.8 x 36.8 cm. (each)
Printed by K. Brown at Crown Point Press, Oakland, CA
Published by Parasol Press, Ltd., New York and The Wadsworth
Atheneum, Hartford, Connecticut
Wadsworth Atheneum, Hartford, Connecticut

27. BRUCE NAUMAN
born Fort Wayne, IN 1941
Raw-War, 1971
Lithograph on Arches paper
Edition of 100
Size: 56.5 x 71.7 cm.
Printed by Cirrus Editions Workshop, Los Angeles
Co-published by Castelli Graphics, New York and Nicholas
Wilder Gallery, Los Angeles
Cirrus Editions, Ltd., Copyright 1995 Bruce Nauman/Artists
Rights Society (ARS), New York, Photo by: William Nettles

28. ALAN J. SHIELDS
born Harrington, KS 1944
Sun/Moon Title Page or Pampas Little Joe, 1971
Double-sided lithograph, relief print, screenprint, and
collage with stitching
Edition of 100
Size: 66.0 x 66.0 cm.
Printed by W. Weege and G. Coniff, Jones Road Print Shop
Published by the Jones Road Print Shop and Stable, Barneveld,
WI, and Omar Space Corporation, New York
Madison Art Center, Purchase, Photo by: Angela Webster

29. CHUCK CLOSE
born Monroe, WA 1940
Keith, 1972
Mezzotint on Rives BFK paper
Edition of 10
Size: 129.6 x 105.4 cm.
Printed by K. Brown, Crown Point Press, Oakland, CA
Published by Parasol Press, Ltd., New York
The Brooklyn Museum, Gift of Mr. and Mrs. Henry Welt

30. WILLIAM T. WILEY
born Bedford, IN 1937
Coast Reverse (diptych), 1972
Lithograph on paper and chamois with handpainted additions
on Special Arjomari paper
Edition of 35 with 10 artist's proofs
Size: right panel (paper): 83.9 x 116.8 cm., left panel (chamois):
167.7 x 167.7 cm. (irreg.)
Printed by J. Lemon and A. Kleinman at Landfall Press, Inc.
Published by Landfall Press, Inc., Chicago, Illinois
Landfall Press, Chicago

31. ROBERT COTTINGHAM
born Brooklyn, NY 1935
Fox, 1973
Lithograph on Special Arjomari paper
Edition of 100 with 10 artist's proofs
Size: 58.4 x 58.4 cm.
Printed by D. Keister and T. Minkler at Landfall Press, Inc.
Published by Landfall Press, Inc., Chicago
National Museum of American Art, Smithsonian Institution

32. SAM GILLIAM
born Tupelo, MS 1933
Pink Horse Shoes, 1973
Screenprint with flocking and glitter on Arches Cover paper
Edition of 42 with 3 artist's proofs
Size: 45.1 x 63.5 cm.
Printed by W. Weege and L. Folgueras at the Jones Road Print
Shop and Stable, Barneveld, WI
Published by the Barbara Fendrick Gallery, Washington, D.C.
Fendrick Gallery, Photo by: Mark Gulezian/QuickSilver
Photographers

33. DAVID HOCKNEY
British, born 1937
Mist, from *The Weather Series*, 1973
Lithograph from a series of six
Edition of 98
Size: 94.0 x 81.0 cm.
Printed at Gemini G.E.L.
Published by Gemini G.E.L., Los Angeles
Martha Singer, Long Island, New York, Copyright David
Hockney/Gemini G.E.L., Photo by: Michael Tropea

34. JASPER JOHNS
born Augusta, GA 1930
Flags I, 1973
Screenprint on J. B. Green paper
Edition of 65 with 7 artist's proofs
Size: 70.0 x 89.3 cm.
Printed by T. Shimada, K. Nonaka, and H. Kawanishi at Simca

Print Artists, New York
Published by the artist and Simca Print Artists, Tokyo
Rona and Harvey Malofsky, Copyright 1995 Jasper
Johns/Licensed by VAGA, New York, NY

35. ARAKAWA (SHUSAKU)
American, born Japan 1936
Untitled 1, from *No! Says the Signified*, 1973–74
Lithograph with collage on Arches Cover paper
Edition of 60 with 6 artist's proofs
Size: 57.2 x 76.4 cm.
Printed by P. Clinton, C. Ringness and D. Saff at Graphicstudio,
University of South Florida-Tampa
Co-published by Graphicstudio and Multiples, Inc., New York
University of South Florida Collection, Courtesy USF
Contemporary Art Museum, Tampa, Photo by: Dean Beasom

36. ARAKAWA (SHUSAKU)
Untitled 5, from *No! Says the Signified*, 1973–74
Lithograph with screenprinting on Arches Cover paper
Edition of 60 with 6 artist's proofs
Size: 57.2 x 76.4 cm.
Printed by P. Clinton, J. Juristo, C. Ringness, and D. Saff at
Graphicstudio, University of South Florida-Tampa
Co-published by Graphicstudio and Multiples, Inc., New York
University of South Florida Collection, Courtesy USF
Contemporary Art Museum, Tampa, Photo by: Dean Beasom

37. JAMES ROSENQUIST
born Grand Forks, ND 1933
Off the Continental Divide, 1973–74
Lithograph on Ivory wove Japan paper
Edition of 43 with 5 artist's proofs
Size: 106.7 x 198.1 cm.
Printed by W. Goldston and J. V. Smith at Universal Limited
Art Editions
Published by Universal Limited Art Editions, West Islip,
New York
The University of Iowa Museum of Art, Purchased with the
aid of the National Endowment for the Arts and matching
contributions by Mr. and Mrs. William O. Aydelotte, Edwin
Green, Sylvia and Clement Hanson, Mr. and Mrs. Melvin R.
Novick and William and Lucille Jones Paff. Copyright 1995
James Rosenquist/Licensed by VAGA, New York, NY

38. ALEX KATZ
born New York, NY 1927
The Swimmer, 1974
Aquatint on German Etching paper
Edition of 84
Size: 71.4 x 91.4 cm.
Printed by P. Laucheron, New York
Co-published by Brooke Alexander Editions, Inc., and

Marlborough Graphics, New York
The Jane Voorhees Zimmerli Art Museum, Rutgers—The State
University of New Jersey, Purchased in part with a grant from
The National Endowment for the Arts, Photo by: Victor Pustai.
Copyright 1995 Alex Katz/Licensed by VAGA, New York, NY

39. PAT STEIR
born Newark, NJ 1940
Roll Me a Rainbow, 1974
Lithograph on Arches Cover white paper
Edition of 35 with 10 artist's proofs
Size: 55.9 x 74.9 cm.
Printed by J. Lemon, assisted by D. Panosh and T. Minkler
at Landfall Press, Inc.
Published by Landfall Press, Inc., Chicago
Landfall Press, Chicago

40. PETER MILTON
born Lower Merion, PA 1930
Daylilies, 1975
Etching and engraving on Murillo paper
Edition of 160 with 15 artist's proofs (an Impressions Workshop
edition of 18 was printed on Rives BFK Heavyweight buff paper)
Size: 64.8 x 96.6 cm.
Printed by R. E. Townsend at Impressions Workshop
Published by the artist and Impressions Workshop, Boston
R. E. Townsend Studio, Photo by: Greg Heins, Boston

41. ROMARE BEARDEN
born Charlotte, NC 1914–1988
The Train, 1975
Photo-etching and aquatint on Arches Cover paper
Edition of 125 (a deluxe edition of 25 was printed on Fabriano
paper and hand-colored by the artist)
Size: 56.5 x 76.5 cm.
Printed by R. Blackburn, K. Caraccio, and E. Trevor at The
Printmaking Workshop, New York
Published by Transworld Art, New York
K. Caraccio Etching Studios, Copyright courtesy of the
Estate of Romare Bearden, Photo by: Jack Abraham
(non-ZAM artwork)

42. ED PASCHKE
born Chicago, IL 1939
Hubert, 1976–1977
Lithograph on Arches Cover white paper
Edition of 35
Size: 89.0 x 71.2 cm.
Printed by J. Lemon, T. Morgan, and T. Cvikota at Landfall
Press, Inc.
Published by Landfall Press, Inc., Chicago
Mary and Leigh Block Gallery, Northwestern University,
Photo by: Michael Tropea

43. ELLSWORTH KELLY
born Newburgh, NY 1923
Wall, 1976–79
Aquatint and etching on Arches Cover paper
Edition of 50 with 16 artist's proofs
Size: 80.3 x 71.3 cm.
Printed by K. Tyler, B. Fiske, and R. Konopaki at Tyler
Graphics, Ltd.
Published by Tyler Graphics, Ltd., Mt. Kisco, New York,
copyright Ellsworth Kelly/Tyler Graphics Ltd., 1994, Walker Art
Center, Minneapolis, Tyler Graphics Archive, 1984

44. JIM NUTT
American, born 1938
"oh! my goodness (NO NO)," 1977
Etching on HMP handmade paper
Edition of 50 with 5 artist's proofs
Size: 51.9 x 53.2 cm. (irreg.)
Printed by T. Berry, Teaberry Press
Published by Teaberry Press, Chicago (currently San Francisco)
Mary and Leigh Block Gallery, Northwestern University, Photo
by: Michael Tropea

45. JIM NUTT
"your so coarse (tish tish)," 1977
Etching on HMP handmade paper
Edition of 50 with 5 artist's proofs
Size: 49.0 x 40.0 cm.
Printed by T. Berry, Teaberry Press
Published by Teaberry Press, Chicago (currently San Francisco)
Mary and Leigh Block Gallery, Northwestern University,
Photo by: Michael Tropea

46. HELEN FRANKENTHALER
born New York, NY 1928
Essence Mulberry—State I, 1977
Woodcut on gray Maniai handmade paper
Edition of 10 with 2 trial proofs
Size: 100.3 x 46.9 cm.
Printed by J. Hutcheson and K. Tyler at Tyler Graphics, Ltd.
Published by Tyler Graphics, Ltd., Bedford Village, New York
Walker Art Center, Minneapolis, Gift of Professional Art Group
I and II, 1983

47. ROGER BROWN
born Hamilton, AL, 1941
Standing While All Around You Are Sinking, 1977
Etching and aquatint on Rives BFK paper
Edition of 50
Size: 65.5 x 56.0 cm.
Printed by T. Berry at Teaberry Press
Published by Teaberry Press, Chicago (currently San Francisco)

Mary and Leigh Block Gallery, Northwestern University,
Photo by: Michael Tropea

48. JENNIFER BARTLETT
born Long Beach, CA 1941
Graceland Mansions, 1978–79
Drypoint, aquatint, screenprint, wood relief and lithograph
(five panels) on J. B. Green and Rives BFK papers
Edition of 40
Size: 61.0 x 61.0 cm. (each panel)
Printed by P. Laucheron (drypoint and aquatint), H. Kawanishi at
Simca Print Artists (screenprint), C. Elwell (wood relief) and
M. Sánchez at Derrière L'Etoile Studios (lithograph)
Co-published by Brooke Alexander, Inc. and Paula Cooper
Gallery, New York
Paula Cooper Gallery, New York, Photos by: D. James Dee

49. SUSAN ROTHENBERG
born Buffalo, NY 1945
Untitled (May #1), 1979
Open-bite, spit-bite, and hard-ground etching
with burnishing on Fabriano Etching paper
Edition of 45 with 12 artist's proofs
Size: 74.9 x 55.9 cm.
Printed by G. Gelb and P. Drake at Aeropress, New York
Published by Parasol Press, Ltd., New York
Mount Holyoke College Art Museum, South Hadley,
Massachusetts, Museum purchase, Henry Rox Memorial Fund
for the acquisition of works by Contemporary Women Artists,
1984

50. SUSAN ROTHENBERG
Untitled (May #4), 1979
Soft-ground, sugar-lift, and spit-bite etching on Fabriano
Etching paper
Edition of 45 with 12 artist's proofs
Size: 75.2 x 55.7 cm.
Printed by G. Gelb and S. Sturman at Aeropress, New York
Published by Parasol Press, Ltd., New York
Mount Holyoke College Art Museum, South Hadley,
Massachusetts, Museum purchase, Henry Rox Memorial Fund
for the acquisition of works by Contemporary Women Artists,
1984

51. VITO ACCONCI
born Brooklyn, NY 1940
Three Flags for One Space and Six Regions, 1979–81
Photo-etching with aquatint on Rives BFK paper
Edition of 25 with 10 artist's proofs
Size: 179.1 x 156.8 cm. (overall); consists of six
panels measuring 59.7 x 78.4 cm. each
Printed by N. Anello at Crown Point Press

Published by Crown Point Press, Oakland, California
Marshall Erdman & Associates

52. DONALD JUDD
born Excelsior Springs, MO 1928–1994
Untitled, 1980
Three aquatints from a series of six
Edition of 150 with 20 artist's proofs
Size: 74.0 x 86.5 cm. (each)
Printed by Styria Studios, New York
Published by the artist
Edition Schellmann, Cologne, New York, Photo copyright 1994,
D. James Dee

53. ELIZABETH MURRAY
born Chicago, IL 1940
Untitled (States I–V), 1980
Series of five lithographs on Arches Cover paper
Edition of 35 with 8 artist's proofs
Size: 57.8 x 45.2 cm. (each)
Printed by M. Sánchez at Derrière L'Etoile Studios, New York
Co-published by Brooke Alexander, Inc. and Paula Cooper
Gallery, New York
The Jane Voorhees Zimmerli Art Museum, Rutgers—The
State University of New Jersey, Promised gift of Maurice
Sánchez, Derrière L'Etoile Studios, Photo by: Jack Abraham

54. SYLVIA PLIMACK MANGOLD
born Bronx, NY 1938
View of Shumnemunk Mountain, 1980
Screenprint and lithograph with handcoloring on Arches
Cover paper
Edition of 50 with 5 artist's proofs
Size: 53.4 x 82.0 cm.
Printed by C. O'Brien, R. Evans, P. Catanzaro, and S. Sangenario
at Styria Studio, New York
Published by 724 Prints, Inc., New York
Mount Holyoke College Art Museum, South Hadley,
Massachusetts, Museum purchase, The Henry Rox Memorial
Fund for the acquisition of works by Contemporary Women
Artists, 1985

55. RICHARD BOSMAN
American, born India 1944
Man Overboard, 1981
Wood relief on Japanese Etching paper
Edition of 36 with 10 artist's proofs
Size: 66.3 x 41.2 cm.
Printed by C. Elwell and T. Warner, Chip Elwell Fine Prints
Published by Brooke Alexander Editions, New York
Brooke Alexander Editions, New York, Photo by: D. James Dee

56. CLAES OLDENBURG
born Stockholm, Sweden 1929
Double Screwarch Bridge (State III), 1981
Etching and aquatint with monotype on Arches paper
Edition of 25
Size: 80.0 x 147.3 cm.
Printed by P. Branstead and Y. S. Min at Aeropress, New York
Published by Multiples/Goodman Inc., New York
Multiples Inc., Photo courtesy of Claes Oldenburg and Multiples
Inc., New York, Photo by: Dorothy Zeidman, New York

57. SAM FRANCIS
born San Mateo, CA 1923–1994
Untitled (SFM82–049), 1982
Woodcut monotype on handmade paper
Unique impression
Size: 108.6 x 198.7 cm.
Printed by the artist in collaboration with Garner Tullis
at Experimental Workshop
Published by Experimental Workshop, Santa Barbara, California
The Samuel L. Francis Art Museum, Inc./The Litho Shop, Inc.,
Santa Monica, CA, and The Experimental Workshop, San
Francisco

58. ROBERT KUSHNER
born Pasadena, CA 1949
Rhonda VII, 1982
Mixed media monoprint with lithography and collage
on Twinrocker handmade paper embedded with vermiculite,
fabric, and sequins
Unique impression from a series of 11
Size: 94.4 x 68.6 cm.
Printed by A. Brooks at Solo Press, Inc.; assembled with
additional paper pulp and fabric additions by artist and
J. Solodkin at Twinrocker Paper
Published by Solo Press, Inc., New York
Solo Impression Inc.

59. T. L. SOLIEN
born Fargo, ND 1949
The Three Sailors, 1982
Lithograph, intaglio, and screenprint on J. Koller HMP paper
Edition of 43
Size: 81.3 x 115.6 cm.
Printed by S. Andersen, P. Barber, D. Rounds, and M. Reid
at Vermillion Editions Ltd.
Published by Vermillion Editions Ltd., Minneapolis, Minnesota
Steve Andersen at Akasha Press, Minneapolis

60. JEAN-MICHEL BASQUIAT
born Brooklyn, NY 1960–1988
Back of the Neck, 1983
Screenprint with handpainting on Stonehenge paper

Edition of 24 with 3 artist's proofs
Size: 128.3 x 259.1 cm.
Printed by J. Stearns at New City Editions
Published by Larry Gagosian and New City Editions
The Brooklyn Museum, Charles S. Smith Memorial Fund

61. LOUISA CHASE
American, born Panama City, Panama, 1951
Red Sea, 1983
Wood relief with hand-coloring on Sekishu paper
Edition of 25
Size: 83.8 x 97.8 cm.
Printed by C. Elwell at Chip Elwell, New York
Published by Diane Villani Editions, New York
Diane Villani Editions

62. JIM DINE
born Cincinnati, OH 1935
The Heart and the Wall, 1983
Soft-ground and spit-bite etching, aquatint, and power tool
drypoint (four panels) on Somerset Textured paper
Edition of 28 with 15 artist's proofs
Size: Two upper sheets: 110.8 x 88.3 cm. each, Two lower sheets:
116.2 x 88.3 cm. each
Printed by S. Hennessy, S. McDonough, D. Saff, and S. Thomas
at Graphicstudio II, University of South Florida-Tampa
Published by Pace Editions, New York
University of South Florida Collection, Courtesy USF
Contemporary Art Museum, Tampa, Photo by: Dean Beasom

63. ROBERT LONGO
born Brooklyn, NY 1953
Men in the Cities (Jonathon), 1988
Lithograph on Arches 350 paper
Edition of 48 with 10 artist's proofs
Size: 182.8 x 91.5 cm.
Printed by M. Sánchez and J. Miller at Derrière L'Etoile Studios,
New York
Published by Edition Schellmann & Klüser, Munich-New York
The Jane Voorhees Zimmerli Art Museum, Rutgers—The State
University of New Jersey, Promised gift of Maurice Sánchez,
Derrière L'Etoile Studios, Photo by: Jack Abraham

64. FRANK STELLA
born Malden, MA 1936
Pergusa Three, State I, from the *Circuits Series*, 1983
Wood relief on handmade, hand-colored white TGL paper
Edition of 10
Size: 167.6 x 132.1 cm.
Printed by S. Reeves, T. Strianese, K. Tyler, and P. Duchess
with assistance of B. Cross; papermaking by S. Reeves and
T. Strianese at Tyler Graphics
Published by Tyler Graphics Ltd.

The University of Michigan Museum of Art, Gift of the Friends
of the Museum, 1983/1.157, Copyright The University of
Michigan Museum of Art

65. ROBERT MOTHERWELL
born Aberdeen, WA 1915–1991
Mexican Night II, 1984
Etching and aquatint on Joe Witter paper
Edition of 70 with 10 artist's proofs
Size: 45.0 x 44.5 cm.
Printed by C. Mosley for Tyler Graphics
Published by Tyler Graphics, Bedford Village, NY
The Jane Voorhees Zimmerli Art Museum, Rutgers—The State
University of New Jersey, Gift of Catherine Mosley, Photo by:
Jack Abraham. Copyright 1995 Dedalus Foundation/Licensed by
VAGA, New York, NY

66. JOAN SNYDER
born Highland Park, NJ 1940
Things Have Tears and We Know Suffering, 1984
Wood relief with handcoloring on Yamoto paper
Edition of 9 with 4 artist's proofs
Size: 66.0 x 63.5 cm.
Printed by C. Elwell, Chip Elwell, New York
Published by Diane Villani Editions, New York
Diane Villani Editions

67. TERRY WINTERS
born Brooklyn, NY 1949
Double Standard, 1984
Lithograph on Arches paper
Edition of 40 with 8 artist's proofs
Size: 197.0 x 107.7 cm.
Printed by J. Lund and D. Volle at Universal Limited Art Editions
Published by Universal Limited Art Editions, West Islip, New
York
Universal Limited Art Editions, West Islip

68. JOHN BUCK
born Ames, IA 1946
Father & Son, 1985
Wood relief on Suzuki handmade paper
Edition of 30 with 4 artist's proofs
Size: 209.5 x 92.7 cm.
Printed by Bud Shark, R. Colachis, J. Pless, and Barbara Shark
at Shark's, Inc.
Published by Shark's, Inc., Boulder, Colorado
National Museum of American Art, Smithsonian Institution,
Museum purchase made possible by the William R. and Nora H.
Lichtenberg Endowment Fund, copyright 1986, John Buck

69. VIJA CELMINS
American, born Latvia 1939

The View, four mezzotints for book with
text written by Czeslaw Milosz, 1985
Mezzotints on Rives BFK paper
Edition of 120
Sheet size: 37.8 x 27.7 cm.
Overall book size: 38.4 x 28.8 cm.
Printed by D. Simmelink, Los Angeles; designed by
E. Caponigro; letterpress printed by Meriden-Stinehour Press on
paper made by K. Clark at Twinrocker Paper; and bound by
G. Wieck at Moroquain, Inc., Hopewell Junction, New York
Published by the Library Fellows of the Whitney Museum of
American Art, New York
Simmelink/Sukimoto Editions, Mezzotint by Vija Celmins from
The View by Czeslay Milosz, 1985

70. DENNIS KARDON
born Des Moines, IA 1950
Charlotte's Gaze, 1985
Lithograph and wood relief on Gasen Natural paper
Edition of 38 with 4 artist's proofs
Size: 63.2 x 69.2 cm.
Printed by D. Keister and D. Calkins, Echo Press
Published by Echo Press, Bloomington, Indiana
Echo Press, Indiana University, Photo by: Michael Kavanagh and
Kevin Montague

71. BARBARA KRUGER
born Newark, NJ 1945
Untitled (We Will No Longer Be Seen and Not Heard), 1985
Offset lithograph with screenprint (nine panels) on
Arches 88 paper
Edition of 50 with 10 artist's proofs
Size: 52.0 x 52.0 cm. (each panel)
Printed by J. Miller, D. Schulman, and M. Sánchez at
Derrière L'Etoile Studios, New York
Published by Peter Blum Edition, New York
The Jane Voorhees Zimmerli Art Museum, Rutgers—The State
University of New Jersey, Promised gift of Maurice Sánchez,
Derrière L'Etoile Studios, Photos by: Jack Abraham

72. IDA APPLEBROOG
born Bronx, NY 1929
Just Watch and See, 1985
Lithograph with handpainted additions on Arches Cover paper
(two sheets)
Edition of 40 with 6 artist's proofs
Size: 56.5 x 74.4 cm. (each sheet)
Printed by J. Nichols, assisted by A. Brooks, at John Nichols
Printmakers and Publishers, New York
Published by Strother/Elwood Art Editions, New York
The Jane Voorhees Zimmerli Art Museum, Rutgers—The State
University of New Jersey, Photo by: Jack Abraham

73. JULIAN SCHNABEL
born Brooklyn, NY 1951
Mother, 1985
Etching and aquatint printed on a commercial color
lithographic map
Edition of 35 with 10 artist's proofs
Size: 180.3 x 119.4 cm.
Printed by The Spring Street Workshop, New York, and
A. Crommelynck, New York
Published by Pace Editions, New York
Pace Editions, New York

74. RICHARD SERRA
born San Fransisco, CA 1939
Clara Clara I, 1985
Screenprint with Paintstik
Edition of 28 with 7 artist's proofs
Size: 91.5 x 182.9 cm.
Printed by T. Angelo, S. Baden, E. Garcia, J. McGowan,
R. McPherson, R. Mendez, and R. White at Gemini G.E.L.
Published by Gemini G.E.L., Los Angeles
David Winton Bell Gallery, Brown University, Gift of Frank and
Nan Tull Wezniak in honor of the Class of 1954 on his fortieth
reunion, Copyright 1995 Richard Serra/Artists Rights Society
(ARS), New York

75. HOLLIS SIGLER
born Gary, IN 1946
Where Daughters Fear Becoming Their Mothers, 1985
Three-dimensional lithograph on Arches Cover black paper
Edition of 30 with 3 artist's proofs
Size: 35.6 x 30.5 x 40.7 cm.
Printed by B. Shark, R. Colachis, and R. Trujillo at Shark's Inc.
Published by Shark's Inc., Boulder, Colorado
Shark's Inc., Boulder, Colorado, Copyright Hollis Sigler

76. YVONNE JACQUETTE
born Pittsburgh, PA 1934
Mississippi Night Lights (Minneapolis), 1985–86
Lithograph and screenprint on Arches paper
Edition of 60 with 15 artist's proofs
Size: 147.6 x 91.8 cm.
Printed by M. Sánchez, J. Miller and M. French at Derrière
L'Etoile Studios, New York
Published by Brooke Alexander Editions, Inc., New York
The Jane Voorhees Zimmerli Art Museum, Rutgers—The
State University of New Jersey, Promised gift of Maurice
Sánchez, Derrière L'Etoile Studios, Photo by: Jack
Abraham

77. JOHN BEERMAN
born Greensboro, NC 1958
The Stones Silent Witness, 1986

Etching with aquatint on German Etching paper
Edition of 60 with 5 artist's proofs
Size: 78.7 x 108.0 cm.
Printed by S. Mallozzi and J. Hesse at Hudson River Editions, Nyack, New York
Published by the Rutgers Archives for Printmaking Studios, The Jane Voorhees Zimmerli Art Museum
The Jane Voorhees Zimmerli Art Museum, Rutgers—The State University of New Jersey, 1986 Rutgers Archives for Printmaking Studios Commission Print, Photo by: Jack Abraham

78. RICHARD DIEBENKORN
born Portland, OR 1922–1993
Green, 1986
Color spit-bite aquatint, with soap-ground aquatint and dry-point on Somerset paper
Edition of 60
Size: 111.7 x 88.9 cm.
Printed by M. Bartholme at Crown Point Press
Published by Crown Point Press, Oakland, California
Kathan Brown, Crown Point Press

79. MICHAEL MAZUR
born New York, NY 1935
Wakeby Day, 1986
Lithograph, wood relief, and chine collé with monoprinting on Arches white and Sekishu handmade papers
Edition of 50 with 14 artist's proofs
Left panel size: 76.5 x 51.9 cm., center panel size: 76.5 x 56.8 cm., right panel size: 76.2 x 46.1 cm.
Printed by J. Solodkin and the artist, with assistance by T. Shinozaki, D. Stack, D. Belzycki at Solo Press, Inc.
Published by Solo Press, Inc., New York
Judith Solodkin, Solo Impression Inc.

80. JOHN NEWMAN
born New York, NY 1952
Two Pulls, 1986
Etching, aquatint and drypoint on T. H. Saunders paper
Edition of 39 with 6 artist's proofs
Size: 114.8 x 64.0 cm.
Printed by J. Melby, New York
Published by Editions Ilene Kurtz, New York
Editions Ilene Kurtz

81. STEVEN SORMAN
born Minneapolis, MN 1948
Havannah Lake, 1986
Lithograph, linocut, woodcut, engraving, and collage with gold leaf, gouache, watercolor and graphite on Persimmon-stained Shibugami, Kayasuki and Oka paper
Edition of 38 with 4 artist's proofs
Size: 194.6 x 78.7 cm.

Printed by D. Keister, Echo Press
Published by Echo Press, Bloomington, Indiana
Echo Press, Indiana University, Photo by: David Keister

82. FRANCESCO CLEMENTE
born Naples, Italy 1952
Untitled, 1987
Portfolio of five soft-ground etchings on J. B. Green Renaissance paper
Edition of 50 with 10 artist's proofs
Size: 64.5 x 50.8 cm. (each)
Printed by M. Payne at Maurice Payne, New York
Published by Raymond Foye Editions, New York
Raymond Foye Editions

83. EMMA AMOS
born Atlanta, GA 1938
Diver, from *The Aquarium Series*, 1987
Silk collagraph on Rives BFK paper
Edition of 5
Size: 117.7 x 80.0 cm.
Printed by K. Caraccio and E. G. Light at K. Caraccio Etching Studios, New York
Published by the artist, New York
The Jane Voorhees Zimmerli Art Museum, Rutgers—The State University of New Jersey, Purchased in part with a grant from The National Endowment for the Arts, Photo by: Jack Abraham

84. MICHELLE STUART
born Los Angeles, CA 1919
Navigating Coincidence: Reflecting on the Voyages of Captain Js. Cook, 1987
Intaglio (portfolio of 5 prints) on Rives BFK paper
Edition of 33
Size: 55.9 x 76.2 cm. (each sheet)
Printed by L. Rogan and J. D'Amario at the Printmaking Workshop, New York
Published by the artist
Fawbush Gallery, Photos by: Tom Warren

85. DONALD SULTAN
American, born 1951
Black Lemons and Egg, April 14, 1987, from *Lemons*, a portfolio of four aquatints, 1987
Aquatint on Somerset Satin paper
Edition of 14 with 10 artist's proofs
Size: 159.4 x 125.1 cm.
Printed by C. Weaver, F. Harlan and J. Parker at Jeryl Parker Editions, New York
Published by Parasol Press, Ltd., New York
The Museum of Fine Arts, Houston; Gift of Wallace and Isabel Wilson

86. JOHN BALDESSARI
born National City, CA 1931
The Fallen Easel, 1988
Lithograph and screenprint on Arches 88 and Ragcote
paper and metal
Edition of 35 with 15 artist's proofs
Size: 188.0 × 241.3 cm. (overall)
Printed by R. Dansby, R. Hammond and F. Siquieros at Cirrus
Editions Workshop
Published by Cirrus Editions Workshop, Los Angeles, and
Multiples Inc., New York
Cirrus Editions, Ltd., Photos by William Nettles

87. MEL BOCHNER
born Pittsburgh, PA 1940
First Quartet, 1988
Aquatint on four sheets on Arches Watercolor paper
Edition of 15
Size: 98.4 × 97.8 cm. (overall)
Printed by M. Payne at Maurice Payne, New York
Published by Parasol Press, Ltd., New York
Collection of the Artist

88. MEL BOCHNER
Second Quartet, 1988
Aquatint on four sheets on Arches Watercolor paper
Edition of 15
Size: 124.5 × 96.5 cm. (overall)
Printed by M. Payne at Maurice Payne, New York
Published by Parasol Press, Ltd., New York
Collection of the artist

89. MEL BOCHNER
Third Quartet, 1988
Aquatint on four sheets on Arches Watercolor paper
Edition of 15
Size: 123.2 × 121.9 cm. (overall)
Printed by M. Payne at Maurice Payne, New York
Published by Parasol Press, Ltd., New York
Collection of the artist

90. MEL BOCHNER
Fourth Quartet, 1988
Aquatint on four sheets on Arches Watercolor paper
Edition of 15
Size: 97.8 × 121.3 cm. (overall)
Printed by M. Payne at Maurice Payne, New York
Published by Parasol Press, Ltd., New York
Collection of the artist

91. SEAN SCULLY
American, born Dublin, Ireland 1945
Sotto Voce, 1988

Color soap-ground and spit-bite aquatint with aquatint and
drypoint on Somerset Textured paper
Edition of 40 with 10 artist's proofs
Size: 106.7 × 132.1 cm.
Printed by B. Shure, assisted by P. Paulson and D. Sywulak,
at Crown Point Press
Published by Crown Point Press, San Fransisco, California
Kathan Brown, Crown Point Press

92. AL TAYLOR
born Springfield, MO, 1948
Untitled (Large Tape), 1988
Aquatint and etching with sugar-lift and
spit-bite on Somerset Satin paper
Edition of 20 with 7 artist's proofs
Size: 86.3 × 49.5 cm.
Printed by F. Harlan and C. Weaver at Harlan & Weaver
Intaglio, New York
Published by Mere Image, Inc. and Lorence-Monk Gallery,
New York
Harlan & Weaver Intaglio, Photo by: James Dee

93. ROBERT CUMMING
born Worcester, MA 1943
Alexandria, 1989
Wood relief on Shoji handmade paper
Edition of 30 with 10 artist's proofs
Size: 118.7 × 88.3 cm.
Printed by J. C. Erickson and R. McDonald at Vinalhaven Press
Published by Vinalhaven Press, Vinalhaven, Maine
Vinalhaven Press, Photo by: Michael Tropea. Copyright 1995
Robert Cumming/Licensed by VAGA, New York, NY

94. SHERRIE LEVINE
born Hazelton, PA 1947
Meltdown (After Kirchner), 1989
Wood relief on Korean Kozo paper, from a suite of four prints
Edition of 35 with 10 artist's proofs
Size: 92.5 × 65.0 cm.
Printed by J. Miller, M. Sánchez, and L. Gray at Derrière L'Etoile
Studios, New York
Published by Peter Blum Edition, New York
The Jane Voorhees Zimmerli Art Museum, Rutgers—The State
University of New Jersey, Promised gift of Maurice Sánchez,
Derrière L'Etoile Studios, Photo by: Jack Abraham

95. JOEL SHAPIRO
born New York, NY 1941
untitled, 1989
Wood relief on Whatman paper
Edition of 21
Size: 53.3 × 43.8 cm.
Printed by L. Miller, Grenfell Press

Published by Grenfell Press, Ltd., New York
The Grenfell Press, Photo by: Quesada/Burke, New York

96. MARK STOCK
American, born Germany 1951
The Butler's in Love, 1989
Lithograph on Rives BFK paper
Edition of 50 with 5 artist's proofs
Size: 49.5 x 41.9 cm.
Printed by R. Dula and D. Farnsworth at Magnolia Editions
Published by the artist and Magnolia Editions, Oakland,
California
The Jane Voorhees Zimmerli Art Museum, Rutgers—The State
University of New Jersey, Gift of Magnolia Editions, Photo by:
Jack Abraham

97. NANCY HAYNES
American, born 1947
Untitled (GT/NH 6–90 W–7), 1990
Monotype on handmade paper
Size: 107.3 x 114.3 cm.
Printed by G. Tullis at the Garner Tullis Workshop
Published by the Garner Tullis Workshop, New York
The Museum of Fine Arts, Houston, Gift of Pamela P.
Auchincloss and Garner H. Tullis

98. JASPER JOHNS
born Augusta, GA 1930
The Seasons, 1990
Intaglio on Arches en tout cas paper
Edition of 50
Size: 128.3 x 113.4 cm.
Printed by K. Brintzenhofe, S. Ji-hong, H. Kido, J. Lund, and
C. Zammiello at Universal Limited Art Editions
Published by Universal Limited Art Editions, Inc., West Islip,
New York
Museum of Fine Arts, Houston, Museum purchase with funds
provided by Mr. and Mrs. Jack S. Blanton, Jr. and Mr. and Mrs.
Jack S. Blanton, Sr., Copyright 1995 Jasper Johns/Licensed by
VAGA, New York, NY

99. BRICE MARDEN
born Bronxville, NY 1938
Cold Mountain Series, Zen Studies #5 (Early State), 1990
Etching and sugar-lift aquatint on Whatman paper
Edition of 3 with 2 artist's proofs
Size: 69.5 x 89.5 cm.
Printed by J. Melby, New York
Published by the artist
The Baltimore Museum of Art, Print and Drawing Society Fund,
with proceeds from the 1991 Contemporary Print Fair, BMA
1991.72

100. ALEXIS ROCKMAN
born New York, NY 1962
Untitled (Squirrel & Amaryllis), 1990
Monotype; unique impression on Rives BFK paper
Size: 76.2 x 55.9 cm.
Printed by C. Pelavin at Pelavin Editions
Published by Pelavin Editions, New York
The Brooklyn Museum, Gift of Rita Fraad in Memory of her husband, Daniel J. Fraad, Jr.

101. MIRIAM SCHAPIRO
American, born in Canada 1923
Frida and Me, 1990
Lithograph and photo-lithograph with xerography and fabric
collage on Rives BFK and Mohawk superfine papers
Edition of 81 with 3 artist's proofs
Size: 104.2 x 74.9 cm.
Printed by the E. Foti and A. Szykitka at the Rutgers Center for
Innovative Printmaking
Published by The Jane Voorhees Zimmerli Art Museum,
Rutgers—The State University of New Jersey
The Jane Voorhees Zimmerli Art Museum, Rutgers—The State
University of New Jersey, 1990 Rutgers Archives for Printmaking
Studios Commission Print, Photo by: Victor Pustai

THE
PLATES

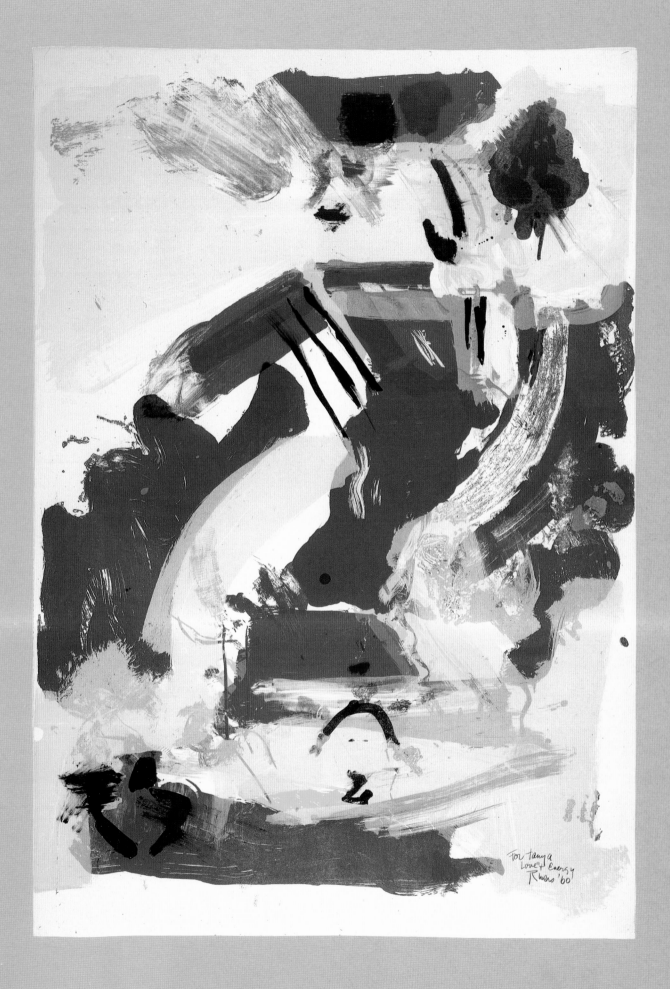

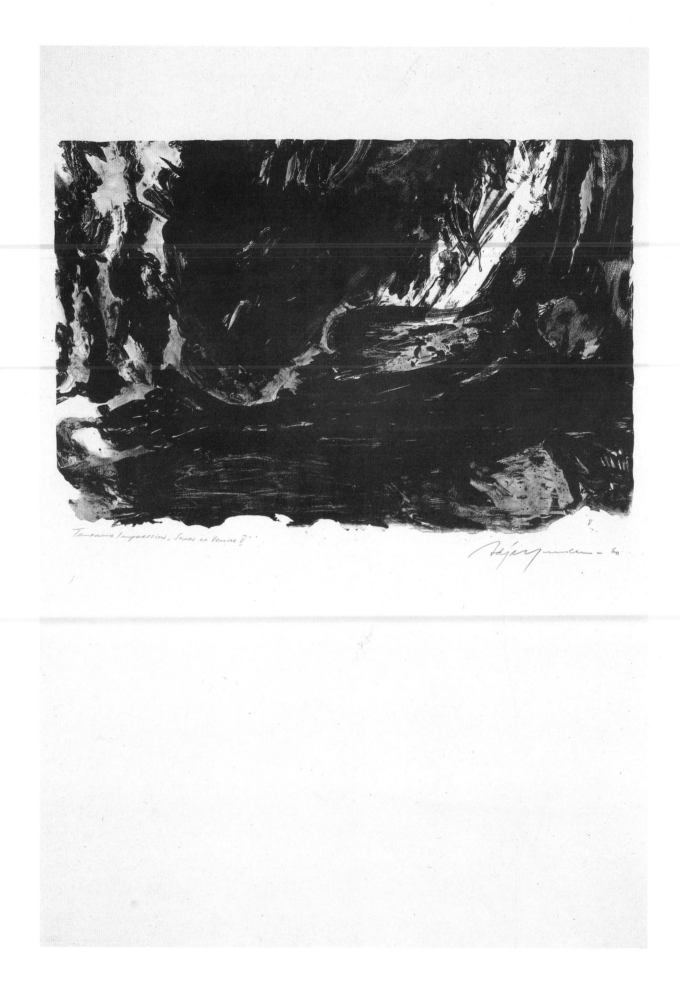

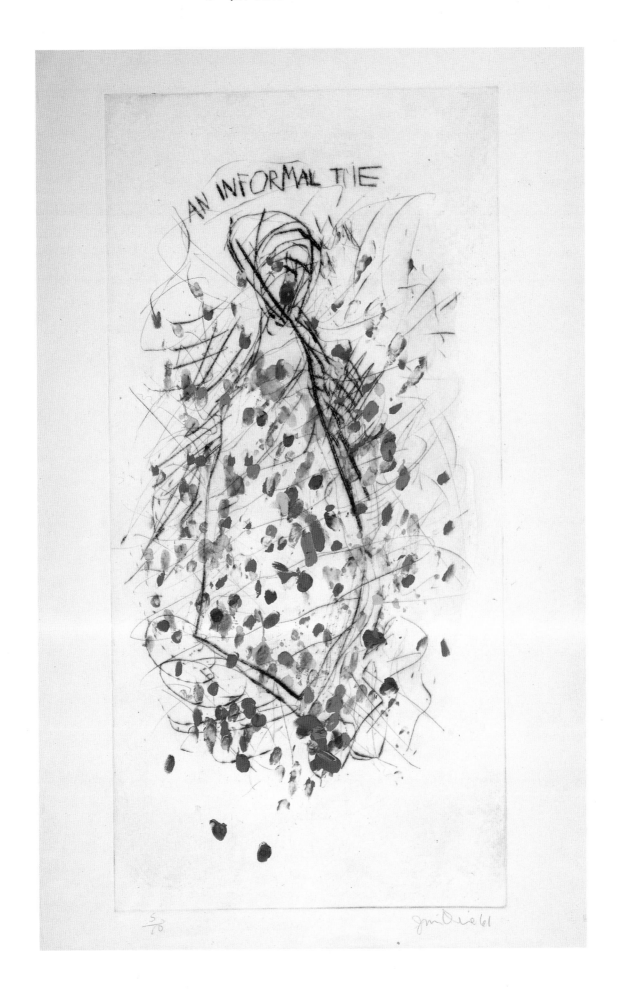

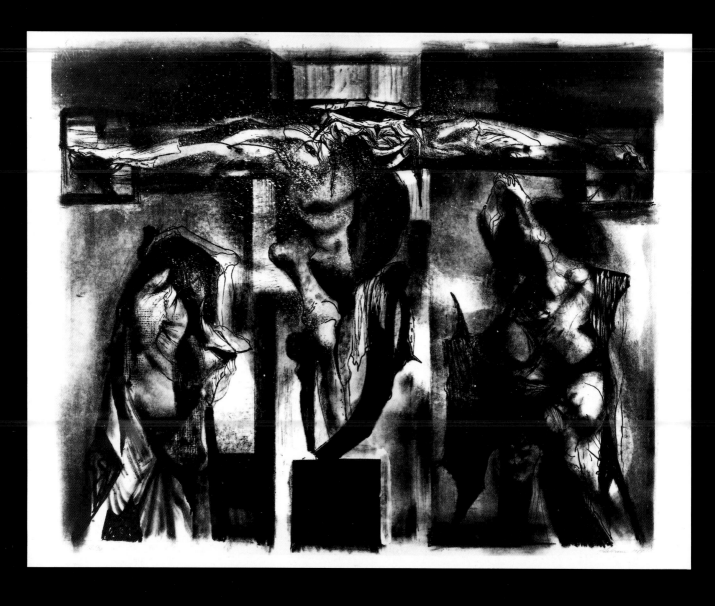

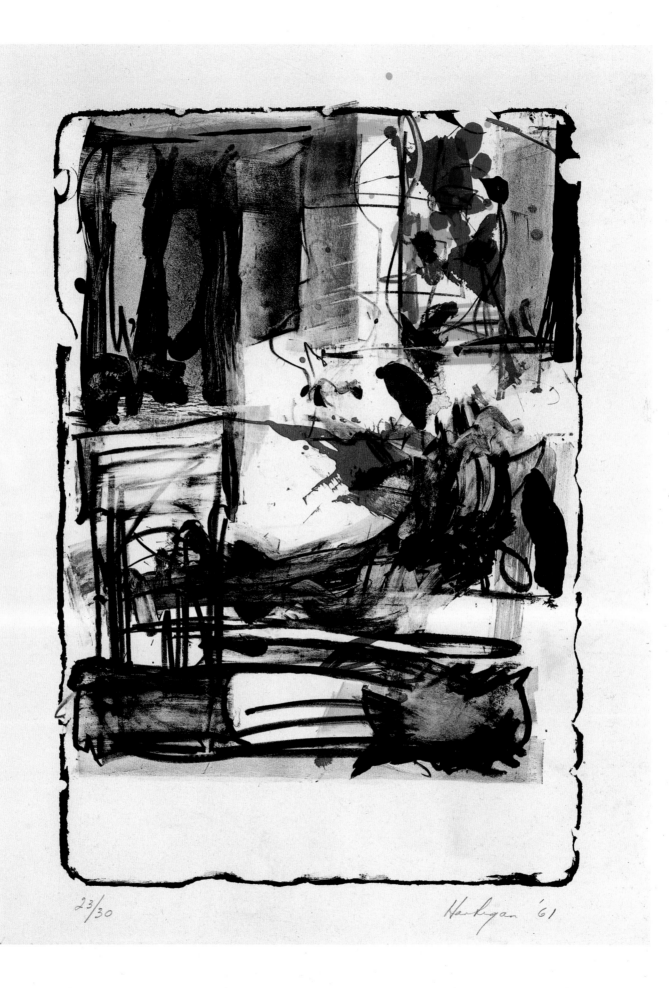

23/30 Hartigan '61

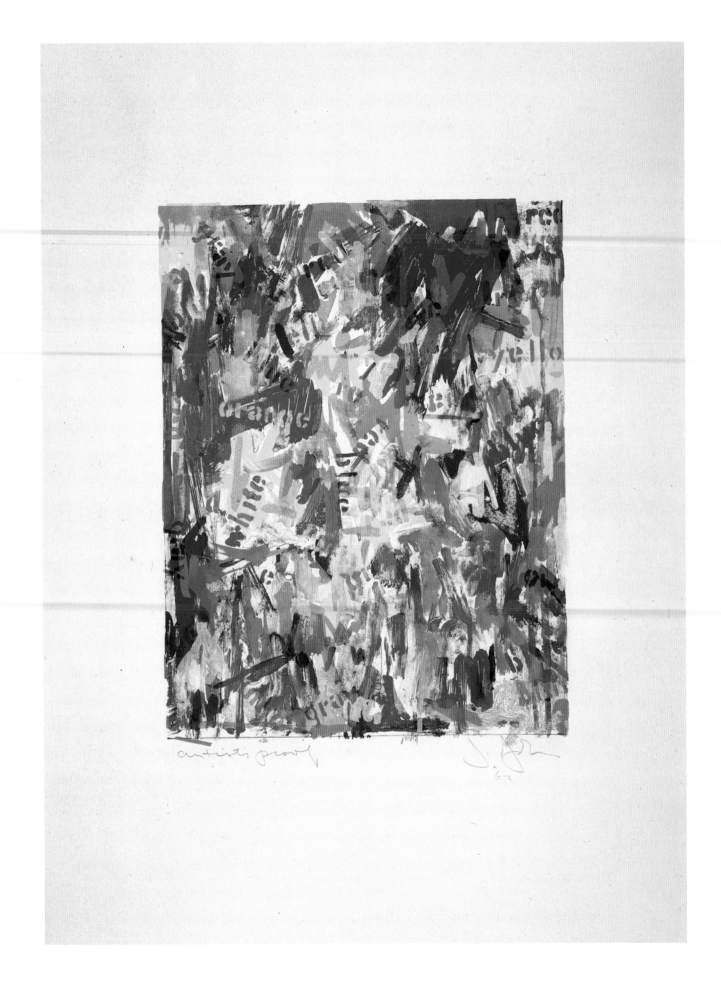

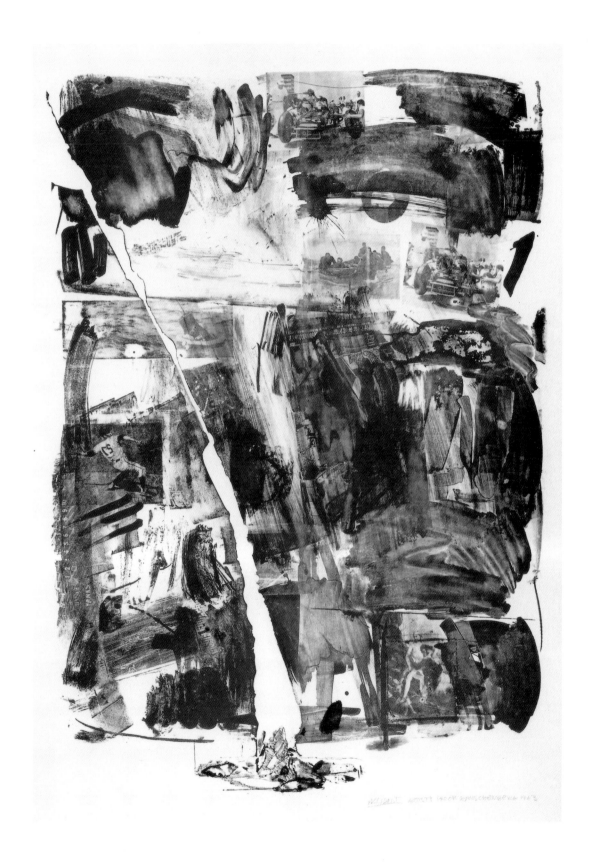

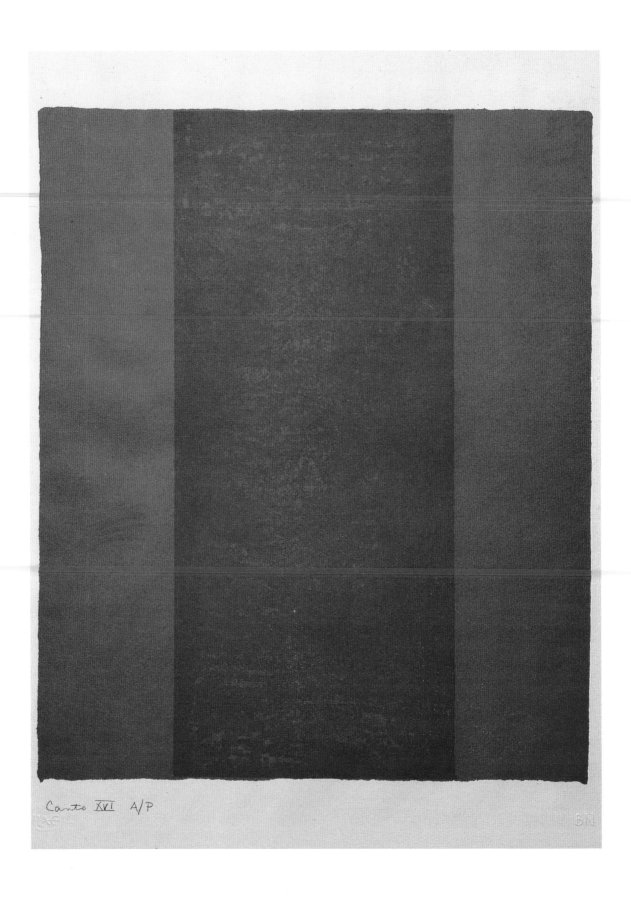

Canto XVI A/P

9 ▪ (TOP LEFT) JOSEF ALBERS ▪ *UNTITLED* (MIDNIGHT AND NOON V)

10 ▪ (TOP RIGHT) JOSEF ALBERS ▪ *UNTITLED* (MIDNIGHT AND NOON VI)

11 ▪ (BOTTOM) JOSEF ALBERS ▪ *UNTITLED* (MIDNIGHT AND NOON III)

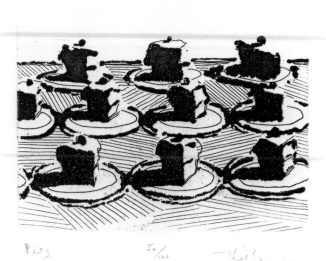

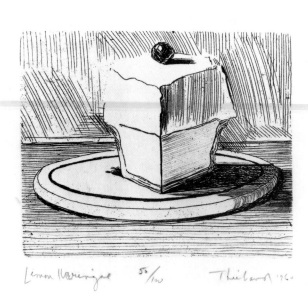

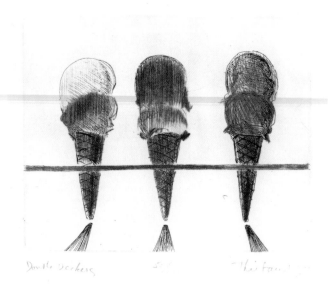

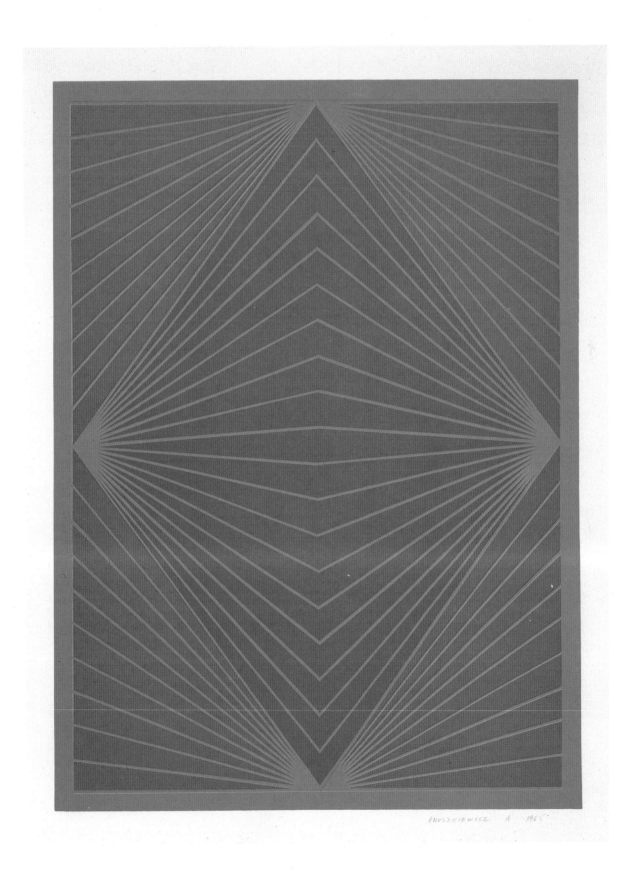

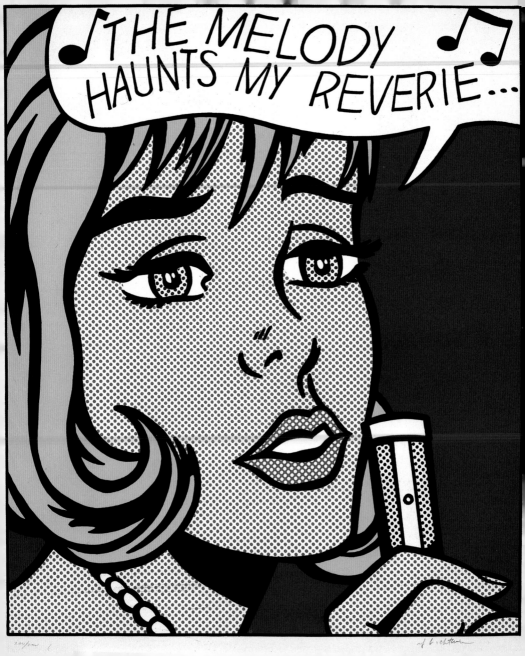

S.6 H.C. BONTECOU M65-68

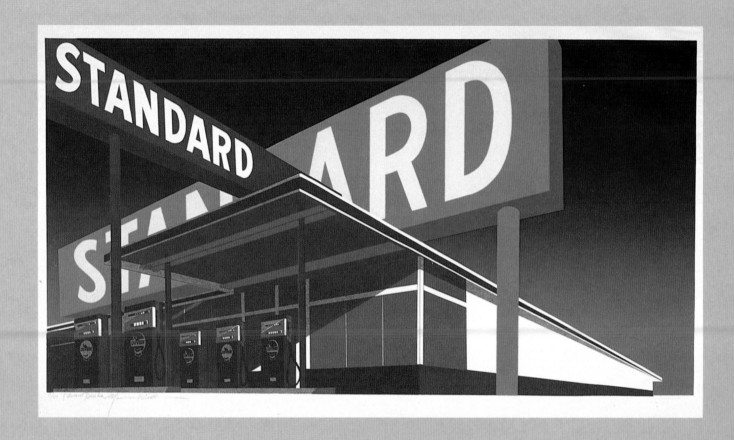

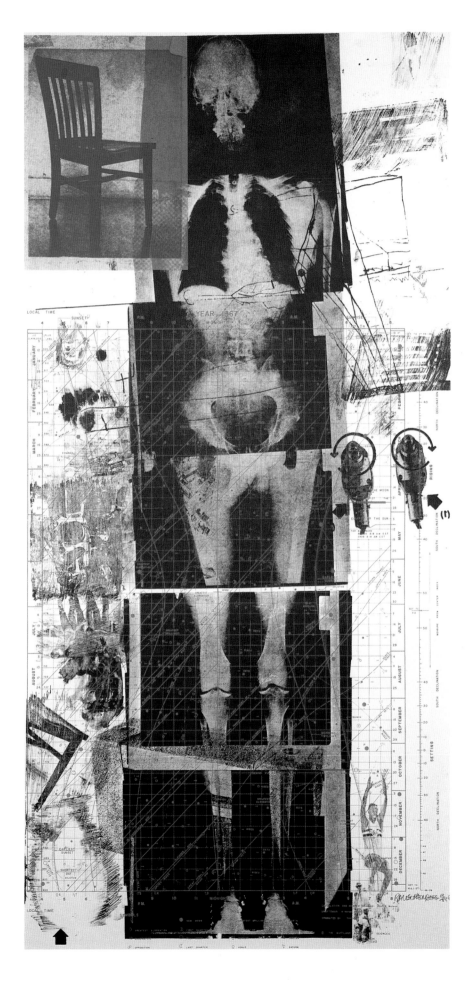

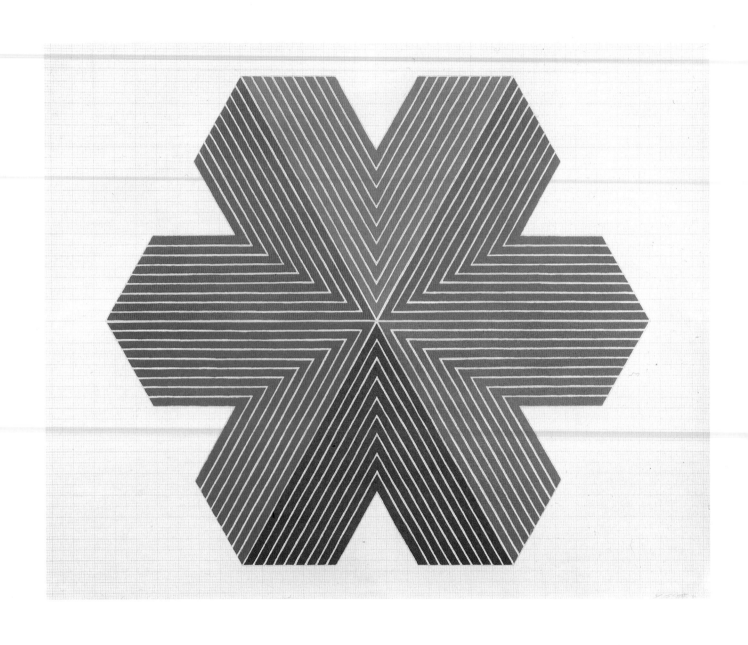

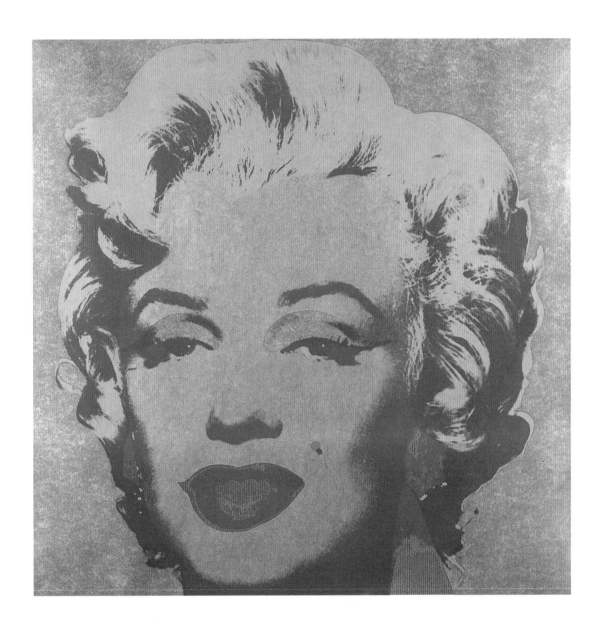

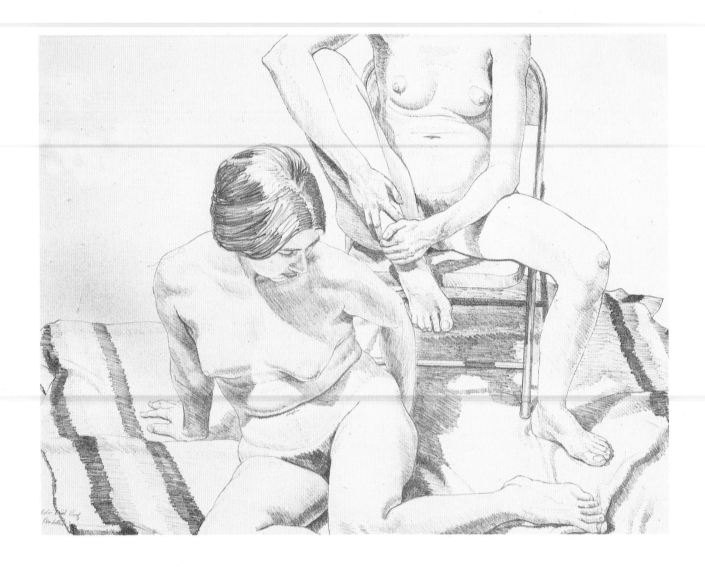

143

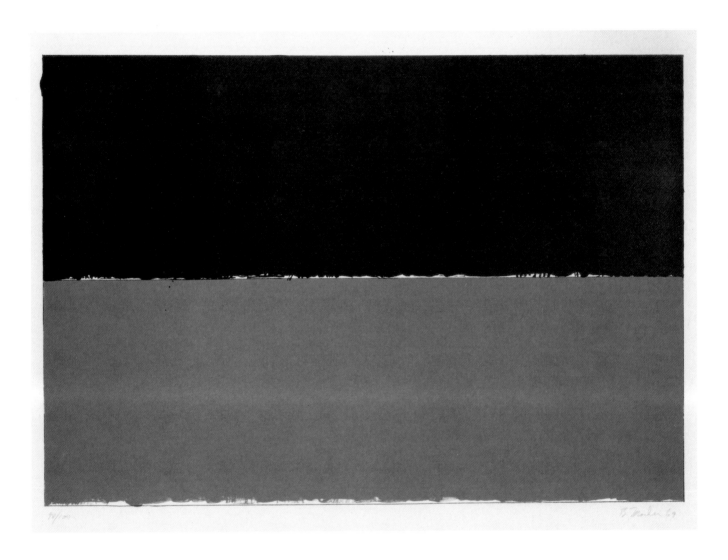

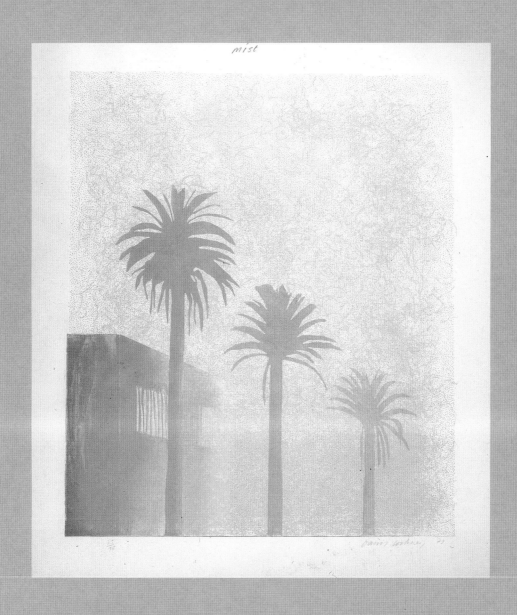

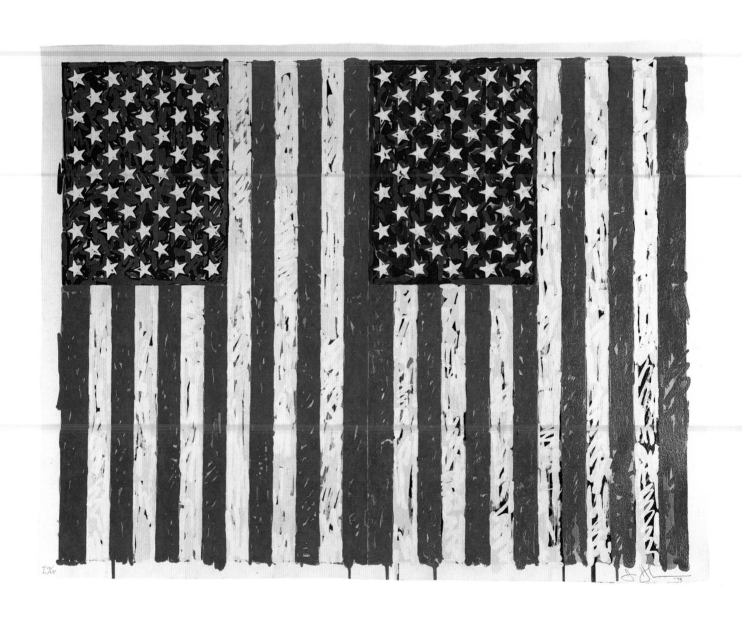

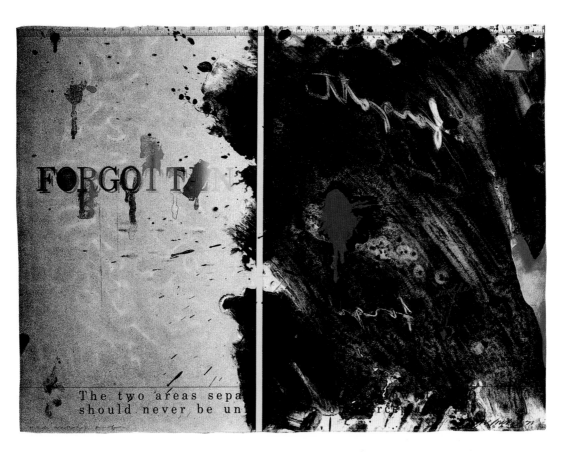

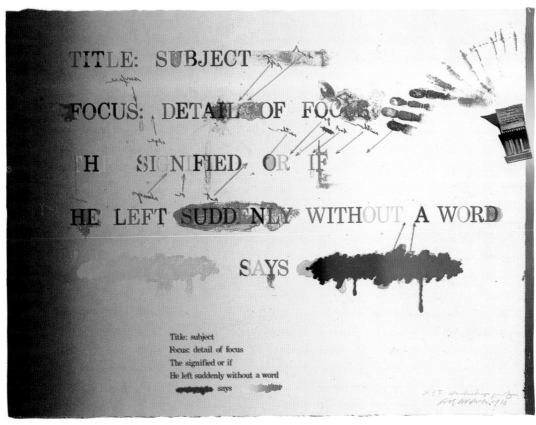

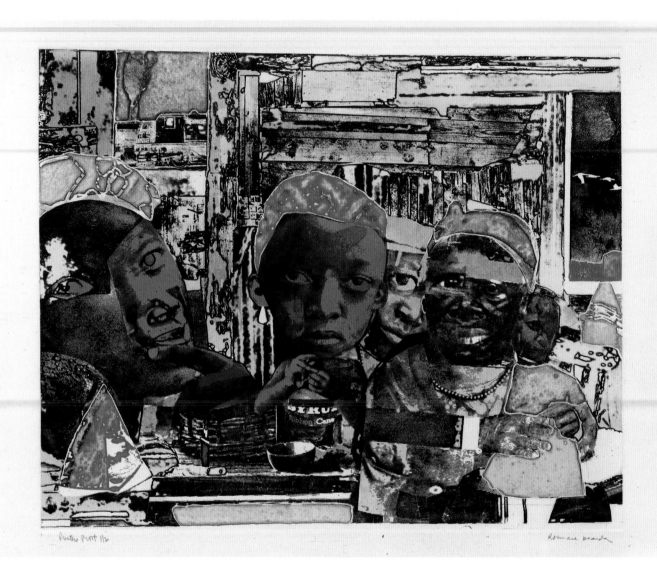

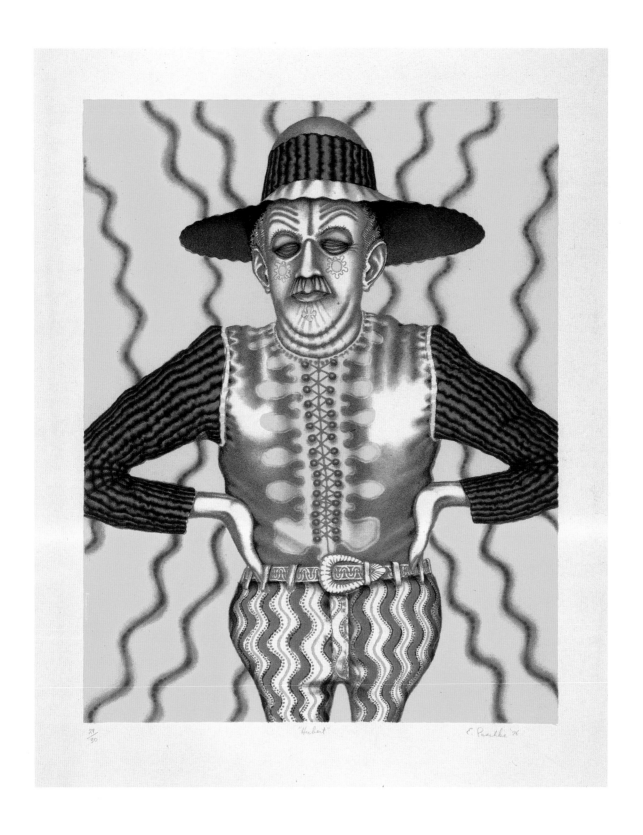

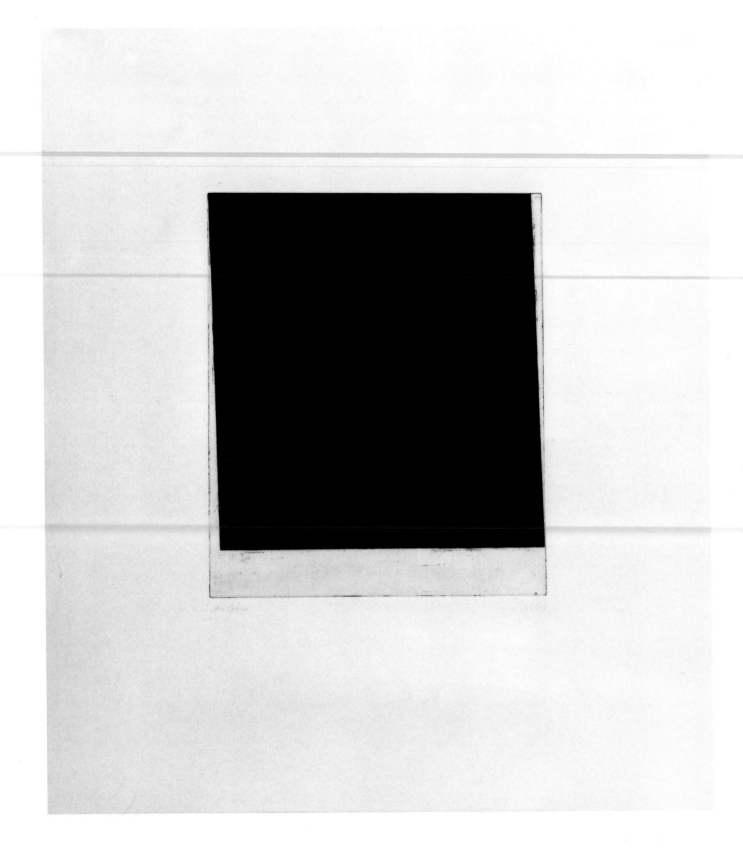

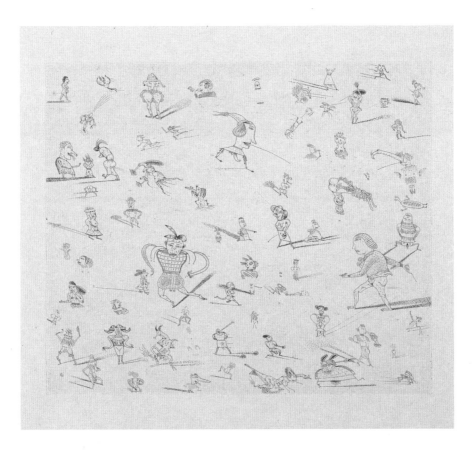

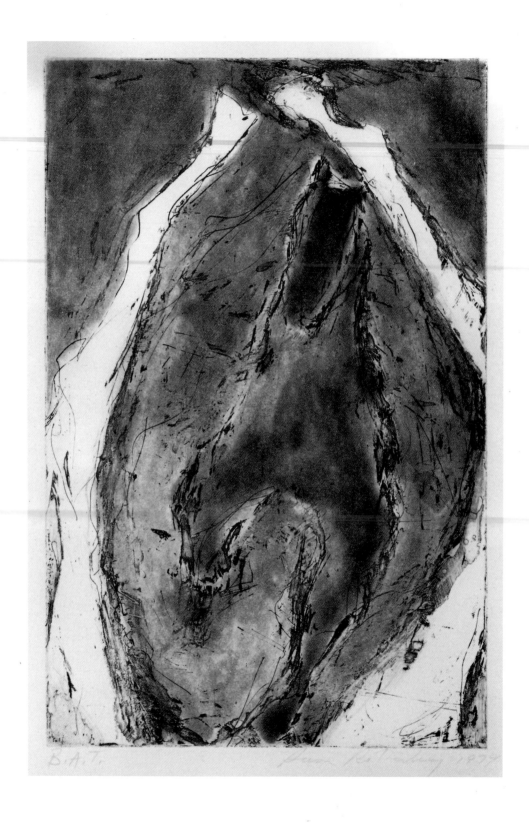

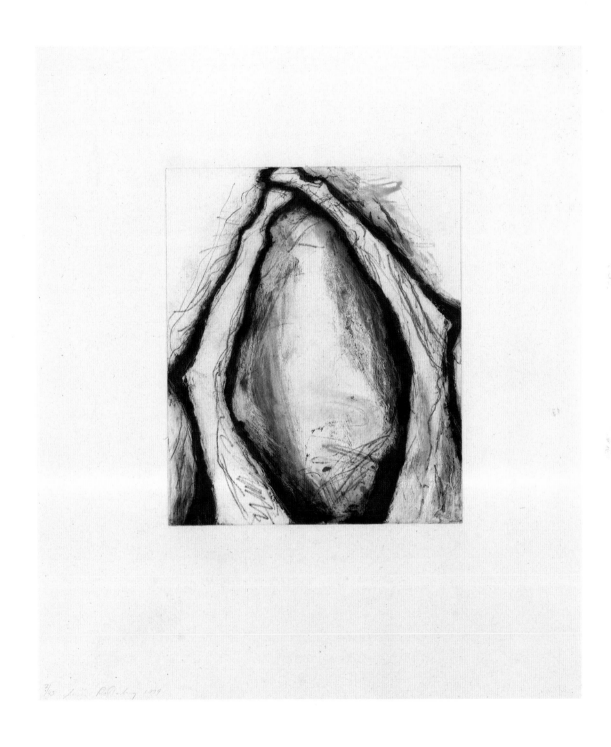

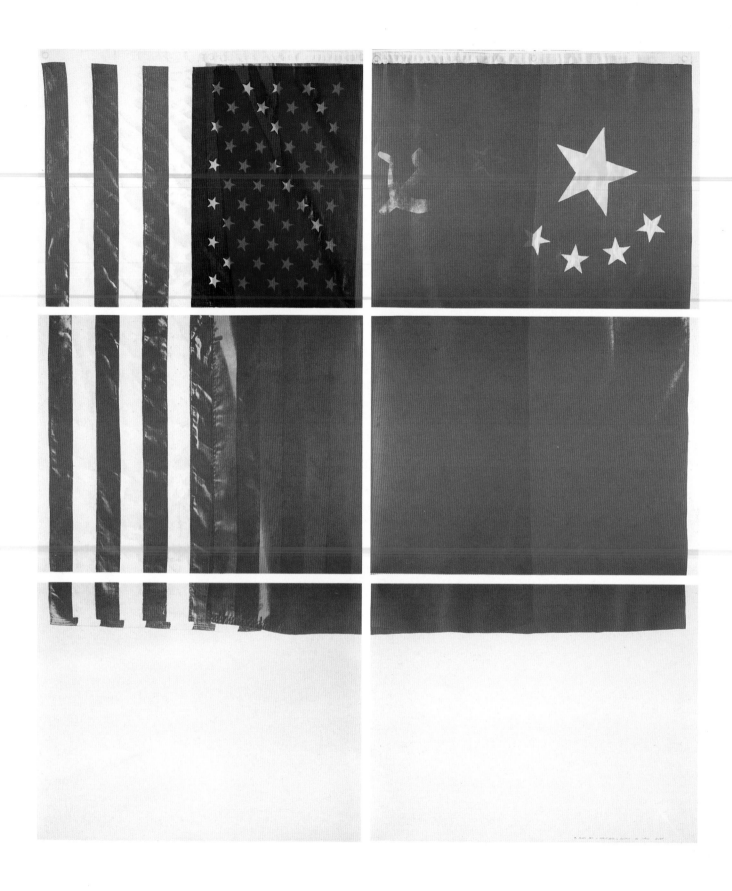

39/36 Bosman

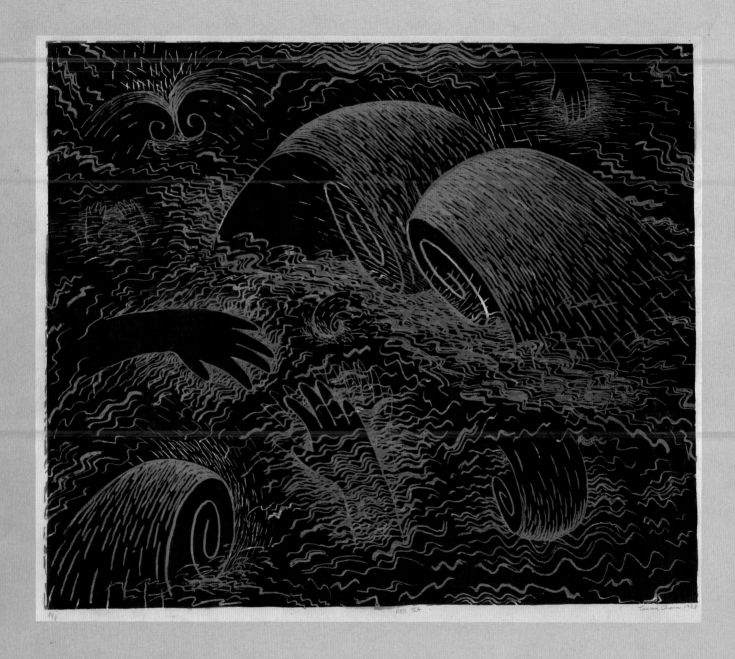

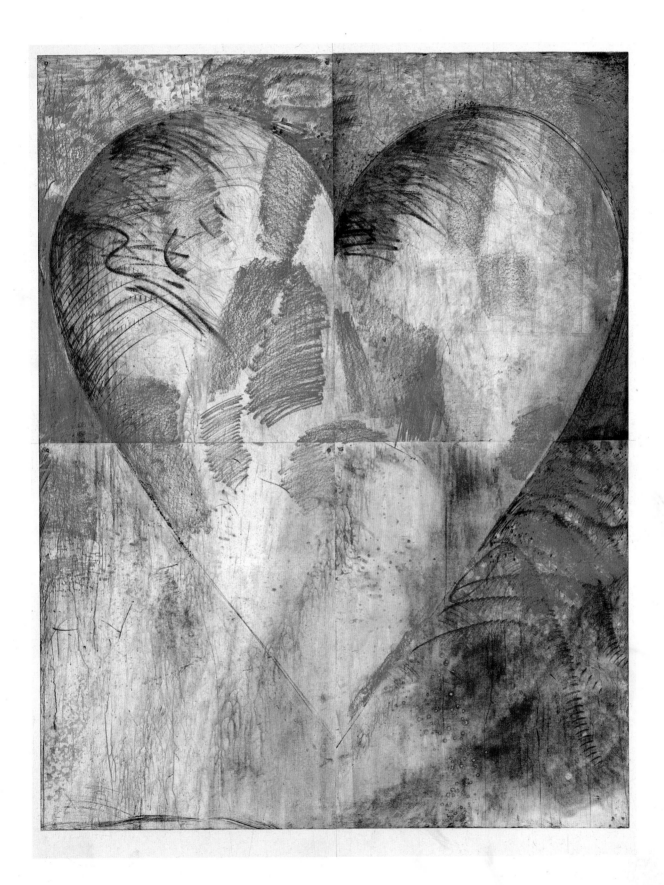

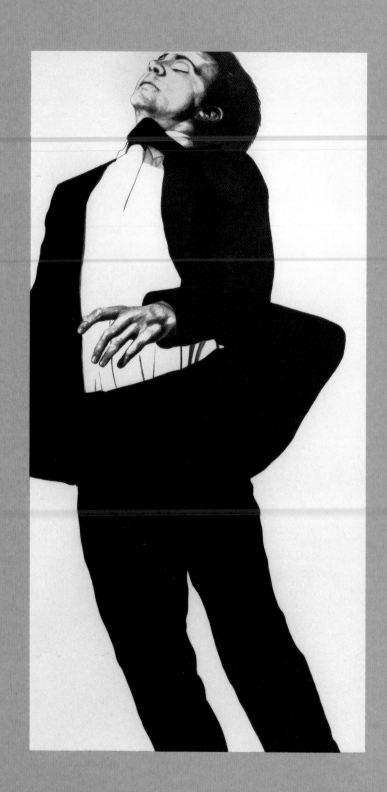

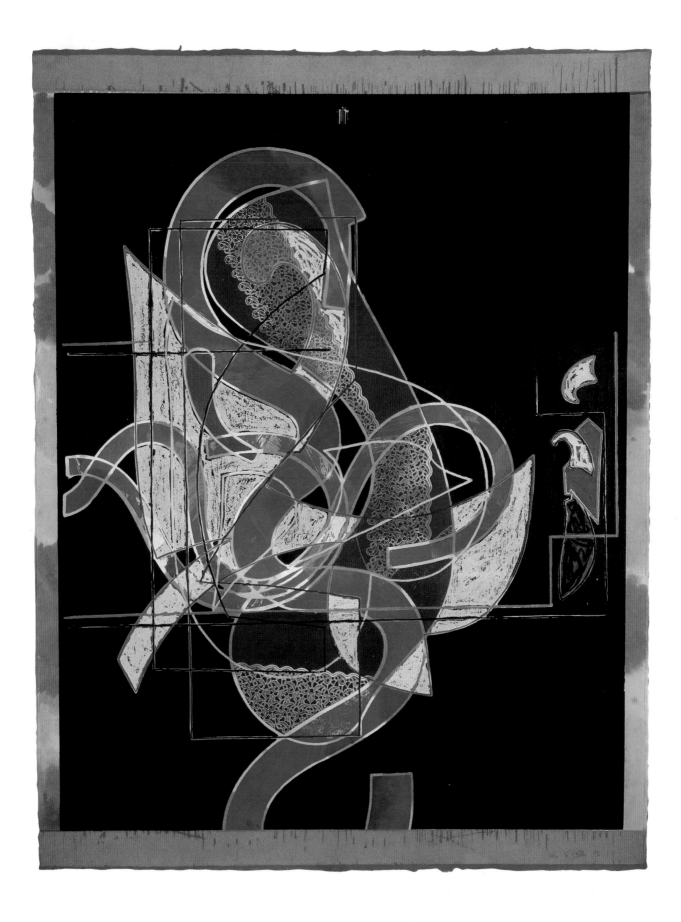

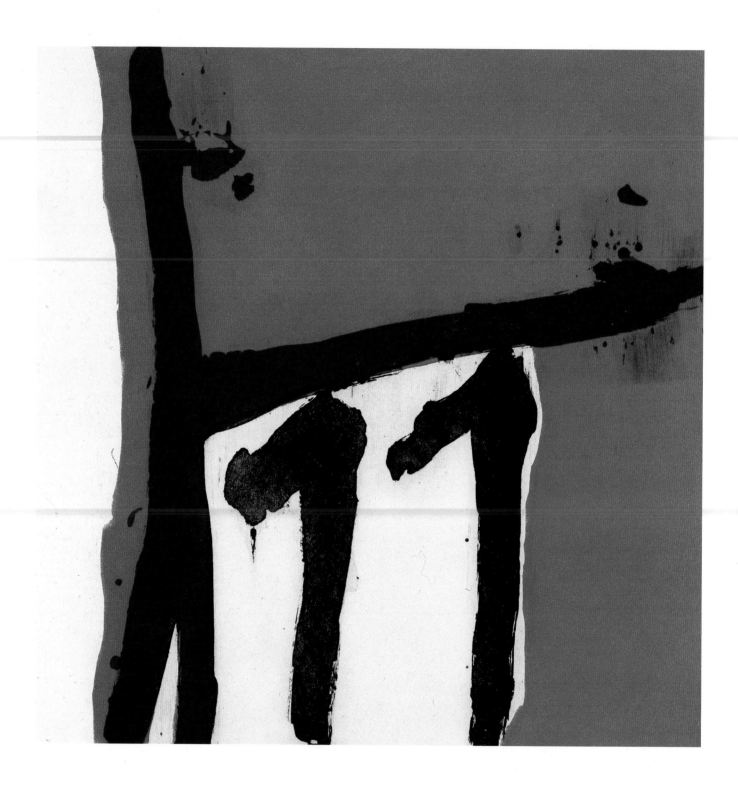

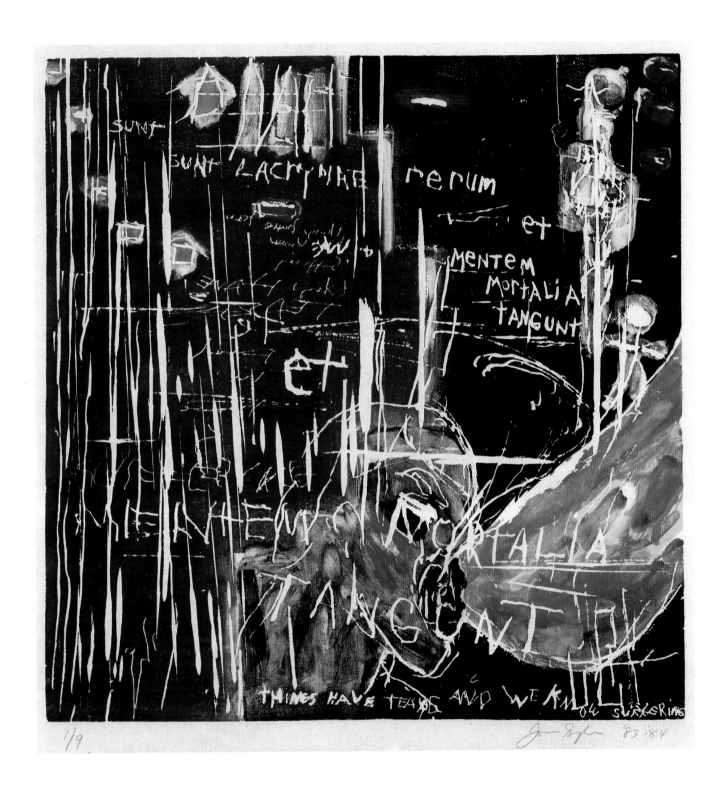

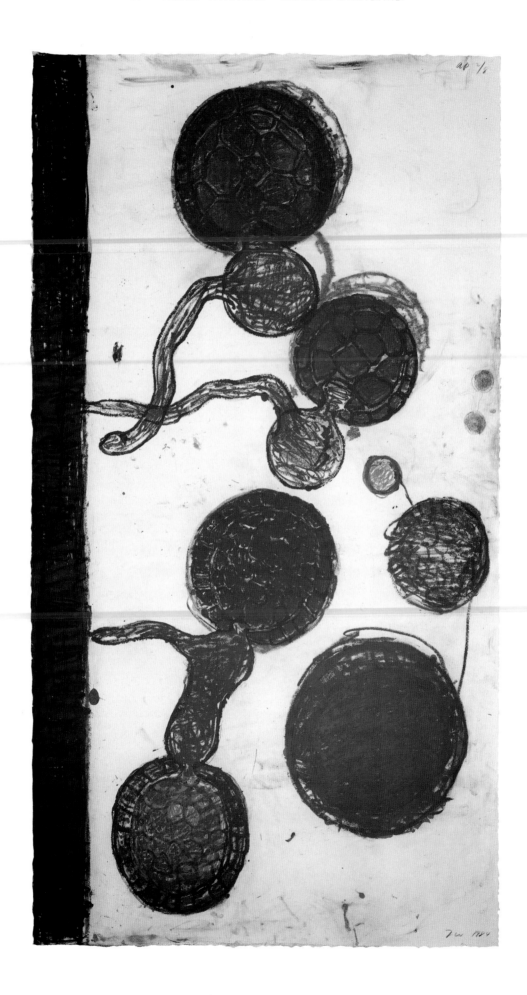

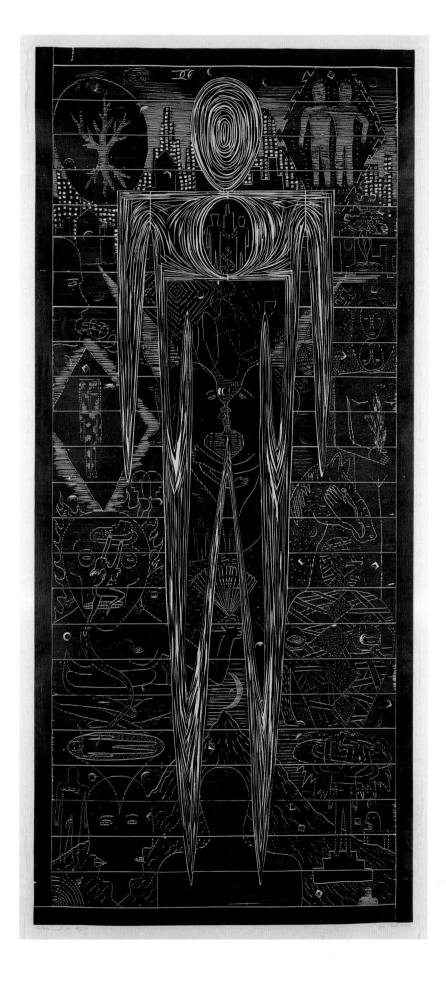

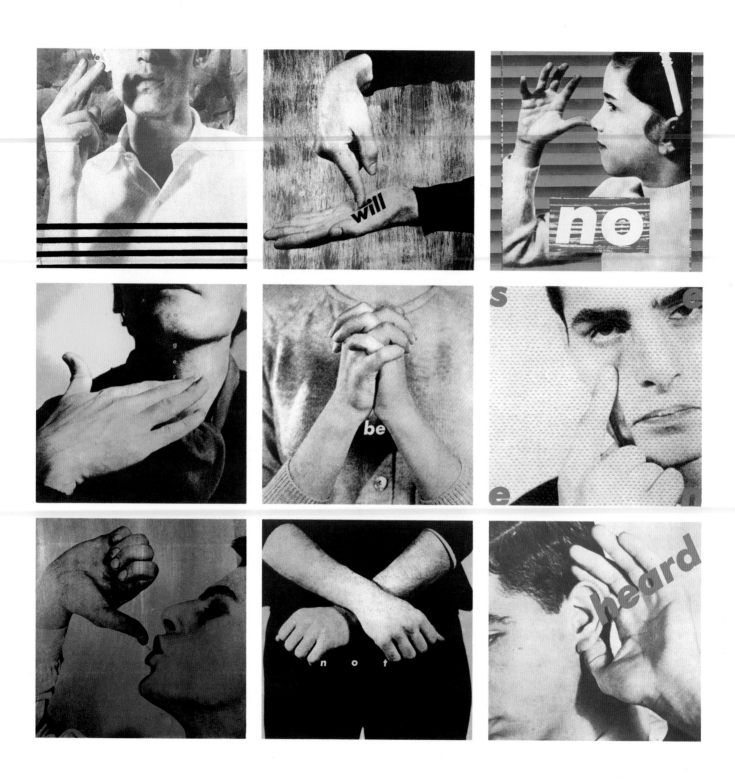

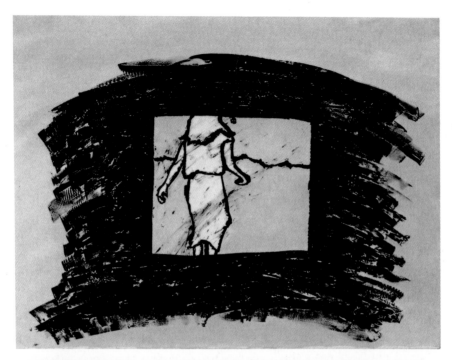

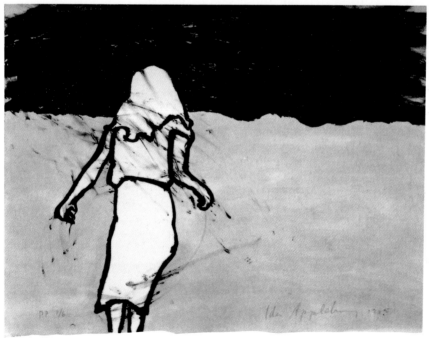

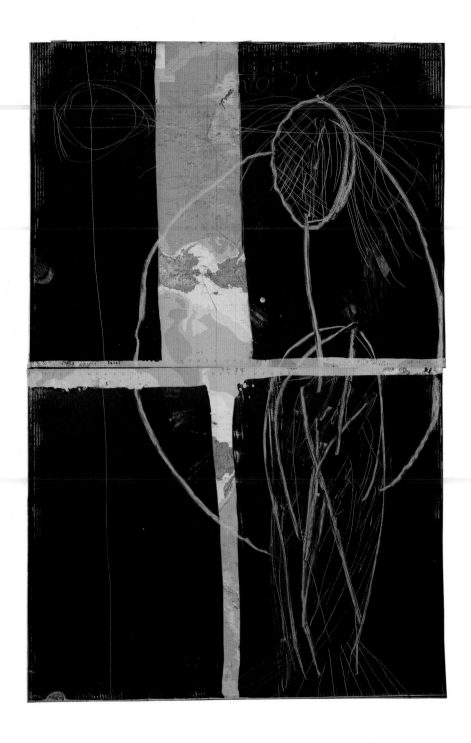

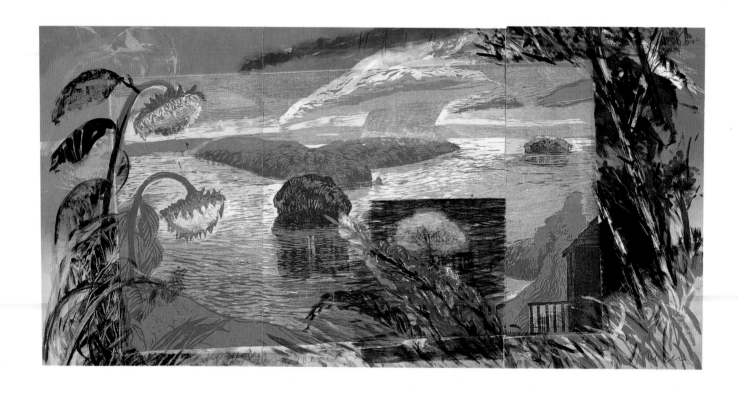

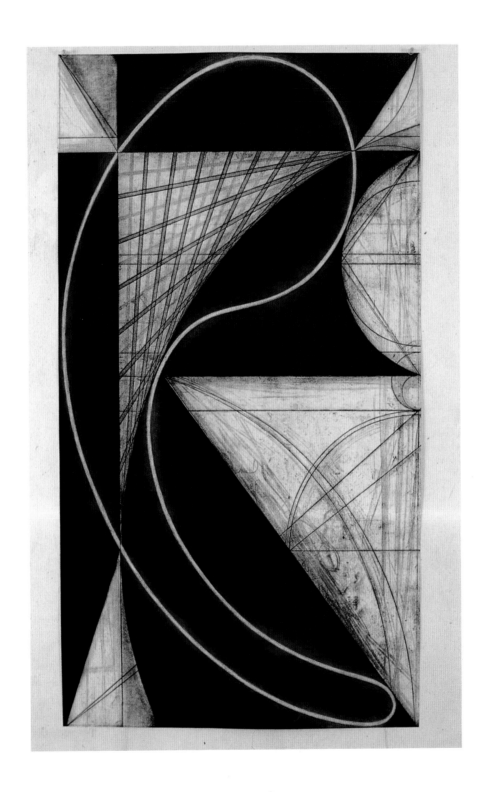

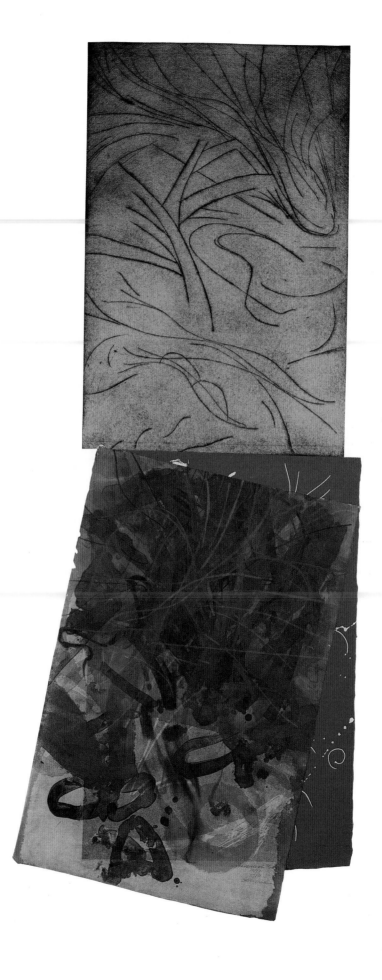

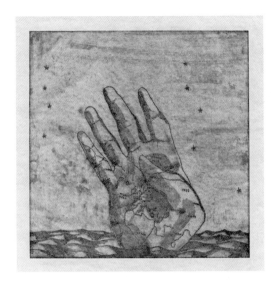

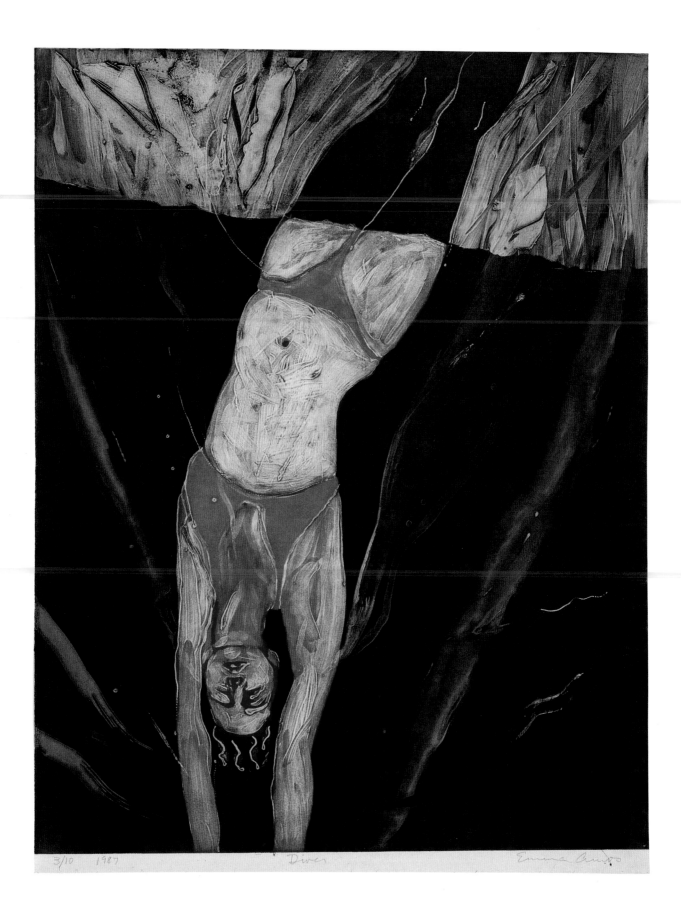

85 ▪ DONALD SULTAN ▪ *BLACK LEMONS AND EGG, APRIL 14, 1987, FROM LEMONS PORTFOLIO*

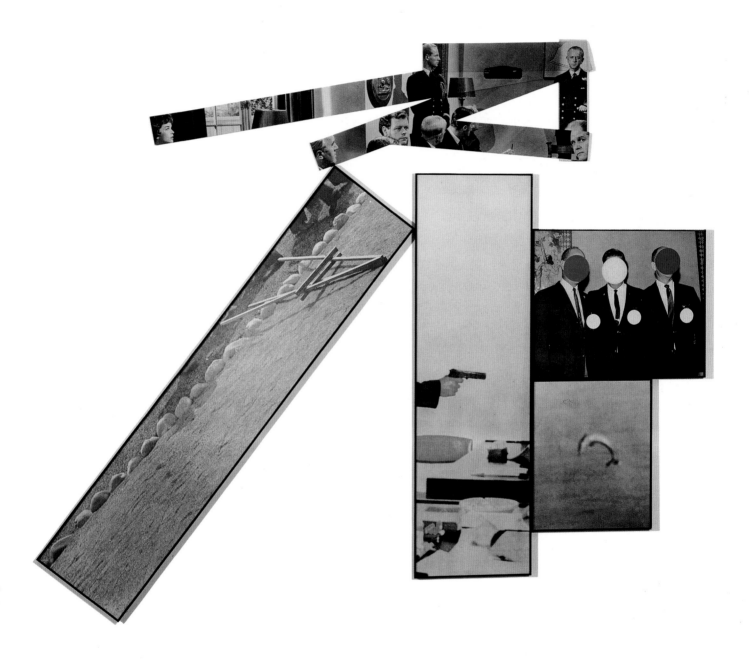

87 ▪ (TOP LEFT) MEL BOCHNER ▪ *FIRST QUARTET*

88 ▪ (TOP RIGHT) MEL BOCHNER ▪ *SECOND QUARTET*

89 ▪ (BOTTOM LEFT) MEL BOCHNER ▪ *THIRD QUARTET*

90 ▪ (BOTTOM RIGHT) MEL BOCHNER ▪ *FOURTH QUARTET*

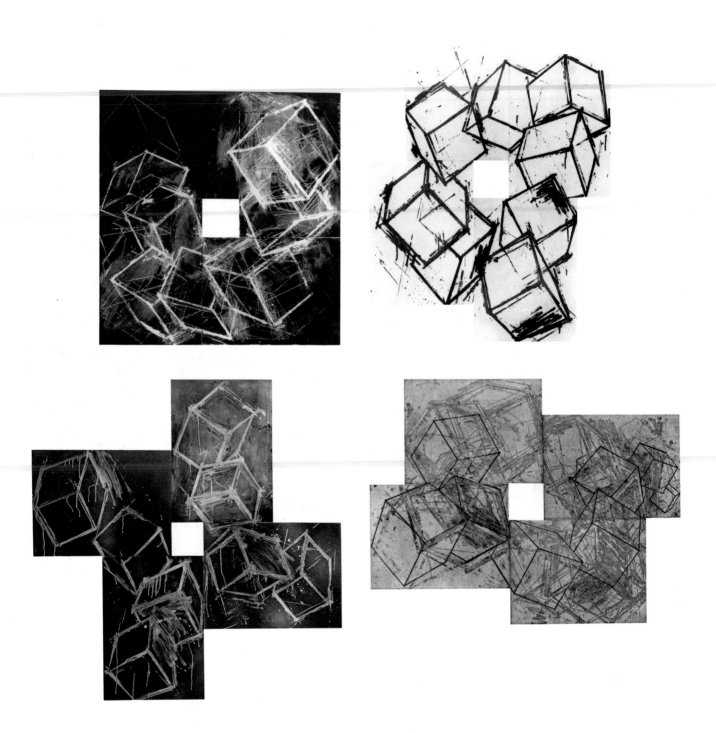

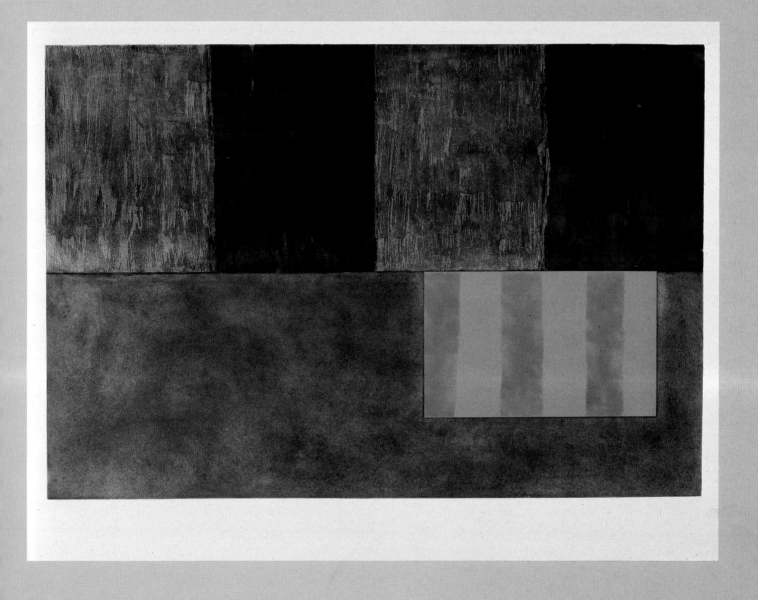

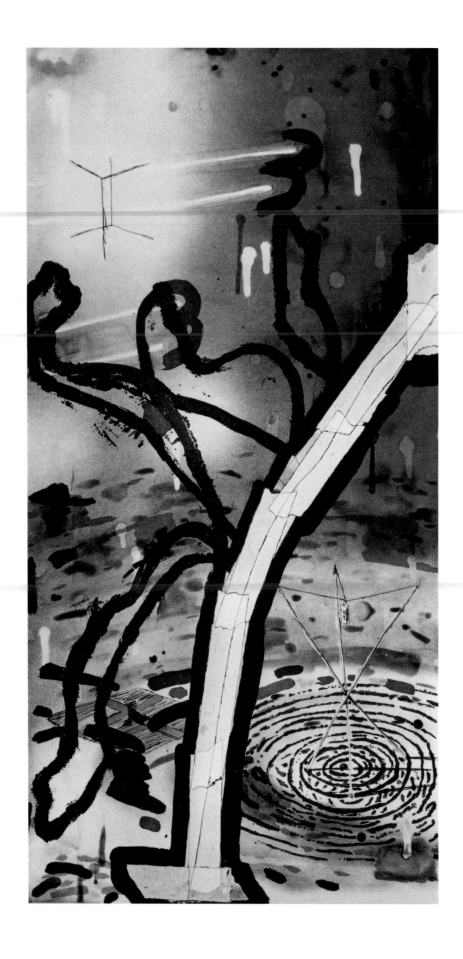

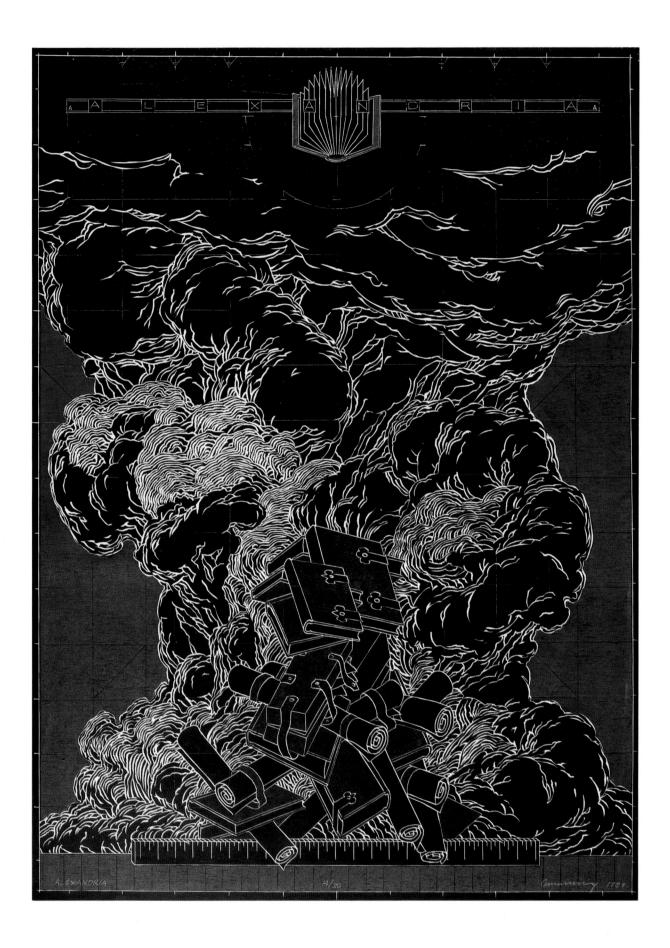

THE BUTLER'S IN LOVE

SELECTED BIBLIOGRAPHY

PART I: CONTEMPORARY PRINTMAKING

Ackley, Clifford S. *70s into 80s: Printmaking Now*. Boston: Museum of Fine Arts, 1986.

———. *The Unique Print: 70s into 90s*. Boston: Museum of Fine Arts, 1990.

———, Thomas Krens, and Deborah Menaker. *The Modern Art of the Print: Selections from the Collection of Lois and Michael Torf*. Williamstown, MA: Williams College Museum of Art; Boston: Museum of Fine Arts, 1984.

Acton, David. *A Spectrum of Innovation: Color in American Printmaking, 1890–1960*. Wooster, MA: Worcester Art Museum; New York: Norton, 1990.

Adams, Clinton. *American Lithographers, 1900–1960: The Artists and their Printers*. Albuquerque: University of New Mexico Press, 1983.

———. *Printmaking in New Mexico, 1890–1990*. Albuquerque, NM: University of New Mexico Press, 1991.

Adrian, Dennis and Richard A. Born. *The Chicago Imagist Print: Ten Artists' Works, 1958–1987, A Catalogue Raisonné*. Chicago: David and Alfred Smart Gallery, University of Chicago, 1987.

Alexander, Brooke, et al. "Cast of Four with a Target: The Contemporary Print Market." *Print Collector's Newsletter* 21, no. 6 (January–February 1991): 214–224. [Jackie Brody interviews Brooke Alexander, Dick Solomon, Tomoko Liquori, and John Hanley.]

American Printmakers 1900–1989: Edward Hopper to Jasper Johns. Chicago: R. S. Johnson Fine Art, 1989.

American Prints, 1960–1980. Milwaukee: Milwaukee Art Museum, 1982.

American Prints, 1960–1985. New York: The Museum of Modern Art, 1986.

American Prints from the Sixties. New York: Susan Sheehan Gallery, 1989.

American Women Printmakers. St. Louis: University of Missouri, 1976.

Antreasian, Garo Z. "Some Thoughts about Printmaking & Print Collaborations," *Art Journal* 39, no. 3 (Spring 1980): 180–88.

Armstrong, Elizabeth and Marge Goldwater. *Images and Impressions: Painters Who Print*. Minneapolis: Walker Art Center, 1984.

———, and Sheila McGuire. *First Impressions: Early Prints by Forty-Six Contemporary Artists*. Minneapolis: Walker Art Center; New York: Hudson Hills Press, 1989.

———. "First Impressions." *Print Collector's Newsletter* 20 (May 1989): 41–46.

Ars Multiplicata: vervielfältigte Kunst seit 1945. Cologne: Wallraf–Richartz–Museum in der Kunsthalle Köln, 1968

Art and Technology: Offset Prints. Bethlehem, PA: Ralph Wilson Gallery, 1983.

Baro, Gene. *30 Years of American Printmaking: The Twentieth National Print Exhibition*. Brooklyn, NY: Brooklyn Museum, 1977.

———. *Twenty-First National Print Exhibition*. Brooklyn, NY: Brooklyn Museum, 1978.

———. *Twenty-Second National Print Exhibition*. Brooklyn, NY: Brooklyn Museum, 1981.

Beall, Karen F. *American Prints in the Library of Congress*. Baltimore: Library of Congress and Johns Hopkins University Press, 1970.

Big Prints. Albany, NY: State University of New York Art Gallery, 1968.

Big Prints. London: Arts Council of Great Britain, 1982.

Boorsch, Suzanne. *Contemporary American Prints: Gifts from the Singer Collection*. NY: The Metropolitan Museum of Art, 1976.

Boyle, Jane M. *Contemporary Mezzotints*. Williamstown, MA: Williams College Museum of Art, 1978.

Brody, Jacqueline. "New Prints with a Question of Taste." *Print Collector's Newsletter* 10, no. 4 (September–October 1979): 109–119. [Jaqueline Brody interviews Brooke Alexander, Riva Castleman, Richard Field, Alex Katz, Kathryn Markel, and Janice Oresman.]

Bromberg, Craig. "That Collaborative Itch." *Art News* 87, no. 9 (November 1988): 160–3.

Capasso, Nicholas J. *Relief Printing in the 1980s: Prints and Blocks from the Rutgers Archives for Printmaking Studios*. New Brunswick, NJ: The Jane Voorhees Zimmerli Art Museum, Rutgers University, 1988.

Carey, Frances and Antony Griffiths. *American Prints, 1879–1979*. London: British Museum, 1980.

Castleman, Riva. *American Prints: 1913–1963*. Leeds, UK: The Arts Council of Great Britain, 1976.

———. *Printed Art: A View of Two Decades*. New York: The Museum of Modern Art, 1980.

———. *Prints from Blocks: Gauguin to Now*. New York: The Museum of Modern Art, 1983.

———. *American Impressions: Prints since Pollock*. New York: The Museum of Modern Art and Alfred A. Knopf, 1985.

———. *Prints of the Twentieth Century: A History*. London and New York: Thames and Hudson, 1988.

———. *Seven Master Printmakers: Innovations in the Eighties*. New York: The Museum of Modern Art, 1991.

Cebulski, F. "Microcosm of Printmaking." *Artweek* 14 (10 December 1983): 5–6.

"Checklist of Recent Print Catalogues." *Print Review* 13 (Spring 1981): 77–80.

Clisby, Roger D. *Contemporary American Monotypes*. Norfolk, VA: The Chrysler Museum, 1985.

Cohen, Ronny H. "Paper Routes." *Art News* 82, no. 8 (October 1983): 78–85.

———. "The New Graphic Sensibility Transcends Media." *Print Collector's Newsletter* 14 (November 1983): 157–59.

———. "Up and About: The Market for Contemporary Prints" *Print Collector's Newsletter* 20, no. 1 (March–April 1989): 10–14.

———. "Jumbo Prints: Artists Who Paint Big Want to Print Big." *Art News* 83, no. 8 (October 1984): 80–87.

———. "The Medium Isn't the Message." *Art News* 84, no. 8 (October 1985): 74–81.

———. "Prints about Art." *Print Collector's Newsletter* 16 (November 1985): 164–68.

———. "New Abstraction V." *Print Collector's Newsletter* 18 (March 1987): 9–13.

———. "Minimal Prints." *Print Collector's Newsletter* 21, no. 2 (May–June 1990): 42–46.

Contemporary Woodblock Prints. Jersey City, NJ: Jersey City Museum, 1990.

Coplans, John. *Serial Imagery.* Pasadena, CA: Pasadena Art Museum, 1968.

Curiger, Bice. *Looks et Tenebrae: Nine Monographs on the Portfolios Published by Peter Blum Edition (Neun Monographien zu den Portfolio der Peter Blum Edition).* New York and Zurich: Peter Blum Edition, 1984.

Curtis, Verna Posever. *American Prints 1960–1980.* Milwaukee: The Milwaukee Art Museum, 1982.

Davies, Hanlyn and Hiroshi Murata. *Art and Technology: Offset Prints.* Bethlehem, PA: Ralph Wilson Gallery, Lehigh University, 1983.

Dean, Sonia. *The Artist and the Printer: Lithographs 1966–1981: A Collection of Printer's Proofs.* Melbourne, Australia: National Gallery of Victoria, 1982.

DeDomizio, Lucrezia. "Jorg Schellmann." *Contemporanea* 2, no. 2 (June 1989): 68–71.

D'Oench, Ellen G., ed. *Collaborative Printmaking Today.* Middletown, CT: Davison Art Center, Wesleyan University, 1987.

Dolan, Margo. *Impressions I: Experimental Prints.* Philadelphia: Associated American Artists, 1984.

Donson, Theodore B. *Prints and the Print Market: A Handbook for Buyers, Collectors, and Connoisseurs.* New York: Thomas Y. Crowell, 1977.

Downey, Cleta H. *Lithography I: The First Biennial Exhibition of Contemporary Lithography.* Albuquerque: University Art Museum, University of New Mexico, 1975.

Dunham, Judith. *The Monumental Image.* Rohnert Park, CA: University Art Gallery, Sonoma State University, 1987.

Edition Schellmann, 1969–1989. Munich and New York: Edition Schellmann, 1989.

Eichenberg, Fritz. *The Art of the Print: Masterpieces, History, Techniques.* New York: Harry N. Abrams, Inc., 1976.

———. *Lithography and Silkscreen: Art and Technique.* New York: Harry N. Abrams, Inc., 1978.

"Expressionism Today: An Artists' Symposium." *Art in America* 70, no. 11 (December 1982): 58–75.

Farmer, Jane. *New American Paperworks.* San Francisco, CA: World Print Council, 1982.

Feinblatt, Ebria and Bruce Davis. *Los Angeles Prints, 1883–1980.* Los Angeles: Los Angeles County Museum of Art, 1980.

Feinstein, Roni. *American Print Renaissance, 1958–1988.* New York: Whitney Museum of American Art, 1988.

Field, Richard S. *Silkscreen: History of a Medium.* Philadelphia: Philadelphia Museum of Art, 1971.

———. "Silkscreen: The Media Medium" *Art News* 70, no. 9 (January 1972): 40–43, 74–75.

———. "The Painterly Print" *Print Collectors Newsletter* 11, no. 6, (January–February, 1981): 202–204.

———. *Recent American Etching.* Middletown, CT: Wesleyan University Davidson Art Center, 1975.

———. "Collaboration East and West: A Discussion." *Print Collector's Newsletter,* (January–February 1986): 196–205. [Richard Field moderates a discussion with Jennifer Bartlett, Alex Katz, Michael Berdan, Clifford S. Ackley, Pat Gilmour, and Robert Flynn Johnson.]

———. "On Recent Woodcuts." *Print Collector's Newsletter* 13, no. 1 (March–April, 1982): 1–6.

——— and Daniel Rosenfeld. *Prints by Contemporary Sculptors.* New Haven, CT: Yale University Art Gallery, 1982.

——— and Louise Sperling. *Offset Lithography.* Middletown, CT: Wesleyan University Press, 1973.

——— and Ruth Fine. *A Graphic Muse: Prints by Contemporary American Women.* South Hadley, MA: Mount Holyoke College Art Museum; New York: Hudson Hills Press, 1987.

Finch, Christopher. "Breaking Through the Print Barrier" *Art News* 70, no. 9 (January 1972): 34–39.

Fine, Ruth, ed. *The 1980s: Prints from the Collection of Joshua P. Smith.* Washington, DC: National Gallery of Art, 1989.

Flint, Janet. *New Ways with Paper.* Washington, DC: National Collection of Fine Arts, 1978.

Fort Worth Art Museum. *The Pop Art Print.* Fort Worth, TX: Fort Worth Art Museum, 1984.

Fryberger, Betsy G. *The Anderson Collection: Two Decades of American Graphics 1967–1987: Prints, Multiples, Monotypes, Works on Paper.* Stanford, CA: Stanford University Museum of Art, 1987.

Gambrell, Jamey. "All the News That's Fit for Prints: A Parallel of Social Concerns of the 1930s and 1980s." *The Print Collector's Newsletter* 18, no. 2 (May–June 1987): 52–55.

Gilmour, Pat. *Modern Prints.* London and New York: Studio Vista, 1970.

———. *The Mechanized Image: An Historical Perspective on 20th Century Prints.* London: Arts Council of Great Britain, 1978.

————, ed. *Lasting Impressions: Lithography as Art*. London: Alexandria Press, 1988.

———— and Anne Willsford. *Paperwork*. Canberra: Australian National Gallery; Philadelphia: University of Pennsylvania Press, 1982.

Glaubinger, Jane. *Paper Now: Bent, Molded, and Manipulated*. Cleveland, OH: The Cleveland Museum of Art and the Indiana University Press, 1986.

Glueck, Grace. "Two Print Shows Testify to the Vitality of the Print." *New York Times* (Sunday, 9 December 1984).

Goldman, Judith. "Sort of A Commercial for Objects." *Print Collector's Newsletter*, (January–February 1972) 117–121.

————. "Print Criteria." *Art News* 70, no. 9 (January 1972): 48–51.

————. "The Print Establishment: Part I." *Art in America* 61, no. 4 (July–August 1973): 105–109.

————. "The Print Establishment: Part II." *Art in America* 61, no. 5 (September–October 1973): 102–104.

————. *Brooke Alexander: A Decade of Print Publishing*. Boston: Boston University Art Gallery, 1978.

————. *Print Publishing in America*. Washington, DC: United States International Communication Agency, 1979.

————. "Printmaking: The Medium Isn't the Message Anymore." *Art News* 79, no. 3 (March 1980): 82–85.

————. "The Proof is in the Process: Painters as Printmakers." *Art News* 80, no. 7 (September 1981): 148–151.

————. *American Prints: Process and Proofs*. New York: Whitney Museum of American Art, 1981.

————. "Twenty-Five Years of American Prints and Printmaking, 1956–1981." *Print Review* 13 (Spring 1981): 7–14.

————. *Block Prints*. New York: Whitney Museum of American Art, 1982.

————. "Woodcuts: A Revival?" *Portfolio* 4 (November 1982): 66–71.

————. *Print Acquisitions 1974–1984*. New York: Whitney Museum of American Art, 1984.

————. *Twentieth Century American Printmakers*. New York: Whitney Museum of American Art, 1984.

Goodman, C.J. *A Study of the Economic Aspects of a Lithography Workshop*. Los Angeles: Tamarind Lithography Workshop, 1963.

————. *A Study of the Marketing of the Original Print*. Los Angeles: Tamarind Lithography Workshop, 1964.

————. *Acquiring an Inventory of Original Prints: An Art Market Study*. Los Angeles: Tamarind Lithography Workshop, 1968.

————. "Monotype: A Singular Form." *American Artist* 45 (January 1981): 58–63.

Graham, F. Lanier. *The Spontaneous Gesture: Prints and Books of the Abstract Expressionist Era*. Canberra: Australian National Gallery, 1987; Seattle: University of Washington Press, 1989.

Grant, A. "Art First, Printmaking Second." *Art and Artists*, no. 221 (February 1985): 23–25.

Greene, David A. *Second State: The New Painter/Printmaker*. Middletown, CT: Davidson Art Center, Wesleyan University, 1990.

Grundberg, Andy and Katherine McCarthy Gauss. *Photography and Art: Interactions Since 1946*. Fort Lauderdale, FL: Florida Museum of Art; New York: Abbeville Press, 1987.

Gustafson, Donna. *Surface Printing in the 1980s: Lithographs, Screenprints, and Monotypes from the Rutgers Archive for Printmaking Studios*. New Brunswick, NJ: The Jane Voorhees Zimmerli Art Museum, Rutgers University, 1989.

Hansen, Trudy V. *Intaglio Printing in the 1980s: Prints, Plates, and Proofs from the Rutgers Archive for Printmaking Studios*. New Brunswick, NJ: The Jane Voorhees Zimmerli Art Museum, Rutgers University, 1990.

———— and Eleanor Heartney. *Presswork: The Art of Women Printmakers*. New York: Lang Communications, 1991.

Heartney, Eleanor. "Images and Impressions at the Walker Art Center: Belief in the Possibility of Authenticity." *Arts* 59, no. 4 (December 1984): 118–121.

Heller, Jules. *Printmaking Today: A Studio Handbook* (2nd ed.). New York: Holt, Rinehart and Winston, Inc., 1972.

Henry, Gerrit. "Paper in Transition." *Print Collector's Newsletter* 10, no. 3 (July–August 1979): 83–86.

Hess, Thomas B. "Prints: Where History, Style and Money Meet." *Art News* 70, no. 9 (January 1972): 29, 66–67.

Howard, Jan. *Marking the Decades: Prints 1960–1990*. Baltimore, Maryland: The Baltimore Museum of Art, 1992.

International Index of Multiples, from Duchamp to the Present. Köln: Verlag der Buchhandlung Walther Køonig, 1993

Ives, Colta, et al. *The Painterly Print: Monotypes from the 17th to the 20th Century*. New York: Metropolitan Museum of Art, 1980.

Ivins, William M., Jr. *Prints and Visual Communication*. Cambridge, MA: Harvard University Press; New York: Da Capo Press, 1953. Cambridge, MA: MIT Press, 1978.

Jacobowitz, Ellen, and Ann Percy. *New Art on Paper: Acquired with Funds from the The Hunt Manufacturing Co*. Philadelphia: Philadelphia Museum of Art, 1988.

Janis, Eugenia Parry. "Deviation and Its Imperatives—The Plight of the Unique Print." *Print Collector's Newsletter* 21, no. 6 (January–February 1991): 211–213.

Johnson, Elaine L. *Contemporary Painters and Sculptors as Printmakers*. New York: The Museum of Modern Art, 1966.

Johnson, Una E. *American Prints and Printmakers: A Chronicle of over 400 Artists and their Prints from 1900 to the Present*. Garden City, NY: Doubleday & Co., 1980.

————. *Fifteenth National Print Exhibition*. Brooklyn: The Brooklyn Museum, 1966.

————. *Sixteenth National Print Exhibition*. Brooklyn: The Brooklyn Museum, 1968.

Kainen, Jacob. *Photography in Printmaking*. New York: Associated American Artists, 1968.

Karn, Lynn. *Works on Twinrocker Handmade Paper*. Indianapolis, IN: Indianapolis Museum of Art, 1975.

Karshan, Donald. "The Unprecedented Print Phenomenon." *Auction* 3, no. 4 (January 1970): 32–34.

———. "The End of 'the Cult of the Unique'." *Studio International* 181, no. 934 (June 1971): 285–288.

Kase, Thelma Green. *The Artist, the Printer, and the Publisher: A Study in Printmaking Partnerships, 1960–1970*. Unpublished Master's Thesis, University of Missouri, 1973.

Katz, Vincent. "An Interview with Peter Blum." *Print Collector's Newsletter* 21, no. 4 (September–October 1990): 136–140.

Kelder, Diane. "Tradition and Craftsmanship in Modern Prints." *Art News* 70, no. 9 (January 1972): 56–59, 69–73.

———. "The Graphic Revival." *Art in America* 61, no. 4 (July–August 1973): 110–113.

Kolstern Steve. *Cucchi, Fischl, Kruger, Stadler, Turrell*. Groningen, Holland: Groningen Museum and New York: Peter Blum Editions, 1985.

Krauss, Rosalind. "Retaining the Original? The State of the Question." *Retaining the Original: Multiple Originals, Copies, and Reproductions. Studies in the History of Art* 20, Center for Advanced Study in the Visual Arts Symposium Papers VII. Washington, DC: National Gallery of Art, 1989.

Kreneck, Lynwood. *Color Print USA*. Lubbock, TX: Texas Tech University, 1983.

La Charité, Mary Garity, ed. *Pop! Prints from the Milwaukee Art Museum*. Milwaukee: The Milwaukee Museum of Art, 1993.

Larson, Philip. "Words in Print." *Print Collector's Newsletter* 5, no. 3 (July–August 1974): 53–56.

———. "Aquatints Again." *Print Collector's Newsletter* 8, no. 3 (July–August 1977): 61–65.

———. "New Expressionism." *Print Collector's Newsletter* 15, no. 6 (January–February 1985): 199–200.

Lewallen, Constance M. and Beth Wilson. *Print Factory: America. From Warhol to Longo*. Tokyo: Nippon Advisart K.K., 1990.

Lewis, L. "Point of View, the Print and the Mass Media." *Artweek*, no. 10 (1 December 1979): 3.

Long, Paulette, ed. *Paper — Art & Technology: Based on Presentations Given at the International Paper Conference Held in San Francisco, March 1978*. San Francisco: World Print Council, 1979.

Loring, John. "Bad Printing." *Print Collector's Newsletter* 6, no. 1 (March–April 1975): 1–3, 21.

Lovejoy, Margot. "Innovations in American Printmaking: 1956–1981." *Print Review* 13 (Spring 1981): 38–54.

Lynton, N., et al. *Minimal Art: Prints*. Hanover, West Germany: Kestner Gesellschaft, 1976.

Meisel, Susan Pear. *The Complete Guide to Photo-Realist Printmaking*. New York: Louis K. Meisel Gallery, 1978.

Miller, Jo. *Eighteenth National Print Exhibition*. Brooklyn: The Brooklyn Museum, 1973.

———. "Pricing Prints or The Poor Man's Art?" *Print Collector's Newsletter* 6, no. 1 (March–April 1975): 4–11.

Minimalist Prints. New York: Susan Sheehan Gallery, 1990.

New American Paperworks. San Francisco: World Print Council, 1982.

Newton, Charles. *Photography in Printmaking*. London: Victoria and Albert Museum and Pitman, 1979.

Offset Prints. South Hadley, MA: Mount Holyoke College Art Museum, 1977.

"On Art: The Revival of Lithography." *Architectural Digest* 27, no. 5 (March–April 1971): 4, 68–77.

Perkins, Larry D. *Collaborative American Printmaking*. Syracuse, NY: Joe and Emily Lowe Art Gallery, Syracuse University, 1988.

Phillips, Deborah C. "Definitely Not Suitable for Framing." *Art News* 80, no. 10 (December 1981): 62–67.

———. "Looking for Relief? Woodcuts are Back." *Art News* 81, no. 4 (April 1982): 92–96.

"Printmakers Choose Printmakers." *Visual Dialog* 4 (Summer 1979): 32–35.

Prints/Multiples. Seattle: University of Washington, 1969.

Ratcliff, Carter. *Hand Colored Prints 1973*. New York: Brooke Alexander, Inc., 1973.

Riggs, Timothy A. "Two Decades of American Printmaking: 1957–1977." *Worcester Art Museum Bulletin* 7, nos. 1 & 2 (February 1978): 1–26.

Robison, Andrew. *Paper in Prints*. Washington, DC: National Gallery of Art, 1977.

Roder, S. "Monotypes for all Seasons." *Artweek* 15 (November 17, 1984): 1.

Rosenthal, Nan. "Brightening the Scene: List Art Posters." *Art in America* 53, no. 2 (April 1965): 56–65.

Ross, Conrad H. "The Monoprint and the Monotype: A Case of Semantics." *Art Voices South* 2, no. 4 (July–August 1979): 89–91.

Ross, John, Clare Romano, and Tim Ross. *The Complete Printmaker. Techniques/Traditions/Innovations* (revised and expanded edition). New York: The Free Press, 1990.

Ruhe, Harry. *Multiples, et cetera*. Amsterdam: Tuja Books, 1991.

Sacilotto, Deli. *Photographic Printmaking Techniques*. New York: Watson-Guptill, 1982.

——— and Donald Saff. *Printmaking: History and Process*. New York: Holt, Rinehart and Winston, 1978.

Saff, Donald. *Modern Masters of Intaglio*. Flushing, NY: Paul Klapper Library, Queens College, 1965.

———, ed. "Printmaking: The Collaborative Art." *Art Journal* 39, no. 3 (Spring 1980): 167.

———. *Screenprinting: History and Process*. New York: Holt, Rinehart and Winston, 1979.

Saft, Carol. *Artist and Printer: Printmaking as a Collaborative Process*. New York: Pratt Graphics Center, 1981.

Schwartzman, Allan. "Committed to Print." *Print Collector's Newsletter* 19, no. 2 (May–June 1988): 41–47.

Selected Prints 1960–1977. New York: Brooke Alexander Editions, 1977.

Servis, Nancy. *Process and Print*. Bronxville, NY: Sarah Lawrence College Art Gallery, 1988.

Shapira, Nathan. *Big Prints from Rome: 2RC*. Los Angeles: Center for Contemporary Culture, 1980.

Smagula, Howard J. "Printmaking: Art in the Age of Mechanical Reproduction." In *Currents: Contemporary Directions in the Visual Arts*, 99–133. Englewood Cliffs, NJ: Prentice Hall, 1989.

Small, Janus. *Art as Progressive: Prints from a Corporate Collection*. Cleveland, Ohio: The New Gallery of Contemporary Art, 1983.

Smith, Robert. *Prints by Los Angeles Artists*. Los Angeles: California State University, 1987.

Solomon, Elke. *Oversize Prints*. New York, NY: The Whitney Museum of American Art, 1971.

Spencer, Charles. *A Decade of Printmaking*. London: Academy Editions; and New York: St. Martins Press, 1973.

Stasik, Andrew. "Toward a Broader View and Greater Appreciation of America's Graphic Artist: The Printmaker, 1956–1981." *Print Review* 13 (Spring 1981): 24–37.

Stein, Donna. "Photography in Printmaking." *Print Review* 16 (1983): 4–20.

Stevens, Elisabeth. *Prints Today*. The Washington Print Club, 1971.

Stretch, Bonnie Barrett. "Prints and Photographs: A Rich Mix of Mediums." *Art News* 87, no. 2 (February 1988): 56, 62.

Sundell, Nina Castelli. *The Turning Point: Art and Politics in 1968*. Cleveland: Cleveland Center for Contemporary Art, 1988.

Tallman, Susan. "Independent Print Publishers: The New Breed." *Print Collector's Newsletter* 17, no. 5 (November–December 1987): 160–167.

———. "The Woodcut in the Age of Mechanical Reproduction." *Arts* 65, no. 5 (January 1989): 21–22.

———. *Contemporary Woodblock Prints*. Jersey City, New Jersey: Jersey City Museum, 1990.

Tancock, John L. *Multiples: The First Decade*. Philadelphia: The Philadelphia Museum of Art, 1971.

Taylor, Sue. *Pop! Prints from the Milwaukee Art Museum*. Milwaukee, WI: Milwaukee Art Museum, 1993.

Three to Infinity: New Multiple Art. London: Whitechapel Art Gallery, 1970.

The Unique Touch: Monotypes. Milwaukee: Milwaukee Art Museum, 1989.

Tyler, Kenneth E. et al. "Printing Today: Eight Views." *Print Collector's Newsletter* 13, no. 6 (January–February 1983): 190–200. [Ken Tyler moderates a discussion with Pat Branstead, Chip Ewell, Alexander Heinrici, Jack Lemon, Bud Shark, Judith Solokin, and Jeff Wasserman.]

Velesco, Frances, and Suzanne Fried. "Combining Color Xerography with the Techniques of Silkscreen and Intaglio." *Leonardo* 17, no. 1 (Spring 1984): 27–31.

Volmer, Suzanne. "Drawings and Prints: As the Twain Meet." *Arts* 57, no. 6 (February 1983): 84–85.

Walker, Barry. *The American Artist as Printmaker: 23rd National Print Exhibition*. Brooklyn, NY: The Brooklyn Museum, 1983.

———. *Public and Private: American Prints Today: The Twenty-Fourth National Print Exhibition*. Brooklyn, NY: The Brooklyn Museum, 1986.

———. *The Combination Print 1980's*. Summit, NJ: New Jersey Center for the Visual Arts, 1988.

———. *Projects and Portfolios: The Twenty-Fifth National Print Exhibition*. Brooklyn, NY: The Brooklyn Museum and Hines Editions, 1989.

———. "The Single State." *Art News* 83, no. 3 (March 1984): 60–65.

Walker, Samuel, and Larry J. Feinberg. *Acid and Light: Contemporary Photo-Etchings*. Oberlin, OH: Allen Memorial Art Museum, Oberlin College, 1987.

Watrous, James. *A Century of American Printmaking, 1880–1980*. Madison, WI: The University of Wisconsin Press, 1984.

———. *American Color Woodcuts: Bounty from the Block, 1890s–1990s*. Madison, WI: Elvehjem Museum of Art, University of Wisconsin–Madison, 1993.

Weidemann, K. *30 Jahre Domberger, 20 Jahre Haas, 15 Jahre Kicherer: 3 Werkstatten zeigen Serigraphien von 120 Kunstleren*. Tübingen, Germany: Kunsthalle, 1979.

Weitman, Wendy. *For Twenty-Five Years: Brooke Alexander Editions*. New York: The Museum of Modern Art, 1994.

Williams, Reba and Dave. *American Screenprints*. New York: National Academy of Design, 1987.

———. *Black and White Since 1960*. Raleigh, North Carolina: City Gallery of Contemporary Art, 1989.

Wilson, William H. "Revolutionary Street Poster Workshop: Boston, Spring 1970." *Print Collector's Newsletter* 7, no. 3 (July–August 1976): 77–80.

Wye, Deborah. *Committed to Print: Social and Political Themes in Recent American Printed Art*. New York, NY: The Museum of Modern Art, 1988.

Young, Joseph E. "Serial Prints." *Print Collector's Newsletter* 6, no. 4 (September–October 1975): 89–93.

PART II: PRINTMAKING WORKSHOPS

Acton, David, et. al. *Working Proof: Experimental Etching Studio.* Boston, MA: Boston Public Library, 1992.

Adams, Clinton. "Margaret Lowengrund and The Contemporaries." *Tamarind Papers* 7, no. 1 (Spring 1984): 17–23.

———. *Printmaking in New Mexico, 1880–1990.* Albuquerque, NM: University of New Mexico Press, 1991.

——— and Garo Z. Antreasian. *The Tamarind Book of Lithography: Art and Techniques.* Los Angeles: The Tamarind Lithography Workshop and New York: Harry N. Abrams, Inc., 1971.

——— and June Wayne. "Tamarind Anniversary Album." *Tamarind Papers* 4, no. 1 (Winter 1980–81): 6–12.

Adrian, Dennis. *Master Prints from Landfall Press.* Chicago: David and Alfred Smart Gallery, The University of Chicago, 1980.

Allen, Virginia. *Tamarind: Homage to Lithography.* New York: The Museum of Modern Art and Greenwich, CT: New York Graphic Society, 1969.

American Federation of Arts. *Contemporary Intaglios: The Etching Process.* New York: American Federation of Arts, 1974.

Andersen, Steven. *Vermillion Publications: 1978–1983.* Vol. I. Minneapolis: Vermillion Editions, 1983.

Antreasian, Garo Z. "Ken Tyler, Master Printer, and the American Print Renaissance." *Tamarind Papers* 9, no. 1 (Spring 1986): 32–36.

Armstrong, Elizabeth. *Prints from Tyler Graphics.* Minneapolis: Walker Art Center, 1984.

———, Pat Gilmour and Kenneth Tyler. *Tyler Graphics: The Extended Image.* Minneapolis: Walker Art Center; New York: Abbeville Press, 1987.

Ball, Maudette. *Black Dolphin Prints.* Long Beach, CA: The Art Galleries of California State University-Long Beach, 1978.

Baro, Gene. *Graphicstudio USF: An Experiment in Art and Education.* Brooklyn: The Brooklyn Museum, 1978.

Baskett, Mary Welsh. *American Graphic Workshops: 1968.* Cincinnati, OH: The Cincinnati Museum, 1968.

Beal, Graham. *Artist and Printer: Six American Print Studios.* Minneapolis: Walker Art Center, 1980.

Becker, David P. *Vinalhaven at Bowdoin: One Press, Multiple Impressions.* Brunswick, ME: Bowdoin College Museum of Art, 1992.

Bloch, E. Maurice. *Tamarind: A Renaissance of Lithography.* Washington, DC: International Exhibitions Foundation, 1971.

———. *Words and Images: Universal Limited Art Editions.* Los Angeles, CA: The Frederick S. Wight Art Gallery, 1978.

Bossman, Michael. *You Have the Tools: Social Serigraphy in the Bay Area 1966–1986.* Santa Clara, CA: Santa Clara University, de Saisset Museum, 1987.

Brach, P. *Lithographs from Gemini.* San Diego: San Diego Art Gallery, University of California, 1968.

Brodsky, Judith H. *Master Prints from the Rutgers Center for Innovative Printmaking: The First Five Years.* Princeton, NJ: The Gallery at Bristol-Meyers Squibb, 1992.

Brooke, Alexander. *A Decade of Print Publishing.* Boston: Boston University Art Gallery, 1978.

Brown, Kathan. *Crown Point Press.* San Francisco, CA: Emanuel Walter Gallery, San Francisco Art Institute, 1972.

———. "Wasting and Wasting Not: How (And Why) Artists Work at Crown Point Press." *Art Journal* 39, no. 3 (Spring 1980): 176–179.

Butler, Charles T., and Marilyn Laufer. *Recent Graphics from American Print Shops.* Mount Vernon, IL: Mitchell Museum, 1986.

Castleman, Riva. *Technics and Creativity: Gemini G.E.L.* New York: The Museum of Modern Art, 1971.

Cate, Philip Dennis and Jeffrey Wechsler. *The Rutgers Archives for Printmaking Studios.* New Brunswick, NJ: The Jane Voorhees Zimmerli Art Museum, 1983.

Cebulski, F. "Sculptors as Printmakers (Crown Point Press)." *Artweek* 13 (August 28, 1982): 16.

Clothier, P. "Decade at Cirrus, 1970–1980, Los Angeles." *Artweek* 11 (January 26, 1980): 7.

Cockburn, C. "Comment: The Printers and Their Skill, a Craft Destroyed." *Crafts* no. 60 (January–February 1983): 12–14.

Cohen, Sarah R. "Print Workshops U.S.A. II — A Listing." *Print Collector's Newsletter* (January–February 1993): 210–218.

Cohrs, Timothy. "Hudson River Editions, Pelavin Editions—A Report Back From the Other-World of Printmaking." *Arts* 61, no. 3 (November 1986): 41–43.

Collaboration in Print: Stewart & Stewart Prints, 1980–1990. Ann Arbor, MI: Washtenaw Community College Foundation, 1990.

Contemporary American Prints from Universal Limited Art Editions: The Rapp Collection. Toronto: Art Gallery of Ontario, 1979.

Cowart, Jack and James Elliott. *Prints from the Untitled Press/Captiva, Florida.* Hartford, CT: Wadsworth Atheneum, 1973.

Cronin, Patricia Ann. *History of Shark's Lithography Ltd* (Unpublished thesis). Denver: University of Denver, 1983.

Cudd, Patricia and Trudy V. Hansen. *The Rutgers Archives for Printmaking Studios: Catalogue of the Acquisitions 1988–1990.* New Brunswick, NJ: The Jane Voorhees Zimmerli Art Museum, Rutgers University, 1992.

——— and Maggie Patrick. *The Rutgers Archives for Printmaking Studios: Catalogue of the Aquisitions 1991–1993.* New Brunswick, NJ: The Jane Voorhees Zimmerli Art Museum, Rutgers University, 1994.

Dane, William J. and Deborah Cullen. *The Robert Blackburn Legacy: The Printmaking Workshop at Forty-Five.* Newark, NJ: The Newark Public Library, 1994.

Danieli, Fidel A. "Gemini Ltd.: New Lithography Workshop in Los Angeles." *Artforum* 4, no. 8 (April 1966): 20–22.

Davis, Bruce. *Made in Los Angeles: The Prints of Cirrus Editions.* Los

Angeles: Los Angeles County Museum of Art, 1994.

Dean, Sonia. *The Artist and the Printer: Lithographs, 1966–1981*. Victoria, Canada: The National Gallery of Victoria, 1982.

Devon, Margorie. *Tamarind: 25 Years*. Albuquerque: University of New Mexico Art Museum, 1985.

Driesbach, David F. *A Collaboration Between Printer and Artist*. DeKalb, IL: University of Northern Illinois, 1985.

Echo Press: A Decade of Printmaking. Bloomington, IN: Indiana University Art Museum, 1990.

Edition Schellmann 1969–1989: Catalogue Raisonné. Munich and New York: Edition Schellmann, 1989.

Faberman, Hilarie. *Hine Editions/Limestone Press: The Archive at Stanford University Museum of Art*. Stanford: Stanford University Museum of Art, 1994.

Farnsworth, Donald and David Kimball. *Magnolia Editions: Works on Paper, 1981–1992*. Oakland, CA: Magnolia Editions, 1992.

Fine Arts Presses of San Francisco and the Bay Area. San Francisco: Office of the Mayor, City of San Francisco, 1992.

Fine, Ruth E. *Gemini G.E.L.: Art and Collaboration*. Washington, DC: National Gallery of Art; New York: Abbeville Press, 1984.

Fine, Ruth E., David Joselit, and Genevieve Linnehan. *Donald Saff: Mixed Metaphors, 1956–1989*. Tampa, FL: Tampa Museum of Art, 1989.

Fine, Ruth E. and Mary Lee Corlett. *Graphicstudio: Contemporary Art from the Collaborative Workshop at the University of South Florida*. Washington, D. C.: National Gallery of Art, 1991.

Flint, Janet. *George Miller and American Lithography*. Washington, D.C.: The Smithsonian Institution National Collection of Fine Arts, 1976.

Fox, Louis. *Art of Collaboration: Monotypes from the Studio of Garner Tullis*. San Bernardino, CA: California State University, 1985.

Gedeon, Lucinda H. *Tamarind: From Los Angeles to Albuquerque*. Los Angeles: Gunwald Center for the Graphic Arts, University of California, 1984.

Gemini G.E.L. Genève: Musée Rath, 1973.

Gilmour, Pat. *Artists at Curwen: A Celebration of the Gift of Artists' Prints from the Curwen Studio*. London: Tate Gallery, 1977.

———. *Kelpra Studio: Artists' Prints 1961–1980*. London: Tate Gallery, 1980.

———. "Symbiotic Exploitation or Collaboration: Dine and Hamilton with Crommelynck." *Print Collector's Newsletter* 14, no. 6 (January–February 1984): 193–198.

———. *Ken Tyler, Master Printer, and the American Print Renaissance*. Canberra: Australian National Gallery; New York: Hudson Hills Press, 1986.

Glenn, Constance W. "Words and Images: ULAE at UCLA." *Print Collector's Newsletter* 9, no. 3 (July–August 1978): 75–77.

Goldman, Judith. "Gemini Prints at the Museum of Modern Art." *Print Collector's Newsletter* (May–June 1971): 30–31.

———. *Art Off the Picture Press: Tyler Graphics, Ltd.* Hempstead, NY:

Emily Lowe Art Gallery, Hofstra University, 1977.

———. "The Master Printer of Bedford, N.Y." *Art News* 76, no. 7 (September 1977): 50–54.

———. *Brooke Alexander: A Decade of Print Publishing*. Boston: Boston University Art Gallery, 1978.

Goodman, Calvin J. "Master Printers and Print Workshops." *American Artist* 40, no. 411 (October 1976): 67–74.

Gouma-Petersen, Thalia, Kathleen McManus Zurko, and Ruth E. Fine. *Prints from Solo Impression Inc*. Wooster, OH: The College of Wooster Art Museum, 1994.

Grafica Oggi: Contemporary Graphics from the Studio 2RC in Rome. New York, NY: The Finch College Museum of Art, 1974.

Grafton, Samuel. "Tamarind: Where Artist and Craftsman Meet," *Lithopinion*, Tamarind Lithography Workshop, undated.

Gray, Cleve. "Tamarind Workshop" *Art in America* 51, no. 5 (October 1963): 98–99.

———. "Tatyana Grosman's Workshop." *Art in America* 53, no.6 (December–January 1965–66): 83–85.

Groschwitz, Gustave von. *Tamarind: Suite Fifteen*. Albuquerque, Tamarind Institute and University of New Mexico Art Museum, 1977.

Henning, Robert Jr. "Artists-Research-Technology." *Print Review* 10 (1979): 4–12.

Hollander, Irwin, with Clinton Adams and Gustave von Groschwitz. "Life and Work: Thoughts of an Artist-Printer." *Tamarind Papers* 8, no. 1/2 (1985): 34–43.

Hotton, Julia, et. al. *Art in Print: A Tribute to Robert Blackburn*. New York: The New York Public Library, Astor, Lenox, and Tilden Foundation, 1984.

Hughes, Robert. "Gemini Rising: The Print Renaissance." *Time* (January 18, 1971): 56–57.

Jacobson, Cynthia and Lindsay Leard. *The Rutgers Archives for Printmaking Studios: Catalogue of the Acquisitions 1985–1987*. New Brunswick, NJ: The Jane Voorhees Zimmerli Art Museum, Rutgers University, 1988.

Jemison, Noah. *Bob Blackburn's Printmaking Workshop: Artists of Color*. New York: The Printmaking Workshop, 1992.

Jonas, Abner. *Kathan Brown, Publisher: A Selection of Prints by Crown Point Press*. Athens, OH: Trisolini Gallery, Ohio University, 1985.

Jones, Elizabeth. "Robert Blackburn, An Investment in an Idea." *Tamarind Papers* 6, no. 1 (Winter 1982–1983): 10–14.

Jones-Popescu, Elizabeth. "American Lithography and Tamarind Lithography Workshop/Tamarind Institute 1900–1980." Unpublished PhD. dissertation. Albuquerque: University of New Mexico, 1980.

Jones Road Print Shop and Stable 1971–1981: A Catalogue Raisonné. Madison: Madison Art Center, 1983.

Karson, Terry. *Universal Limited Art Editions*. Billings, MT: Yellowstone Art Center, 1990.

Katz, Vincent. "Graham Nash: An Interview." *Print Collector's Newsletter* (March–April 1992): 12–15.

Klein, Hillary Dole. "Pamela Auchincloss and Garner Tullis: An Open Door to Art." *Santa Barbara* 12, (April–May 1986).

Knigin, M. and M. Zimiles. *The Contemporary Lithography Workshop Around the World*. New York: Van Nostrand Reinholt, 1974.

Landfall Press: A Survey of Contemporary Prints (1970–1977). Chicago: Museum of Contemporary Art, 1977.

Langsner, Jules. "Is There An American Print Revival? Tamarind Workshop." *Art News* 60, no. 7 (January 1962): 34–35, 58.

Larson, Philip. *Prints from Gemini, G.E.L.: Johns, Kelly, Lichtenstein, Motherwell, Nauman, Rauschenberg, Serra, Stella*. Minneapolis: Walker Art Center, 1974.

Leering, J. *Gemini G.E.L.: Experiment in Grafiek*. 1971.

Lehrer, Leonard. "Artist and Printer: Some Matches are Made in Heaven and Others…" *Tamarind Papers* 8, no. 1/2 (1985): 44–49.

"Lithographs and Original Prints" *Studio International* 172, no. 884 (December 1966): 1–20. Special "Print Supplement," first of several biannual supplements published in December and June of each year.

Lithographs from Gemini. Davis, CA: Memorial Union Art Gallery, University of California, Davis, 1969.

Lithographs from the Tamarind Workshop. Los Angeles: University of California, Los Angeles Art Galleries, 1962.

Luminous Impressions: Prints From Glass Plates. Charlotte, NC: Mint Museum, 1987.

Mayfield, Signe. *Directions in Bay Area Printmaking: Three Decades*. Palo Alto, CA: Palo Alto Cultural Center, 1992.

Morano, Lizbeth. *Parasol and Simca: Two Presses, Two Processes*. Lewisburg, PA: Center Gallery of Bucknell University, 1984.

Moser, Joann. *Landfall Press 1970–1980*. Washington, D.C.: United States Information Agency, 1981.

———. "Paper Alchemy at Pyramid Atlantic." *Hand Papermaking* 8, no. 1 (Summer 1993): 11–14.

One of a Kind Monoprints: A Creative Process. Minneapolis: Forecast Public Artspace Productions, 1985.

Newland, Amy Reigle. *Paperworks from Tyler Graphics*. Minneapolis: Walker Art Center, 1985.

Parris, Nina. *Through a Master Printer: Robert Blackburn and The Printmaking Workshop*. Columbia, SC: The Columbia Museum, 1985.

———. *Robert Blackburn, A Life's Work*. New York: The Alternative Museum, 1988.

Perkins, Pamela Gruninger. *Nine Printmakers and the Working Process*. Stamford, CT: Whitney Museum of American Art, Fairfield County, 1985.

Peters, Lisa. "Print Workshops USA—A Listing." *Print Collector's Newsletter* 13, no. 6 (January–February 1983): 201–206.

Phillips, Deborah C. "Artist and Printer: A Coincidence of Sympathies." *Art News* 80, no. 3 (March 1981): 100–106.

Plous, Phyllis. (ed.) *Collaborations in Monotype*. Santa Barbara, CA: University of California Santa Barbara Art Museum; Seattle: University of Washington Press, 1988.

———. *Collaborations in Monotype II: Garner Tullis Workshop*. Santa Barbara, CA: University of California Santa Barbara Art Museum, 1989.

Printers' Impressions: Honoring the Work of Robert Blackburn, Kathan Brown, Serge Lozingot, Kenneth Tyler. Albuquerque: The Tamarind Institute and The University of New Mexico Art Museum, 1990.

"Printing Today: Eight Views." *Print Collector's Newsletter* (January–February 1983): 189–200.

"Private Presses: In and Around Oakland, A Roundup." *Print Collector's Newsletter* 13, no. 3 (July–August 1982): 94.

"Private Presses, New Publishing, New Style." *Print Collector's Newsletter* 14 (November/ December 1983) 169–70.

Pulin, Carol. *Guide to Print Workshops in Canada and the United States*. Washington, D.C.: American Print Alliance, 1993.

Ritchie, Charles. *Gemini G.E.L.: Recent Prints and Sculpture*. Washington: National Gallery of Art, 1994.

Rosenthal, Mark. *Artists at Gemini G.E.L.: Celebrating the 25th Year*. Los Angeles: Gemini G.E.L.; New York: Harry N. Abrams, Inc., 1993.

Saft, Carol. "The Growth of Print Workshops and Collaborative Printmaking Since 1956." *Print Review* 13 (Spring 1981): 55–68.

Sam Francis: The Litho Shop 1970–1979. New York: Brooke Alexander Gallery, 1979.

San Francisco Area Printmakers. Cincinnati: Cincinnati Art Museum, 1973.

Slaton, Amy, "Pratt Graphics Center: 1956–1981." *Print Review* 13 (Spring 1981): 15–24.

Schnelker, Rebecca, and Judith Booth. *Tamarind Lithographs. A Complete Catalogue of Lithographs Printed at the Tamarind Institute 1970–1979*. Albuquerque, NM: Tamarind Institute, 1980.

Shark, Bud. *Recent Prints*. Boulder, CO: Shark's Inc., 1992.

Shaw, L. E. "Kathan Brown and Crown Point Press." *Art Papers* (May–June 1986): 6–7.

Sherrill. Robert. "Gemini G.E.L." *Lithopinion* 5, no. 2 (Summer 1970): 50–63.

Smith, Kathryn A. et. al. *Made in California: An Exhibition of Five Workshops*. Los Angeles: Grunwald Graphic Arts Foundation, Dickson Arts Center, University of California Los Angeles, 1971.

Sparks, Esther and Amei Wallach. *Universal Limited Art Editions: A History and Catalogue, The First Twenty-Five Years*. Chicago: Art Institute of Chicago; New York: Harry N. Abrams, 1989.

Spencer, Charles. *A Decade of Printmaking*. London, England: Academy Editions; New York: Saint Martin's Press, 1973.

Sprout, Sally. "Bud Shark, Master Printer." *Ocular* (Fall 1977): 57–58.

Tabak, May Natalie. "Tamarind Lithography Workshop," *Craft Horizons* 30, no. 5 (October 1970): 28–33, 63–64.

———. "Herring." *Craft Horizons* 31, no. 1 (February 1971): 34–37, 60.

Tamarind 25 Years: 1960–1985. Albuquerque: University of New Mexico Art Museum, 1985.

Tancock, John, L. *Multiples: The First Decade.* Philadelphia: Philadelphia Museum of Art, 1971.

Three Contemporary Presses. New York: Associated American Artists, 1989. [Echo Press, Seattle Publishing Co., and Sharks, Inc.]

"Three New Lithography Workshops." *Tamarind Technical Papers* 4 (July 1975) 63–64. [Shark's Lithography, Ltd.; Western Graphics Workshop, and Solo Press].

Tomkins, Calvin. "The Skin of the Stone." *Reports on Post-Modern Art.* New York: Viking Press, 1970. 55–83.

Tousley, Nancy. "In Conversation with Kathan Brown." *Print Collector's Newsletter* 13, no. 5 (November-December 1977): 129–134.

"An Interview with Kathan Brown of Crown Point Press." *California Society of Printmakers Newsletter* (Summer 1982): 3–6.

Towle, Tony and Peter Gale. *Contemporary American Prints from Universal Limited Art Editions/The Rapp Collection.* Toronto: Art Gallery of Ontario, 1979.

Tuten, Frederic. *Lithographs from Gemini.* Davis, CA: Memorial Union Art Gallery, University of California-Davis, 1969.

Tyler, Kenneth E. *Tyler Graphics: Catalogue Raisonné, 1974–1985.* Minneapolis: Walker Art Center; New York: Abbeville Press, 1987.

———. "Printing Today: Eight Views." *Print Collector's Newsletter* 13, no. 6 (January–February 1983): 190–200. [Ken Tyler moderates a discussion with Pat Branstead, Chip Ewell, Alexander Heinrici, Jack Lemon, Bud Shark, Judith Solokin, and Jeff Wasserman.]

Von Meier, K. *Lithographs, Gemini G.E.L.* San Antonio, TX: San Antonio Art League and Museum Association, 1968.

Wayne, June. *About Tamarind.* Los Angeles, 1969.

Weinberg, Adam P. *Aldo Crommelynck Master Prints with American Artists.* New York: Whitney Museum of American Art, 1989.

Wilkinson, Jeanne, *The Printmaking Workshop: Bob Blackburn's Collection.* Reading, PA: Freedman Gallery, Albright College, 1992.

Wittrock, Wolfgang. *25 Jahre Universal Limited Art Editions 1957–1982.* Dusseldorf: Wolfgang Wittrock Kunsthandel, 1982.

Yates, Sam. *The Intimate Collaboration: Prints from the Teaberry Press.* Knoxville, TN: Ewing Gallery of Art and Architecture, University of Tennessee, 1993.

Young, Joseph E. *Recent Prints from Gemini.* Los Angeles: The Los Angeles County Museum of Art, 1970.

———. "Los Angeles Gemini G.E.L." *Art International* (December 20, 1971): 7.

PART III: ARTISTS

ACCONCI, VITO

Armstrong, Elizabeth and Sheila McGuire. *First Impressions: Early Prints by Forty-Six Contemporary Artists.* Minneapolis: Walker Art Center; New York: Hudson Hills Press, 1989, 72–73.

Avgikos, Jan. "Interview: Vito Acconci." *Art Papers* 5, (January–February 1981): 1–5.

Kirshner, Judith R. *Vito Acconci: A Retrospective, 1969–1980.* Chicago, IL: Museum of Contemporary Art, 1980.

White, Robin. "Vito Acconci" [An Interview.] *View* 2, no. 5/6 (October–November 1979).

ALBERS, JOSEF

Bucher, François. *Josef Albers: Despite Straight Lines: An Analysis of his Graphic Constructions.* Cambridge, MA: MIT Press, 1977.

Feeney, Kelly. *Josef Albers: Works on Paper.* Alexandria, VA: Art Services International, 1991.

Gilmour, Pat. *Ken Tyler and the American Print Renaissance.* Canberra: Australian National Gallery, 1986. 37–46.

Hunter, Sam, et. al. *Josef Albers: Paintings and Graphics, 1917–1970.* Princeton, NJ: The Art Museum, Princeton University, 1971.

Josef Albers: Hommage to the Square. Wien: Hochschule für Angewandte Kunst, 1992.

Miller, Jo. *Josef Albers: Prints 1915–1976.* Brooklyn, NY: The Brooklyn Museum, 1973.

———. "Josef Albers and His Prints: Notes from the 1960s." *Print Review* 6 (1976): 76–80.

Tyler, Kenneth E. *Josef Albers: Embossed Linear Constructions.* Los Angeles: Gemini G.E.L., 1969.

———, Josef Albers, and Henry T. Hopkins. *Josef Albers: White Line Squares.* Los Angeles: Los Angeles County Museum of Art and Gemini G.E.L., 1966.

AMOS, EMMA

Bibby, Deirdre L. *Emma Amos: The Water Series.* New York: Parker Bratton Gallery, 1987.

Gouma-Peterson, Thelma, et al. *Emma Amos: Paintings and Prints 1982–1992.* Wooster, OH: The College of Wooster Art Museum, 1993.

Hooks, Bell. *Emma Amos: Changing the Subject: Paintings and Prints 1992–1994.* New York: Art in General, 1994.

ANUSZKIEWICZ, RICHARD

Richard Anuszkiewicz: Prints and Multiples 1964–1979. Williamstown, MA: Sterling and Francine Clark Art Institute, 1979.

Karshan, Donald H. "Graphics '70: Richard Anuszkiewicz." *Art in America* 58, no. 2 (March–April 1970): 56–59.

Varian, Elayne H. and Albert Stewart. *Richard Anuszkiewicz, Prints.* Tallahassee, FL: University Fine Art Galleries, Florida State University, 1980.

APPLEBROOG, IDA

Cohen, Ronny H. "Ida Applebroog: Her Books." *Print Collector's Newsletter* 15, no. 2 (May–June 1984): 49–51.

Feldman, Ronald, Lucy Lippard, et. al. *Ida Applebroog.* New York: Ronald Feldman Fine Arts, Inc., 1987.

ARAKAWA (SHUSAKU)

Arakawa and Madeline Gins. *The Mechanism of Meaning.* New York: Abbeville Press, 1988.

Loring, John. "Re Turning Points and Revolutions." *Print Collector's Newsletter* 13, no. 2 (May–June 1977): 37–39.

The Prints of Arakawa. Williamstown, MA: Williams College Museum of Art, 1979.

BALDESSARI, JOHN

Bruggen, Coosje van. *John Baldessari.* Los Angeles: The Museum of Contemporary Art; New York: Rizzoli International Publications, 1990.

Henry, Gerrit. "John Baldessari, Gentleman." *Print Collector's Newsletter* 20, no. 2 (May–June 1989): 51–53.

Hoffberg, Judith A. "Conceptual Bookmaking: A Conversation with John Baldessari." *Artweek* 22 (June 6, 1991): 18–19.

Tucker, Marcia and Robert Pincus–Witten. *John Baldessari: Work 1966–1980.* New York: The New Museum, 1981.

BARTLETT, JENNIFER

Armstrong, Elizabeth and Sheila McGuire. *First Impressions: Early Prints by Forty-Six Contemporary Artists.* Minneapolis: Walker Art Center; New York: Hudson Hills Press, 1989. 106–108.

Dunham, Judith. *The Monumental Image: Prints.* Rohnert Park, CA: Sonoma State University Art Gallery, 1987.

Field, Richard S. "Jennifer Bartlett: Prints, 1978–1983." *Print Collector's Newsletter,* vol. XV, no. 1 (March–April 1984): 1–6.

——— and Ruth E. Fine. *A Graphic Muse: Prints by Contemporary American Women.* South Hadley, MA: Mount Holyoke College Art Museum; New York: Hudson Hills Press, 1987. 48–54.

Goldman, Judith. *Three Printmakers: Jennifer Bartlett, Susan Rothenberg, Terry Winters.* New York: Whitney Museum of American Art, 1986.

Russell, John. *In the Garden: Jennifer Bartlett.* New York: Harry N. Abrams, Inc., 1982.

Scott, Sue A. and Richard S. Field. *Jennifer Bartlett: A Print Retrospective.* Orlando, FL: Orlando Museum of Art, 1993.

BASQUIAT, JEAN-MICHEL

Marshall, Richard. *Jean-Michel Basquiat.* New York: Whitney Museum of American Art, 1992 (distributed by Harry N. Abrams, Inc.).

BEARDEN, ROMARE

Gelburd, Gail, et. al. *A Graphic Odyssey: Romare Bearden as Printmaker.* Philadelphia, PA: University of Pennsylvania Press, 1992.

Kenner, Hugh. "Cut and Paste: Romare Bearden's Collages Reflect His Life in Many Worlds." *Art & Antiques* (May 1992): 96.

Schwartzman, Myron. *Romare Bearden, His Life and Art.* New York: Harry N. Abrams, 1990.

Sims, Lowery Stokes. *Romare Bearden.* New York: Rizzoli, 1993.

BEERMAN, JOHN

Coffey, John W. *Finding the Forgotten: Landscape Paintings by John Beerman.* Raleigh, NC: North Carolina Museum of Art, 1991.

Hansen, Trudy V. "An Interview at Hudson River Editions with Sylvia Roth, Mary Seibert, and John Beerman." *Intaglio Printing in the 1980s.* New Brunswick, NJ: The Jane Voorhees Zimmerli Art Museum, Rutgers University, 1990. 22–28.

BOCHNER, MEL

Cummings, Paul. "Interview: Mel Bochner Talks with Paul Cummings." *Drawing* 10, (May–June 1988): 9–13.

French, Christopher. "Making the Simple Complicated." *Artweek* (November 9, 1985): 3.

King, Elaine A. and Charles Stuckey. *Mel Bochner: 1973–1985.* Pittsburgh: Carnegie–Mellon University Art Gallery and Carnegie Mellon University Press, 1985.

"Mel Bochner's Art as a Study of Mental Process." *Arts* 58 (May 1984): 86–89.

Prints: Bochner, Lewitt, Mangold, Marden, Martin, Renouf, Rockburne, Ryman. Toronto: Art Gallery of Toronto, 1975.

Schwabsky, Barry. "Reverse Continuity: The Prints of Mel Bochner." *Print Collector's Newsletter* 25, no. 3 (July–August 1994): 85–88.

BONTECOU, LEE

Field, Richard S. *Prints and Drawings by Lee Bontecou.* Middletown, CT: Davison Art Center, Wesleyan University, 1975.

Sparks, Esther and Amei Wallach. *Universal Limited Art Editions: A History and Catalogue, the First Twenty-Five Years.* Chicago: Art Institute of Chicago; New York: H.N. Abrams, 1989. 50–54, 287–297.

Towle, Tony. "Two Conversations with Lee Bontecou." *Print Collector's Newsletter* 2, no. 2 (May–June 1971): 25–28.

BOSMAN, RICHARD

Armstrong, Elizabeth and Sheila McGuire. *First Impressions: Early Prints by Forty-Six Contemporary Artists.* Minneapolis: Walker Art

Center; New York: Hudson Hills Press, 1989. 118–119.

Hoyem, Andrew. "Working Together: Collaboration in the Book Arts." *Visible Language* 25 (Spring 1991): 197–215.

Stevens, Andrew. *Prints by Richard Bosman: 1978–1988.* Madison, WI: Elvehjem Museum of Art, The University of Wisconsin, 1989.

Tallman, Susan. "Prints and Editions: High Tide, Low Tide —The Unsettling Work of Richard Bosman." *Arts* 65 (February 1991): 13–14.

BROWN, ROGER

Adrian, Dennis and Richard A. Born. *The Chicago Imagist Print: Ten Artists' Works, 1958–1987: A Catalogue Raisonné.* Chicago: The David and Alfred Smart Gallery, The University of Chicago, 1987.

BUCK, JOHN

Armstrong, Elizabeth and Sheila McGuire. *First Impressions: Early Prints by Forty-Six Contemporary Artists.* Minneapolis: Walker Art Center; New York: Hudson Hills Press, 1989. 120–121.

Guenther, Bruce. *John Buck.* San Antonio, TX: San Antonio Art Institute, 1987.

Guheen, Elizabeth. *John Buck.* Billings, MT: Yellowstone Art Center, 1983.

Porges, Maria. "The Look of Political Power." *Artweek* 19 (October 29, 1988): 3.

Yau, John. *John Buck: Woodblock Prints.* San Francisco, CA: The Fine Arts Museums of San Francisco, 1993.

CELMINS, VIJA

Bartman, William S. (ed.) *Vija Celmins interviewed by Chuck Close.* New York: A.R.T. Press and Distributed Art Publishers, 1992.

Field, Richard S. and Ruth E. Fine. *A Graphic Muse: Prints by Contemporary American Women.* South Hadley, MA: Mount Holyoke College Art Museum; New York: Hudson Hills Press, 1987. 59–63.

Tannenbaum, Judith, Douglas Blau, and Dave Hickewy. *Vija Celmins.* Philadelphia: Institute of Contemporary Art, University of Pennsylvania, 1992.

Ratcliff, Carter. "Vija Celmins: An Art of Reclamation." *Print Collector's Newsletter* 14, no. 6 (January–February 1984): 193–195.

CHASE, LOUISA

Field, Richard S. and Ruth E. Fine. *A Graphic Muse: Prints by Contemporary American Women.* South Hadley, MA: Mount Holyoke College Art Museum; New York: Hudson Hills Press, 1987. 64–67.

Henry, Gerrit. "New York Review: Louisa Chase." *Art News* 80, no. 6 (Summer 1981): 238.

Moorman, Margaret. "New Editions (Louisa Chase)." *Art News* 83, no. 8 (October 1984): 100.

Schwartz, Ellen. "Louisa Chase: I Want Everything at Once." *Art News* 80, no. 5 (May 1981): 81–82.

CLEMENTE, FRANCESCO

Geldzahler, Henry, et. al. *Francesco Clemente.* New York: Metropolitan Museum of Art, 1985.

Hawthorne, Don. "Prints from the Alchemist's Laboratory." *Art News* 85, no. 2 (February 1986): 89–95.

Henry, Gerrit. "'The Departure of the Argonaut:' A Departure for Clemente." *Print Collector's Newsletter* 17, no. 3 (July–August 1986): 87–89.

Percy, Ann, Raymond Foye, Stella Kramrisch and Ettore Sottsass. *Francesco Clemente: Three Worlds.* Philadelphia: The Philadelphia Museum of Art, 1990.

Rubinstein, Meyer R. "Singular Volumes: Artist's Collaborations with Harry Mathews." *Arts* 64, no. 7 (March 1990): 29–33.

CLOSE, CHUCK

Armstrong, Elizabeth and Sheila McGuire. *First Impressions: Early Prints by Forty-Six Contemporary Artists.* Minneapolis: Walker Art Center; New York: Hudson Hills Press, 1989. 82–83.

Chuck Close: Editions: A Catalogue Raisonné and Exhibition. Youngstown, OH: Butler Institute of American Art, 1989.

Chuck Close: Recent Works. New York: Pace Gallery, 1993.

Curtis, Verna Posever. "The Photograph and the Grid," essay in *Chuck Close-Handmade Paper Editions — David Hockney: Photo-Composites.* Milwaukee, WI: Milwaukee Art Museum, 1984.

———. "Through the Grid: Chuck Close and David Hockney." *Tamarind Papers* 10, no. 2 (Fall 1987): 54–63.

Lyons, Lisa and Martin Friedman, eds. *Close Portraits.* Minneapolis: Walker Art Center, 1980.

Schapiro, Michael. "Changing Variables: Chuck Close & His Prints." *Print Collector's Newsletter* 9, no. 3 (July–August 1978): 69–73.

Solomon, Richard. *Chuck Close, Handmade Paper Editions.* New York: Pace Gallery, 1982.

COTTINGHAM, ROBERT

Landwehr, William C. and John Arthur. *Robert Cottingham: A Print Retrospective 1972–1986.* Springfield, MO: Springfield Art Museum, 1986 (includes a catalogue raisonné).

Marcus, Stanley E. "Photorealism by Design." *Artweek* 17 (April 12, 1986): 3.

CUMMING, ROBERT

Heartney, Eleanor. "Mechanical Illusions by Robert Cumming." *Art News* 85, no. 9 (November 1986): 137.

Stevens, Andrew. *Visions and Revisions: Robert Cumming's Works on Paper.* Madison, WI: Elvehjem Museum of Art, University of Wisconsin-Madison, 1991.

Rathbone, Belinda. "Robert Cumming: An Update." *Print Collector's Newsletter* 19, no. 5 (November–December 1988): 169–173.

DIEBENKORN, RICHARD

Newlin, Richard. *Richard Diebenkorn: Works on Paper*. Houston, TX: Houston Fine Art Press, 1987.

Nordland, Gerald. *Richard Diebenkorn: Graphics 1981–1988*. Billings, MT: Yellowstone Art Center, 1989.

Plous, Phyllis. *Richard Diebenkorn: Intaglio Prints 1961–1978*. Santa Barbara, CA.: The University of California Santa Barbara Art Museum, 1979.

Richard Diebenkorn: Works on Paper from the Harry W. Anderson Collection. Los Angeles: Fisher Gallery of the University of Southern California, 1993.

Stevens, Mark and Kathan Brown. *Richard Diebenkorn: Etchings and Drypoints 1949–1980*. Houston, TX: Houston Fine Art Press, 1981 (includes a catalogue raisonné).

DINE, JIM

Armstrong, Elizabeth and Sheila McGuire. *First Impressions: Early Prints by Forty-Six Contemporary Artists*. Minneapolis: Walker Art Center; New York: Hudson Hills Press, 1989. 30–33.

Barrett, Cyril. "Jim Dine's London." *Studio International* 172, no. 881 (September 1966): 122–123.

Beal, Graham W. *Jim Dine: Five Themes*. Minneapolis: Walker Art Center; New York: Abbeville Press, 1984.

Dine, Jim. "Two Artists Discuss their Recent Work: Allen Jones and Jim Dine." *Studio International* 175, no. 901 (June 1968): 337.

Gilmour, Pat. "Symbiotic Exploitation or Collaboration: Dine & Hamilton with Crommelynck." *Print Collector's Newsletter* (January–February 1985): 193–198.

Glenn, Constance. *Jim Dine Drawings*. New York: Harry N. Abrams, 1985 (includes a conversation with Dine).

Gruen, John. "Jim Dine and the Life of Objects" *Art News* 76, no. 7 (September 1977): 38–43.

Hennessey, Susie. "A Conversation with Jim Dine." *Art Journal* 39, no.3 (Spring 1980): 168–75.

Jim Dine: The Hand-Coloured Viennese Hearts 1989–90. London: Waddington Graphics, and New York: Pace Prints, 1990.

Jim Dine: Recent Graphics. Hanover, NH: Hopkins Center Art Galleries, Dartmouth College, 1974.

Krens, Thomas. *Jim Dine Prints: 1970–1977*. New York: Harper & Row, in conjunction with Williams College, 1977.

Metropolitan Museum of Art. *Prints by Five New York Painters: Jim Dine, Roy Lichtenstein, Robert Rauschenberg, Larry Rivers and James Rosenquist*. New York: Metropolitan Museum of Art, 1969.

Noël, Bernard. *Jim Dine: Monotypes et Gravures*. Paris: Galerie Maeght, 1983.

D'Oench, Ellen G. and Jean E. Feinberg. *Jim Dine Prints 1977–1985*.

Middletown, CT: Wesleyan University; New York: Harper & Row, 1986.

Robinson, Frank and Michael Shapiro. "Jim Dine at 40." *Print Collector's Newsletter* 7, no. 4 (September–October 1976): 101– 105.

Rise Up, Solitude! Prints 1985–86. New York: Pace Prints, 1986.

Russell, John, Tony Towle, and Wieland Schmied. *Jim Dine: Complete Graphics*. Berlin: Galerie Mikro; London: Petersburg Press, 1970.

Sparks, Esther and Amei Wallach. *Universal Limited Art Editions: A History and Catalogue, the First Twenty-Five Years*. Chicago: Art Institute of Chicago; New York: Harry N. Abrams, 1989. 57–69, 299–311.

FRANCIS, SAM

Feinblatt, Ebria and Jan Butterfield. *Sam Francis Monotypes*. Los Angeles, CA: Los Angeles County Museum of Art, 1980.

Fine, Ruth E. *Gemini G.E.L.: Art and Collaboration*. Washington, DC: National Gallery of Art; New York: Abbeville Press, 1984. 179–189.

Francis, Sam and George Page. *Sam Francis: The Litho Shop, 1970–1979*. New York: Brooke Alexander, 1979.

Hoyer, Annelisa. *Sam Francis Drawings and Lithographs*. San Francisco, CA: San Francisco Museum of Art, 1967.

Lembark, Connie W., ed., and Ruth Fine. *The Prints of Sam Francis: A Catalogue Raisonné, 1960–1990*. New York: Hudson Hills Press, 1992.

Sam Francis: 55 Lithographs 1960–1973. Bonn: Galerie Pudelko, 1977.

Sam Francis: Etchings 1973–1985. Bern: Galerie Kornfeld, 1985.

Sam Francis: Montotypes et Peintures. Saint-Paul, France: Fondation Maeght, 1983.

Sam Francis: Works on Paper, A Survey 1948–1979. Boston, MA: The Institute of Contemporary Art and the United States International Communication Agency, 1981.

Schneider, Pierre. *Sam Francis at Gemini*. Los Angeles: Gemini G.E.L., 1971,

Selz, Peter. *Sam Francis*. New York: Harry N. Abrams, Inc., 1982 (includes an essay on Francis's prints by Susan Einstein).

Sparks, Esther and Amei Wallach. *Universal Limited Art Editions: A History and Catalogue, the First Twenty-Five Years*. Chicago: Art Institute of Chicago; New York: Harry N. Abrams, 1989. 71–73, 312.

Wilder, Nicholas. *Sam Francis: Lithographs at Gemini G.E.L. 1975–1977*. Los Angeles: Gemini G.E.L., 1977.

FRANKENTHALER, HELEN

Fine, Ruth. *Helen Frankenthaler: Prints*. Washington, D.C.: National Gallery of Art; New York: H. N. Abrams, 1993.

Frankenthaler, Helen. "The Romance of Learning a New Medium for An Artist." *Print Collector's Newsletter* 8, no. 3 (July–August 1977): 66–67.

Harrison, Pegram. *Frankenthaler Prints: Catalogue Raisonné 1961–1992*. Barcelona: Ediciones Poligraphia (forthcoming in 1994).

Helen Frankenthaler: an Exhibition of Monotypes Made at the Experimental Workshop in San Francisco. New York: Andre Emmerich Gallery, 1982.

Helen Frankenthaler: Ediciones Poligrafa. New York: Galeria Joan Prats, 1988.

Krens, Thomas. *Helen Frankenthaler: Prints 1961–1979.* New York: Harper & Row, 1980.

Prints by Four New York Painters: Helen Frankenthaler, Jasper Johns, Robert Motherwell, and Barnett Newman. New York: Metropolitan Museum of Art, 1969.

Sparks, Esther and Amei Wallach. *Universal Limited Art Editions: A History and Catalogue, the First Twenty-Five Years.* Chicago: Art Institute of Chicago; New York: Harry N. Abrams, 1989. 74–91, 313–324.

Wilkin, Karen. *Frankenthaler, Works on Paper 1949–1984.* New York: G. Braziller and International Exhibitions Foundation, 1984.

GILLIAM, SAM

Allen, Jane Addams. "Letting Go." *Art in America* 74, no. 1 (January 1986): 98–105.

Sam Gilliam: Paintings and Works on Paper. Louisville, KY: J.B. Speed Art Museum, 1976.

GROOMS, RED

Alexander, Brooke and Virginia Cowles, with an essay by Paul Richard. *Red Grooms: A Catalog Raisonné of His Graphic Work 1957–1981.* Nashville: The Cheekwood Fine Arts Center, 1981.

Stein, Judith, John Ashberry, and Janet K. Cutler. *Red Grooms: A Retrospective, 1956–1984.* Philadelphia, Pennsylvania Academy of Fine Arts, 1985.

HARTIGAN, GRACE

Barber, Allen. "Making Some Marks." *Arts* 48 (June 1974): 49–51.

Mattison, Robert Saltonstall. *Grace Hartigan: A Painter's World.* New York: Hudson Hills Press, 1990.

Nemser, Cindy. "Grace Hartigan." In *Art Talk: Conversations with Twelve Women Artists.* New York: Scribner's, 1975: 149–78.

Sparks, Esther and Amei Wallach. *Universal Limited Art Editions: A History and Catalogue, the First Twenty-Five Years.* Chicago: Art Institute of Chicago; New York: Harry N. Abrams, 1989. 116–121, 341–345.

HAYNES, NANCY

Clark, Trinkett. *Parameters: Nancy Haynes.* Norfolk, VA: The Chrysler Museum, 1992.

HOCKNEY, DAVID

Australian National Gallery. *David Hockney Prints.* Canberra, Australia: Australian National Gallery, 1976.

Brighton, Andrew. *David Hockney Prints, 1954–1977.* Nottingham, England: Midland Group Gallery and the Scottish Arts Council; London: Petersburg Press, 1979.

Butterfield, Jan. "David Hockney: Blue Hedonistic Pools." *Print Collector's Newsletter* 10, no. 3 (July–August 1979): 73–76.

Clothier, Peter. *David Hockney.* New York: Abbeville, 1995.

Curtis, Verna Posever. "Through the Grid: Chuck Close and David Hockney." *Tamarind Papers* 10, no. 2 (Fall 1987): 54–63.

David Hockney: 23 Lithographs 1978–1980. Bedford Village, NY: Tyler Graphics, Ltd., 1980.

David Hockney: Dessins et Gravures. Paris: Galerie Claude Bernard, 1975.

David Hockney: Prints and Drawings. Washington, DC: International Exhibitions Foundation, 1978.

Glazebrook, Mark. *David Hockney: Paintings, Prints and Drawings 1960–1970.* London: Whitechapel Art Gallery, 1970.

Hockney, David. "Colin Self and David Hockney Discuss their Recent Work." *Studio International* 176, no. 906 (December 1968): 278.

Livingstone, Marco. *David Hockney: Etchings and Lithographs.* London: Thames and Hudson and Waddington Graphics, 1988.

Silver, Kenneth. E. *David Hockney.* New York: Rizzoli, 1994.

Stangos, Nikos, ed., and David Hockney. *Paper Pools.* New York: Harry N. Abrams, Inc., 1980.

Towle, Tony. "Notes on Jim Dine's Lithographs" *Studio International* 179, no. 921 (April 1970): 165–168.

JACQUETTE, YVONNE

Armstrong, Elizabeth and Sheila McGuire. *First Impressions: Early Prints by Forty-Six Contemporary Artists.* Minneapolis: Walker Art Center; New York: Hudson Hills Press, 1989. 89–91.

Burke, James D. *Currents: 22, Yvonne Jacquette.* St. Louis: St. Louis Art Museum, 1983.

Denby, Edwin, ed. *Aerial: a Collection of Poetry* (images by Yvonne Jacquette). New York: Eyelight Press, 1981.

Field, Richard S. and Ruth E. Fine. *A Graphic Muse: Prints by Contemporary American Women.* South Hadley, MA: Mount Holyoke College Art Museum; New York: Hudson Hills Press, 1987. 96–99.

Phillips, Jayne Anne. *Fast Lanes* (drawings by Yvonne Jacquette). New York: Vehicle Editions and Brooke Alexander, Inc., 1984.

Ratcliff, Carter. "Yvonne Jacquette: American Visionary." *Print Collector's Newsletter* 12, no. 3 (July–August 1981): 65–68.

JOHNS, JASPER

Armstrong, Elizabeth and Sheila McGuire. *First Impressions: Early Prints by Forty-Six Contemporary Artists.* Minneapolis: Walker Art Center; New York: Hudson Hills Press, 1989. 26–29.

Armstong, Elizabeth. *Jasper Johns: Printed Symbols.* With essays by Robert Rosenblum, John Yau, Charles W. Haxthausen, and James

Cuno and an inteview with Jasper Johns by Katrina Martin. Minneapolis: Walker Art Center, 1990.

Bernstein, Roberta. "Johns and Beckett: Foirades/Fizzles." *Print Collector's Newsletter* 7, no. 5 (November–December 1970): 141–145.

———. *Jasper Johns: The Seasons*. New York: Brooke Alexander Editions, 1991.

Carrow, Bernard and Manfred de la Motte. *Jasper Johns: die Graphik*. Hannover: Kunstverein Hannover, 1971.

Castleman, Riva. *Jasper Johns: A Print Retrospective*. New York: Museum of Modern Art, 1986.

Coplans, John. "Fragments According to Johns: an Interview with Jasper Johns." *Print Collector's Newsletter* 3, no. 2 (May–June 1972): 29–32.

Debs, Barbara Knowles. "On the Permanence of Change: Jasper Johns at the Modern." *Print Collector's Newsletter* 17, no. 4 (September–October 1986): 117–123.

Field, Richard S. *Jasper Johns: Prints 1960–1970*. Philadelphia: Philadelphia Museum of Art; New York: Praeger Publishers, 1970.

———. "Jasper Johns' Flags." *Print Collector's Newsletter* 7, no. 3 (July–August 1976): 69–77.

———. *Jasper Johns: Screenprints*. New York: Brooke Alexander, Inc. 1977.

———. *Jasper Johns: Prints 1970–1977*. Middletown, CT: Wesleyan University, 1978.

———. *Jasper Johns: Prints 1960–1993*. New York: Universal Limited Art Editions, 1994.

Fine, Ruth E. *Gemini G.E.L.: Art and Collaboration*. Washington, DC: National Gallery of Art; New York: Abbeville Press, 1984. 161–177.

Geelhaar, Christian. *Jasper Johns: Working Proofs*. Basel: Kunstmuseum Basel; London: Petersburg Press, 1979.

Gilmour, Pat. *Ken Tyler and the American Print Renaissance*. Canberra: Australian National Gallery, 1986. 55–60.

Goldman, Judith. *Jasper Johns: Prints 1977–1981*. Boston: Thomas Segal Gallery, 1981.

———. *17 Monotypes/Jasper Johns*. West Islip, NY: Universal Limited Art Editions, 1982.

Jasper Johns: Graphik. Bern: Kornfeld and Kliptein, 1971.

Jasper Johns: Gravures et Dessins de la Collection Castelli, 1960–1991. Arles, France: Fondation Vincent Van Gogh, 1992.

Jasper Johns: l'oeuvre graphique de 1960 à 1985. Saint-Paul, France: Fondation Maeght, 1986.

Larson, Philip. "Artist Bottoms Out in Love Nest with his own Shadow: Critics Claim One Thing Led to Another." *Print Collector's Newsletter* 21, no. 3 (July–August 1990): 89–91.

Rose, Barbara. "The Graphic Work of Jasper Johns: Part I." *Artforum* 8, no. 7 (March 1970): 39–45.

Rose, Barbara. "The Graphic Work of Jasper Johns: Part II." *Artforum* 9, no. 1 (September 1970): 65–74.

Rountree, Melissa, with Craig Allen Subler. *Jasper Johns: Collecting*

Prints. Augusta, GA: Morris Museum of Art, 1994.

Sparks, Esther and Amei Wallach. *Universal Limited Art Editions: A History and Catalogue, the First Twenty-Five Years*. Chicago: Art Institute of Chicago; New York: Harry N. Abrams, 1989. 122–149, 346–389.

Tallman, Susan. "Jasper Johns." *Arts* (September 1990): 17–18.

JUDD, DONALD

Loring, John. "Judding from Descartes, Sandbacking, and Several Tuttologies." *Print Collector's Newsletter* 7, no. 6 (January–February 1977): 165–168.

Schellmann, Jörg and Mariette Josephus Jitta, eds. *Donald Judd: Prints and Works in Editions. A Catalogue Raisonné*. Cologne and New York: Edition Schellmann, 1993.

Smith, Bryden. *Donald Judd: A Catalogue of the Exhibition at the National Gallery of Canada with a Catalogue Raisonné of Paintings, Objects and Wood Blocks 1960–1974*. Ottawa: National Gallery of Canada, 1975.

KARDON, DENNIS

Jayne, Kristie. "Richard Beckett, Dennis Kardon, Milo Rice." *Arts* 57, no. 10 (June 1983): 34.

KATZ, ALEX

Armstrong, Elizabeth and Sheila McGuire. *First Impressions: Early Prints by Forty-Six Contemporary Artists*. Minneapolis: Walker Art Center; New York: Hudson Hills Press, 1989. 51–53.

Maravell, Nicholas P. *Alex Katz: The Complete Prints*. New York: Alpine Fine Arts Collection, 1983 [includes an interview with Alex Katz by Carter Ratcliff].

Solomon, Elke M. and Richard S. Field. *Alex Katz: Prints*. New York: Whitney Museum of American Art, 1974.

Walker, Barry. *Alex Katz: A Print Retrospective*. Brooklyn, NY: The Brooklyn Museum, in association with Burton Skira Inc., 1987.

KELLY, ELLSWORTH

Armstrong, Elizabeth and Sheila McGuire. *First Impressions: Early Prints by Forty-Six Contemporary Artists*. Minneapolis: Walker Art Center; New York: Hudson Hills Press, 1989. 48–50.

Axsom, Richard H. and Phylis Floyd. *The Prints of Ellsworth Kelly: A Catalogue Raisonné 1949–1985*. New York: Hudson Hills Press, in association with The American Federation of Arts, 1987.

Coplans, John. *Ellsworth Kelly*. Los Angeles: Gemini G.E.L., 1970.

Debs, Barbara Knowels. "Ellsworth Kelly's Drawings." *Print Collector's Newsletter* 3, no. 4 (September–October 1972): 73–77.

Fine, Ruth E. *Gemini G.E.L.: Art and Collaboration*. Washington, DC: National Gallery of Art; New York: Abbeville Press, 1984. 127–143.

Upright, Diane. *Ellsworth Kelly: Works on Paper*. New York: Harry N. Abrams and Fort Worth, TX: Fort Worth Art Museum, 1987.

Waldman, Diane. *Ellsworth Kelly: Drawings, Collages, Prints.* Greenwich, CT: New York Graphic Society, 1971.

DE KOONING, WILLEM

Ashberry, John. "Willem de Kooning: A Suite of New Lithographs Translates his Famous Brushstroke into Black and White." *Art News Annual* 37 (1971): 117–128.

Fourcade, Xavier. ed. *Lithographs by de Kooning, Fairfield Porter, Paul Waldman.* New York: Knoedler Gallery, 1971.

Graham, Lanier. "The Prints of Willem de Kooning: An Illustrated Catalogue of His Editions 1960–1971." *Tamarind Papers* 2, (1988).

———— ed. *The Prints of Willem de Kooning: A Catalogue Raisonné Vol. I, 1957–1971.* Paris: Baudoin Lebon Editeur, 1991.

————. *Willem de Kooning: Printer's Proofs from The Collection of Irwin Hollander, Master-Printer.* New York: Salander-O'Reilly Gallery, 1991.

Larson, Philip. "Willem de Kooning: The Lithographs." *Print Collector's Newsletter* 5, no. 1 (March–April 1974): 6–7.

Mason, Rainer Michael. ed. *Willem de Kooning: Sculptures, Lithographies, Peintures.* Geneva: Musée d'Art et d'Histoire, 1977.

Willem de Kooning: Untitled. Los Angeles: Gemini G.E.L., 1972.

"Willem de Kooning, 'Untitled' (1986)." *Print Collector's Newsletter* 18, no. 3 (July–August 1987): 103.

KRUGER, BARBARA

Foster, Hal. "Subversive Signs." *Art in America* 70, no. 9 (November 1982): 88–92.

Linker, Kate. "Barbara Kruger Interview." *Flash Art* 121 (March 1985): 36–37.

————. *Love For Sale: The Words and Pictures of Barbara Kruger.* New York: Harry N. Abrams, Inc., 1990.

Owens, Craig. "The Medusa Effect, or, The Specular Ruse." *Art in America* 72, no. 1 (January 1984): 97–105.

KUSHNER, ROBERT

Bernstein, Roberta. "The Joy of Ornament: The Prints of Robert Kushner." *Print Collector's Newsletter* 11, no. 6 (January–February 1981): 194–197.

Gilmour, Pat. "Thorough Translators and Thorough Poets: Robert Kushner and His Printers." *Print Collector's Newsletter* 16, no. 5 (November–December 1985): 159–164.

White, Robin. "Interview with Robert Kushner at Crown Point Press." *View* (February–March 1980): 15.

Marshall, Richard. *Robert Kushner: Paintings on Paper.* New York: Whitney Museum of American Art, 1984.

LEVINE, SHERRIE

Buchloh, Benjamin H.D. "Allegorical Procedures: Appropriation and Montage in Contemporary Art." *Artforum* 21 (September 1982): 43–56.

Cameron, Dan. "Absence and Allure: Sherrie Levine's Recent Work." *Arts* 58 (December 1983): 84–87.

Siegel, Jeanne. "Uncanny Repetition: Sherrie Levine's Multiple Originals." *Arts* 66, no. 1 (September 1991): 31–35.

Tallman, Susan. "Meltdown" *Arts Magazine* 64, no. 8 (April 1990): 25–26.

LEWITT, SOL

Armstrong, Elizabeth and Sheila McGuire. *First Impressions: Early Prints by Forty-Six Contemporary Artists.* Minneapolis: Walker Art Center; New York: Hudson Hills Press, 1989. 69–71.

Legg, Alicia. ed. *Sol LeWitt.* New York: Museum of Modern Art, 1978 [essays by Lucy Lippard, Bernice Rose, and Robert Rosenblum].

Lewison, Jeremy. *Sol LeWitt: Prints 1970–1986.* London: Tate Gallery, 1986.

Sol LeWitt: Graphik 1970–1975. Siebdrucke, Lithographien, Radierungen, Bücher. Basel: Kunsthalle; and Bern: Verlag Kornfeld & Cie., 1976.

LICHTENSTEIN, ROY

Armstrong, Elizabeth and Sheila McGuire. *First Impressions: Early Prints by Forty-Six Contemporary Artists.* Minneapolis: Walker Art Center; New York: Hudson Hills Press, 1989. 36–37.

Coplans, John. *Roy Lichtenstein: Graphics, Reliefs and Sculpture 1969–1970.* Los Angeles: Gemini G.E.L., 1970.

————. "Lithographs and Original Prints; Lichtenstein's Graphic Works; Roy Lichtenstein in Conversation with John Coplans." *Studio International* (December 1970): 263–65.

Corlett, Mary Lee. *The Prints of Roy Lichtenstein: A Catalogue Raisonné.* Washington, DC: National Gallery of Art; New York: Hudson Hills Press, 1994

Cowart, Jack. *Roy Lichtenstein, 1970–1980.* New York: Hudson Hills Press, in conjunction with the St. Louis Museum of Art, 1981.

Fine, Ruth E. *Gemini G.E.L.: Art and Collaboration.* Washington, DC: National Gallery of Art; New York: Abbeville Press, 1984. 191–207.

Gilmour, Pat. *Ken Tyler and the American Print Renaissance.* Canberra: Australian National Gallery, 1986. 61–68.

Prints by Five New York Painters: Jim Dine, Roy Lichtenstein, Robert Rauschenberg, Larry Rivers and James Rosenquist. New York: Metropolitan Museum of Art, 1969.

Roy Lichtenstein: Graphics, Reliefs, and Sculpture, 1969–1970. Los Angeles, CA: University of California-Irvine Art Gallery, 1970.

Waldman, Diane. *Roy Lichtenstein: Drawings and Prints.* New York: Chelsea House Publishers, 1971.

Young, Joseph E. "Lichtenstein: Printmaker." *Art and Artists* 4, no. 1 (March 1970): 50–52.

LONGO, ROBERT

Armstrong, Elizabeth and Sheila McGuire. *First Impressions: Early Prints by Forty-Six Contemporary Artists*. Minneapolis: Walker Art Center; New York: Hudson Hills Press, 1989. 128–129.

Fox, Howard N. (ed.) *Robert Longo*. Los Angeles: Los Angeles County Museum of Art; New York: Rizzoli; 1989.

Prince, Richard. *Robert Longo: Men in the Cities*. New York: Harry N. Abrams, 1986.

Ratcliff, Carter. "Robert Longo: The City of Sheer Image." *Print Collector's Newsletter* 14, no. 3 (July–August 1983): 95–98.

———. *Robert Longo*. New York: Rizzoli International, 1985.

MANGOLD, SYLVIA PLIMACK

Field, Richard S. and Ruth E. Fine. *A Graphic Muse: Prints by Contemporary American Women*. South Hadley, MA: Mount Holyoke College Art Museum; New York: Hudson Hills Press, 1987. 110–114.

D'Oench, Ellen G. "Sylvia Plimack Mangold's Monoprints of the Provincetown Trees." *Print Collector's Newsletter* 23, no. 1 (March–April 1992): 9–11.

——— and Hilarie Faberman. *Sylvia Plimack Mangold: Works on Paper 1968–1991, With a Catalogue Raisonné of the Prints*. Middletown, CT: Wesleyan University; Ann Arbor, MI: University of Michigan Museum of Art, 1992.

Paoletti, John T. "Sylvia Plimack Mangold: Uses of the Past." *Arts* 57, no. 9 (May 1983): 90–93.

Ravenal, John B. "Sylvia Plimack Mangold: Framework." *Arts* 57, no. 9 (May 1983): 94–96.

MARDEN, BRICE

Brice Marden: Cold Mountain Studies. Munchen: Schirmer/Mosel, 1991

Gilmour, Pat. "The Prints of Brice Marden." *Print Collector's Newsletter* 23, no. 2 (May–June 1992): 49–52.

Lewison, Jeremy. *Brice Marden: Prints 1961–1991*. London: Tate Gallery, 1992.

Mignot, Dorine and Edy de Wilde. *Brice Marden, Paintings, Drawings, Etchings, 1975–80*. Amsterdam: Stedelijk Museum, 1981.

Richardson, Brenda. *Brice Marden — Cold Mountain*. Houston, TX: Houston Fine Art Press, 1992.

Serota, Nicholas, Stephen Bann, and Roberta Smith. *Brice Marden: Paintings, Drawings and Prints, 1975–80*. London: Whitechapel Art Gallery, 1981.

Steir, Pat. *Brice Marden: Recent Drawings and Etchings*. New York: Matthew Marks Gallery, 1991.

White, Robin. "Brice Marden Interview." *View* (1980): 1–24.

MAZUR, MICHAEL

Corbett, William. "Michael Mazur's New Work." *Arts* 59, no. 5 (January 1985): 114–115.

Halbreich, Kathy, Eugenia Parry, and Kathy Kline. *Wakeby Day Wakeby Night*. Cambridge, MA: Massachusetts Institute of Technology, 1983.

Michael Mazur. Chicago: The Arts Club of Chicago, 1985.

Robinson, Frank. *Michael Mazur: Vision of a Draughtsman*. Brockton, MA: Brockton Art Center, 1976.

Sandback, Amy Baker. "Not Fully Repeatable Information: Michael Mazur and Monotypes." *Print Collector's Newsletter* 21, no. 5 (November–December 1990): 180–181 (interview).

MILTON, PETER

McNulty, Kneeland and Peter Milton. *Complete Etchings 1960–1976*. Boston: Impressions Workshop, Inc., 1977.

———. *Prints by Peter Milton*. Washington, D.C.: International Exhibitions Foundation, 1977.

MOTHERWELL, ROBERT

Cohen, Arthur A. *Robert Motherwell: Selected Prints 1961–1974*. New York: Brooke Alexander Gallery, 1974.

Colsman-Freyberger, Heidi. "Robert Motherwell: Words and Images." *Print Collector's Newsletter* 4, no. 6 (January–February 1974): 125–129.

Kelder, Diane. "Motherwell's 'A la Pintura.'" *Art in America* 60, no. 5 (September–October 1972): 100–101.

Mattison, Robert S. "Two Decades of Graphic Art by Robert Motherwell." *Print Collector's Newsletter* 11, no. 6 (January–February 1981): 197–201.

Robert Motherwell: Collage Prints. Bedford Village, NY: Tyler Graphics, 1984.

Sparks, Esther and Amei Wallach. *Universal Limited Art Editions: A History and Catalogue, the First Twenty-Five Years*. Chicago: Art Institute of Chicago; New York: Harry N. Abrams, 1989. 164–194, 404–417.

Terenzio, Stephanie C. and Dorothy C. Belknap. *The Prints of Robert Motherwell: A Catalogue Raisonné 1943–1990* (3rd edition). New York: Hudson Hills Press, in association with The American Federation of Arts, 1991.

Tyler, Kenneth E. *Robert Motherwell: Summer Light Series*. Los Angeles: Gemini G.E.L., 1973.

MURRAY, ELIZABETH

Armstrong, Elizabeth and Sheila McGuire. *First Impressions: Early Prints by Forty-Six Contemporary Artists*. Minneapolis: Walker Art Center; New York: Hudson Hills Press, 1989. 114–117.

Becker, David P. and Keith S. Brintzenhofe. *Elizabeth Murray Prints 1979–1990*. Boston, MA: Barbara Krakow Gallery, 1990.

Brody, Jacqueline. "Elizabeth Murray, Thinking in Print." *Print Collector's Newsletter* 13, no. 3 (July–August 1982): 74–77 (interview).

Field, Richard S. and Ruth E. Fine. *A Graphic Muse: Prints by Contemporary American Women*. South Hadley, MA: Mount

Holyoke College Art Museum; New York: Hudson Hills Press, 1987. 119–125.

Murry, Jesse. "Quintet: The Romance of Order and Tension in Five Paintings by Elizabeth Murray." *Arts* 55 (May 1981): 102–105.

Simon, Joan. "Mixing Metaphors: Elizabeth Murray." *Art in America* 72, no. 4 (April 1984): 140–147.

NAUMAN, BRUCE

Armstrong, Elizabeth and Sheila McGuire. *First Impressions: Early Prints by Forty-Six Contemporary Artists*. Minneapolis: Walker Art Center; New York: Hudson Hills Press, 1989. 66–68.

Cordes, Christopher and Debbie Taylor. *Bruce Nauman: Prints 1970–1989. A Catalogue Raisonné*. New York: 1989.

Livingston, Jane and Marcia Tucker. *Bruce Nauman: Work from 1965 to 1972*. Los Angeles: Los Angeles County Museum of Art; New York: Praeger, 1972.

Tallman, Susan. "Clear Vision: The Prints of Bruce Nauman." *Arts* 64, no. 3 (November 1989): 17–18.

van Bruggen, Coosje. *Bruce Nauman*. New York: Rizzoli International, 1988.

NEWMAN, BARNETT

Davies, Hugh M. and Riva Castleman. *The Prints of Barnett Newman*. New York: The Barnett Newman Foundation, 1983.

Hess, Thomas B. *Barnett Newman*. New York: The Museum of Modern Art; Greenwich, CT: New York Graphic Society, 1971.

———. "Notes on Newman's 'Notes'." *The Print Collector's Newsletter*, vol. 2, no. 6 (January–February) 1972: 121–123.

Newman, Barnett. *Barnett Newman: Selected Writings and Interviews*. Berkeley: University of California Press, 1992.

Rosenberg, Harold. *Barnett Newman*. New York: Harry N. Abrams, Inc., 1978.

Sparks, Esther and Amei Wallach. *Universal Limited Art Editions: A History and Catalogue, the First Twenty-Five Years*. Chicago: Art Institute of Chicago; New York: Harry N. Abrams, 1989. 195–211, 418–429.

NEWMAN, JOHN

Princenthal, Nancy. "John Newman: Notes from a Conversation." *Print Collector's Newsletter* 19, no. 6 (January–February 1989): 209–212.

———. *Beyond the Zero: John Newman's Recent Prints, Drawings and Sculpture*. Mount Kisco, NY: Tyler Graphics, Ltd., 1990.

Saunders, Wade. "Talking Objects: Interviews with Ten Sculptors: John Newman." *Art In America* 73, no. 11 (November 1985): 128–129.

NUTT, JIM

Adrian, Dennis and Richard A. Born. *The Chicago Imagist Print: Ten Artists' Works, 1958–1987: A Catalogue Raisonné*. Chicago: The David and Alfred Smart Gallery, The University of Chicago, 1987.

Adrian, Dennis. "The Metaphysics of Perception in the Drawings of Jim Nutt." *Drawing* 15, (July–August 1993): 25–29.

Johnson, Ken. "Jim Nutt's Human Comedy." *Art In America* 80 (February 1992): 84–91.

OLDENBURG, CLAES

Armstrong, Elizabeth and Sheila McGuire. *First Impressions: Early Prints by Forty-Six Contemporary Artists*. Minneapolis: Walker Art Center; New York: Hudson Hills Press, 1989. 34–37.

Baro, Gene. *Claes Oldenburg: Drawings and Prints*. Secaucus, NJ: Wellfleet Books, 1988.

Bruggen, Coosje van. *Claes Oldenburg: Drawings, Watercolors and Prints*. Stockholm: Moderna Museet, 1977.

"Claes Oldenburg at Gemini." *Artist's Proof* 9 (1969).

Copland, John. "The Artist Speaks: Claes Oldenburg." *Art in America* 57, no. 2 (April 1967): 69–75.

Gilmour, Pat. *Ken Tyler and the American Print Renaissance*. Canberra: Australian National Gallery, 1986. 69–84.

Goldman, Judith. "Sort of a Commercial for Objects." *Print Collector's Newsletter* 2, no. 6 (January–February 1972): 117–121.

———. "The Case of the Baked Potatoes." *Print Collector's Newsletter* 3, no. 2 (May–June 1972):34–37.

Leavin, Margo. *Claes Oldenburg: Works in Edition*. Los Angeles: Margo Leavin Gallery, 1971.

———. *Claes Oldenburg: The Alphabet in L. A.* Los Angeles: Margo Leavin Gallery, 1975.

Oldenburg, Claes. *Notes*. Los Angeles: Gemini G.E.L., 1968.

Platzker, David (ed.). *Claes Oldenburg: Multiples in Retrospect, 1964–1990*. New York: Rizzoli International Publications, 1991.

Rose, Barbara. "The Airflow Multiple of Claes Oldenburg." *Studio International* 179, no. 923 (June 1970): 254–255.

Sparks, Esther and Amei Wallach. *Universal Limited Art Editions: A History and Catalogue, the First Twenty-Five Years*. Chicago: Art Institute of Chicago; New York: Harry N. Abrams, 1989. 212–214, 429.

PASCHKE, ED

Adams, Brooks. "The Progress of Ed Paschke." *Art in America* 70, no. 9 (October 1982) 114–122.

Adrian, Dennis, Linda L. Cathcart and Richard Flood. *Ed Paschke: Selected Works 1967–1981*. Chicago: Chicago Museum of Contemporary Art, 1982.

———. and Richard A. Born. *The Chicago Imagist Print: Ten Artists' Works, 1958–1987: A Catalogue Raisonné*. Chicago: The David and Alfred Smart Gallery, The University of Chicago, 1987.

Armstrong, Elizabeth and Sheila McGuire. *First Impressions: Early Prints by Forty-Six Contemporary Artists.* Minneapolis: Walker Art Center; New York: Hudson Hills Press, 1989. 78–79.

Benezra, Neil, with contributions by Dennis Adrian, Carol Schreiber and John Yau. *Ed Paschke.* Chicago: Art Institute of Chicago; New York: Hudson Hills Press, 1990.

Blinderman, Barry. "Ed Paschke: Reflections and Digressions on 'The Body Electric.'" *Arts* 56 (May 1982): 130–131.

PEARLSTEIN, PHILIP

Adrian, Dennis. "The Prints of Philip Pearlstein." *Print Collector's Newsletter* 4, no. 3 (July–August 1973): 49–52.

Drüchers, Alexander. *Philip Pearlstein: Drawings and Prints 1946–1972.* Berlin: Staatliche Museum, 1973.

Field, Richard S. *Philip Pearlstein: Prints, Drawings, Paintings.* Middletown, CT: Davison Art Center, Wesleyan University, 1979.

———— and William C. Landwehr. *The Lithographs and Etchings of Philip Pearlstein.* Springfield, MO: The Springfield Art Museum, 1978 (includes a catalogue raisonné of prints from 1958–1978).

Viola, Jerome. *Philip Pearlstein: Landscape Aquatints 1978–1980.* New York: Brooke Alexander Gallery, 1981.

RAUSCHENBERG, ROBERT

Alloway, Lawrence. *Rauschenberg: Graphic Art.* Philadelphia: Institute of Contemporary Art, University of Pennsylvania, 1970.

————. "Rauschenberg's Graphics." *Art and Artists* 5, no. 6 (September 1970): 18–23.

Armstrong, Elizabeth and Sheila McGuire. *First Impressions: Early Prints by Forty-Six Contemporary Artists.* Minneapolis: Walker Art Center; New York: Hudson Hills Press,1989. 42–44.

Cowart, Jack and James Elliott. *Prints from Untitled Press/Captiva Florida.* Hartford, CT: Wadsworth Atheneum, 1973.

Davis, Douglas M. "Rauschenberg's Recent Graphics." *Art in America* 57, no. 4 (July–August 1969): 90–95.

Feinstein, Roni. *Robert Rauschenberg: The Silkscreen Paintings, 1962–1964.* New York: Whitney Museum of American Art; Boston: Bullfinch Press, 1990.

Fine, Ruth E. *Gemini G.E.L.: Art and Collaboration.* Washington, DC: National Gallery of Art; New York: Abbeville Press, 1984. 105–125.

Foster, Edward A. *Robert Rauschenberg: Prints 1948/1970.* Minneapolis: Minneapolis Institute of Arts, 1970.

Garver, Thomas. H. *Robert Rauschenberg in Black and White: Paintings 1962–1963/Lithographs 1962–1967.* Balboa, CA: Newport Harbor Art Museum, 1969.

Gilmour, Pat. *Ken Tyler and the American Print Renaissance.* Canberra: Australian National Gallery, 1986. 47–53.

Ginsburg, Susan. "Rauschenberg's Dialogue." *Print Collector's Newsletter* 6, no. 6 (January–February 1976): 152–155.

Glueck, Grace. "Robert Rauschenberg's 'Revolvers.'" *New York Times* (May 27, 1967).

Henry, Gerrit. "Personal Retrenchment." *Art and Artists* 6, no. 11 (February 1972): 42–45.

Karshan, Donald. "Graphics 70: Robert Rauschenberg." *Art in America* 58, no. 6 (November–December 1970): 48–49.

Lippard, Lucy. *Robert Rauschenberg: Booster and 7 Studies.* Los Angeles: Gemini G.E.L., 1967.

Prints by Five New York Painters: Jim Dine, Roy Lichtenstein, Robert Rauschenberg, Larry Rivers and James Rosenquist. New York: Metropolitan Museum of Art, 1969.

Ratcliff, Carter. "Rauschenberg's Solvent-Transfer Drawings." *Print Collector's Newsletter* 18, no. 2 (May–June 1987): 49–51.

Rauschenberg at Graphicstudio. Tampa: Library Gallery, Universtiy of South Florida, 1974.

Rauschenberg Overseas Culture Exchange. Washington, DC: National Gallery of Art, 1991.

Robert Rauschenberg: Cardbirds. Los Angeles: Gemini G.E.L., 1971.

Robert Rauschenberg: Collagen, Grafiken, Multiples. Graz: Neue Galerie Landesmuseum Joanneum, 1977.

Robert Rauschenberg: Pages and Fuses. Los Angeles: Gemini G.E.L., 1974.

Saff, Donald. *7 Characters: Rauschenberg.* Los Angeles: 1983.

Seckler, Dorothy Gees. "The Artist Speaks: Robert Rauschenberg." *Art in America* 54, no. 3 (May–June 1966): 73–84.

Sparks, Esther and Amei Wallach. *Universal Limited Art Editions: A History and Catalogue, the First Twenty-Five Years.* Chicago: Art Institute of Chicago; New York: Harry N. Abrams, 1989. 215–238, 430–467.

Towle, Tony. "Rauschenberg: Two Collaborations—Robbe Grillet & Voznensky." *Print Collector's Newsletter* 10, no. 2 (May–June 1979): 37–41.

Tyler, Kenneth and Rosamund Felson. "Two Rauschenberg Paper Projects." Essay in *Paper — Art and Technology.* San Francisco: World Print Council, 1979, 81–86.

Young, Joseph E. "Pages and Fuses: An Extended View of Robert Rauschenberg." *Print Collector's Newsletter* 5, no. 2 (May–June 1974): 25–30.

RIVERS, LARRY

Armstrong, Elizabeth and Sheila McGuire. *First Impressions: Early Prints by Forty-Six Contemporary Artists.* Minneapolis: Walker Art Center; New York: Hudson Hills Press, 1989. 22–25.

Hunter, Sam. *Larry Rivers.* New York: Rizzoli, 1989.

Prints by Five New York Painters: Jim Dine, Roy Lichtenstein, Robert Rauschenberg, Larry Rivers and James Rosenquist. New York: Metropolitan Museum of Art, 1969.

Rivers, Larry. "My Life Among the Stones." *Location* (Spring 1983).

Rivers, Larry with Carol Brightman. *Drawings and Digressions*. New York: Clarkson N. Potter, Inc., 1979.

Sparks, Esther and Amei Wallach. *Universal Limited Art Editions: A History and Catalogue, the First Twenty-Five Years*. Chicago: Art Institute of Chicago; New York: Harry N. Abrams, 1989. 239–255, 468–502.

ROCKMAN, ALEXIS

Armstrong, Richard. *Alexis Rockman*. Pittsburgh, PA: The Carnegie Museum of Art, 1992.

Blau, Douglas. *Alexis Rockman*. New York: Jay Gorney Gallery and Los Angeles, CA: Tom Solomon's Garage, 1992.

Dion, Mark. "The Origin of Species: Alexis Rockman on the Prowl." *Flash Art* (October 1993).

Martin, Richard. "Alexis Rockman: An Art Between Taxonomy and Taxidermy." *Arts* 62 (October 1987): 2–24.

Morales, Juan. "Solid as a Rockman." *Detour Magazine* (November 1993).

Paparoni, Demetrio. "Alexis Rockman." *Tema Celeste* (Italian edition–Trieste), January 1994.

Schwartz, Arturo. "Il modelo interiore." *Tema Celeste* (Italian edition–Trieste), January 1994.

ROSENQUIST, JAMES

Armstrong, Elizabeth and Sheila McGuire. *First Impressions: Early Prints by Forty-Six Contemporary Artists*. Minneapolis: Walker Art Center; New York: Hudson Hills Press, 1989. 38–39.

Bernstein, Roberta. "Rosenquist Reflected: The Tampa Prints." *Print Collector's Newsletter* 4, no. 1 (March–April 1973) 6–8.

Bloem, Marja. *Rosenquist* (Catalog of his lithographic work). Amsterdam: Stedelijk Museum, 1973.

Glenn, Constance W. *James Rosenquist: Time Dust. Complete Graphics 1962–1992*. New York: Rizzoli, 1993.

Goldman, Judith. *James Rosenquist: Welcome to the Water Planet and House of Fire 1988–1989*. Mt. Kisco, New York: Tyler Graphics, Ltd., 1989.

James Rosenquist: Gemalde, Raume, Graphik. Koln: J. P. Bachem, 1972.

Saff, Donald J. *James Rosenquist at USF*. Tampa: University of South Florida, 1988.

Sparks, Esther and Amei Wallach. *Universal Limited Art Editions: A History and Catalogue, the First Twenty-Five Years*. Chicago: Art Institute of Chicago; New York: Harry N. Abrams, 1989. 256–269, 503–510.

Swenson, Gene. "Social Realism in Blue: an interview with James Rosenquist." *Studio International* 175, no. 897 (February 1968): 76–83.

Tucker, Marcia. *James Rosenquist*. New York: Whitney Museum of American Art, 1972.

Varian, Elayne H. *James Rosenquist Graphics Retrospective*. Sarasota, Florida: John and Mable Ringling Museum of Art, 1979.

Yau, John. *James Rosenquist: Never Mind: From Thoughts to Drawing*. New York: Universal Limited Art Editions, 1990.

ROTHENBERG, SUSAN

Ackley, Clifford. "I Don't Really Think of Myself as a Printmaker: Susan Rothenberg." *Print Collector's Newsletter*, vol. 15, no. 5, (September–October 1984): 128.

Armstrong, Elizabeth and Sheila McGuire. *First Impressions: Early Prints by Forty-Six Contemporary Artists*. Minneapolis: Walker Art Center; New York: Hudson Hills Press, 1989. 98–99.

Field, Richard S. and Ruth E. Fine. *A Graphic Muse: Prints by Contemporary American Women*. South Hadley, MA: Mount Holyoke College Art Museum; New York: Hudson Hills Press, 1987. 139–143.

Friedman, Ceil. *Susan Rothenberg Prints 1977–1984*. Boston: Barbara Kracow Gallery, 1984.

Goldman, Judith. *Three Printmakers: Jennifer Bartlett, Susan Rothenberg, Terry Winters*. New York: Whitney Museum of American Art, 1986.

Herrera, Hayden. "In a Class by Herself." *Connoisseur* (April 1984): 112–117.

Maxwell, Rachel Robertson, et al. *Susan Rothenberg: The Prints*. Philadelphia: Peter Maxwell, 1987. (A catalogue raisonné.)

Nilson, Lisbet. "Susan Rothenberg." *Art News* 83, no. 2 (February 1984): 47–54.

Rathbone, Eliza. *Susan Rothenberg*. Washington, DC: Phillips Collection, 1985.

Simon, Joan. *Susan Rothenberg*. New York: Harry N. Abrams, 1991.

RUSCHA, EDWARD

Armstrong, Elizabeth and Sheila McGuire. *First Impressions: Early Prints by Forty-Six Contemporary Artists*. Minneapolis: Walker Art Center; New York: Hudson Hills Press, 1989. 45–47.

Bogle, Andrew. *Graphic Works by Edward Ruscha*. Aukland, New Zealand: Auckland City Art Gallery, 1978.

Edward Ruscha: Prints and Publications, 1962–74. London: Arts Council of Great Britain, 1975.

Foster, Edward A. *Edward Ruscha: (Ed-werd Rew-shay) Young Artist*. Minneapolis: Minneapolis Institute of Arts, 1972.

Fox, Christopher. "Ed Ruscha discusses his latest work with Christopher Fox." *Studio International* 179, no. 923 (June 1990): 281.

Hickey, David and Peter Plagens. *The Works of Edward Ruscha*. San Francisco: San Francisco Museum of Modern Art; New York: Hudson Hills Press, 1982.

Larson, Philip. "Ruscha in Minneapolis." *Print Collector's Newsletter* 3, no. 3 (July–August 1972): 52–54.

Pindell, Howardena. "Words With Ruscha." *Print Collector's Newsletter* 3, no. 6 (January–February 1973): 125–128.

SCHAPIRO, MIRIAM

Broude, Norma. "Miriam Schapiro and 'Femmage': Reflections on the Conflict between Decoration and Abstraction in Twentieth-Century Art." In *Feminism and Art History — Questioning the Litany*, edited by Norma Broude and Mary D. Garrard. New York: Harper and Row, 1982. 315–329.

Garver, Thomas H. *Paul Brach and Miriam Schapiro: Paintings and Graphic Works*. Balboa, CA: Newport Harbor Art Museum, 1969.

Gouma-Peterson, Thalia. *Miriam Schapiro A Retrospective: 1953–1980*. Wooster, OH: The College of Wooster Art Museum, 1980.

———. "The Theater of Life and Illusion in Miriam Schapiro's Recent Work." *Arts* 60, no. 7 (March 1986): 38–43.

Sanford, Christy, and Pamela Daniels, eds. "An Interview with Miriam Schapiro." *Women Artists News* 11 (Spring 1986): 22–26.

SCHNABEL, JULIAN

Adams, Brooks, Donald Kuspit, and Jorg Zutter. *Julian Schnabel: Arbeiten auf Papier, 1975–1988*. Munchen: Prestel, 1989.

Julian Schnabel: Works on Paper 1976–1992. New York: Matthew Marks Gallery, 1992.

Zutter, Jörg, Donald Kuspit and Brooks Adams. *Julian Schnabel: Works on Paper 1975–1988*. Basel: Museum für Gegenwartskunst, 1990.

SCULLY, SEAN

Auchincloss, Pamela. *Sean Scully, Monotypes from the Garner Tullis Workshop*. Santa Barbara, CA: Pamela Auchincloss Gallery, 1987.

Lewallen, Constance. "Sean Scully: An Interview with the Artist." *View* 5 (1985).

Meyers, Michelle. *Sean Scully, Donald Sultan: Abstraction, Representation*. Stanford, CA: Stanford University Museum of Art, 1990.

Poirier, Maurice. *Sean Scully*. New York: Hudson Hills Press, 1990.

Ratcliff, Carter (with intro. by Catherine Lampert). *Sean Scully: Paintings and Works on Paper 1982–1988*. London: Whitechapel Art Gallery, 1989.

SERRA, RICHARD

Hoppe-Sailer, Richard. *Richard Serra: Prints: A Catalogue Raisonné*. Bochum: Galerie für Film, Foto, Neue Koncrete Kunst und Video, 1988.

Princenthal, Nancy. "The 'Afangar Icelandic Series': Serra's Recent Etchings." *Print Collector's Newletter* 22, no. 5 (November–December 1991): 158–160.

Richard Serra at Gemini 1980–81. Los Angeles, CA: Gemini G.E.L., 1982.

Richard Serra at Gemini 1983–1987. Los Angeles, CA: Gemini G.E.L., 1988.

Wortz, Melinda. "Richard Serra: Prints." *Print Collector's Newsletter* 17, no. 1 (March–April 1986): 5–7.

SHAPIRO, JOEL

Bass, Ruth. "Minimalism Made Human." *Art News* 86, no. 3 (March 1987): 94–101.

Princenthal, Nancy. "Against the Grain: Joel Shapiro's Prints." *Print Collector's Newsletter* 20, no. 4 (September–October 1989): 121–123.

Ratcliff, Carter. "Joel Shapiro's Drawings." *Print Collector's Newsletter* (March–April 1978): 1–4.

Smith, Roberta. *Joel Shapiro*. New York: Whitney Museum of American Art, 1982.

SHIELDS, ALAN

Armstrong, Elizabeth and Sheila McGuire. *First Impressions: Early Prints by Forty-Six Contemporary Artists*. Minneapolis: Walker Art Center; New York: Hudson Hills Press, 1989. 62–63.

Cohen, Ronnie H. *Alan Shields: Print Retrospective*. Cleveland: Cleveland Center for Contemporary Art, 1986.

Pindell, Howardena. "Tales of Brave Ulysses: Alan Shields Interviewed." *Print Collector's Newsletter* 5, no. 6 (January–February 1975): 137–143.

SIGLER, HOLLIS

Donato, Debora Duez. *Hollis Sigler. Breast Cancer Journal: Walking With the Ghosts of My Grandmothers*. Rockford, IL: Rockford College Art Gallery, 1993.

Guenther, Bruce. *States of War: New European and American Paintings*. Seattle: Seattle Art Museum, 1985.

Lyons, Lisa. *Eight Artists: The Anxious Edge*. Minneapolis, MN: Walker Art Center, 1982.

Posner, Helaine. *Domestic Tales*. Amherst, MA: University Gallery, University of Massachusetts–Amherst, 1984.

Scott, Steven. *The Visual Confessions of Hollis Sigler* (unpublished Master's Thesis). College Park, MD: The University of Maryland, 1988.

Tannenbaum, Barbara. *Hollis Sigler*. Akron, OH: Akron Art Museum, 1986.

SNYDER, JOAN

Field, Richard S. and Ruth E. Fine. *A Graphic Muse: Prints by Contemporary American Women*. South Hadley, MA: Mount Holyoke College Art Museum; New York: Hudson Hills Press, 1987. 148–152.

Herrera, Hayden. *Joan Snyder: Seven Years of Work*. Purchase, NY: Neuberger Museum, 1978.

McNear, Sarah Anne. *Joan Snyder: Works with Paper.* Allentown, PA: Allentown Art Museum, 1993.

Walls, Michael. *Joan Snyder.* San Francisco, CA: San Francisco Art Institute, 1979.

SOLIEN, T. L.

Armstrong, Elizabeth and Sheila McGuire. *First Impressions: Early Prints by Forty-Six Contemporary Artists.* Minneapolis: Walker Art Center; New York: Hudson Hills Press, 1989. 124–125.

Sherman, Roger, et. al. *T. L. Solien.* Moorhead, MN: Plains Art Museum, 1988.

SORMAN, STEVEN

Armstrong, Elizabeth and Sheila McGuire. *First Impressions: Early Prints by Forty-Six Contemporary Artists.* Minneapolis: Walker Art Center; New York: Hudson Hills Press, 1989. 102–103.

Bass, Ruth. "Steven Sorman." *Arts* 58 (February 1984): 12.

Larson, Philip. "If You Want the Print To Stay, Paste It Down: Steven Sorman at Tyler Graphics." *Print Collector's Newsletter* 20, no. 3 (July–August 1989): 90–94.

Larson, Philip. "Steven Sorman: An Interview." *Print Collector's Newsletter* 11, no. 2 (May–June 1980): 42–44.

Riddle, Mason. "Steven Sorman: New Monoprints and Variant Editions." *Print Collector's Newsletter* 16, no. 1 (March–April 1985): 11–12.

Sorman, Steven and Clinton Adams. "Leading Into the Work: A Conversation about Making Prints." *Tamarind Papers* 10, no. 1 (Spring 1987): 4–15.

STEIR, PAT

Armstrong, Elizabeth and Sheila McGuire. *First Impressions: Early Prints by Forty-Six Contemporary Artists.* Minneapolis: Walker Art Center; New York: Hudson Hills Press, 1989. 92–93.

Broun, Elizabeth. *Form, Illusion, Myth: Prints and Drawings of Pat Steir.* Lawrence, KS: Spencer Museum of Art, The University of Kansas, 1983.

Brown, Kathan. *Pat Steir.* San Francisco, CA: Crown Point Press, 1981 (includes an interview with the artist).

Field, Richard S. and Ruth E. Fine. *A Graphic Muse: Prints by Contemporary American Women.* South Hadley, MA: Mount Holyoke College Art Museum; New York: Hudson Hills Press, 1987. 153–158.

McEvilley, Thomas. *Pat Steir.* New York: Harry N. Abrams, 1994.

Pat Steir: Gravures/Prints 1976–1988. Genève: Cabinet des Etampes, Musée d'art et Histoire; London: The Tate Gallery, 1988.

Pat Steir: Who. Kyoto, Japan: Kyoto Shoin International Co., Ltd., 1991.

Willi, Juliane et. al. *Pat Steir: Gravures/Prints 1976–1988.* Geneva, Switzerland: Musée d'art et d'histoire; and London: The Tate Gallery, 1988.

STELLA, FRANK

Ackley, Clifford S. "Frank Stella's Big Football Weekend." *Print Collector's Newsletter* 12, no. 6 (January–February 1983): 207– 208.

Armstrong, Elizabeth and Sheila McGuire. *First Impressions: Early Prints by Forty-Six Contemporary Artists.* Minneapolis: Walker Art Center; New York: Hudson Hills Press, 1989. 60–61.

Axsom, Richard H. "Frank Stella's Graphics." *Print Collector's Newsletter* 11, no. 1 (March–April 1980): 1–3.

————. *The Prints of Frank Stella: A Catalogue Raisonné 1967–1982.* Ann Arbor: University of Michigan Museum of Art; New York: Hudson Hills Press, 1983.

————. "Looking at Prints: Grand Prix Print." *Art News,* 81, no. 7 (September 1982): 62–63.

Frank Stella: The Circuits Prints. Minneapolis, MN: Walker Art Center, 1988.

Frank Stella: Works and New Graphics. London: Institute of Contemporary Arts, 1985.

Gilmour, Pat. *Ken Tyler and the American Print Renaissance.* Canberra: Australian National Gallery, 1986. 77–79.

Goldman, Judith. *Frank Stella: Fourteen Prints with Drawings, Collages, and Working Proofs.* Princeton, NJ: The Art Museum, Princeton University, 1983.

————. *Frank Stella: Prints 1967–1982.* New York: Whitney Museum of American Art, 1983.

Hughes, Robert. *Frank Stella: The Swan Engravings.* Fort Worth, TX: Fort Worth Art Museum, 1984.

Leider, Philip. *Frank Stella: Star of Persia I and II, Black Series I.* Los Angeles: Gemini G.E.L., 1967.

Rubin, William. *Frank Stella: 1970–1987.* New York: The Museum of Modern Art and Boston: Little Brown, 1987.

STOCK, MARK

Gray, Don. "Mark Stock, Nancy Reese, Dan McCleary." *Art News* 86, no. 5 (May 1987): 164.

Huneven, Michelle. "The Butler's In Love." *California Magazine* 13, no. 5 (May 1988): 114.

STUART, MICHELLE

Beal, Graham. "On Art and Artists: Michelle Stuart." *Profile* (Video Data Bank, School of the Art Institute of Chicago), 1983.

Henry, Gerrit. "Michelle Stuart: Navigating Coincidence." *Print Collector's Newsletter* 18, no. 6 (January–February 1988): 193–195.

Lovelace, Carey. "Michelle Stuart's Silent Gardens." *Arts* 63, no. 1 (September 1988): 76–79.

Robins, Corinne. "Michelle Stuart: The Mapping of Myth and Time." *Arts* 51 (June 1976): 83–85.

Westfall, Stephen. "Melancholy Mapping." *Art in America* 75, no. 2 (February 1987): 104–109.

Wilson, William H. "Michelle Stuart's 'Green River Massachusetts: Variations': The Mapping of Time, Place, and Season in Books Without Words." *Print Collector's Newsletter* 13, no. 5 (November–December 1977): 135–136.

SULTAN, DONALD

Armstrong, Elizabeth and Sheila McGuire. *First Impressions: Early Prints by Forty-Six Contemporary Artists.* Minneapolis: Walker Art Center; New York: Hudson Hills Press, 1989. 109–111.

Dunlop, Ian and Lynne Warren. *Donald Sultan.* Chicago: Museum of Contemporary Art; New York: Harry N. Abrams, 1987.

Friedman, Ceil. *Donald Sultan Prints 1979–1985.* Boston: Barbara Krakow Gallery, 1985.

Henry, Gerrit. "Donald Sultan: His Prints." *Print Collector's Newsletter,* 16, no. 6 (January–February 1986): 193–195.

Ratcliff, Carter. "The Short Life of the Sincere Stroke." *Art in America* 71, no.1 (January 1983): 73–79, 139.

Meyers, Michelle. *Sean Scully, Donald Sultan: Abstraction, Representation.* Stanford, CA: Stanford University Museum of Art, 1990.

Walker, Barry. *Donald Sultan: A Print Retrospective.* New York: American Federation of Arts in association with Rizzoli, 1992.

THIEBAUD, WAYNE

Berkson, Bill and Robert Flynn Johnson. *Vision and Revision: Hand-colored Prints by Wayne Thiebaud.* San Francisco, CA: Chronicle Books, 1991.

Shone, Richard. *Wayne Thiebaud: Prints and Hand-Coloured Etchings.* London: Karsten Schubert Ltd., 1990,

Tsujimoto, Karen. *Wayne Thiebaud.* Seattle: University of Washington Press, in conjunction with the San Francisco Museum of Modern Art, 1985.

Wayne Thiebaud Graphics: 1964–1971. New York: Parasol Press, 1971.

Wayne Thiebaud: Paintings, Drawings, Graphics 1961–1983. Carlisle, PA: Dickinson College, 1983.

WARHOL, ANDY

Andy Warhol, Portrait Screenprints, 1965–1980. London: Arts Council of Great Britain, 1981 (includes "Andy Warhol" by Suzi Gablik).

Armstrong, Elizabeth and Sheila McGuire. *First Impressions: Early Prints by Forty-Six Contemporary Artists.* Minneapolis: Walker Art Center; New York: Hudson Hills Press, 1989. 40–41.

Castleman, Riva. *Andy Warhol, Graphik.* Dresden: Staatliche Kunstsammlungen, 1980.

———. *The Prints of Andy Warhol.* New York: The Museum of Modern Art, 1991.

Coplans, John and Jean Baudrillard and Bastian Heiner. *Andy Warhol: Silkscreens from the Sixties.* New York: The Estate and Foundation of Andy Warhol, 1988; and Mosel: Schirmer's Visuelle Bibliothek, 1990.

De Salvo, Donna (ed.). *Success is a Job in New York: The Early Art and Business of Andy Warhol.* New York: Grey Art Gallery and Study Center, New York University; Pittsburgh: The Carnegie Museum of Art, 1989. Essays by De Salvo, Ellen Lupton, J. Abbott Miller, and Trevor Fairbrother.

Feldman, Frayda and Jorg Schellmann (eds.). *Andy Warhol Prints: A Catalogue Raisonné.* New York: Ronald Feldman Fine Arts. Inc., Abbeville Press, and Editions Schellmann, 1989 (with introduction by Henry Geldzahler and essays by Roberta Bernstein and Rupert Smith).

Hapgood, Marilyn Oliver. *Wallpaper and the Artist: From Durer to Warhol* New York: Abbeville Press, 1992.

Josephson, Mary. "Warhol: The Medium as Cultural Artifact." Art in America 59, no. 3 (May–June 1971): 41–47.

Kraynak, Janet. *Andy Warhol: Unique Prints from the Estate of Rupert Jasen Smith.* New York: Vrej Baghoomian Gallery and the Fred Dorfman Gallery, 1991.

Livingstone, Marco. "Do it Yourself: Notes on Warhol's Techniques." *Andy Warhol: A Retrospective.* New York: The Museum of Modern Art; and Boston: Little, Brown, 1989. 63–78.

Malanga, Gerard. "A Conversation with Andy Warhol." *Print Collector's Newsletter* 1, no. 6 (January–February 1971) 125–127.

The Prints of Andy Warhol. Paris: The Cartier Foundation for Contemporary Art and Flammarion Press, 1991.

Ratcliff, Carter. *Andy Warhol.* New York: Abbeville Press, 1983.

Wünsche, Hermann. *Andy Warhol: Das Graphische Werk, 1962–1980.* Bonn: Bonner Universitäts Buchdruckerei, 1981. Catalogue raisonné in English, French, and German, with essays by Gerd Tuchel and Arl Vogel.

WESSELMANN, TOM

Fairbrother, Trevor J. *Tom Wesselmann: Graphics 1964–1977, A Retrospective of Work in Edition Form.* Boston: Institute of Contemporary Art, 1978.

Stealingworth, Slim. *Tom Wesselmann.* New York: Abbeville, 1980.

Hunter, Sam. *Tom Wesselmann.* New York: Rizzoli, 1994

WILEY, WILLIAM T.

Armstrong, Elizabeth and Sheila McGuire. *First Impressions: Early Prints by Forty-Six Contemporary Artists.* Minneapolis: Walker Art Center; New York: Hudson Hills Press, 1989. 86–88.

Beal, Graham W. J. and John Perreault. *Wiley Territory.* Minneapolis, MN: Walker Art Center, 1979.

Lewallen, Constance. *William T. Wiley at Crown Point Press.* San Francisco, CA: Crown Point Press, 1989.

Richardson, Brenda. *William T. Wiley: Graphics 1967–1979.* Chicago: Landfall Press, 1980.

White, Robin. "William Wiley. Honesty Lies Somewhere Between."
View 2 (May 1979).

WINTERS, TERRY

Ackley, Clifford. "`Double Standard': The Prints of Terry Winters."
The Print Collector's Newsletter 18, no. 4 (September–October
1987): 122–124.

Armstrong, Elizabeth and Sheila McGuire. *First Impressions: Early
Prints by Forty-Six Contemporary Artists.* Minneapolis: Walker Art
Center; New York: Hudson Hills Press, 1989. 126–127.

Goldman, Judith. *Three Printmakers: Jennifer Bartlett, Susan
Rothenberg, Terry Winters.* New York: Whitney Museum of
American Art, 1986.

Kertess, Klaus, and Martin Kunz. *Terry Winters.* Lucerne: Kustmuseum
Luzern, 1985 (in English and German).

Knight, Christopher and Phyllis Plous. *Terry Winters: Painting and
Drawing.* Santa Barbara: University of California Santa Barbara Art
Museum; Seattle: University of Washington Press, 1987.

Phillips, Lisa and Klaus Kertess. *Terry Winters.* New York: Whitney
Museum of American Art and Harry N. Abrams, 1991.

YUNKERS, ADJA

Acton, David, et. al. *Adja Yunkers. Prints: 1942–1982.* Albion, MI: Albion
College, 1982.

Adams, Clinton. *Adja Yunkers Woodcuts 1927–1966.* New York:
Associated American Artists, 1988.

Conway, Robert P. and David Acton. *Adja Yunkers: Paintings, Drawings
& Prints 1940–1983.* New York: Associated American Artists, 1990.

Johnson, Una E. and Jo Miller. *Adja Yunkers: Prints 1927–1967.* Brooklyn,
NY: The Brooklyn Museum, 1969.

INDEX

Page numbers in *italics* refer to illustrations.